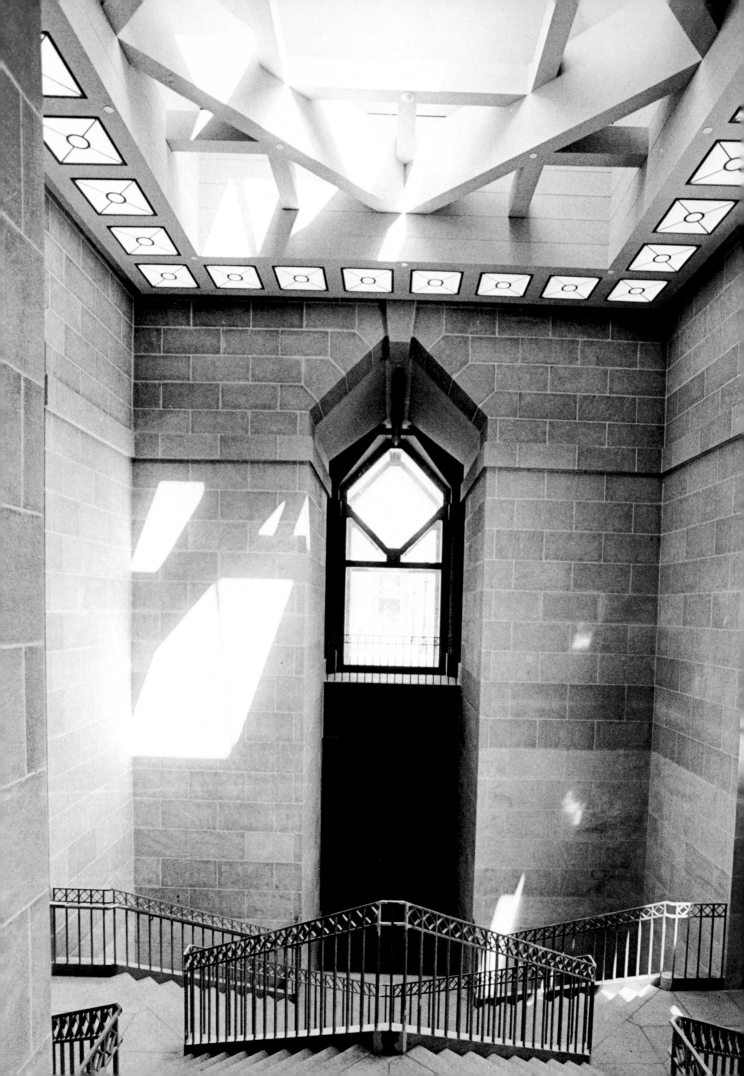

The Inaugural Gift

Asian Art

in the Arthur M. Sackler Gallery

Thomas Lawton
Shen Fu
Glenn D. Lowry
Ann Yonemura
Milo C. Beach

Arthur M. Sackler Gallery, Smithsonian Institution, Washington, D.C.

Published on the occasion of the opening
of the Arthur M. Sackler Gallery
Smithsonian Institution, Washington, D.C.
September 1987

Library of Congress
Cataloging-in-Publication Data

Arthur M. Sackler Gallery
(Smithsonian Institution)
Asian art in the Arthur M. Sackler Gallery.

Bibliography: p.
Includes index.
1. Art, Asian—Catalogs. 2. Art—Washington
(D.C.)—Catalogs. 3. Arthur M. Sackler Gallery
(Smithsonian Institution)—Catalogs. 1. Lawton,
Thomas, 1931 –
11. Title.
N7262.A78 1987 709'.5'0740153
86-33834
ISBN 0-87474-267-6 (pbk. : alk. paper)

Frontispiece: Interior, Arthur M. Sackler Gallery
pavilion
Cover: The Arthur M. Sackler Gallery
Cover and frontispiece photography by Kim
Nielsen

The paper used in this publication meets the
minimum requirements of the American
National Standard for Permanence of Paper for
Printed Materials z39. 48-1984.

Contents

ASIA AND THE NEAR EAST

SOVIET UNIO

BLACK SEA

• Istanbul
• Ankara
TURKEY

CASPIAN
SEA

MEDITERRANEAN
SEA

LEBANON
Beirut •

SYRIA

IRAQ

• Tehran

IRAN

Kabul •

Islamabad •

AFGHANISTAN

• Damascus

ISRAEL
Jerusalem •
Cairo •

• Amman
JORDAN

Baghdad

• Kuwait City

PAKISTAN

Delh •

EGYPT

KUWAIT

PERSIAN
GULF

QATAR
Doha •

SAUDI
ARABIA

• Riyadh

Abu Dhabi •

• Muscat

RED SEA

UNITED
ARAB
EMIRATES

OMAN

IND

ARABIAN
SEA

• Sanaa

NORTH
YEMEN

SOUTH
YEMEN

Aden •

GULF OF ADEN

Colomb

6

Foreword

ENLIGHTENED PHILANTHROPY has been an essential part of American cultural life ever since the founding of the republic. The Smithsonian Institution in Washington, D.C., which has played a vital role in our national cultural development for almost two centuries, was itself made possible by the gift of James Smithson, an Englishman who never visited the United States. Smithson's splendid bequest marked an auspicious beginning and, during the ensuing years, many other donors have contributed to the Institution established in his name.

The newest addition to the Smithsonian, a museum dedicated to the arts of Asia, is named for the late Dr. Arthur M. Sackler, the man who generously assisted in funding the construction of the building and whose collection of Asian art constitutes the basis of the museum's holdings. The magnitude of Dr. Sackler's gift, which includes Chinese, South and Southeast Asian, and Near Eastern objects, will be immediately apparent to visitors who attend the inaugural exhibition.

Trained in medicine, Dr. Sackler began collecting art after graduating from medical school. In the 1940s he focused on pre- and early Renaissance paintings as well as those of the Impressionists and post-Impressionists. At that time he also actively supported contemporary American painters. In 1950 Dr. Sackler started collecting Asian art, turning to Chinese ceramics and later to Chinese bronzes, jades, and sculpture along with Near Eastern and Indian sculpture and painting. Examples from his Asian collections have appeared in numerous major international exhibitions and publications, so that the scope and quality of his holdings are well known.

"I collect as a biologist," Dr. Sackler has said. "To really understand a civilization or a society, you must have a large enough corpus of data. You can't know twentieth-century art

by looking only at Picassos and Henry Moores." On another occasion he remarked, "Art and science are two sides of the same coin. Science is a discipline pursued with passion; art is a passion pursued with discipline. At pursuing both, I've had a lot of fun."

We at the Smithsonian Institution, who are deeply indebted to so many admirable donors, take pride in being custodians of some of the richest collections of treasures in the world. We are grateful to Dr. Sackler for his extraordinary gift and for his enthusiastic support during the planning and construction of the Arthur M. Sackler Gallery. He was an ideal donor, always ready to discuss matters relating to the gallery and to its collections. In fact, it is difficult to imagine how the project would have succeeded without his active participation.

As Americans, we are constantly striving for a better awareness of our own cultural traditions—cultural traditions that are the more complex because they are influenced by people and by societies from every corner of the globe. In this volume we are presenting a selection of the art treasures given by Dr. Sackler to the Smithsonian and, at the same time, to the people of the United States and to the people of the world. The comments about the objects are meant to provide a concise but informative cultural view of the collection. Even this small selection of works from the Sackler Gallery will make clear the importance of Dr. Sackler's gift.

Dr. Sackler's sudden, unexpected death, just a few months before the gallery opened to the public has saddened all of us. For we had looked forward to sharing with him the excitement of seeing each of the objects in his gift displayed in a specifically designed setting. This book, which he reviewed in manuscript, is one of the many publications Dr. Sackler had planned for the gallery. In a real sense, it now provides a tangible way of expressing our gratitude to Dr. Sackler for his understanding, his generosity and, most of all, his patience.

THOMAS LAWTON
Director
Arthur M. Sackler Gallery

Preface

Our Common Roots

THE ARTS, as all cultural manifestations of Asia, reflect the diversity of the peoples of the continent and the lands washed by its seas. And we of the West are the beneficiaries of the heritage in all the media in which the creativity of humankind evidences itself. Impressionism, Pointillism, cubism, abstractionism, and other manifold progressions of modern and contemporary painting and sculpture are readily discernible in the early calligraphy, painting, and sculpture of Asia.

The manifold and distinctive arts of the different peoples of Asia evidence a common characteristic in their high aesthetic attainments. This is to be expected because all of us, regardless of race, share basic neuroendocrine, sensory, and muscular patterns rooted in a common evolutionary history. Furthermore, our physiologies have not evolved significantly since Magdalenian times, as twenty thousand years may not be a significant evolutionary interval.

Individual differences even within different groups should not startle us, as biochemical individuality characterizes every single person, not only in our fingerprints but even in secretions to such an extent as to enable precise identification of one individual out of four billion.

The common aesthetic roots of each individual are in part shaped by polymorphic social structures, as well as by religious and other beliefs, and these in turn are subject to other determinants such as the state of technologies and the sciences. That so much in the arts of ancient Asia and proximate societies should have anticipated, even by centuries or millennia, the artistic creations in painting and sculpture of the West occasions no surprise to those familiar with the high level of social organization and technical innovations of earlier Asiatic and Mediterranean peoples. In addition to painting and sculpture, this is reflected in the working of stones and gems, the remarkable level of metallurgy, the incredible masterpieces

of the bronze casters and of the gold- and silversmiths, and the continuous use and progressive perfection of ceramics in structure and form, painting and glazes.

At this time and in this place we can, through the arts, be enlightened and uplifted by those peoples and individuals who, even as they came centuries and millennia before us, can hurdle the gap of time and space to move us through their aesthetic achievements. I have observed that in just forty years modern science has forever altered many of the so-called verities of four billion years; that same science now demands that if we are to survive, we must extend those bonds which, in addition to linking the peoples of the past to the peoples of the present, must create better channels of communication and understanding, respect and esteem, to assure the future progress as well as the survival of the arts, the sciences, and the humanities, so richly and rewardingly presented in this gallery.

ARTHUR M. SACKLER, M.D.

Arthur M. Sackler, 1913–1987

Acknowledgments

WE ARE ESPECIALLY grateful to the AMS Foundation and to Michael Sonnenreich for generous support of this publication.

During every phase of the preparation of the text, Karen Sagstetter has provided quiet, effective guidance in matters relating to style, clarity, and precision. Her ability to coax an author to refine sentences and, thereby, to attain greater coherence and elegance is admirable. One could not hope for a more capable or efficient editor.

Carol Beehler has transformed the jumbled masses of paper, photographs, and drawings into a unified whole. Her patience in listening to suggestions regarding the design and layout of the book has been extraordinary. With almost magical skill, she has integrated a number of disparate elements into a balanced volume that reflects the quality of the objects in the Sackler Gallery.

On more occasions than he would like to remember, John Tsantes has responded to requests for special photographs and color transparencies. His forbearance in the face of seemingly never-ending comments about how specific objects should be photographed reflects his characteristic good humor and sound judgment.

The task of typing and retyping the manuscript fell to Victoria Cox Buresch, Elsie Kronenburg-Lee, Lisa Lubey, and Gail P. Price. They were unstinting in their efforts to provide a text that would be acceptable to curators, editor, designer, and printer. For that accomplishment alone, they deserve special recognition.

Patricia M. Bragdon ably and efficiently coordinated the early stages of this project, and Lily Kecskes skillfully checked the transliteration of Chinese characters. Andrea T. Merrill provided invaluable and prompt editing and proofreading assistance.

Craig Korr worked closely with everyone on the staff in making objects in the Sackler Gallery available for study and, together with Martin Amt and James Smith, measured every object published here. Mr. Korr's own comments on a number of the pieces were of assistance in preparing the written entries.

W. T. Chase, head conservator, and his colleagues—John Winter, Paul Jett, Jane Norman, Elisabeth Fitzhugh, Stephen Koob, Janet Snyder, and Martha Smith—did yeomen's service in checking all of the objects in the Sackler Gallery before they were photographed. While there is no question about the fine quality of the individual artifacts, the fact that each of them presents so handsome an appearance in this volume is directly related to the unstinting efforts of the members of the Technical Laboratory staff.

We are grateful to Yasuhiro Nishioka of the Tokyo National Museum for sharing his observations on the Chinese lacquers and to Dr. Ann Gunter as well as Dr. Guitty Azarpay, Dr. Trudy Kawami, Dr. Edith Porada, and Dr. Marvin Powell for comments and suggestions concerning several of the more problematic objects in the ancient Near Eastern collection. We are also grateful to the scholarship of Dr. Prudence Oliver Harper for many of the ideas presented here.

Introduction

The Arthur M. Sackler Gallery

No AREA OF THE WORLD rewards the student or traveler more profoundly than Asia. From classical times to the present day, visitors have exalted the variety of its landscapes, the wealth of its religions and languages, and the multitude of its cultures and ethnic groups. Often elusive and puzzlingly complex to Westerners, Asia has never been less than intriguing. And for millennia, the peoples of Asia have expressed themselves through images and objects of great beauty and visual power.

While we may talk of Asia as if it were a cultural unity, it is not. Nor was there ever a central artistic tradition—an equivalent to the classical world or the Renaissance—within Asia as a whole. Instead, in ancient times major geographic centers arose in West Asia (or the Near East), South Asia (dominated by the Indian subcontinent), and East Asia. These were linked through history by trade, pilgrimage, and missionary routes, but each area developed and maintained a distinctive cultural identity. Other regions—sometimes small in size and often isolated by geographic barriers—were inevitably influenced by these three centers, but they nonetheless often evolved uniquely expressive artistic traditions of their own. The richness and variety of ritual and functional objects and of creative designs produced continually for thousands of years throughout Asia are astonishing.

The Arthur M. Sackler Gallery is a new museum for the arts of Asia at the Smithsonian Institution. To inaugurate the museum, an outstanding collection of almost one thousand objects was given by Dr. Arthur M. Sackler of New York City, of which more than two hundred are presented in this volume. The importance of this gift is tied to the depth and thoroughness with which Dr. Sackler had assembled works from those areas of his greatest personal interest—China and the Near East—although the gift includes a significant group of sculptures from South and Southeast Asia as well. Thoughtful observation of this superb

group of objects can introduce us to matters with which the Sackler Gallery will be continually occupied.

MUCH OF OUR KNOWLEDGE of the ancient world—the period of greatest interest to Dr. Sackler—comes from objects dug from the earth during this century. Such insight was often gained from carefully organized archaeological excavations, but at other times by chance. By either method, the results could be exceptionally rewarding.

For example, less than a century ago, so little literary, historical, and material evidence had remained that the existence of the Shang dynasty (ca. 1700–ca. 1050 B.C.) in China was doubted. In the late nineteenth century, however, farmers plowing fields in northern China unearthed fragments of bones covered with inscriptions. Thinking they were dragon bones, people ground the first finds to dust to be used for medicine—dragon bones reputedly having therapeutic powers. Eventually, however, some reached the Beijing art market, where their importance was recognized. They were oracle bones, and the inscriptions had been used in ceremonies to interpret present and past actions and to divine the future.

It was not until 1928 that official excavations at these sites began, and they uncovered the first abundant examples of Shang bronzes, for beneath the farmers' fields was the late Shang capital, Anyang. And not only was the existence of the dynasty confirmed, but scholars were then able to propose that Shang society was highly centralized and ruled by a powerful king and that it practiced rituals of ancestor worship and human sacrifice. The sheer quantity of bronze vessels, jade ornaments, and elaborate ritual objects that have been discovered since the first finds additionally prove the Shang to have been wealthy as well as highly sophisticated both artistically and technically. Moreover, it is now clear that many of the attitudes and forms of later Chinese art were born during that period.

Knowledge of the Shang makes vivid the significance that the past held in China. Dr. Sackler's abundant gift to the gallery allows us to examine types of vessels and their decoration in extraordinary detail, and this shows that change came slowly, perhaps even reluctantly. Long after Shang vessels had lost their ritual and functional importance, the shapes continued to be made, and eventually these objects became valuable primarily as evocations of—and homage to—an increasingly distant past. The principles of this deliberate archaism, which is equally well revealed through the worship of ancestors, occur throughout Chinese art and can be seen in other inaugural gift objects. Chinese painters, for instance, continually refer to and make visual comments about the styles and subjects of past artists. If viewers today can remark that a painting by the Qing dynasty master Wang Hui is "reminiscent of the style of the Yuan master Wang Meng" or that the same painter "was guided by the theories of [the Ming master] Dong Qichang" (no. 207), they are recognizing deep-seated and important Chinese categories of esteem. Frequently, these relationships are the true subjects of the works that Chinese scholar-artists (also called literati-painters) circulated quietly among their friends; mountains, hills, and streams are merely the vocabulary with which they made these visual observations.

The inaugural gift contains an important group of Chinese paintings by these scholar-artists, including major works of the twentieth century. Chinese paintings at first seem to have little connection with earlier bronzes and jades, until one notices the slow, historical transition from these ancient objects (decorated with fantastic and composite animals and exuding a sense of terrifying, magic powers) to a concern with the natural world. The ability of later Chinese artists to observe nature closely is unexcelled; the superb jade carvings in the Sackler gift alone are evidence of this. Decorative, often witty, and always highly observant, jade carvings are at once images that delight and shrewd comments on the world we inhabit.

Chinese paintings are frequently accompanied by invaluable historical documentation. Seals of the artist or past owners were routinely placed on the surface of paintings, and inscriptions were often added to describe the circumstances under which the work was made or to manifest the reactions of particularly prestigious viewers. For early periods throughout Asia, however, objects themselves seldom provide such exact information about their contexts. Instead, the story is more likely to unfold during controlled archaeological excavations that allow the placement and relationship of objects and their architectural settings to be re-corded—sometimes revealing both how and why the artifacts were buried. Many objects from the ancient Near East have come onto the market from clandestine digs, so that little is known about where they were found. Of the society that produced the impressive metalwork report-edly from Luristan in western Iran, for example, we know virtually nothing (nos. 11, 12, 13). Like those Shang bronzes and oracle bones unearthed in the early decades of the twentieth century, these objects were also found by villagers and quickly sold off, with no chance (at least until recently) for study. Such lack of information, initially frustrating, means that careful examination of every aspect of an object is required—a serious and often enthralling form of detective work.

The great sculptural traditions of the ancient Near East, as represented by the bull (no. 1) or the stag (no. 19) in the Sackler gift, were severely curtailed by the rise of Islam in the seventh century. A radical shift in artistic ideals resulted with the dominance of the new religion. This lack of continuity between recent and distant past is further explanation of the difficulty of interpreting ancient Near Eastern objects, and it distinguishes this regional tra-dition from the continuous historical evolution of Chinese art.

No such mystery surrounds the sculptures of South and Southeast Asia. There the devotion of people to Hinduism was (and is) so powerful that even tiny villages have towering, richly decorated temples, sometimes the only stone structures that villagers ever see. These buildings are covered with elaborate carvings, fragments of which may be seen in many European and North American museums. Human and animal forms have always dominated the artistic traditions in South Asia, and they inevitably relate to narratives about the lives of gods. This is public art, and sculptures comparable to those in the Sackler Gallery are still actively worshiped in India. Religious devotion fostered many of the works in the inaugural gift, but only in South and Southeast Asia do we experience so strongly the importance such objects still hold within living traditions. The study of sculpture from these areas, therefore,

makes quite different demands than does study of the art of China or the Near East, and provides very different rewards.

THE ARTHUR M. SACKLER GALLERY was created to celebrate the artistic traditions of all the peoples of Asia. Toward this end, the groups of objects donated by Dr. Sackler include important works of provincial origin—objects crafted in regional centers. Often these works were created in direct response to mainstream, and most frequently imperial, traditions. This characteristic of the collection will certainly provoke new examinations of geographic and social interrelationships. And it will also allow us to develop a more complete awareness of the significance of the arts to entire societies. Royal patronage has long been the focus of interest for scholarly study and museum acquisitions. This inaugural collection and the ongoing exhibition program of the Arthur M. Sackler Gallery will encourage new exploration of a broader range of arts and study of the artists and the environments in which they worked.

MILO C. BEACH
Assistant Director
Arthur M. Sackler Gallery

Chronology

ANCIENT NEAR EAST

	MESOPOTAMIA (SOUTH)	MESOPOTAMIA (NORTH)	IRAN	ANATOLIA
3500 B.C.				
3000 B.C.				Early Bronze Age 3000–2000
	Early Dynastic period 2900–2334			
2500 B.C.				
	Akkadian period 2334–2154		Akkadian rule in Susa 2300–2200	
2000 B.C.	Neo-Sumerian period 2150–2000	Old Assyrian period 1920–1750	Old Elamite period 1900–1500	Assyrian Colony period 1920–1750
	Old Babylonian period 1894–1595			Old Hittite period 1650–1400
1500 B.C.	Kassite period 1595–1157	Middle Assyrian period 1350–1000	Middle Elamite period 1500–1100	Hittite empire 1400–1200
			Iron Age I-II ca. 1500–800	
1000 B.C.	Second Dynasty of Isin 1156–1025			
		Neo-Assyrian empire 883–612	Neo-Elamite period 1100–550	
500 B.C.	Neo-Babylonian period 625–539		Iron Age III ca. 800–650	
			Achaemenid empire 550–331	
B.C.	Seleucid dynasty 312–129	Seleucid dynasty 312–129	Seleucid dynasty 550–331	Seleucid dynasty 312–129
0				
A.D.	Parthian period (Arsacid dynasty) 247 B.C.–A.D. 224	Parthian period (Arsacid dynasty) 247 B.C.–A.D. 224	Parthian period (Arsacid dynasty) 247 B.C.–A.D. 224	
A.D. 500	Sasanian empire 224–651	Sasanian empire 224–651	Sasanian empire 224–651	
A.D. 1000				
A.D. 1500				
A.D. 2000				

CHINA

Late Neolithic period
5000–1700

Shang dynasty, 1700–1050

Zhou dynasty, 1050–221
 Western Zhou, 1050–771
 Eastern Zhou, 770–221
 Spring and Autumn period
 770–481
 Warring States period
 480–221

Qin dynasty, 221–206
Han dynasty, 206 B.C.–A.D. 220

Six Dynasties period
 Three Kingdoms dynasty, 220–
 265
 Jin dynasty, 265–420
 Northern and Southern Dynasties
 420–589
Sui dynasty, 581–618
Tang dynasty, 618–907
Five Dynasties, 907–960
Song dynasty, 960–1279
 Northern Song, 960–1127
 Southern Song, 1127–1279
Yuan dynasty, 1279–1368
Ming dynasty, 1368–1644
Qing dynasty, 1644–1911

Republic period, 1911–
People's Republic, 1949–

INDIA

Indus Valley civilizations
2500–1500

Kushan dynasty, A.D. 50–320

Gupta dynasty, 320–647

Chola dynasty, ca. 846–1310

Vijayanagar period, 1336–1646

OTHER WORLD EVENTS

Sea divides Britain from Europe
5000

Stonehenge
2000–1501

Ethiopia becomes an independent
 power, 1100–1000

First recorded Olympic games, 776
Birth of Buddha, 563

Venus de Milo sculpture
490 B.C.–A.D. 1

Birth of Christ
Rome celebrates its thousandth
 birthday, A.D. 248

Muhammad born, 570
Charlemagne crowned first Holy
 Roman Emperor, 800
Angkor period, Cambodia
877–1201

Tale of Genji written
 ca. 1028–1087

American and French Revolutions
Industrial Revolution
World War I, World War II
1751–present

5000 B.C.

4500 B.C.

4000 B.C.

3500 B.C.

3000 B.C.

2500 B.C.

2000 B.C.

1500 B.C.

1000 B.C.

500 B.C.

B.C.
0
A.D.

A.D. 500

A.D. 1000

A.D. 1500

A.D. 2000

ANCIENT NEAR EAST

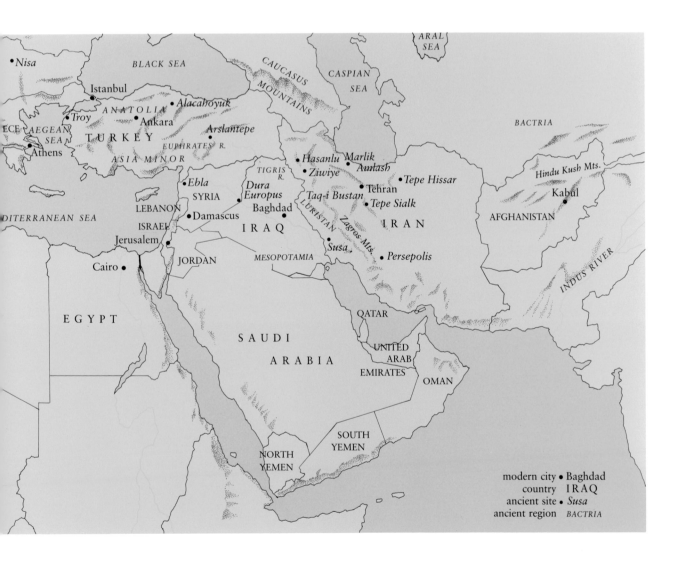

A note on the text

The current political designation is used for most place-names. For Chinese characters, the Pinyin system of transliteration is used. Measurements of objects are given as maximum dimensions, and height precedes width, depth, and diameter, unless otherwise specified. Dimensions are given first in centimeters, followed by inches in parentheses. Accession numbers follow measurements.

Art of the
Ancient Near East

T HE ANCIENT NEAR EAST is a vast geographic and cultural entity whose chronology spans more than five millennia, starting with the earliest farming communities of Mesopotamia and continuing until the rise of Islam during the mid-seventh century A.D. Geographically this area begins at the edges of Europe in the west, includes Anatolia (Asia Minor) in the northwest and Mesopotamia in the south, and stretches to Central Asia in the east. Culturally it included a variety of ethnic groups that have persisted through many diverse social, economic, political, and religious systems. The Sumerians, for instance, ruled large parts of ancient Mesopotamia (roughly, modern Iraq) from the middle of the fourth to the end of the third millennium B.C. and developed a complex form of kingship centered on numerous city-states, each of which was the home of a specific god. The people who lived in northwestern Iran at the same time, however, are virtually unknown, as they have left no written records despite the fact that they produced many finely worked artifacts. The distinctions between these cultures and the regions they populated are great, although modern scholars often refer to them collectively as the pre-Islamic Near East.

The Sackler Gallery collection reflects this geographic and cultural diversity and includes works of art from Anatolia, the Caucasus (the mountainous region between the Black Sea and the Caspian Sea), and Iran. The majority of the collection, however, is Iranian and includes several important vessels from the Achaemenid (550–331 B.C.), Parthian (247 B.C.–A.D. 224), and Sasanian (A.D. 224–651) periods, as well as a number of objects from the second and the early first millennia B.C. The period represented by these pieces is one of the richest in Iran's long history. The Achaemenids, under Cyrus the Great (ca. 559–530 B.C.), for example, established an empire that included most of Iran and Mesopotamia as well as parts of India and Asia Minor. The highly stylized and majestic works of art produced by the

Achaemenids are as beautiful as they are moving and powerful.

Alexander the Great's invasion of the Near East in 334 B.C., however, and his burning of Persepolis, the Achaemenid capital, four years later, brought the dynasty to an end. It was not until a century passed, when the Parthian dynasty was created, that Iran and Mesopotamia were brought together again as a unified empire. The incorporation of the many Greek settlements left over from Alexander's conquests into their empire resulted in the mixing of Iranian and classical Greek forms and iconography. The carefully realized features of the Sackler Gallery's lynx-headed rhyton, or ceremonial drinking vessel (no. 17), with its taut yet elegant lines is typical of the finest Parthian works and reflects, in the naturalism of its modeling, classical interests. In A.D. 224 the Sasanian king, Ardeshir (reigned 224–41), ended Parthian rule. The dynasty that he founded ultimately grew to include Afghanistan in the east and large parts of what is now Syria, North Yemen, South Yemen, and Egypt in the south and west. Despite the wealth and power of the Sasanians, they were unable to resist the Arab conquests of the mid-seventh century. The objects they created, however, set standards of quality, luxury, and iconography that affected the development of Iranian art for close to a thousand years.

The forms represented by the objects in the Sackler Gallery are remarkable: from simple vessels decorated with abstract vegetable and geometric designs (no. 10) to large, naturalistically rendered animals (nos. 16, 20). Although in general the later works tend to be more carefully modeled and detailed, many of the earlier objects in the gallery, such as the bull (no. 1) and the ibex (no. 4), are treated with great sensitivity and understanding. Often small details, such as a horn or a beak, are exaggerated in order to produce startling effects. The result of this is to focus attention on the critical elements of an object's composition. The monumental antlers of the stag possibly from Central Asia, for instance, indicate the animal's power and suggest its importance (no. 19).

Images of horses, cattle, goats, mythical animals, dancing women, and royal couples are among the most common subjects of these pieces. Although their functions are not always clear, and we know almost nothing about the artists who made them, some were clearly used as drinking vessels, others as horse trappings, arms, objects of worship, or jewelry. The broad range of interests represented by these pieces is echoed by the materials from which they are made. Gold and silver, for instance, were used for royal and aristocratic objects, while copper alloys, such as bronze, and clay were employed for cult images, tools, and everyday wares. The techniques used to create and embellish these pieces included casting, modeling, hammering, repoussé, chasing, engraving, painting, and gilding.

Three groups of objects in the collection are of particular interest: three Parthian rhytons; part of an alleged hoard of second millennium B.C. silver ornaments, blades, and vessels; and a series of provincial Sasanian vessels. The rhytons, one of which is inscribed around its horn in Parthian, are significant because of their rarity and beauty. The Sasanian vessels, however, are important because of what they may eventually tell us about the allocation of precious resources, iconographic developments, and the quality of craftsmanship between metropolitan and provincial centers.

It is the hoard, however, that raises the most interesting questions. When and where was it made? Are all the pieces of the same moment? What, if anything, can be learned about the culture that produced it? These questions are, to a large extent, characteristic of much of the study of ancient Near Eastern art because so many of the objects come from undocumented excavations. The loss of the archaeological context of these pieces makes it difficult to determine function, date, and provenance in any meaningful way.

Popular attributions to sites or areas such as Marlik along the southern shores of the Caspian Sea, or Luristan in the central Zagros Mountains of western Iran, though convenient, are ambiguous at best, since few objects can be shown actually to have come from these places. In the case of the alleged hoard, recent scientific studies indicate that it consists of at least two groups of objects: one that appears to be ancient and perhaps closely related to early second millennium material from northeastern Iran and another that may be more recent.

The experience gained from studying these objects is invaluable, as they provide direct contact with the past. In many instances—such as the second millennium metal artifacts of northwestern Iran—such study is one of our only ways of understanding the achievements of these civilizations.

GLENN D. LOWRY

1 *Bull*

Anatolia or Caucasus
3d millennium B.C.
copper alloy
height 24.6, width 22.4, depth 12.8 cm
(9¹¹⁄₁₆ × 8 ¹³⁄₁₆ × 5¹⁄₁₆ in)
S87.0135

This cast bull, with its inlaid ivory eyes and exaggerated horns, is both powerfully designed and sensitively modeled. The stand that rises from the beast's back was used to support a small vessel. The flaring horns, carefully articulated face, and well-developed haunches of the bull emphasize its weight and mass.

Although only one other similar piece is known (an ibex in the Walters Art Gallery in Baltimore), several third millennium B.C. metal objects found at Maikop in the Caucasus and Alacahoyuk, an important pre-Hittite site in northern Anatolia, are close to it in style and scale. Among the many items excavated at Alacahoyuk were gold vessels, jewelry, precious stones, hammers, axes, and statues of bulls and ibex. It is believed that these objects were worshiped as sacred animals of the gods.

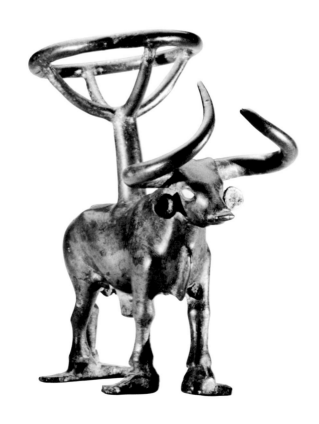

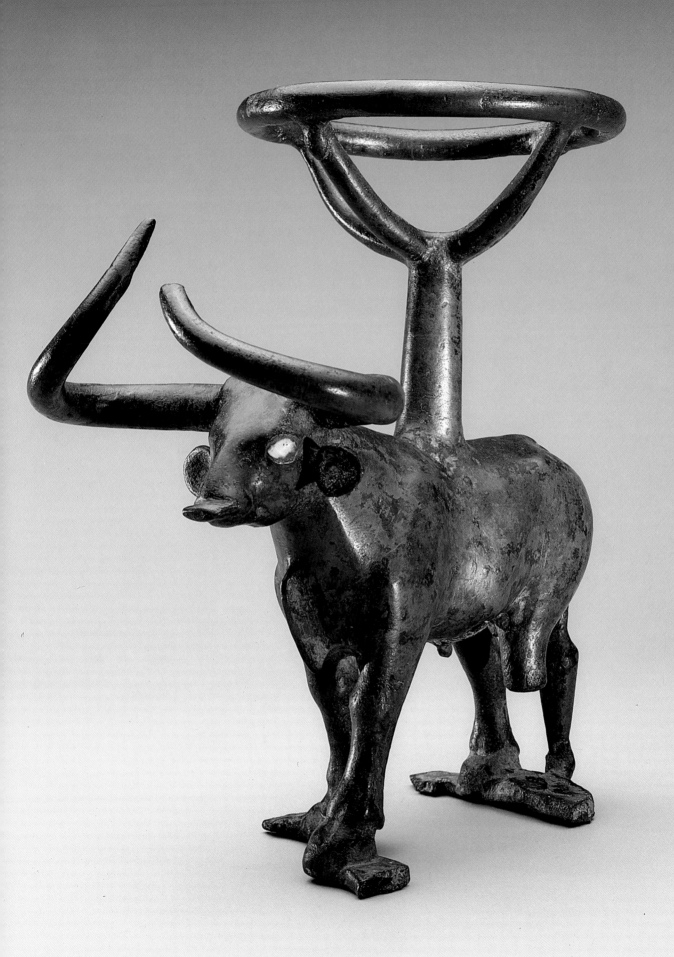

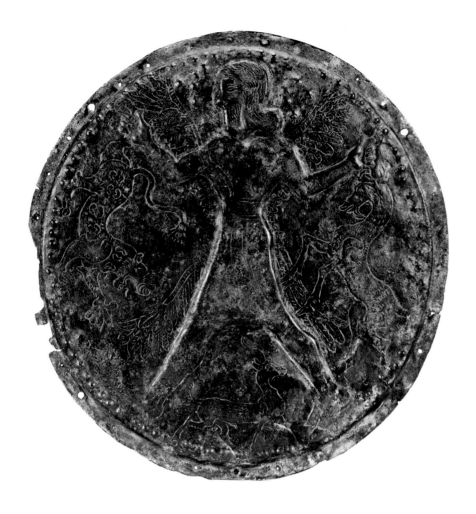

2 Plaque

northwestern Iran
late 3d–early 2d millennia B.C.
copper alloy
depth 1.3, diameter 22.3 cm
(8½ × 8¾ in)
s87.0121

Executed in repoussé with chased details, this plaque depicts a bearded figure with wings holding a gazelle by its horns in his left hand and a lionlike animal by its tail in his right hand. Between the figure's legs is another gazelle. A large number of second and first millennia B.C. plaques and disk-headed pins exist that have similar designs. Most of these can be attributed to either western or northwestern Iran. Although the specific meaning of these motifs is not clear, they seem to derive from representations of bull and lion demons taming animals that can be dated to around 3000 B.C. The association of this imagery with notions of power and control is reinforced in the Sackler plaque by the contrast in scale between the central figure's massive legs and heavy torso and the small delicately rendered animals. Because these images have a long history in the Near East, it is difficult to establish a precise date for this piece.

3 Animal Figures

Iran, 2d millennium B.C. (?)
silver
(a) height 8, width 18.5, depth 4.2 cm
(3⅛ × 7¼ × 1⅝ in)
s87.0195
(b) height 8.2, width 15.9, depth 4.2 cm
(3¼ × 6¼ × 1⅝ in)
s87.0194

These feline-like animals are from a set of twelve objects of varying size that probably served an ornamental function. At least sixteen more pieces of similar size, shape, and form have been identified. It has been claimed that they are all part of an alleged hoard that was supposed to have been found in northeastern Iran. Other items from the hoard include bowls, ewers, blades, bracelets, and coils. A small hole runs through the middle of each creature's back. The largest animal is the exception; it has a socket on its back that may have supported a rod upon which the others could have been arranged. The weight of these figures, which have been cast and then embellished with simple chased designs, ranges dramatically from twenty-three to 2,782 grams. The surfaces of the six smallest pieces are fairly rough, and the decoration consists of deeply incised lines; they resemble early second millennium objects excavated at Tepe Hissar in northeastern Iran. The larger animals have smooth surfaces, more finely cut lines, and a slightly different silver composition. Scholarly opinion varies concerning the precise dating of these pieces, and the possibility exists that they may not all be from the same time and place.

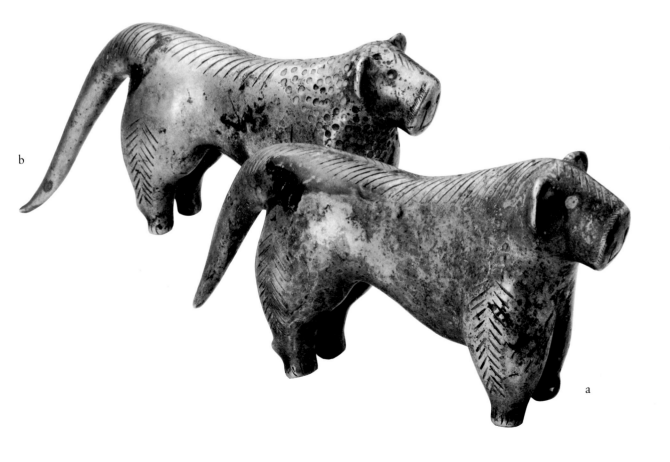

b

a

4 Ibex

northwestern Iran, 2d–1st millennia B.C.
copper alloy inlaid with ivory
height 26, width 15.8,
depth across horns 8.7 cm
(10¼ × 6³⁄₁₆ × 3⁷⁄₁₆ in)
s87.0018

The clearly defined musculature, exaggerated horns, and strongly modeled face of this ibex are typical of late second millennium B.C. objects from northwestern Iran. Ibex are among the most frequently represented animals in ancient Near Eastern art. The earliest portrayals of ibex can be traced to ceramic vessels from Tepe Hissar and sites in northeastern Iran that date to the middle of the fourth millennium B.C. Ibex also appear on fourth millennium cylinder seals and stamps. Similar, though more stylized, cast ibex, attributable to the ninth to eighth century B.C., are said to come from the Luristan area in the central Zagros Mountains of western Iran.

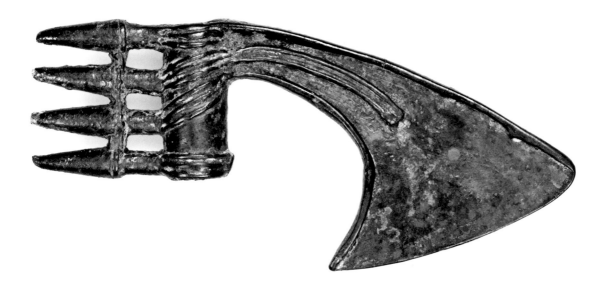

5 *Shaft-Hole Ax Head*

Luristan, ca. 1350–1000 B.C.
copper alloy
height 20.2, width 9.1, depth 2.7 cm
(7¹⁵⁄₁₆ × 3⁹⁄₁₆ × 1¹⁄₁₆ in)
s87.0072

During the 1930s the antiquities markets of Tehran,
Paris, London, and New York suddenly saw the ap-
pearance of a vast number of bronze objects. Many
were extremely beautiful and elaborately decorated
and came allegedly from the western Iranian prov-
ince of Luristan. Since several sites in Luristan were
not systematically excavated until the 1960s, specific
attributions concerning the bronzes said to come
from this region are difficult at best. The ax head in
the Sackler Gallery belongs to a group of tools of
presumably practical function that range in design
from the simple, such as this one, to the more elabo-
rate, such as those incorporating birds, animals, and
human figures into their compositions. All of these
ax heads are cast, and some bear inscriptions of
twelfth- and eleventh-century B.C. rulers that suggest
approximate dates for the group. The long graceful
curve of this ax head and its tapered butt spikes give
it a streamlined appearance, typical of these objects.

6 Female Statuette

northwestern Iran, ca. 1350–800 B.C.
ceramic
height 47, width 15.5, depth 12.7 cm
(18½ × 6¹/₁₆ × 5 in)
s87.0068

The pronounced hips, buttocks, and elongated neck of this figure are typical of a group of first millennium B.C. statuettes often associated with the region around Amlash near the southern shore of the Caspian Sea. Burnished and simply decorated with incised lines, this figure's stylized features are dramatic and haunting. Although there is almost no historical information concerning the culture that produced this image, and consequently little knowledge about its function, it is clear from the number of fine objects that have survived from this period that it must have been made by a people enjoying great prosperity.

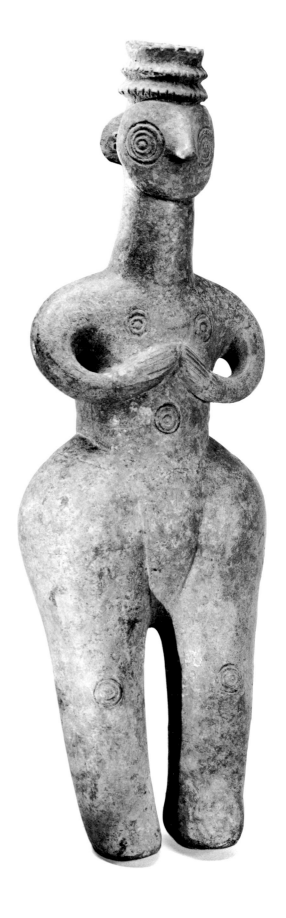

7 Rhyton

northwestern Iran, ca. 1350–800 B.C.
ceramic
height 15.9, width 24.7, depth 9.1 cm
(6¼ × 9¹¹⁄₁₆ × 3⁹⁄₁₆ in)
S87.0100

The strong, though simplified, form of this bull-shaped vessel is typical of a large number of ceramic objects generally associated with northwestern Iran and the Amlash area in particular. The burnished surface of this piece and its lack of decoration emphasize the animal's weight and volume. Although zoomorphic vessels have a long history in the ancient Near East, they seem to have been particularly popular during the first millennium B.C. Excavations at Marlik and other sites along the Caspian Sea indicate that these objects were made by a cattle-breeding people. The remarkably sensitive and evocative forms of this vessel may thus be seen as a reflection of its pastoral background.

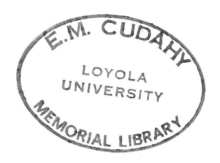
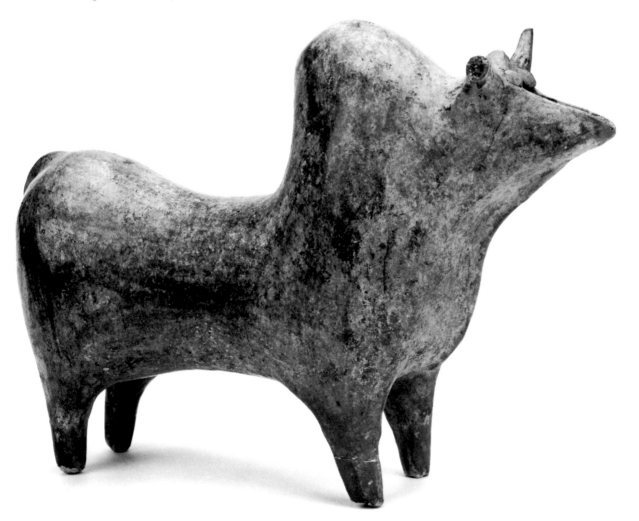

a

b

8 *Two Fragments of a Plaque*

northwestern Iran, 12th–9th centuries B.C.
silver
(a) height 12.9, width 8.5 cm
(5 1/16 × 3 5/16 in)
(b) height 16.5, width 13.1 cm
(6 1/2 × 5 3/16 in)
s87.0120a,b

These two fragments, with their roughly rendered
repoussé figures, once formed part of a large rectan-
gular plaque that was originally mounted on wood
and may have decorated a royal throne. The smaller
piece depicts a man walking with a mace in one
hand, the remains of a fringe, and two horizontal
lines of a second man. Above the first man's shoul-
der is the partial rendering of a cat-like animal. The
second fragment shows two men walking: the first

one carries a spear and a curved weapon in his
hands, the second one a mace. Two birds attacking
the head of a gazelle are depicted above the men. Al-
though the specific meaning of the birds is not
known, similar representations in classical Greek art
are used to convey good fortune to warriors. Both
the drawing and the subject matter of these frag-
ments are similar in style to that of a bowl made of
gold discovered at Hasanlu, in the Solduz region of
Azerbaijan, that can be dated 1200 to 1000 B.C.,
and a silver beaker, also from Hasanlu, attributable
to the ninth century B.C.

9 Spouted Jar

Luristan, ca. 1000–800 B.C.
ceramic
height 23, width 23.6, depth 18.2 cm
(9 1/16 × 9 1/4 × 7 1/8 in)
S87.0099

The elongated spout of this jar, its thick curved
handle, and its painted decoration are characteristic
of a class of vessels said to come from the Luristan
region of western Iran. Excavation of similar jars,
though usually with more attenuated spouts and
more elaborate decoration, at Tepe Sialk near Ka-
shan to the east of Luristan, suggests a first millen-
nium B.C. date for these vessels. The antelope or ga-
zelle's head that punctuates the base of the jar's
handle adds to its visual appeal and distinguishes it
from the simplest versions of this type of vessel.

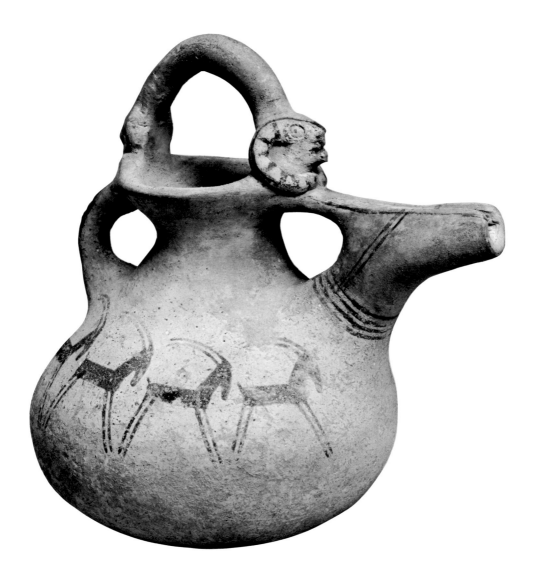

10 *Beaker*

northwestern Iran, ca. 1000–800 B.C.
silver
height 12.8, diameter 8 cm
(5 × 3⅛ in)
s87.0132

The twisting spirals of this elegant drinking vessel
are chased with braided and scalloped designs.
Fashioned from a single sheet of silver, the beaker is
associated with the region around Marlik, although
it also resembles objects said to come from Luristan.
The braiding that decorates every other band on the
vessel is a type of design common to both ceramics
and metalwork from northwestern Iran of the first
millennium B.C. Beakers of almost identical shape
have a long history in the ancient Near East and are
probably derived from chlorite or steatite vessels
covered with braided and woven patterns that can
be dated to the third millennium B.C.

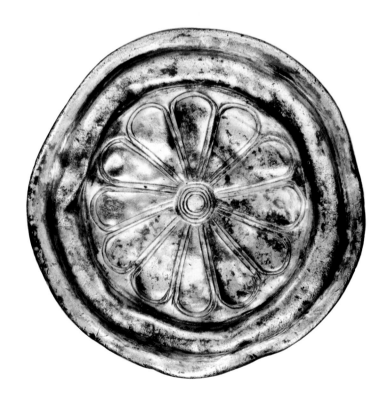

detail of bottom

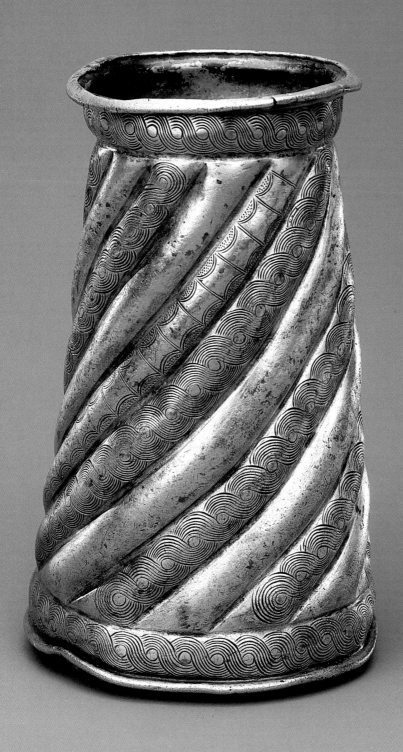

11 *Pair of Cheek Pieces from a Horse Bit*

Luristan, ca. 1000–650 B.C.
copper alloy
(a) height 9.9, width 10.7, depth 2 cm
(3⁷⁄₈ × 4³⁄₁₆ × ¹³⁄₁₆ in)
(b) height 10, width 10.5, depth 2 cm
(3¹⁵⁄₁₆ × 4⅛ × ¹³⁄₁₆ in)
s87.0071a,b

Although no horse trapping so far associated with Luristan can be securely dated before 1000 B.C., the horse must have played a major role in the life of the region prior to that. Cast bits, often depicting real or imagined animals, such as these sphinxes, and decorated with chased or engraved details and inlaid with copper lines, were used by the inhabitants of the region for parade horses and chariots. Organic materials, such as leather, would have been employed for daily use with horses, which were ridden without saddles.

a

b

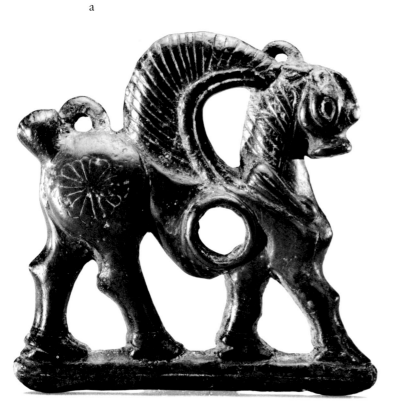
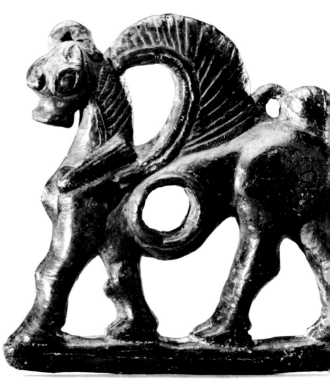

12 *Cheek Piece from a Horse Bit*

Luristan, ca. 1000–650 B.C.
bronze
height 13.6, width 12.7, depth 3.7 cm
(5⅜ × 5 × 1⁷⁄₁₆ in)
s87.0127

This striking image of an ibex, with its sharply
angled neck, is the left half of a cheek piece. It is
similar to a number of horse trappings that are said
to come from Luristan. Although none of these
trappings has been found in controlled excavations,
most of them can be dated to the Iron Age II–III pe-
riod (ca. 1000–650 B.C.) on the basis of their simi-
larity to excavated objects. This cheek piece, like the
preceding ones, would have been attached to its
right half by a simple metal bar.

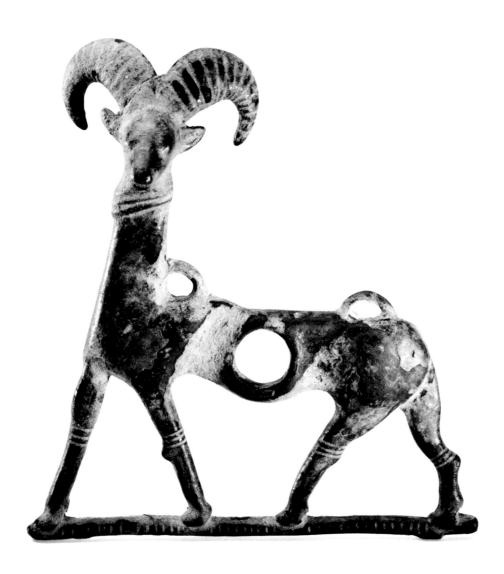

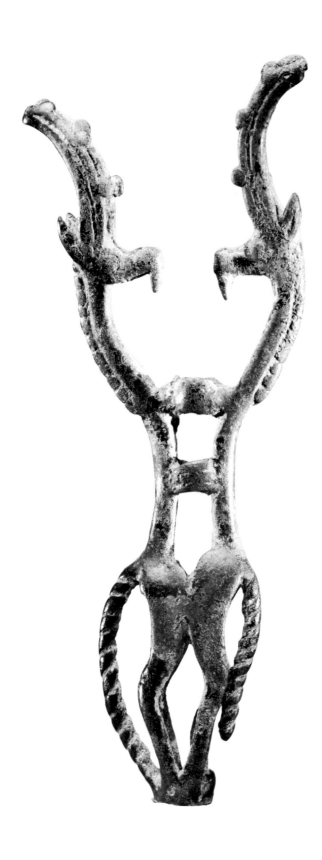

13 *Finial*

Luristan, ca. 1350–800 B.C.
copper alloy
height 18.2, width 7.2, depth 2 cm
(7⅛ × 2¹³⁄₁₆ × ¹³⁄₁₆ in)
s87.0078

Three types of standard finials can be associated with the Luristan region: those depicting rampant wild goats (such as this one); those portraying rampant lions; and those depicting masters/mistresses of animals (no. 14). These finials were probably mounted vertically on bottle-shaped supports either by sheet-metal tubes or by pins attached to their central aperture. Often the images depicted on the finials are so stylized that their decoration seems more important than their form. The elongated and curving bodies of the Sackler goats with their braided tails and nubbly horns are characteristic of a number of similar pieces that can be dated to the Iron Age I–II period (ca. 1500–800 B.C.).

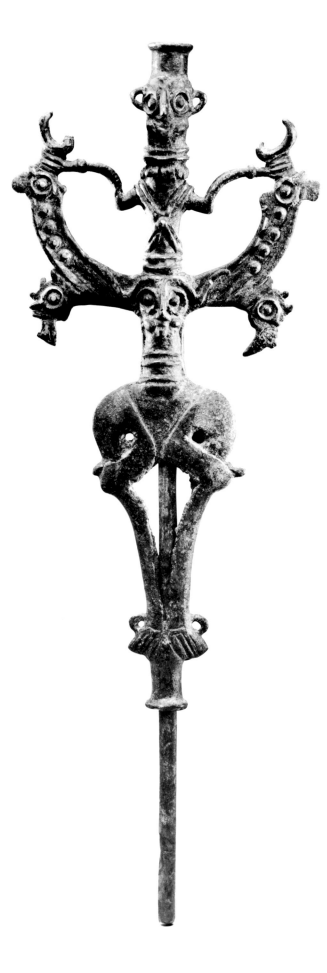

14 *Finial*

Luristan, ca. 1000–650 B.C.
leaded bronze
height 27.8, width 9.8, depth 3 cm
($10^{15}/_{16}$ × $3^7/_8$ × $1^3/_{16}$ in)
s87.0079

The anthropomorphic shape of this finial depicts a man and a woman taming animals, a theme often referred to as the master/mistress of animals. The highly stylized forms of the figures and the rampant animals that flank them are typical of a group of finials from Luristan. These range from relatively simple and unadorned compositions to much more elaborate ones. The Sackler finial, with its well-articulated features and bold pattern of stippled decoration, is a particularly dramatic example. Finials like this one have been excavated from tombs as well as shrines. There is no textual information concerning their function, but they appear to be representations of local demons and gods.

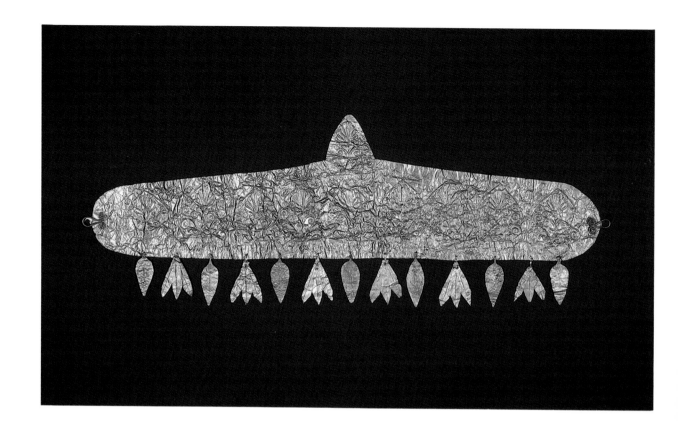

15 *Hair Band*

Caucasus, 4th–3d centuries B.C. (?)
gold
height 14.3, width to ends of loops 40 cm
(5⅝ × 15¾ in)
s87.0146

The shape and the finely worked repoussé decoration of this hair band are derived from classical models. When the Greeks arrived on the north shore of the Black Sea in the early fifth century B.C., classical forms began to influence local traditions. The delicate scrolling of the palmettes on the band, for instance, has been subtly altered from Greek designs so that it is at once more simplified and bold. Headdresses and other ornaments from the Scythian site of Kul Oba on the northeastern shore of the Black Sea are embellished with similarly shaped palmettes. These objects can be attributed to the beginning of the fourth century B.C. and suggest an approximate date for this piece.

16 *Rhyton*

Iran (?), ca. 100 B.C.–A.D. 100
ceramic
height 28.3, width 11.7, depth 18.1 cm
(11⅛ × 4⅝ × 7⅛ in)
s87.0031

One of a number of horn-shaped drinking vessels
that have survived from the ancient Near East, the
beautifully modeled features of this animal-headed
rhyton recall classical Greek forms. The creature's
wrinkled nose, ridged eyebrows, and sharply defined
cheeks are similar to those on several fifth century
B.C. carved reliefs from Daskyleion in western Tur-
key. These features also appear on classical bronze
bulls used as votive offerings to various deities.

Ceremonial vessels shaped as animals were used for
centuries in the ancient Near East and became sym-
bols of power and prosperity. The clearly defined
musculature and bone structure of this animal, how-
ever, distinguish it from the more schematic render-
ings of earlier animals and relate it to a number of
Seleucid (312–129 B.C.) and Parthian objects exca-
vated in Iran and elsewhere in the Near East. Traces
of red pigment on the rhyton's rim and around the
bull's face indicate that it was originally painted.

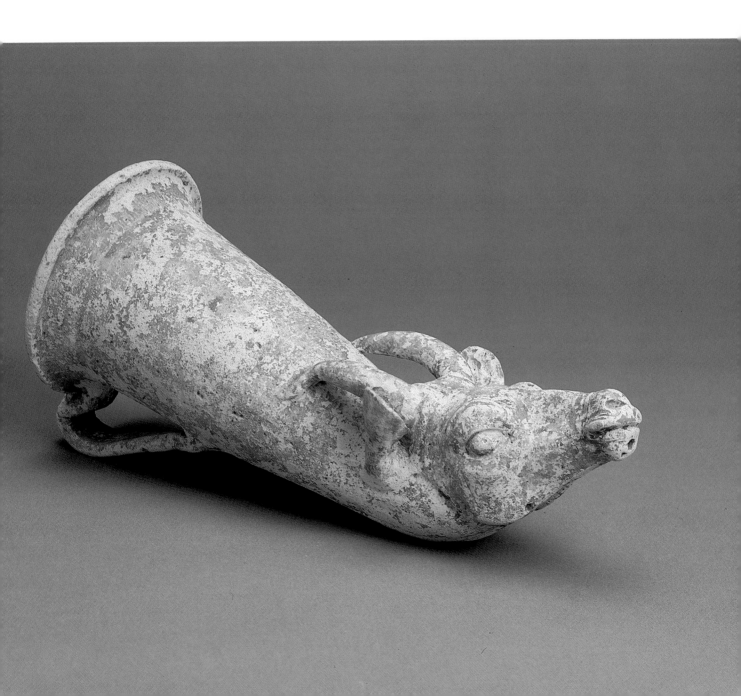

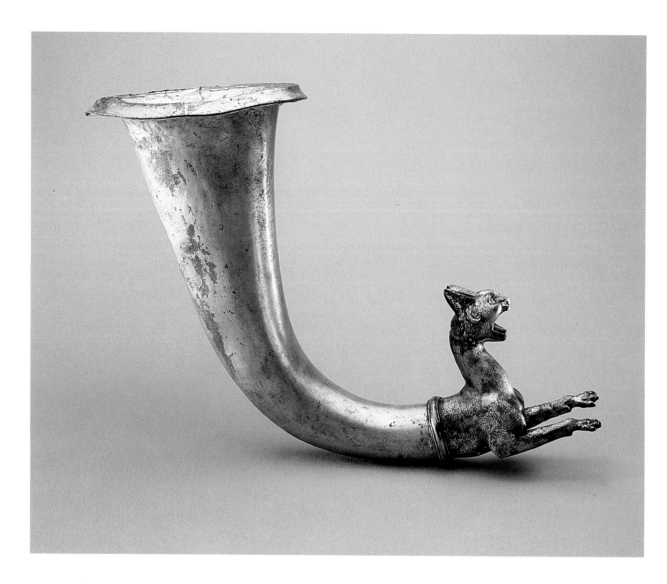

17 *Rhyton*

Iran (?), ca. 100 B.C.–A.D. 100
silver and gilt
height 23.5, width 30.4, depth 12.4 cm
(9¼ × 12 × 4⅞ in)
s87.0131

The outstretched paws, flaring nostrils, and open mouth of the lynx-shaped head of this rhyton are as evocative as they are powerful. Few rhytons combine such ferocious energy with such attenuated elegance. The realistically rendered features of the cat differentiate it from the more stylized forms of Achaemenid objects and suggest a Parthian origin for the vessel. This attribution is confirmed by an inscription written in Parthian on the rim of the rhyton. With the collapse of the Achaemenid empire in the wake of Alexander's conquests of 334–329 B.C.,

Iran was left fragmented and politically unstable. It was not until the rise of the Parthians, whose power was concentrated in Iran and Mesopotamia, during the middle of the second century B.C., that order was established again. Although relatively few Parthian objects are known, most of them seem to share a tendency toward elongated forms (such as the neck of the lynx) and an interest in naturalism that grows out of Greco-Roman traditions.

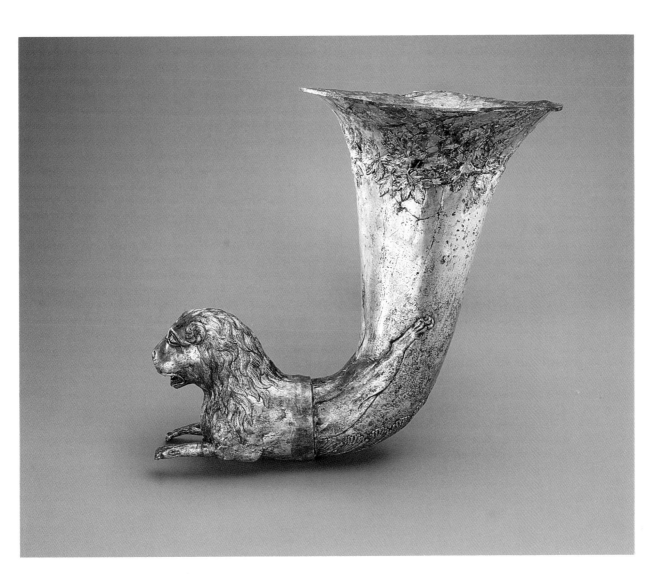

18 Rhyton

Iran (?), ca. 100 B.C.–A.D. 100
silver and gold leaf
height 25.8, width 26.9, depth 17.5 cm
(10⅛ × 10⁹⁄₁₆ × 6⅞ in)
s87.0130

The lion that forms the spout of this vessel consists of two parts: its head and forequarters, rendered in the round, and its hindquarters, rendered in relief on the horn of the rhyton. Below the splayed body of the lion, on the underside of the horn, is a series of acanthus leaves that create a kind of bed upon which the animal rests. A band of foliage derived from Greek designs decorates the vessel's rim and acts as a visual counterpoint to the forward thrust of the lion's body. This rhyton, like the lynx-headed rhyton (no. 17), is one of the few silver objects that can be attributed with any certainty to the Parthian era. Similarly lion-shaped rhytons carved of ivory have been excavated at Nisa, a Parthian site now in Soviet central Asia. These vessels can be dated to the first century B.C. and are close to this rhyton in design.

19 *Stag*

Central Asia (?), 1st millennium A.D.
copper alloy
height 55.8, width 32.4,
depth across antlers 46.3 cm
(22 × 12¾ × 18¼ in)
s87.0119a,b,c,d

The giant flaring antlers of this boldly conceived
stag are attached to its body by means of a skull cap
that is locked into the head of the animal by an L-
shaped prong. The stag is remarkable for its robust,
stylized haunches and protruding tongue. By exag-
gerating its horns the artist of this piece has created
a strikingly powerful image that suggests the impor-
tance of this work. Earlier precedents for animals
with similarly exaggerated features can be traced
back to the second half of the third millennium at
Alacahoyuk. These stags stand on long cylindrical
stems and were considered sacred. It has been sug-
gested that they were used ceremonially during reli-
gious rituals, though there is little evidence to sup-
port this.

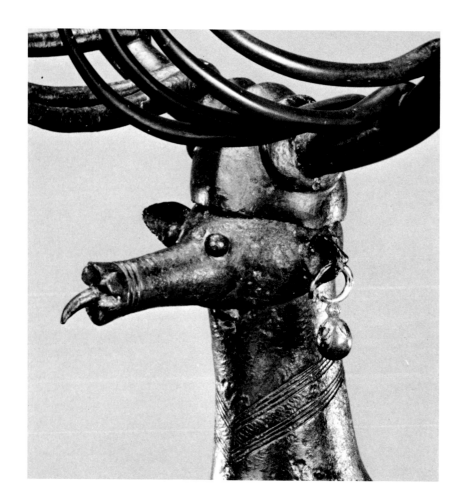

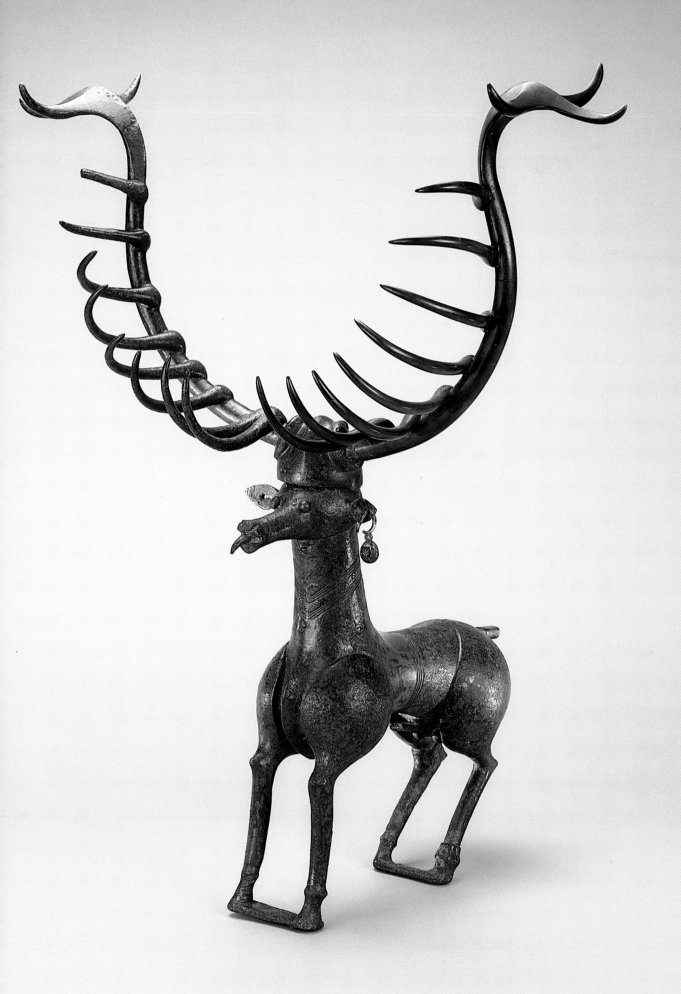

20 Rhyton

Iran (?), 4th century A.D.
silver and gilt
height 15.5, width 25.4, depth 14.1 cm
(6⅛ × 10 × 5⁹⁄₁₆ in)
s87.0033

The animal's face emerges remarkably lifelike from
the base of this striking rhyton, with its broad rim
and fine repoussé and chased features. Depicted on
the side of the rhyton—between the fluted part of
the animal's neck and the rim of the horn—are a
lion and bull on either side of a central tree flanked
by antelopes. The meaning of these figures is not
clear: in Zoroastrian texts the bull symbolizes pros-
perity and animal life, and lions represent royalty.
Both of these animals, however, also have astrologi-
cal connotations, the bull being the sign for Taurus
and the lion the sign for Leo. It has been argued that
the three-branched tree may symbolize fertility and
renewed life, or it may allude to the Pahlavi (a
Middle Persian language) triad of "good thoughts,
good words, good deeds."

Based on the stippled drawing of the lion and
bull, the spot gilding used to highlight various parts
of the rhyton, and the naturalism of the animal's
head that forms the spout of the vessel, this piece
can be attributed to the fourth century A.D.

Note
For further discussion, see Prudence O. Harper, *The Royal
Hunter,* New York, 1978, pp. 36–38.

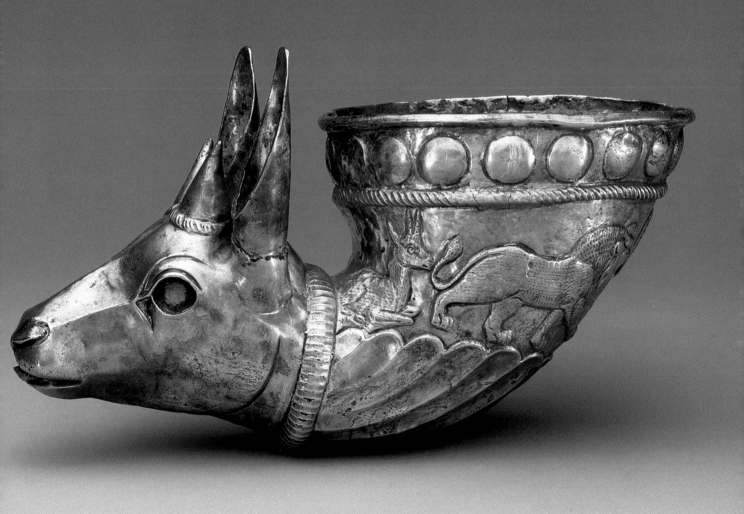

21 *Hair Band*

Caucasus (?), 4th–6th centuries
gold
height 3.9, width 32.6 cm
(1½ × 12¹³⁄₁₆ in)
s87.0136

Arranged symmetrically around a central tree, the repoussé figures of this thin gold band depict archers hunting large catlike animals. Figures with outstretched arms punctuate the ends of the band. Small holes near each corner of the band suggest that it was held in place by strands of wire or cord. Although there are no known direct parallels for the simplified forms of the figures that decorate this piece, several rock carvings from sites in the northern Caucasus Mountains attributable to the fourth century A.D. have similar figures, suggesting an approximate date and possible origin for the hair band.

Note
The author is grateful to Dr. Guitty Azarpay for suggesting this attribution.

22 *High-Footed Bowl*

Iran (?), 6th century
silver and niello
height 10.2, diameter 18 cm
(4 × 7¹⁄₁₆ in)
s87.0106

High-footed bowls with deeply flaring sides like this one are common in late Sasanian metalwork and occur in silver as well as in other metals. These vessels, often with fluted exteriors, are modeled on Roman North African and European bowls that can be dated to the fourth and fifth centuries A.D. The finely drawn peahen in the center of this vessel is typical of the images used to decorate these bowls. Although the workmanship of this vessel is of high quality, its simple iconography and functional shape suggest that it served domestic needs. This is confirmed, in part, by the many representations in Sasanian art of this type of bowl as a food container (such as the almost identically shaped vessel depicted on no. 25).

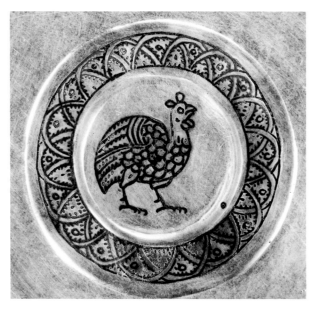

detail of center

Note
For a detailed discussion of this bowl, see Prudence O. Harper, *The Royal Hunter*, New York, 1978, p. 44.

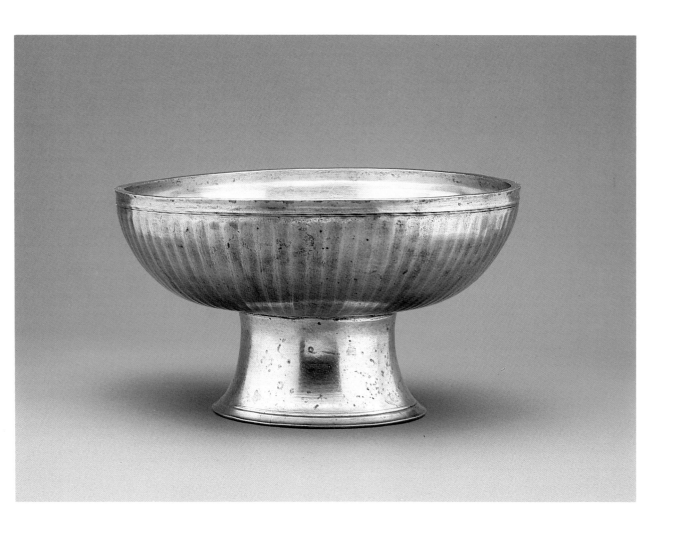

23 Two Ewers with Female Figures

Iran, 6th–7th centuries
silver and gilt
(a) height 35.5, width 16.9, depth 14 cm
(14 × 6⅝ × 5½ in)
s87.0117
(b) height 32.5, width 15.2, depth 12.3 cm
(12¾ × 6 × 4⅞ in)
s87.0118

These elegant ewers, with their repoussé and chased details, belong to a group of vessels of similar shape, size, and design. Derived from late antique forms, the shape of these vessels was common throughout the late Sasanian period (seventh century). The foot, handles, lid, and rings on the Sackler ewers were cast separately from the main body of the vessels. Dancing women—some clothed, others nude—holding various objects decorate the sides of the ewers. It has been argued that the dancers, or "bacchantes," are either representations of Anahita (the Zoroastrian goddess of water and fertility), one of her priestesses, or votaries of a vestigial cult of Dionysus. It is also possible that these flamboyant women, who hold bowls of fruit, drinking vessels, and other objects associated with prosperity, personify seasonal festivals. Their qualities reflect the assimilation of Dionysiac motifs into the repertoire of Sasanian designs related to festive occasions.

Note
For discussion of this type of ewer, see Prudence O. Harper, *The Royal Hunter*, New York, 1978, pp. 60–61.

a left, b right

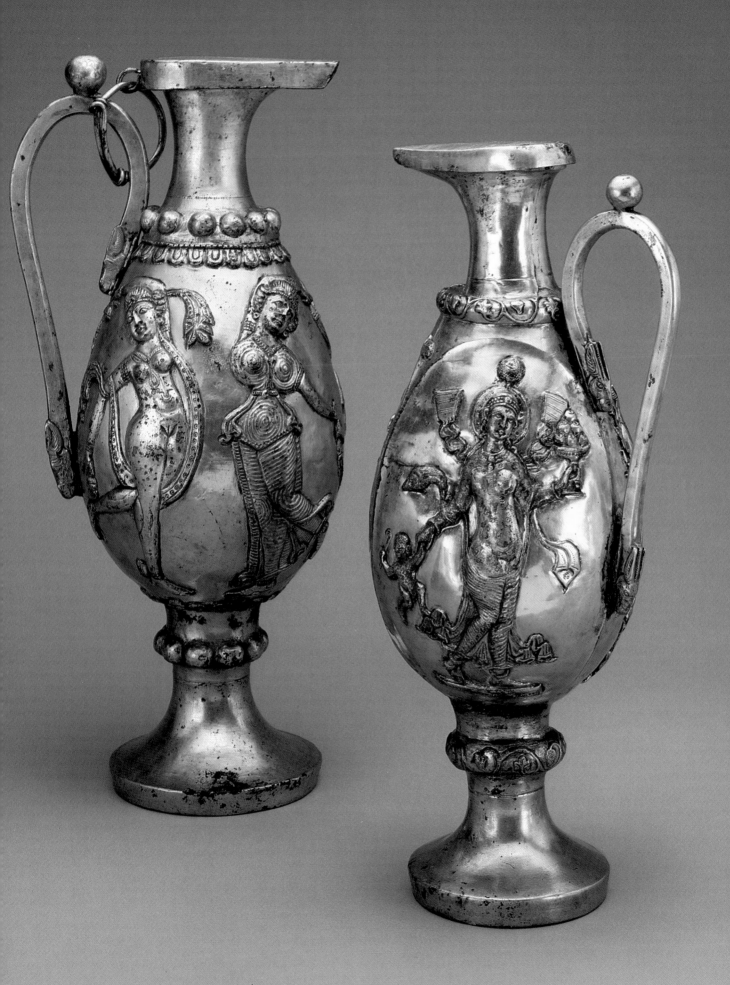

24 Roundel with a Vine Scroll

Iran, 6th–7th centuries
silver and gilt
height 1.3, diameter 12.4 cm
(½ × 4⅞ in)
s87.0107

This small roundel is pierced by four holes, one of which still retains a rivet. Although it is difficult to be certain about the function of the piece, it likely served as a lid to a container. The vine scroll, formed by hammering and chasing, that radiates from the central medallion of the roundel is inhabited with animals and birds. Similar scrolls occur frequently in Sasanian art as well as on contemporary European, Chinese, and Central Asian objects. The symmetrical organization of Sasanian scrolls, however, distinguishes them from those of other traditions.

Note
For further discussion of this roundel, see Prudence O. Harper, *The Royal Hunter*, New York, 1978, p. 62.

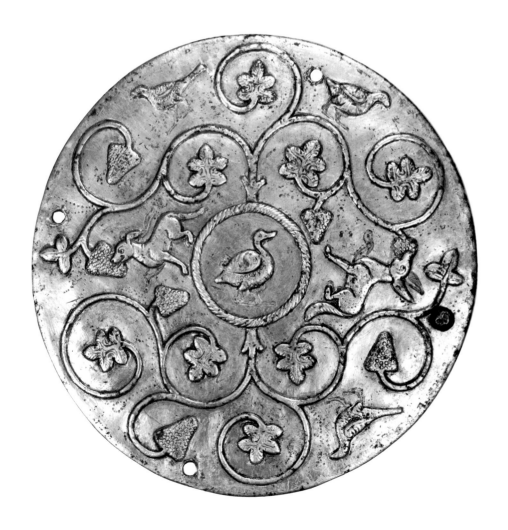

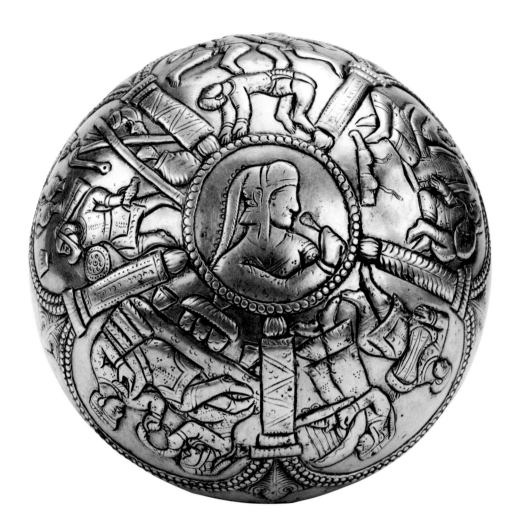

25 *Hemispherical Bowl*

Iran, 7th century
silver and gilt
height 5.7, diameter at rim 14.3 cm
(2¼ × 5⅝ in)
s87.0105

Grouped around a central medallion depicting a woman holding a flower are five scenes: a man and a woman seated on a low platform grasping a large ring; a servant, surrounded by various utensils, who is approaching the couple; a wrestling match; two people playing a board game; and a male musician playing a drum accompanied by a female musician plucking the strings of a harp. Scattered throughout these scenes are a number of vessels, including a high-footed bowl similar to no. 22 and a rhyton similar to no. 20. The most important of these scenes seems to be the one showing the couple holding the large ring. Other representations of this kind of image occur on stone seals and silver plates and have been associated with marriage ceremonies.

Within this context the various activities pictured on the bowl can be seen as part of the nuptial festivities of the couple shown on the low platform.

Despite the wealth of information provided by this imagery, the bowl's patron remains unknown. As a result of the relaxing of the controls governing silver production at the end of the Sasanian period, a new class of patrons developed outside of the court. Although many of these people were part of the landed nobility, it is not possible to identify them with any precision. The costumes of the figures, which are similar to those of the courtiers on the Sasanian rock reliefs at Taq-i Bustan in western Iran, the shape of the ewers and other objects, and the gilding of the background, rather than the design, a technique associated with nonimperial work, reflect the status of the bowl's patron and confirm its date.

Note
For a detailed discussion of this piece, see Prudence O. Harper, *The Royal Hunter*, New York, 1978, pp. 74–76.

26 *Handle and Chapes*

Iran, 7th century
gold
(a) handle parts
height 19.6, width 5, depth 2.8 cm
(7¹¹⁄₁₆ × 1¹⁵⁄₁₆ × 1⅛ in)
s87.0200a,b

upper chape assemblage
height 5.6, width 7.8, depth 3.3 cm
(2³⁄₁₆ × 3 × 1⁵⁄₁₆ in)
s87.0200c–e

lower chape assemblage
height 61.1, width 8.2, depth 2.5 cm
(23¹³⁄₁₆ × 3¼ × 1 in)
s87.0200f–i

(b) belt ornaments
end clasp
height 3.5, width 5.3, depth 1.3 cm
(1⅜ × 2¹⁄₁₆ × ½ in)
s87.0201a

end tab
height 2.8, width 8.5, depth .7 cm
(1⅛ × 3⅜ × ¼ in)
s87.0201x

long ornaments
average: height 4.8, width 2.3, depth .4 cm
(1⅞ × ⅞ × ⁵⁄₃₂ in)
s87.0201b–w

short ornaments
average: height 2.8, width 2.5, depth .5 cm
(1¹⁄₁₆ × 1 × ³⁄₁₆ in)
s87.0201y–ii

The handle and chapes, with their elaborate decoration of twisted wire and granulation, were once part of a large sword that would have been suspended from a belt by the P-shaped mounts along the side of the scabbard. Thirty-five ornaments and two clasps were allegedly found with the handle and chapes and were presumably part of the belt from which the sword would have hung. The P-shaped mounts, though not typical of Sasanian work, are nevertheless common to a number of weapons said to come from Iran. A sword with similar decoration is depicted in a hunting scene at Taq-i Bustan in western Iran that is associated with the reign of Khusrau II (591–628). Swords were obvious symbols of power and authority, and rulers, whether enthroned or mounted on horseback, are always shown wearing them. The finely worked designs of the handle and chapes and the fact that they are made of gold suggest that they were part of a royal weapon.

Note
For a detailed discussion of a closely related sword in the Metropolitan Museum of Art, see Prudence O. Harper, *The Royal Hunter*, New York, 1978, pp. 83–84.

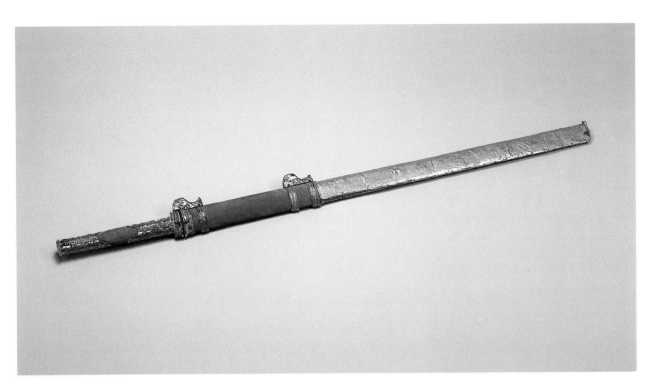

a

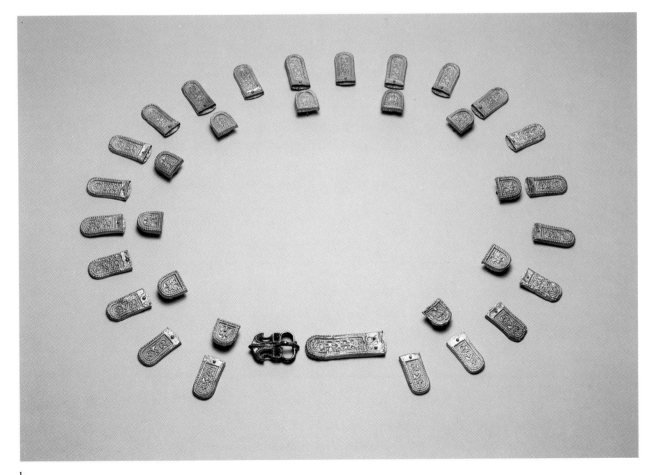

b

SOUTH *and* SOUTHEAST ASIA

CHINA

TIBET

AFGHANISTAN

JAMMU AND KASHMIR

HIMACHAL
PRADESH

PUNJAB

HARYANA

PAKISTAN

Delhi

NEPAL

BHUTAN

ARUNACHAL
PRADESH

SIKKIM

NAGALAND

RAJASTHAN

UTTAR
PRADESH

ASSAM

GANGES R.

INDIA

MEGHALAYA

MANIPUR

BIHAR

TRIPURA

MADHYA
PRADESH

Calcutta

MIZORAM

GUJARAT

BURMA

MAHARASHTRA

ORISSA

BANGLA-
DESH

LAOS

GOA, DAMAN, DIU

Bombay

WEST
BENGAL

ANDHRA
PRADESH

BAY OF
BENGAL

THAILAND

ARABIAN
SEA

Koh Ker

VIETNAM

Vijayanagar

KARNATAKA

Angkor

Madras

CAMBODIA

TAMIL
NADU

KERALA

INDIAN
OCEAN

SOUTH
CHINA
SEA

country **INDIA**
city ● Calcutta
state WEST BENGAL
archaeological site ● *Vijayanagar*

SRI
LANKA

Temple Sculpture

INDIA, A LAND of religious devoutness and ritual events, is dominated by temples, assertive presences in the landscape. The interior shrine space of the Hindu temple is small and dark, but associated with it is a towering superstructure, and upon this the brilliant sun of India plays. Symbolically, the building recreates the mountain abode of the gods, while the inner shrine evokes in the devout worshiper a sense that he has penetrated deep within the earth. This interior cell, termed the *garbha-griha* (womb room), is simple and severe and often so cavelike that it is physically disorienting; the worshiper experiences a mysterious, unearthly realm: "the still point of the turning world" (in T.S. Eliot's words). And if there is imagery here, it is usually a simple, often roughly carved sculpture of the main deity of the temple. However, in the darkness its presence would be sensed rather than seen, and only after a symbolic trip to the center of the world.

The exterior, on the other hand, is covered with sculpture, and this can mean literally thousands of figures, all facing outward. These images celebrate the multiplicity of life, and their quantity indicates the all-pervasiveness of divine energy. Here the gods are represented in their earthly incarnations, while lesser divinities reveal by their actions the vitality of life. The continual creation of life is itself a revelation of divinity, and it is therefore an appropriate subject on temples. For this reason, too, the gods are inevitably shown as young, physically perfect, and bursting with energy.

Throughout the region, dominated by Hinduism and Buddhism—religious systems that developed on the Indian subcontinent—myth, sculpture, and ritual include major, pan-Indian divinities and local, village gods. Often these regional deities have been worshiped longer and more enthusiastically than the major gods. Equally frequently their characteristics and powers have been legitimized (and perhaps brought under priestly control) by absorption

into the official pantheon. The terrifying, blood-drinking goddesses known as the *sapta-matrka* (no. 28), for example, may have been isolated, local deities before their incorporation into the mythology of Shiva.

At the head of the system of established Hindu religious ritual stand Brahma, Vishnu, and Shiva (no. 29), whose realms are, respectively, creation, preservation, and destruction. While each has his own adherents, they are not seen as independent deities; each is simply one aspect of the ultimate divine principle, known as *brahman*. Undefinable, *brahman* is therefore incapable of being represented, and images of gods are simply a way to awaken awareness of the ultimate, formless quality; they are not worshiped for their own sake. This is also the purpose of the multiple forms on the exterior of temples, for the quantity obliterates the individual importance of any single figure. (This is precisely what removal and placement in a museum inappropriately reasserts. Thus the presentation of Indian sculpture in museum settings can contradict its original context.)

The elaborate sculptural program that covers temples prevents us from discussing architecture and sculpture as meaningful categories. However, there is also a tradition of separate, distinct sculptures—the bronze images that were placed on the altars of temples, in ancillary structures, or sometimes in shrines within prominent households (nos. 27, 29, 30). These sculptures were often removed from shrines on festival days and paraded through the town as if the god were himself making a ceremonial procession. Whether physically taken from the temple or placed on the exterior to face the approaching worshiper rather than the god within, temple sculpture was always seen as an emanation of the formless divinity within the *garbha-griha*, just as Brahma, Vishnu, and Shiva were emanations of the indescribable *brahman*.

Just as local divinities were (and are still) known, so the different regions into which the Indian subcontinent is divided by mountains, rivers, and history inevitably produced distinctive artistic traditions. (The Indian collection in the Arthur M. Sackler Gallery concentrates on sculptures from the south, for example.) Artists, members of a hereditary profession, would travel to distant sites, however, when nearby work was not available. The works of sculptors and painters were always under the control of priests and religious scholars, and artists were expected to follow established models rather than develop individualized styles. For this reason, the pace of stylistic change was slow, and few names of sculptors were recorded.

Hinduism remains an immensely potent force within India. The religious devotion that produced images in the tenth century is still at work in the worship of many of these same images today. To see sculpture of such historical age and importance remain part of a living tradition is a moving experience and increases our ability to understand the context—and the original intention—of one of the richest artistic traditions of Asia.

MILO C. BEACH

27 Tirthamkara

A Jain Savior
South India, ca. 10th century
bronze
height 18.5, width 14.5, depth 9.3 cm
(7¼ × 5¹¹⁄₁₆ × 3⅝ in)
S87.0016

One contemporary of the Buddha in India was the sage Mahavira (Great Hero), whose teachings became the basic doctrines of the Jain religion. He is described in texts as the twenty-fourth and last of a series of saviors (*tirthamkaras*) who appeared on earth at intervals of many thousands of years. The origins of Jainism are placed by its believers at the beginning of human earthly existence. The religion was most popular and powerful about A.D. 500; since then the number of adherents has steadily declined, although it remains a potent and important religious system within India.

The Jain code of conduct was based on intense personal asceticism and on the need to release the individual worshiper from the material aspects of life on earth. Jain images may be distinguished from those of Buddhism in that Jain saviors and saints are inevitably depicted nude, a particularly effective way of showing their detachment from material existence. This small image in the Sackler Gallery, which may show Mahavira himself, evokes a monumental calm; the figure, in self-absorbed meditation, seems uninvolved in our world.

Small bronze sculptures of this type could be used on household altars or presented to temples as auspicious gifts; there they would be placed on the altars of subsidiary shrines as evidence of the donor's devotion.

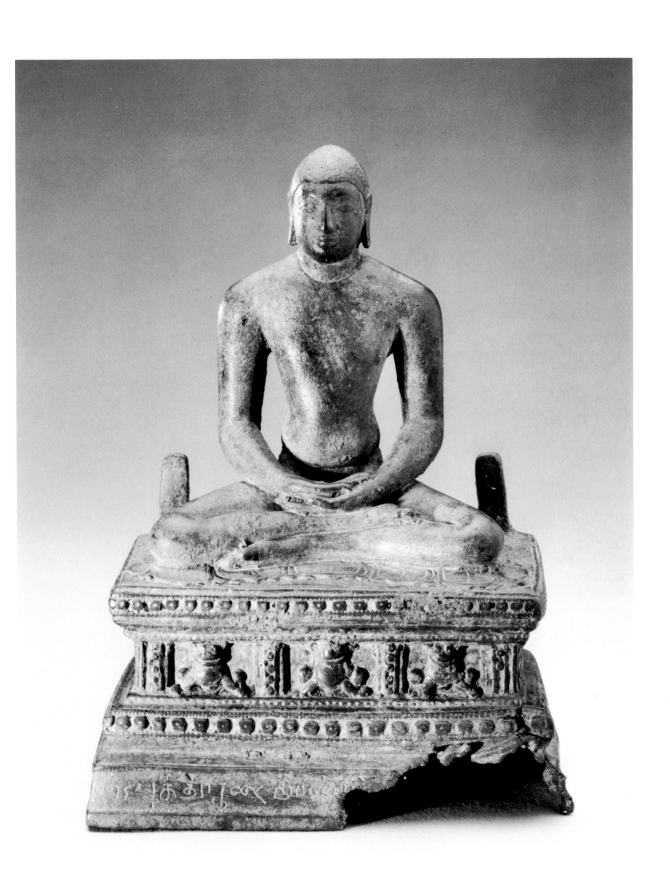

28 Sapta-Matrka

Seated Goddess
South India, Chola dynasty, 10th century
granite
height 116, width 76, depth 43.2 cm
($45^{11}/_{16}$ × $29^{15}/_{16}$ × 17 in)
s87.0905

When Andhaka came to rule over the world of de-
mons (*asuras*), he became so powerful that even the
gods were terrified. They went to the celestial
Mount Kailasa to ask the omnipotent Shiva to in-
tercede. At the same moment Andhaka himself ar-
rived, arrogantly demanding Shiva's own wife, Par-
vati. Enraged, Shiva attacked Andhaka, but as drops
of blood fell to earth from the demon's wounds,
new Andhakas were formed. Shiva instantly created
a *sakti*, a female counterpart, and called on other
gods to send their female emanations. According to
the most popular stories, seven mothers (*sapta-
matrka*) appeared, and they drank the blood shed
by Andhaka, while Shiva slew the demon multi-
tudes.

This work comes from a complete set of images
of the seven mothers and Shiva. (It is now divided
among major North American museums.) Because
the symbolism of the *sapta-matrka* relates closely to
local folk beliefs, which vary in different regions, the
few known full sets of figures are inconsistent in the
attributes, or emblematic objects, that the deities
hold in their hands, as well as in individual postures
or appearances. It therefore is difficult to determine
the identity of this particular goddess.

The style of this powerful *sapta-matrka* figure in-
dicates a date close to 1000 and a provenance in
Tamil Nadu, the region around the city of Madras
on the southeastern coast. This is an early work of
the Chola dynasty (ca. 850–1310), the most bril-
liant period for Hindu sculpture in India.

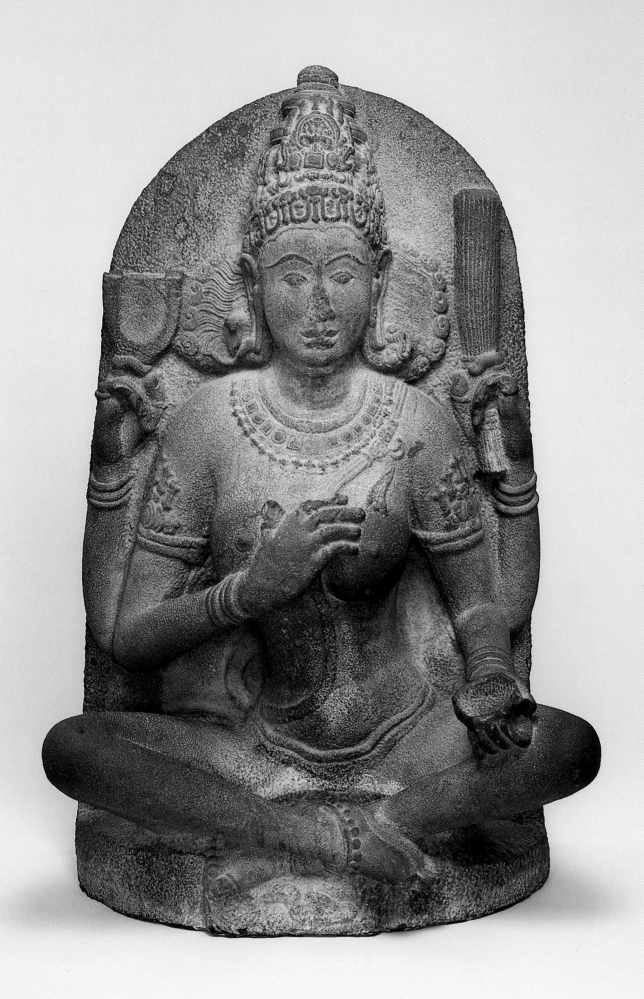

29 *Shiva*

South India, ca. 13th–14th centuries
bronze
height 68.5, width 39.4, depth 35.2 cm
(27 × 15½ × 13⅞ in)
s87.0911

This figure of Shiva, the Hindu god of destruction, was probably made at Vijayanagar and originally formed part of a *Somaskandha* group (no. 30). The god's upper left hand would have held a small deer, symbolic of his role as *pasupati*, the father of the wild animals of the forests, while his lower hand makes a gesture of pacification. Just as Shiva in battle with Andhaka (no. 28) would present a ferocious form of the god, *Somaskandha* images stress the deity's benign character. For the Hindu, a god's power came from his or her universality—the ability to contain all possible aspects of existence.

30 *Somaskandha*

Shiva and Uma
South India, ca. 14th century
bronze
height 59.2, width 71.8, depth 31.6 cm
(23⁵⁄₁₆ × 28¼ × 12⁷⁄₁₆ in)
s87.0907a,b,c

The Indian reverence for children is found through-
out the imagery of Hinduism—worship of the
young god Krishna is its most familiar form. Here
Shiva and his consort Uma would be enthroned with
their son Skandha, the god of war, had his figure
not been lost; and the sculpture stresses the benefi-
cent aspect of the gods. In Sanskrit, the syllable *sa*
(emblematic of Shiva) joins with the name Uma to
become *Soma*, and so the name for this image (*So-
maskandha*) is simply the combined names of the
three deities.

Bronze images were kept on the altars of temples
or household shrines. On specific festival days,
sculptures were removed from temples and carried
through the town in ceremonial processions. The
lugs seen at the base of this *Somaskandha* and other
Indian bronzes allowed the works to be more easily
supported on such occasions.

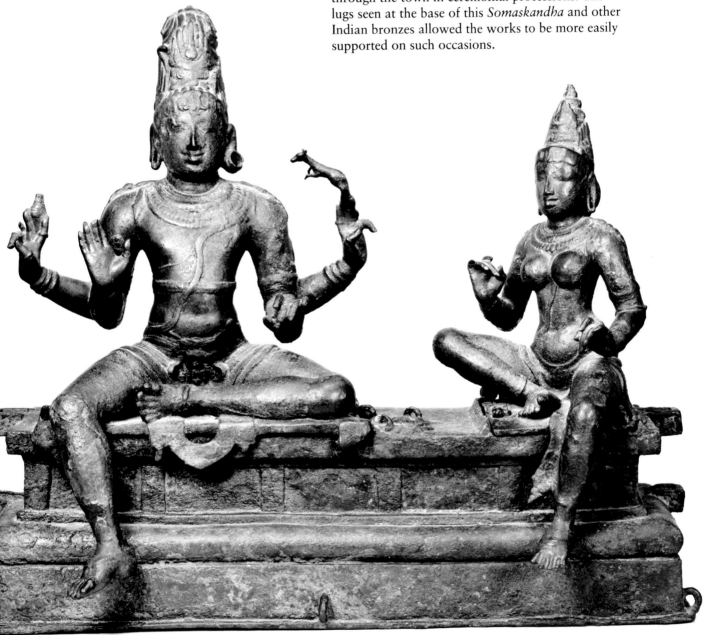

31 *The Goddess Uma*

Cambodia, mid-10th century
gray sandstone
height 124.2, width 37.5, depth 24.3 cm
(48⅞ × 14¾ × 9⁹⁄₁₆ in)
s87.0909

In 921 King Jayavarman IV established a new capital at Koh Ker for those territories in Cambodia controlled by the Khmers. Like his predecessors, he built a temple-mountain complex both to assert his role as a god-king and to proclaim the divinity of his ancestors. Such structures became the center for the king's own funerary ceremonies and for subsequent rituals of worship.

The symbolism of these monuments was drawn from Hinduism, which arrived from India and became increasingly influential in Southeast Asia during the first millennium. The towering forms of the structures evoked Mount Meru, the abode of the gods, which the sculptural decoration then inhabited with deities and heavenly beings. The inference, of course, was that the king was himself divine.

Khmer images are more restrained and quietly sensual than the majority of Hindu sculptures from India. Uma, one of the god Shiva's consorts, stands calmly, her body rigidly symmetrical. The contrast between the strong, parallel ridges of her skirt and the soft flesh of her body increases our awareness that Uma is a goddess of fertility.

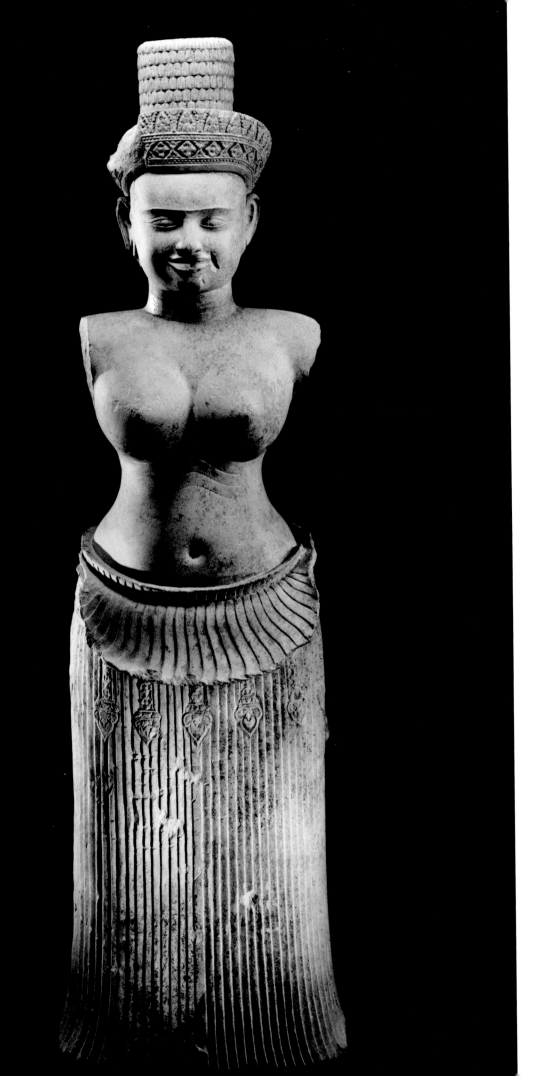

CHINA

HEILONGJIANG

MANCHURIA

JILIN

LIAONING

INNER
MONGOLIA YAN
 Beijing
GANSU Liyu ◆ ◆ Yanxiadu

Xiangtan HEBEI
 ■ Gaocheng
 SHANXI
NINGXIA HUANG HE
 ○ Dawenkou
QINGHAI JIN QI
 Shangcunling
 ■ Anyang SHANDONG
 ZHOU Liulige/Hui Xian
 Houma ◆ ●
Fufeng Xian Xiamengcun Erlitou ● Zhengzhou ○ Suzhou
QIN □□ ○ Ruicheng ○ ● Luoyang ◇ Xinzheng Qingliangang JIANGSU
 Qishan ● Xi'an HENAN ● Yangzhou
 Rujiazhuang Nanjing
 Baoji ◆ Xinye HUAI ● Beiyinyangying Shanghai
SHAANXI HE ● Songjiang
 ZENG Xinyang ANHUI Liangzhu ●
 HUBEI Hangzhou ○ Hemudu
 ◆□ Jiangling ● ○
Chengdu ● Xiuning Shexian ● ZHEJIANG
SICHUAN CHANG JIANG CHU
 (YANGTZE)
 ● Changsha JIANGXI
 HUNAN
GUIZHOU FUJIAN

YUNNAN ○ Shixia
 XI JIANG GUANGDONG
 GUANGXI ● Canton

71

Jade

J ADE, LIKE NO other material, inspires Chinese artists. Reverenced for its beauty and prized for its durability, jade has been worked in China for more than five thousand years. To the Chinese people the term "jade," or *yu*, encompasses a wider range of minerals than the Western definition, which is strictly limited to nephrite and jadeite. For Chinese artists the beauty of the material is paramount, and minerals and stones such as chloromelanite, hornblende, serpentine, and rhyolite have been admired and worked with the same care as nephrite and jadeite.

Of the two stones—nephrite and jadeite—recognized by mineralogists as true jade, only nephrite was available in ancient China. It was imported eastward over immense distances from the riverbeds of Khotan and Yarkand in what is now the northwestern region of Xinjiang and possibly also from around Lake Baikal in eastern Siberia. Jadeite, by contrast, was evidently not worked by the Chinese until the late seventeenth or early eighteenth century, when the stone was imported from northern Burma after Qing dynasty (1644–1911) armies gained control over the far southwest.

Nephrite is a silicate of calcium and magnesium belonging to the amphibole group of minerals and having fibrous crystals structurally interlocked to produce an extremely hard stone. On the Mohs' scale of hardness, nephrite is rated 6.5 (talc is 1; diamond 10); consequently the stone cannot be scratched by metal unless it has first become softened by chemical alteration during burial in the ground or by exposure to weathering. Nephrite exists in a variety of colors, depending on the amount and kind of mineral impurities in the stone— usually some form of iron, sometimes also chromium and manganese. In general, jade that has few mineral inclusions tends to be pale in color and translucent.

Because jade is such a hard material, it is extremely difficult to work. Although it is

customary in English to speak of "carving" jade, in fact abrasives such as Carborundum must be used to slice a boulder or pebble into thin sections and to impose decoration onto its surface. Simple grinding tools apparently have always been employed to produce jades of remarkable form and delicacy. Even today, Chinese jade-carving tools and techniques remain much the same as those used in antiquity.

Given the arduous, time-consuming labor involved in carving jade, the delicate shapes, intricate designs, and high polish that characterize jades made in China as early as the Late Neolithic period (ca. 5000–ca. 1700 B.C.) are all the more remarkable. Although jade is a difficult material to work, those artifacts with thin cross sections and intricate silhouettes are extremely fragile. Many archaic—pre-Han dynasty (206 B.C.–A.D. 220)—Chinese jades were broken and repaired or, on occasion, completely reworked in antiquity.

Chinese jade artists have always devoted special attention to the shape and color of jade boulders and pebbles. Many of the most imposing examples of jade sculpture from all periods were created with a minimum of change to the original contours of the stone and with the forms designed to coincide with natural coloristic variations in the mineral.

As more information about ancient Chinese jade becomes available from archaeological finds, scholars are able to identify idiosyncratic regional shapes and carving techniques that began as early as the Late Neolithic period and continued into historical times. Particularly important is the observation that the earliest Neolithic centers for jade carving appear to have been located in eastern China, rather than northwestern and central China as previously believed.

Late Neolithic jades, which apparently were used in funerary rites, are among the finest ever made in China. Ritual objects, such as the *bi* (disk) and the *cong* (nos. 34, 44, 54, 58), were always made of jade, suggesting a fundamental relationship between mineral and ceremony. The hardness and luster of jade may have been critical features in determining the special regard extended by the Chinese to jade.

In contrast to developments elsewhere throughout the ancient world, Chinese artists did not abandon their Neolithic traditions when the casting of bronze ritual vessels developed during the historical Shang (ca. 1700–ca. 1050 B.C.) and Zhou (ca. 1050–221 B.C.) periods. Those lithic traditions were perpetuated, and functional implements like stone harvesting knives and sturdy stone chisels were fashioned of precious jade. Jade versions of the stone utensils served as ceremonial emblems bestowed by grateful rulers on deserving servitors. At the same time, Chinese artists frequently duplicated bronze weapons, such as dagger-axes, producing jade artifacts of surpassing beauty but with no utilitarian purpose. The jade replicas would have served as ceremonial paraphernalia for Shang or Zhou dynasty grandees.

There are close relationships between the decorative motifs on jade carvings and those on contemporary ritual vessels, thus prompting specialists to date archaeologically unattested jade pieces on the basis of stylistic comparison with datable bronzes. On those jade artifacts where decoration is lacking—as is frequently the case with Late Neolithic, Shang, and Western Zhou jades—carving techniques and changes in shape are critical factors.

The wealth of early jades found in China in the twentieth century has prompted a shift

to stylistic analyses that emphasize the comparison of jades with other jades. A crucial development in our understanding of the relationship between jade and bronze decor is the realization that Chinese jade artists likely initiated some of the decorative motifs that only later appeared on bronze vessels.

By the Han dynasty, Chinese artists were producing funerary jades to serve a remarkable function. In the erroneous belief that jade could prevent the decay of the physical body after death, elegantly fashioned jades of appropriate size were used to block the natural orifices of the human body. Expression of the belief in the preventive powers of jade reached its apogee in Han dynasty shrouds made of innumerable small, thin jade rectangles that were linked together by gold, silver, or copper wire. Jade ensembles of this type obviously could be commissioned only by wealthy or noble patrons.

The dating of later Chinese jades continues to pose special problems. Those jades traditionally assigned to the long period between the beginning of the Han dynasty and the end of the Ming dynasty (1368–1644)—a span of more than a thousand years—have always been difficult to date with any degree of certainty. As has been recognized for centuries, the basic difference in jades dating from the archaic period and those made during later times is the change in emphasis from artifacts intended for ritual purposes to those intended for secular purposes.

Most characteristic of later jades are the small carvings of animals intended to adorn a scholar's desk or to amuse a sophisticated antiquarian. Many of these reflect a keen awareness of the ritual forms and functions of the archaic period, and they are carved with the same regard for preserving the integrity of the original boulder. Jade artists introduced new themes during later periods, drawing upon the richness of Buddhist and Daoist iconography as well as the myriad heroes of China's long history. Although some of the new themes are imbued with appropriate seriousness, others reflect a whimsy that would have astonished patrons of the archaic period.

Chinese jade artists have the remarkable ability to retain the integrity of earlier traditions while at the same time introducing new and varied images—all having subtle allusions—to their complex visual repertoire. The continual development and enrichment of images enabled jade specialists to maintain a vibrant artistic tradition over a long period. At all times, the Chinese have fashioned jades of splendid quality, combining an extraordinary degree of technical skill with impressive aesthetic sensitivity. The degree of perfection attained by Chinese jade artists throughout several millennia has never been surpassed in any other culture of the world.

THOMAS LAWTON

32 *Tubular Ornaments*

Late Neolithic period, ca. 3000 B.C.
(a) height 14.6, width 9.5, depth 6.9 cm
(5¾ × 3¾ × 2¹¹⁄₁₆ in)
s87.0626
(b) height 15.8, width 9.7, depth 7 cm
(6¼ × 3¹³⁄₁₆ × 2¾ in)
s87.0842

A number of jades of this unusual, elliptical shape
have been found. Although their original function
remains uncertain, suggestions offered about their
use include hair ornaments, ceremonial grain
scoops, and ceremonial cuffs.

Opinions about the date of these jades have var-
ied; the Western Zhou through the Ming dynasty
have all been proposed. Uncertainties about the date
of these enigmatic jade objects were resolved, how-
ever, by the discovery of a jade of the same type in

Liaoning Province in 1973. The tubular ornament
found there was one of approximately one hundred
pieces of jade that have been identified as being rep-
resentative of the Hongshan culture in northeastern
China and as dating from the Late Neolithic period.
On the basis of carbon 14 dating, the jades asso-
ciated with the Hongshan culture have been as-
signed to the period ca. 3000 B.C.

In the Chinese archaeological report, the exca-
vated jade is described as shaped like a horse's hoof,
fashioned of blackish-green jade, and tubular in
shape. The opening at one end is flat; the opening at
the opposite, sloping end is diagonal in profile.
Whereas most jades of this type are plain, an ex-
ample in the Grenville L. Winthrop collection in the
Arthur M. Sackler Museum at Harvard University is
decorated with a series of concentric ridges. More
remarkable is a tubular ornament in the British Mu-
seum in London in which an animal mask covers
most of the surface.

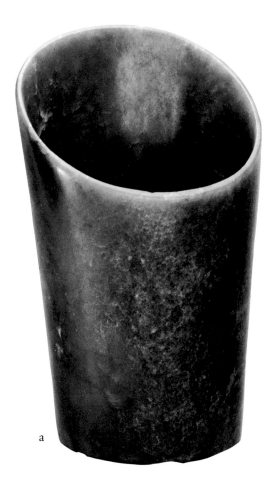

a

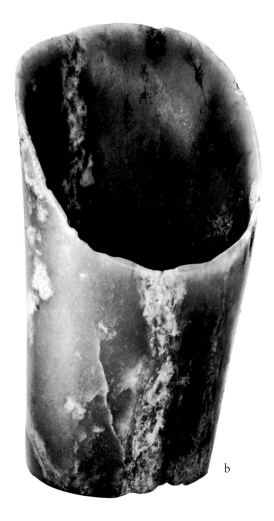

b

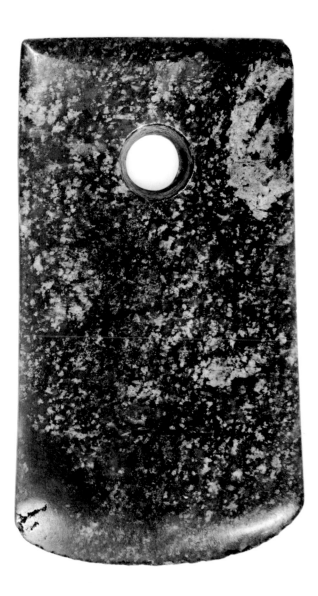

33 Ax

Late Neolithic period, ca. 2500 B.C.
height 15.9, width 9, depth .9 cm
(6¼ × 3½ × ⅜ in)
s87.0722

The refinement in the elongated shape of this sturdy ax provides eloquent proof of the remarkable achievements of Chinese artisans during the Late Neolithic period. Both of the lateral edges of the rectangular ax are slightly concave, and the lower, cutting edge has a pronounced curve. When seen from the side, the ax has a slightly tapering, lentoid body. All of the surfaces are polished to a smooth luster. The interior of the single, conical perforation on the upper portion of the ax is also carefully finished.

Information available from archaeological sites in China makes it clear that jade axes of this type were produced as burial objects and were not meant for practical use. Comparable jade axes have been found in Late Neolithic sites in the eastern coastal areas of China.

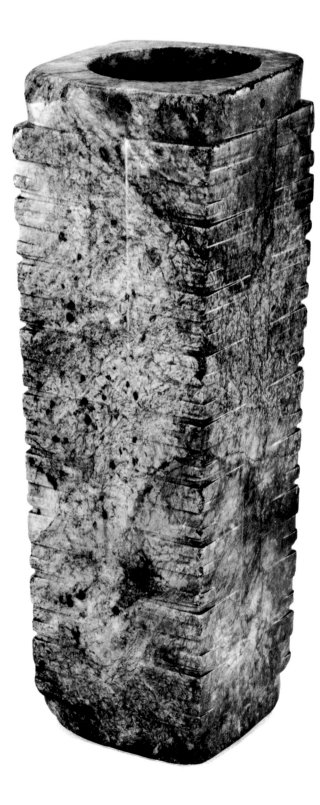

34 Cong

Late Neolithic period, ca. 2500 B.C.
height 22.1, width 7.5, depth 7.6 cm
(8¹¹/₁₆ × 2¹⁵/₁₆ × 3 in)
s87.0468

The function or significance of *cong* remains uncertain, but evidently they were used for ritual purposes. Archaeological excavations in southeastern China have yielded a large number of highly polished and intricately decorated *cong* of this type, suggesting that the shape may have been developed in that area, where it had particular significance. Only later, and in simpler form, did the *cong* appear in northern China in Shang dynasty funerary contexts. Particularly important archaeological finds in Jiangsu Province have yielded crucial information about Late Neolithic jade *cong*. In one instance, more than thirty *cong* were found arranged end to end encircling the body. The arrangement of those *cong* prompted the authors of the Chinese archaeological report to surmise that the jades served a protective role or function. Jade *cong* of this same type have also been found in Late Neolithic sites in Guangdong Province.

The Sackler jade is a slightly tapering prism with a thick-walled projection at either end. Straight vertical channels at the center of each of the four surfaces separate nine superimposed units of decor. Each of these units covers the corners of the jade prism and consists of a narrow horizontal band beneath a wider, upper band decorated with two horizontal bands and a circle on either surface. These details form a series of masks at the four corners. The central perforation was drilled from both sides, resulting in an overlap.

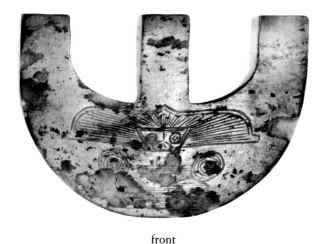

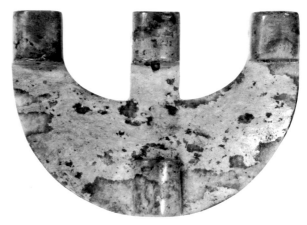

front back

35 *Plaque*

Late Neolithic period, ca. 2500 B.C.
height 4.3, width 6.2, depth 1 cm
(1¹¹⁄₁₆ × 2⁷⁄₁₆ × ⁷⁄₁₆ in)
s87.0734

The top segment of this jade plaque is in the form of
three squared projections. The interior contours of
the projections conform to the rounded edge of the
plaque itself. Decorating the lower portion of the
flat surface of the plaque is a stylized bird with a
trapezoidal head and unfurled wings superimposed
above two oval eyes and horizontal motifs that can
be interpreted as nose and mouth.

Jades decorated with these motifs can be asso-
ciated with the Late Neolithic Liangju culture lo-
cated along the southeastern coast of China. The
precise meaning of the decoration remains uncer-
tain, although such jades probably served a ceremo-
nial function. Their early date makes the possible in-
fluence of Late Neolithic jade motifs on Shang
dynasty ritual bronze vessels seem plausible.

Several jade plaques similar to the Sackler piece
are known. The examples in the Minneapolis Insti-
tute of Arts and the Freer Gallery of Art provide es-
pecially informative comparisons.

36 Blade

Late Neolithic period, ca. 2000 B.C.
height 17, width 47.8, depth .9 cm
(6¹¹⁄₁₆ × 18¹³⁄₁₆ × ³⁄₈ in)
s87.0450

This large, trapezoidal blade has two straight lateral edges. The lower, cutting edge is beveled. Parallel to the back edge are two conical perforations. A smaller perforation, perhaps meant to be used to suspend the blade, was drilled from the reverse side at one end of the blade. A smaller, incomplete perforation appears just below one of the suspension holes. Some damage to one end of the blade interrupts its trapezoidal shape. A series of finely articulated notches project from the complete end of the blade; the notches are closely related to the convex portions of the abstract designs worked into both sides at the end of the blade. Similar designs appear in the center of the blade, and some vestiges are also visible at the broken end.

A jade piece unearthed in a Late Neolithic context at Rizhao, Liangcheng, Shandong Province, is as large as this one. At its widest points the piece from Rizhao measures 26 and 12.4 centimeters (10¼ and 4⅞ inches). Given the lack of finish on the surface of the archaeologically attested blade, it may be incomplete. The large size and relative thinness of both these blades indicate that they were not meant to be practical implements, such as knives or tools.

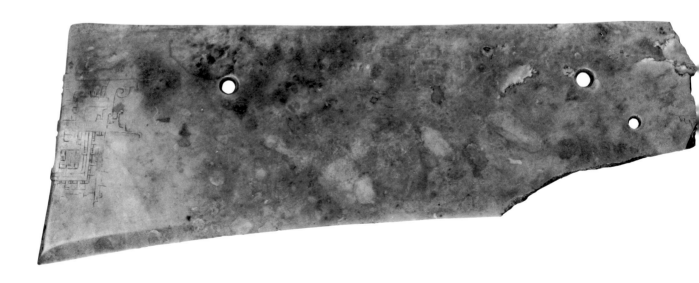

37 Blade

Shang dynasty, 1st half of 2d millennium B.C.
height 10.5, width 73.6, depth 1.4 cm
(4⅛ × 29 × ½ in)
s87.0449

This trapezoidal jade blade derives its shape from
Chinese Late Neolithic harvesting knives, which
were fashioned of stone. Even the five conical perfo-
rations along the thick, upper edge of the blade are
based on those of earlier, stone examples; the perfo-
rations would have enabled a grip of some kind to
be attached. Although the Late Neolithic stone ex-
amples were functional, the jade replicas apparently
were meant for ceremonial purposes. None of the
jade blades, regardless of size, bears any abrasion or
marks that would indicate actual wear.

The lower edge of the Sackler blade is ground
blunt, evidently a token reference to the sharpened
cutting edges of the Neolithic stone examples. Some
areas of the thick, upper edge are irregular and un-
finished, suggesting that the artisan used as much of
the surface of the jade boulder as possible. Irregu-
larly shaped notches of surprisingly crude work-
manship appear on each of the two short ends of the
jade blade. These two portions of the piece, as well
as the bottom edge, are clearly set off from the rest
of the blade by their slightly depressed ground. A
pattern of fine lines is incised into the jade surface at
each end of the blade. Some of those lines are
straight, whereas others are arranged in a crisscross
pattern.

In its unusually large size and sophistication of
finish, the Sackler blade resembles two jade pieces
unearthed in Shang dynasty sites at Erlitou, Henan
Province. The craftsmanship displayed on these and
similar jade pieces is more highly developed than
that seen on contemporary ritual bronze vessels.

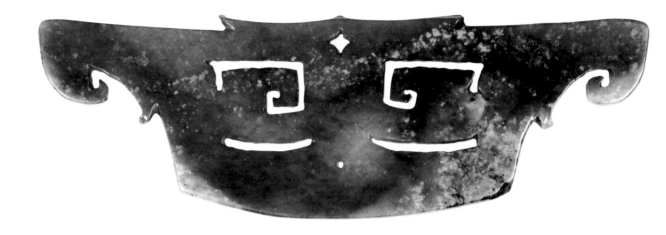

38 Openwork Ornament

Shang dynasty, 2d millennium B.C.
height 6.1, width 18.8, depth .5 cm
(2⅜ × 7⅜ × ¼ in)
S87.0514

Trapezoidal in shape, this ornament is fashioned
from a thin slab of mottled tan-colored jade. While
the overall symmetrical silhouette of the ornament
reflects an impressive degree of sophistication, espe-
cially in the relationship of the concave and convex
surfaces, the perforated decoration was achieved
with surprising crudeness. It is apparent that the
Chinese artisan drilled a series of small holes
through the jade slab and then connected them to
form the irregular reticulated pattern.

A more elaborate jade ornament of this type was
unearthed in one of the royal Shang tombs at Hou-
jiazhuang, Henan Province, in the early years of the
twentieth century. That jade ornament, usually de-
scribed as a headdress decoration, displays the same
curious contrast between its complex silhouette and
crude perforations. Nonetheless, the appearance of
the jade headdress in a royal tomb suggests that it
was regarded with esteem, even though most of the
jades from the royal Shang tombs in the area of
Houjiazhuang display considerably more technical
skill in their decoration.

39 Pendant

Shang dynasty, 2d millennium B.C.
height 6.8, width 3.8, depth 1.3 cm
(2¹¹⁄₁₆ × 1½ × ½ in)
s87.0880

Fashioned of mottled green nephrite, the ferocious mask includes pairs of elongated fangs, a bulbous nose, and slanted eyes. Both ears are embellished with circular earrings, which have their counterparts among the jades found in Late Neolithic and early Shang tombs. An angular headdress with hooked projections further enhances the symmetrical silhouette of the pendant. A tall plume with incised geometric motifs curves upward from the angular headdress. A small, circular perforation on the lower edge would have enabled the jade to be suspended or attached to another surface.

The identity of the ferocious beings depicted in jades of this type is open to question. They might be shamans, or people who supposedly could act as intermediaries between the human and the spirit world. The original function of this type of jade also remains enigmatic.

The redating of some specific types of Chinese jades has been possible only since the mid–1970s because of archaeological finds in China. Among the jades whose dates have been adjusted backward in time, from the early Zhou to the early Shang dynasty, are pendants such as this one in the Sackler Gallery.

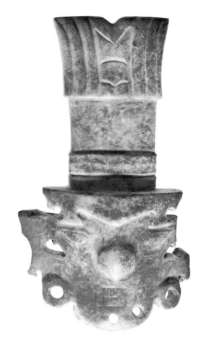

front

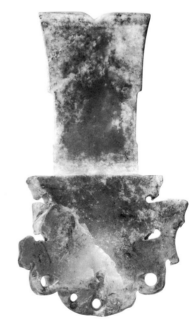

back

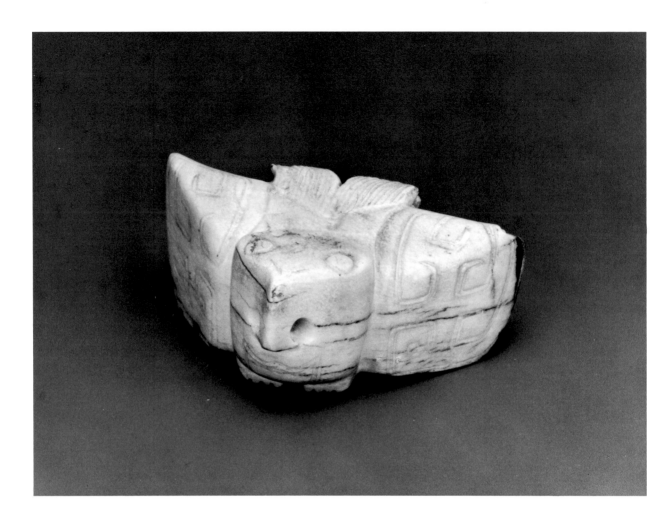

40 *Bird Pendant*

Shang dynasty, 2d millennium B.C.
height 3.2, width 8, depth 5 cm
(1¼ × 3⅛ × 1¹⁵⁄₁₆ in)
s87.0861

The jade bird with wings outstretched is triangular
in form. Circular incised eyes and a pronounced,
hooked beak, which is pierced, establish the identity
of a bird. A bifurcated tail decorated with neat, reg-
ular striations projects from the main body of the
jade opposite the bird's head. The outstretched
wings are embellished with double-outline decora-
tion that ornaments the jade surface without actu-
ally defining the bird's plumage. The perforation
through the bird's beak would have permitted the
piece to be worn as a pendant.

Among the more than 750 jades unearthed in
Tomb No. 5, a Shang royal burial site at Anyang,
Henan Province, in 1976, there were a number of
pieces in which the Chinese artist restricted the bird
and animal representations to precise geometric
forms. In most instances the degree of abstraction in
Shang dynasty jades heightened the visual impact of
their forms and, in spite of their small scale, imbued
them with an imposing sense of monumentality.

41 *Ornament*

Shang dynasty, 2d millennium B.C.
height 9.9, width 3.2, depth 2.2 cm
(3⅞ × 1¼ × ⅞ in)
s87.0837

It has been suggested that this jade might have formed the decoration for the tip of an archer's bow, where it was used to secure the bowstring. That suggestion is based, in part, on the fact that only one side of the jade is decorated. The undecorated side may have been covered by the bow. Jades that presumably decorated an archer's bow usually are considerably thinner than the Sackler piece.

At the top of the jade is an animal head modeled in the round. Details such as the eyes and nostrils are presented as simple, cubic shapes and are further defined with incised lines. Short, capped horns project from the animal's forehead; abstract motifs are added with double outlines. A curving projection at the back of the head is also decorated with motifs in double outlines. The lower portion of the jade, which is clearly defined by a flat projection at the front, is triangular in cross section and tapers to a blunt point. The shape of the jade, which resembles a tooth or tusk, is of the type usually identified by Chinese specialists as a *xi*, which is believed to have been worn at the girdle and used to untie knots.

Note
For further discussion, see Alfred Salmony, *Chinese Jade Through the Wei Dynasty*, New York, 1963, p. 41, plate V–5.

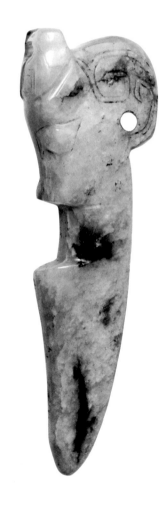

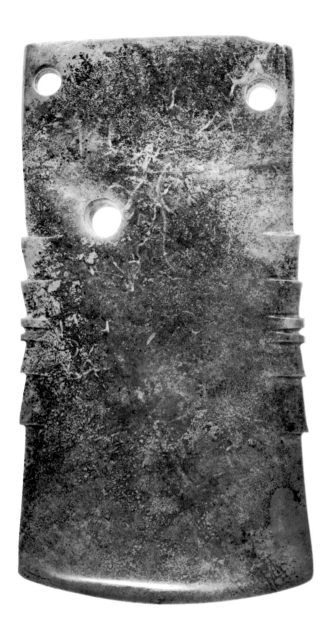

42 Ax

Shang dynasty, 2d millennium B.C.
height 16, width 8.7, depth 1.1 cm
($6^5/_{16}$ × $3^7/_{16}$ × $^7/_{16}$ in)
S87.0673

This sturdy jade ax is rectangular in shape. One end
flares and has a curved, sharpened cutting edge. The
butt end of the ax has a chipped corner, and there
are three irregularly placed conical perforations.
The central portions of the two lateral edges of the
ax are decorated with symmetrically arranged
notches that divide the piece into three equal seg-
ments and differentiate between the tang and the
curving, beveled edge. Textile impressions of a finely
woven material in which the ax was wrapped upon
burial are clearly visible in the mottled red-colored
accretions that cover both sides of the jade.

It is not unusual to find irregular or broken edges,
especially at the corners, on Chinese ritual jades.
Since the jades were not functional, the irregularities
must be understood as part of the original shape.
The broken edges evidently resulted at the time the
jades were placed in the tomb. For instance, most of
the jade ax blades from Tomb No. 5, the royal
Shang burial site found at Anyang, Henan Province,
in 1976, display broken edges. Archaistic copies of
ritual jades made during later periods frequently in-
corporated similar formal irregularities.

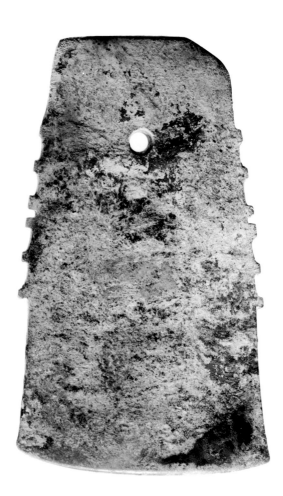

43 Ax

Shang dynasty, 2d millennium B.C.
height 11.1, width 6.6, depth .4 cm
(4⅜ × 2⅝ × ³⁄₁₆ in)
s87.0566

This ax of green nephrite with cream-colored mottling tapers toward the butt. The lateral edges of the ax are decorated with symmetrically arranged rows of squared teeth and beveled notches. The lower, flaring end of the ax has a curved, sharpened cutting edge. There is a small conical perforation at the center toward the butt end of the piece. One corner of the butt is roughly finished. Evidently the Chinese artisan used the material available to the greatest possible advantage, ignoring or perhaps even admiring the variation in the overall symmetry introduced by the irregular corner. There are traces of cinnabar on the surface of the ax.

The development of dentate jade decoration of the type that appears on the lateral edges of the Sackler ax was formerly believed to have begun during the Shang dynasty and to reflect the influence of bronze traditions. Archaeological finds, however, suggest a new theory. The appearance of jade axes from sites that can be dated to the Late Neolithic period and decorated with small, carefully polished projections along their edges supports the theory that this innovation was made by jade artisans well before the Bronze Age.

Among the jade axes unearthed at the Shang dynasty royal Tomb No. 5, the symmetrical dentate patterns are arranged, as they are on the Sackler example, along the central portion of the edges, so that the butt and the curved ends are clearly defined.

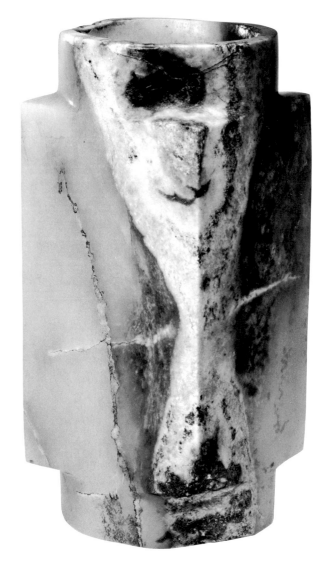

44 *Cong*

Shang dynasty, 2d millennium B.C.
height 16.5, width 7.3, depth 7.3 cm
(6½ × 2⅞ × 2⅞ in)
S87.0466

The shapes of most Chinese ritual jades apparently
were derived from Late Neolithic stone implements,
but the prism-shaped *cong* are a striking exception.
The dimensions and proportions of *cong* vary con-
siderably, even though the essential form remains
the same. Moreover, all of the ancient *cong* known
are made of jade; apparently Chinese artisans never
fashioned them of any other material, such as
bronze, ivory, or bone. Evidently *cong* were meant
for ritual purposes from the outset, although their
exact function or significance remains uncertain.
The assertion in traditional Chinese texts that the
cong were included in ceremonies worshiping earth
adds little to our understanding of how these jades
actually were used.

The outer surfaces of the Sackler *cong*, which ta-
per slightly, are flat and unornamented. The four
corners at each end of the *cong* are beveled, thereby
forming an octagonal collar. Several small, unfin-
ished areas suggest that the artisan conceived the
form as somewhat larger than the jade available.
The interior was drilled longitudinally from both
sides, resulting in a slight horizontal ridge in the
middle of the cylindrical, hollow center.

45 Disk

Shang dynasty, 2d millennium B.C.
depth .5, diameter 9.1 cm
(³⁄₁₆ × 3⁹⁄₁₆ in)
s87.0454

Fashioned of tan jade, this disk, or *xuanji*, has irregular mottled white and brown areas. Some traces of cinnabar are still visible on the surface, which shows irregularities resulting from decomposition. The disk has a central perforation and three curving points, with three sets of symmetrically arranged serrations on the arcs between the points. Jades made in this unusual form appeared in China during the Late Neolithic period, ca. 2000 B.C. *Xuanji* having precisely articulated points and meticulously defined serrations were highly prized and treasured as heirlooms, judging from the Shang dynasty example unearthed in an Eastern Zhou dynasty tomb in Shandong Province.

Speculation about the use of *xuanji* has not resulted in any definite conclusion. The late-nineteenth-century Chinese scholar Wu Dacheng identified jades with this shape as being *xuanji* and suggested they might have been used by astronomers. The French scholar Henri Michel, writing in 1947, elaborated on that theory by suggesting that *xuanji* could have been combined with jade *cong*, or ritual jade of undetermined function (no. 34), to form complex astronomical instruments. There is no consensus regarding any of these theories, and archaeological finds have not yet yielded clarifying information.

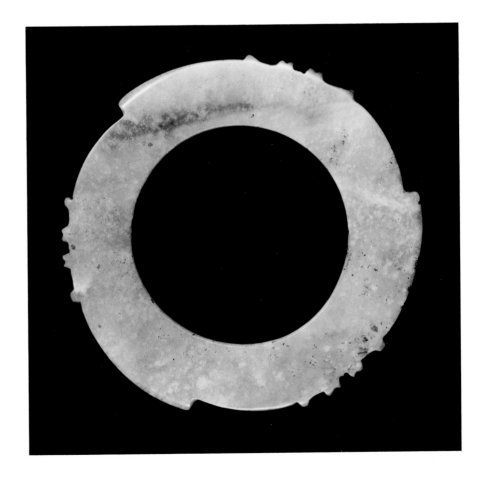

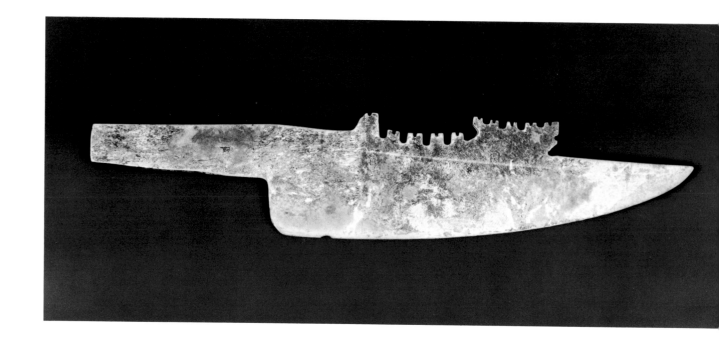

46 Notched Blade

Shang dynasty, 13th–11th centuries B.C.
height 25.7, width 5.4, depth .5 cm
(10⅛ × 2⅛ × ³/16 in)
S87.0706

This jade has a long, thin triangular blade and a
narrow rectangular tang. The lower portion of the
blade has been ground to a blunt cutting edge. Par-
ticularly noteworthy is the elaborate notched pat-
tern that projects from the upper edge of the other-
wise unembellished, geometric jade surface. The
arrangement of the fragile notches in two distinct
levels enhances their aesthetic appeal but reveals
nothing about their specific function. Textile impres-
sions, clearly visible in the irregular, reddish stains
on the surface of the blade, are all that remain of
the finely woven cloth in which the piece was
wrapped at the time it was buried.

Several blades of this same size and shape, fash-
ioned of both jade and bronze, were found in the
Shang dynasty royal Tomb No. 5 at Anyang in
1976. The notches on those archaeologically at-
tested artifacts project from the upper portion of the
jade and bronze blades in an even pattern. Compari-
son of the jade and bronze blades from Tomb No. 5,
which can be dated ca. 1200 B.C., supports the view
that the jades were intended as purely ceremonial
versions of contemporary lethal bronze weapons.

47 Dagger-Ax

Shang dynasty, ca. 1200 B.C.
height 24.2, width 8.7, depth 1.1 cm
(9½ × 3⁷⁄₁₆ × ⁷⁄₁₆ in)
s87.0712

A pronounced median crest extends from the curving point to the butt end of the jade blade of this dagger-ax. The blade is inserted into a bronze tang, which consists of a projecting socket, a hafting bar with a circular perforation, and a butt in the shape of a stylized bird's head. Although there are no traces of inlay, the bronze surface probably was originally decorated with turquoise. The jade surface is heavily encrusted; the bronze tang is corroded.

Bronze *ge*, or dagger-axes, are the most common type of ancient Chinese weapon known. Ceremonial replicas of the sturdier bronze prototypes were occasionally made with jade blades and turquoise tesserae inserted into frets, which were cast with the bronze handles.

The Sackler jade-and-bronze dagger-ax is traditionally said to have been unearthed at Anyang, Henan Province. A number of comparable examples known to have been excavated from Shang dynasty sites in the Anyang region support that attribution.

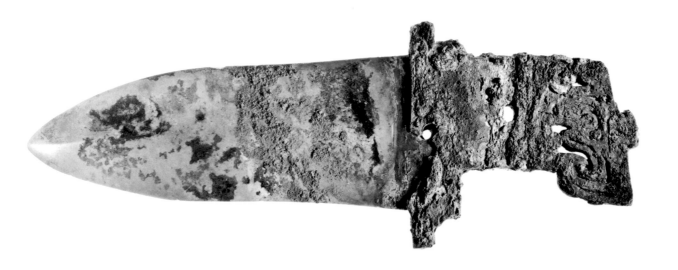

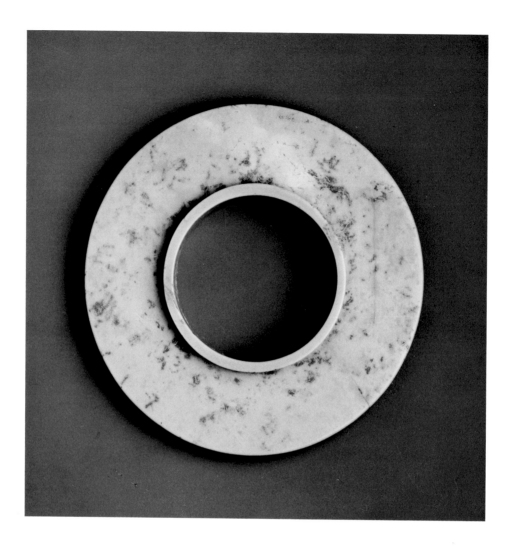

48 Collared Disk

Shang dynasty, ca. 1200 B.C.
depth 2.1, diameter 12.7 cm
(13/16 × 5 in)
s87.0457

This disk is carved of tannish jade with some mottled areas on the plain surface. Although there are traces of earth accretion and cinnabar, the major portion of the jade is highly polished. The low flange, which rises in equal height from each side of the circular perforation, is slightly conical in cross section.

Jade disks of this type are usually referred to as *yuan*, or "rings," in Chinese archaeological reports. The precise function of these jades is uncertain; some specialists have suggested that the disks might have been worn as bracelets. Several disks with raised collars around the central perforation were among the more than 750 jades unearthed in the Shang dynasty Tomb No. 5 at Anyang. Since Tomb No. 5 is generally believed to have been that of Fu-hao, a consort of the Shang ruler Wuding, the jade objects buried with her can be dated ca. 1200 B.C. Similar disks, sometimes fashioned of stone, were made in southern China as late as the Han dynasty.

49 Dragon and Bird Pendant

Shang dynasty, ca. 1200 B.C.
height 7.8, width 4.1, depth .4 cm
(3¹⁄₁₆ × 1⅝ × ³⁄₁₆ in)
s87.0518

Traditional Chinese texts describe the remarkably large number of jades with which the last ruler of the Shang dynasty is supposed to have surrounded himself before committing suicide. There is also mention of the vast quantities of Shang jade seized by the Zhou leader King Wu after his conquest of the Shang. Some substantiation of those extraordinary numbers of jades is given by the contents of Tomb No. 5 at Anyang, found in 1976. That one royal tomb, which is believed to have held the remains of Fuhao, a consort of Wuding, the fourth Shang king to reign at Anyang, yielded more than 750 pieces of jade. Many of those jades were dragon pendants, similar to this one in the Sackler Gallery.

This jade pendant depicts a single-horned, open-mouthed dragon and a bird. Both the dragon and the bird are presented in profile, superimposed one atop the other, so that the dragon might be seen as an appendage of the bird. The flat surfaces of the pendant are embellished with designs in raised lines.

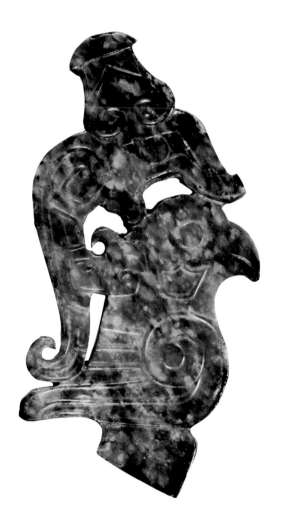

50 *Dagger-Ax*

Shang dynasty, ca. 1200 B.C.
height 23.5, width 7.4, depth .4 cm
(9¼ × 2⅞ × 3⁄16 in)
s87.0701

The fragility of jade dagger-axes of this type is a re-
minder of their ritual function. Although they were
modeled after the bronze *ge*, which was the most
common weapon during the Shang and Zhou dy-
nasties, jade dagger-axes were not used in battle. On
occasion jade blades were fitted with elaborately in-
laid bronze supports. Those ceremonial implements
provide a clear indication of the pageantry that at-
tended Shang dynasty ceremonial functions.

This finely finished dagger-ax has a clearly defined
median crest extending laterally from the point to
the tang. The subtle curve of the median crest re-
peats the contours of the beveled outer edges of the
blade, which merge into the smoothly rounded sur-
faces of the point. Even the upper and lower edges
of the slightly recessed tang echo the outward curve
established by the blade. A small, circular, conical
perforation appears at the central axis on the tang;
there is a smaller perforation at one of the corners.
On each side of the base of the blade, there is a
band of incised lozenges filled with smaller lozenges
and triangles. Areas of darkened cinnabar cover the
surfaces of the blade.

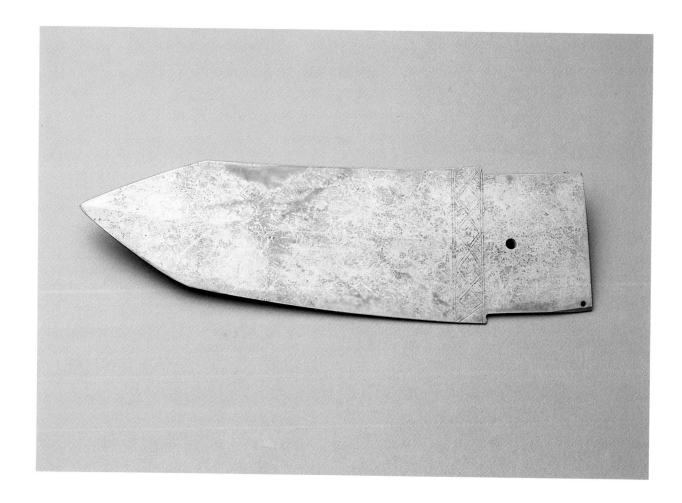

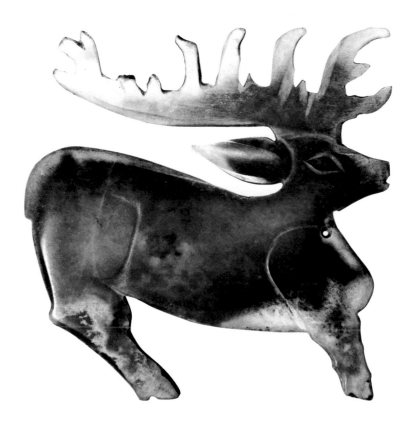

51 *Stag Pendant*

Western Zhou dynasty,
11th–10th centuries B.C.
height 7.6, width 7.7, depth .6 cm
(3 × 3 1/16 × 1/4 in)
s87.0869

Several stag pendants fashioned of thin jade like this one were among the 1,300 jades unearthed in 1974–75 from two richly appointed Western Zhou tombs at Rujiazhuang, Shaanxi Province. One of the tombs contained a double burial chamber and, according to the inscriptions on the bronze ritual vessels also interred with the dead, contained the remains of Qiangbo and his concubine. Some of the jades from that tomb were placed on the lid of the sarcophagus, together with bronze chariot fittings, but most of the large number of jades were placed directly on the bodies of the deceased.

The jade stag is presented in silhouette, with its characteristic horns extending backward to repeat the curving form of the stag's body. Details such as the eye, ear, and haunches are indicated with beveled lines. The animal's cloven hooves are schematically presented. There is a circular perforation on the stag's throat.

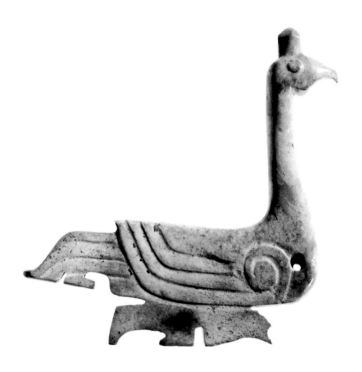

52 *Bird*

Western Zhou dynasty,
11th–10th centuries B.C.
height 6, width 6.2, depth .8 cm
(2⅜ × 2⁷⁄₁₆ × ⁵⁄₁₆ in)
s87.0862

Fashioned of tan, highly polished jade, the bird is
presented in profile. The crested head atop a long,
slender neck lends the bird an elegance that is
echoed in the beveled planes of the upswept wings
and pendant tail. Those beveled planes establish an
abstract, decorative pattern on the jade surface.
Stylized projections on the tail and beneath the
wings provide stabilizing elements for the entire
composition. There is a circular perforation through
the bird's chest.

During the Western Zhou period, birds with elab-
orately stylized wings and tails emerged as the dom-
inant motif on Chinese ritual jades and bronzes
(nos. 53, 125, 127, 129). Chinese artisans presented
the birds as an integrated series of curving bands,
and during succeeding centuries, the increasing ab-
straction of the bird motifs ultimately evolved into
completely geometric designs that, at first glance,
seem to bear almost no relationship to the natural
forms that inspired them.

53 Handle

Western Zhou dynasty, 10th century B.C.
height 11.9, width 2.2, depth .4 cm
(4$^{11}/_{16}$ × $^7/_8$ × $^3/_{16}$ in)
S87.0521

This flat, rectangular handle of tan jade preserves
the general shape and proportions of Shang dynasty
examples. There are angular projections at each side
of the top of the handle that establish a clear separa-
tion from the elongated concave surfaces below. The
slender portion of the silhouette provides an ideal
place in which to grasp the handle. The lower sec-
tion of the jade tapers to a narrow, undecorated
base, evidently meant for insertion into another ma-
terial. On some jade handles, there is a small conical
perforation in the lowest section to ensure an even
more secure joining.

In contrast to Shang dynasty jade handles, in
which the nuances of the silhouette are further ac-
cented by horizontal ridges, the Western Zhou arti-
san who fashioned the Sackler piece allowed the fig-
ural decoration to cover the entire rectangular
surface without any interruption. Consequently, the
separation of the individual parts of the handle—
cap, grip, and shaft—are subordinated to the ele-
gant, curvilinear forms of the bird and tiger that
decorate the surfaces. Both the bird and the tiger,
which are presented one atop the other, are articu-
lated with double incised lines, some of which are
beveled. The abstraction of the two creatures into a
series of flat bands prefigures the importance that
interlaced designs assumed during the latter part of
the Zhou period.

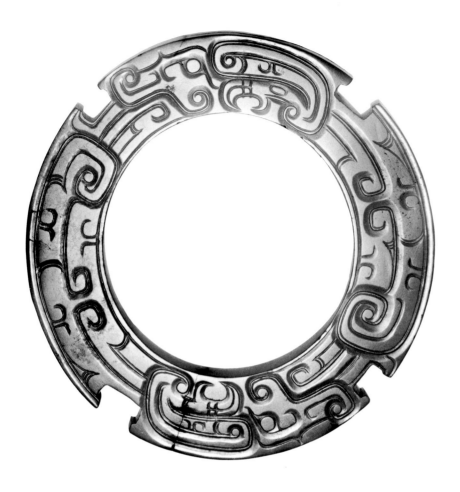

54 *Dragon Disk*

Western Zhou dynasty, 10th century B.C.
depth .6, diameter 11.4 cm
(¼ × 4½ in)
s87.0464

Fashioned of evenly light tan jade, this sturdy disk, or *bi*, is an impressive example of early Western Zhou craftsmanship and design. Four evenly spaced rectangular notches divide the disk into quadrants that coincide with the design of the pair of elongated dragons decorating both sides of the piece. The dragons are presented in profile. The head, horns, and front legs appear in the first quadrant and the extended, curling tail in the second. These dragons are executed in diagonal cuts and incised lines, with an emphasis on long, flowing curves that parallel the decoration found on contemporary bronze ritual vessels.

According to tradition, King Wu, the first ruler of the Zhou dynasty, seized a large number of jade pieces from the Shang palaces following his defeat of the last Shang ruler at the battle of Muye, ca. 1050 B.C. It is also believed that following the conquest, many Shang artisans were moved to the new Zhou capital at Luoyang, where they continued to produce art objects of high quality. The elegant proportions of the Sackler jade disk demonstrate that quality did not diminish in the transition from the Shang to the Zhou dynasty.

55 Pair of Disks

Eastern Zhou dynasty,
Spring and Autumn period,
8th–7th centuries B.C.
(a) (b) depth .2, diameter 6.1 cm
(1/16 × 2 3/8 in)
s87.0497, s87.0498

Jade disks with a central perforation and a radial slit, known as *jue*, have been found in Chinese archaeological sites that can be dated as early as 5000 B.C. Those early examples are round in cross section, as compared with the angular contours of later *jue*. Although the exact function of these jades is uncertain, the traditional Chinese explanation is that they were worn as earrings. A pair of *jue* was unearthed in an Eastern Zhou tomb at Shangcunling, Henan Province. The *jue* were found near the ears of the skeleton, suggesting that the jades may have been worn as earrings or perhaps formed part of a headdress.

On each of the Sackler disks, one face is decorated with incised, overlapping double lines, spirals, and commas. These design units become increasingly small in scale toward the center perforation. During the Spring and Autumn period, abstract motifs of this type evolved from dragon-headed bands. Small circular eyes, which establish the identity of the dragon, do occur on the Sackler jade *jue*, but no longer is there any logical coherence to the individual motifs. It is the overall surface decoration that was most important to the Chinese artist. As is frequently the case with jade *jue*, there are extensive traces of cinnabar and earth on each of the Sackler examples.

a

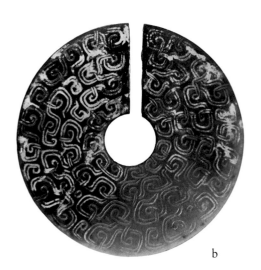

b

56 Dragon Pendants

Eastern Zhou dynasty,
Spring and Autumn period,
6th century B.C.

(a) height 8.8, width 1.1, depth .5 cm
($3\frac{7}{16} \times \frac{7}{16} \times \frac{3}{16}$ in)
s87.0526

(b) height 9, width 1, depth .5 cm
($3\frac{9}{16} \times \frac{3}{8} \times \frac{3}{16}$ in)
s87.0527

(c) height 8.9, width 1.1, depth .5 cm
($3\frac{1}{2} \times \frac{7}{16} \times \frac{3}{16}$ in)
s87.0528

(d) height 8.9, width 1, depth .5 cm
($3\frac{1}{2} \times \frac{3}{8} \times \frac{3}{16}$ in)
s87.0529

Judging from the close relationships in size and decoration, these four pendants form a set and probably were originally arranged with still other jades as part of an elaborate ensemble. Each of the four curved pendants has a horned dragon mask at one end; the gaping mouths of the dragons provide a way to suspend them. Each pendant has a circular perforation at the crest of the arch. The perforations are crudely made and, inexplicably, interrupt the decoration; they may be later additions. The convex surfaces of the pendants are divided into three units of equal length. Pairs of reclining dragons decorate each unit; the large dragon masks are alternately arranged with narrow striated bands separating them. Curvilinear striated bands delineate the bodies of the dragons. Traces of cinnabar appear on all four pendants.

Jade pendants of this type are traditionally identified as originally part of a larger ensemble designed as an elaborate pectoral. Archaeological finds suggest some tentative arrangements of this type of pectoral. It appears that jade pendants like those in the Sackler Gallery probably constituted the matching elements at the bottom of such an ensemble.

The alternating arrangement of the reclining dragons and the emphasis on striated bands are typical features of Chinese jades dating from the Eastern Zhou period. The artist's interest in decorating the jade surfaces with motifs that subordinate the individual details to a rich, overall pattern became increasingly important throughout the period.

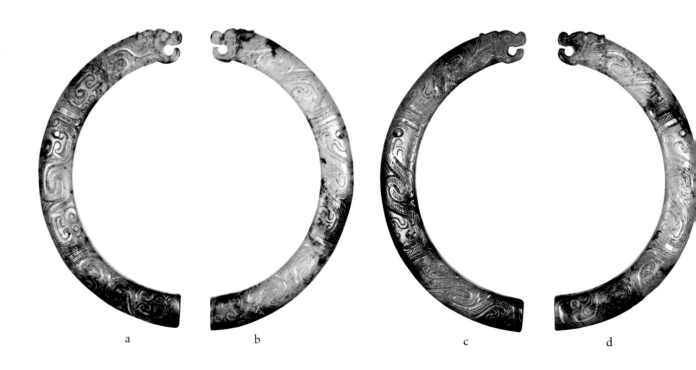

a b c d

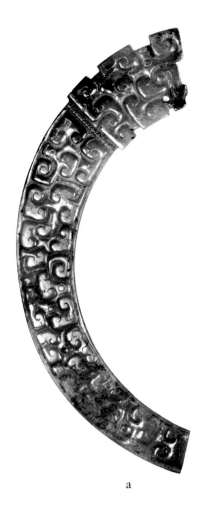

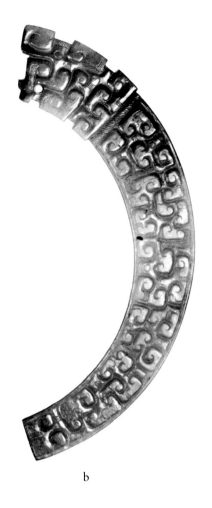

a

b

57 *Pair of Dragon Pendants*

Eastern Zhou dynasty,
Spring and Autumn period,
6th–5th centuries B.C.
(a) height 11, width 2, depth .5 cm
(4⁵⁄₁₆ × ¾ × ³⁄₁₆ in)
s87.0612
(b) height 10.8, width 1.8, depth .5 cm
(4¼ × ¹¹⁄₁₆ × ³⁄₁₆ in)
s87.0613

These simple, crescent-shaped pendants are deco-
rated with stylized dragon heads at the wider ends,
in which the snouts, horns, and tongues are pre-
sented as cubic forms. Small, incised circular eyes
identify the motifs as zoomorphic. The dragon
heads are specifically emphasized by a series of in-
dentations in the overall silhouettes of the widest
portions of the pendants, as well as by the narrow,
striated vertical bands. Both sides of the pendants
are decorated with irregularly composed spirals in

low relief. Small circular perforations at the wider
ends of each pendant suggest the way the pieces
would have been suspended. Traces of cinnabar ap-
pear on both jades.

Several jade pendants of a more elaborate shape,
giving some indication of those complex zoo-
morphic forms that are so abstractly presented on
the Sackler pendants, have been unearthed in Spring
and Autumn period sites in Henan and Hebei prov-
inces. For example, Tomb No. 60 at Liulige, Henan
Province, yielded a group of jades that included a
pair of pendants virtually identical in shape and dec-
oration to those in the Sackler Gallery. The Chinese
archaeological report describes the jades from Tomb
No. 60 as having originally formed a pectoral. But
since the silken threads that linked the individual
jades had rotted, it was not possible to be certain as
to how they should be reassembled.

58 Cong

Eastern Zhou dynasty,
Spring and Autumn period,
6th–5th centuries B.C.
height 4.2, width 7.2, depth 7.2 cm
(1⅝ × 2¹³⁄₁₆ × 2¹³⁄₁₆ in)
S87.0469

At least as early as the Shang dynasty, Chinese artisans were making jade *cong* in which the projections on the four outer corners were treated as separate, clearly defined elements within the overall composition. Those later *cong* are smaller in size and have decorations on their surfaces that clearly are unrelated to the stylized masks that are so conspicuous a feature of the examples produced by the southeastern Liangzhu and Shixia Late Neolithic cultures. Some jade ritual objects, like the *cong*, continued to be made several millennia after the Late Neolithic and Shang examples. The shapes of those later, archaistic *cong* retain some elements of the earlier pieces, but their surface decoration reflects the period during which they were made.

This squat *cong*, with a large central perforation, is enclosed within clearly demarcated square corners in much the same way as those pieces dating from the Shang dynasty. The relief patterns on the surface of the *cong*, which are based on curvilinear dragons, are characteristic of jade motifs dating from the sixth through the fifth century B.C. These patterns are rendered in raised and sunken relief. Diagonal striations accent the relief dragons, which alternate in their orientation on each of the four corners. Similar striations appear on the exterior of the low lips, which project at the top and bottom of the *cong*. There are traces of cinnabar on the surfaces.

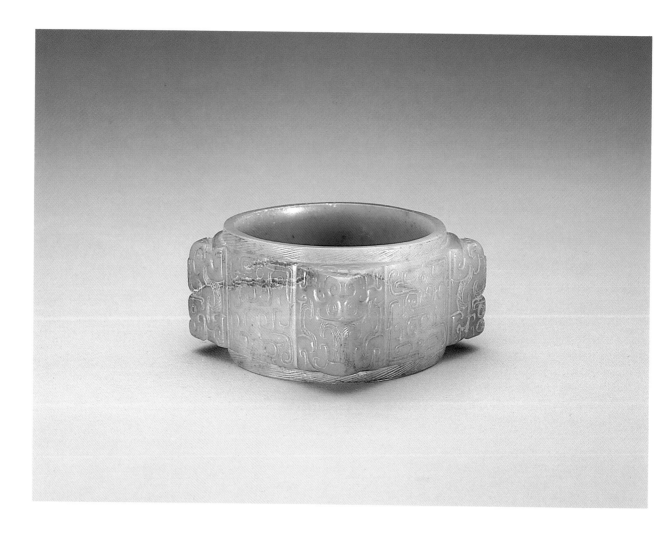

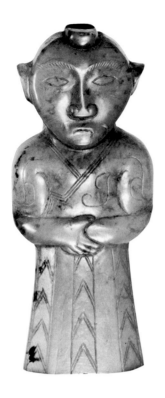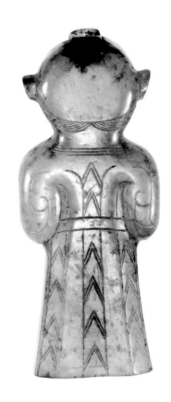

59 *Standing Figure*

Eastern Zhou dynasty, Warring States period,
5th–4th centuries B.C.
height 4.2, width 1.7, depth .7 cm
(1⅝ × ⅝ × ¼ in)
S87.0482

The human figure appears in the crafts of China during the Late Neolithic period. Perhaps the most remarkable of those early human images to have been found in an archaeological context are the clay figurines unearthed in Liaoning Province in 1979 and associated with the Late Neolithic Hongshan culture. Fashioned of reddish clay with traces of pigment, those figurines are distinctly female in character, with large breasts and thighs, giving the appearance of fecundity deities. Thus far, those representations of the human figure are unique. All other images found in China are considerably more restrained.

The three-dimensional, sculptural human figures made of jade that can be dated to the Late Neolithic period are fashioned from flat plaques with emphasis on frontality and reticulation. Some of the most impressive early jade sculptures of the human figure date from the Shang dynasty. An important group of Shang jade figures was found in royal Tomb No. 5 at Anyang, Henan Province, in 1976. In those jade examples the human face, which is the most characteristic feature, is emphasized, both in size and in detail, while the body is reduced to a schematic design. During the succeeding Zhou dynasty, Chinese artists increasingly depicted the human figure, even though representations usually were static and formal, with little suggestion of physical movement.

This standing jade male figure in the Sackler Gallery has an overly large, oval head; its arms are held closely against the sides, and the hands are clasped in front. The basic facial features—eyes, eyebrows, nostrils, and mouth—are carved on broadly modeled planes. Only the ears and the upper portion of the cap project from the main shape of the head. Several strands of the man's long hair, which has been drawn up under the projecting cap, are visible at the back of the head. The figure is clothed in a long robe that joins at the right side and falls to cover the feet. Incised designs articulate the general shape of the robe as well as the vertical chevron decor. A circular channel runs through the figure vertically, probably meant for use in suspending the figure.

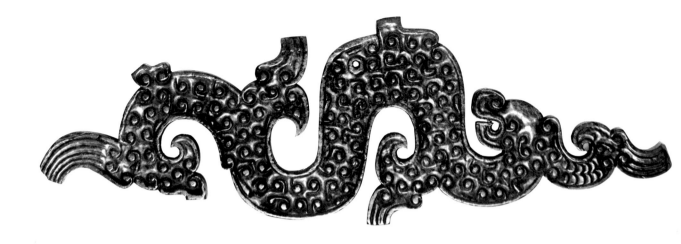

60 Dragon Pendant

Eastern Zhou dynasty, Warring States period,
5th–4th centuries B.C.
height 6.8, width 21.8, depth 1 cm
(2¹¹⁄₁₆ × 8⁹⁄₁₆ × ³⁄₈ in)
s87.0881

On this unusually thick jade dragon pendant, the backward-turning head is distinguished by the striated outline of the lower jaw and the curving muzzle. The body forms a continuously curving band of varying width decorated with raised spirals. The raised decoration contrasts with the pattern of striated volutes and winglike appendages that project from the dragon's body at varying intervals. Both the design and a small perforation at the top center indicate a horizontal position for this jade pendant. Jade pendants of this type of curvilinear dragon in silhouette were sometimes produced in pairs.

Several jade dragon pendants that are related to the Sackler piece in shape and decoration were unearthed in a Warring States period (480–221 B.C.) grave at Liulige, Henan Province. According to the Chinese archaeological report, the jades in Tomb No. 1 were still in place on the chest and stomach areas of the deceased, giving a clear indication of their position at the time of burial.

61 *Dragon Pendant*

Eastern Zhou dynasty, Warring States period,
5th–4th centuries B.C.
height 4.6, width 9.1, depth .5 cm
(1 13/16 × 3 9/16 × 3/16 in)
s87.0868

A serpentine head, presented en face, forms the central element of this symmetrical composition. Above the head, the serpent's body separates and arches downward on either side to meet the pair of coiling serpents beneath. The horizontal edges at the top and bottom of the pendant are formed by wings and horns projecting from the dragons. Flanking this rhomboidal group on either side is a bird seen in profile. The surfaces of the curving, convex bands are richly textured with a combination of striations, cross-hatching, and diagonal lines. A small, circular perforation establishes the direction in which the pendant was suspended.

According to the traditional attribution, this jade pendant was unearthed at Shou Xian, Anhui Province. Jades of similar shape and decoration are associated with the Warring States period finds at Jincun, near Luoyang, Henan Province. Both of those sites have yielded jades parallel in quality to this dragon pendant.

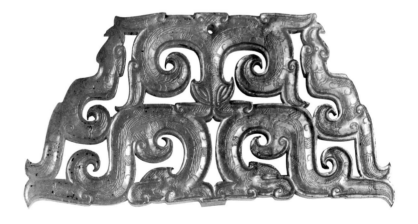

62 Ring

Eastern Zhou dynasty, Warring States period,
5th–4th centuries B.C.
depth .5, diameter 9 cm
(¼ × 3⁹⁄₁₆ in)
S87.0029

The degree of aesthetic and technical perfection attained by Chinese jade artisans during the Warring States period set a standard against which jade artifacts from all later periods can be judged. Some of the finest jades from this period are those originally associated with the site of Jincun, near Luoyang, Henan Province. The site first became known in the late 1930s. Although jades of the type represented by this ring from the Sackler Gallery are frequently referred to as being of "Jincun style," archaeological excavations have demonstrated that jades decorated with comparable motifs actually were made over a wide area of China from the fifth through the fourth century B.C.

The slightly convex surfaces of this narrow jade ring are decorated with precisely arranged raised spirals, linked by incised C-shaped scrolls. Plain bands enclose the inner and outer edges of the ring. The highly polished, glossy surface is a characteristic feature of Chinese jade ornaments dating from the Warring States period.

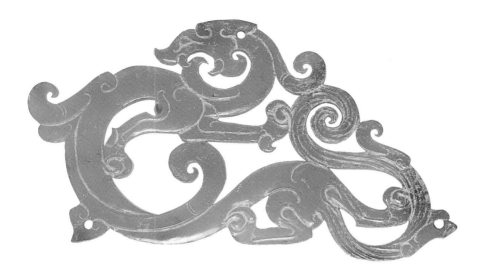

63 *Dragon Pendant*

Eastern Zhou dynasty, Warring States period,
4th–3d centuries B.C.
height 4.9, width 9, depth .6 cm
(1 15/16 × 3 9/16 × 1/4 in)
S87.0030

A rampant dragon, its elongated body and tail
twisting and curling, forms this remarkable compo-
sition. The dragon head is seen in profile, with its
gaping mouth about to devour a curling ruff. Pairs
of muscular legs emerge from the front and rear
haunches of the dragon, while the serpentine body
arches dramatically to reveal its striated spine. The
extreme torsion of the dragon is emphasized by the
flamboyant gestures of the legs and clawed feet. The
dragon's rounded, muscular body also enhances the
suggestion of pent-up energy. By contrast, the curvi-
linear plumes that embellish the composition are
purely decorative, lending an element of playful fan-
tasy.

Fine, curvilinear motifs incised on the jade surface
enrich the textural quality of this elegant, reticulated
piece; boldly worked serpentine motifs on the
haunches of the dragon echo the striated scrolling

tail. Small, circular perforations at the top of the
dragon head and on projections appended to the
body and tail would have enabled the pendant to be
suspended.

The fusion of naturalistic and abstract forms
within a single design is characteristic of Chinese
jades dating from the Warring States period. Highly
polished, glossy surfaces also are a hallmark of the
superlative workmanship of this era.

64 Dragon-Headed Pendant

Eastern Zhou dynasty, Warring States period,
4th–3d centuries B.C.
height 8.3, width 1.3, depth .5 cm
(3¼ × ½ × ³⁄₁₆ in)
S87.0604

This arc-shaped pendant is decorated with a dragon
head at the wider end. The facial features are mod-
eled in low relief. The muzzle, eyes, ears, and mouth
are presented against a plain ground. A curvilinear
perforation emphasizes the dragon's open mouth
and, at the same time, provides a way of suspending
the jade. Twisted parallel grooves curve over the sur-
face of the pendant toward the pointed tail.

Jade pendants of this type are traditionally identi-
fied as *xi* and are believed to have been used to untie
knots. Such jades would have been worn suspended
at the waist.

The Sackler jade is believed to have been found at
Shou Xian, Anhui Province. Although the style of
the decoration makes that provenance a reasonable
one, it has not been verified.

65 Oval Cup

Eastern Zhou–Han dynasties,
3d–2d centuries B.C.
height 3, width 9.9, depth 8.1 cm
(1³⁄₁₆ × 3⁷⁄₈ × 3³⁄₁₆ in)
S87.0645

Oval cups with handles, known as *yushang*, or
"winged cups," in Chinese, were crafted in lacquer,
bronze, pottery, and mother-of-pearl as early as the
late Eastern Zhou and Han periods; jade examples
are extremely rare. The outer surface of the jade cup
in the Sackler Gallery is decorated with a pattern of
interlocking relief spirals, which are arranged more
densely toward the base. A horizontal band of diag-
onally crossed motifs encircles the outer rim. Be-
neath each end of the two projecting handles are
stylized wing patterns. Irregularly shaped dark areas
appear on the handles and on portions of the lip,
forming a dramatic contrast with the lighter color of
the stone.

The closest parallels to the Sackler jade cup are
those in the Freer Gallery of Art and the Grenville
L. Winthrop collection in the Arthur M. Sackler
Museum at Harvard University, which are said to
have come from Jincun, near Luoyang, Henan Prov-
ince, and date from the fifth through the fourth cen-
tury B.C. Handled cups of this general size and
shape continued to be made of precious metals as
late as the Tang dynasty (618–907). A silver cup
with engraved gilt floral decoration was found in the
Tang dynasty hoard in Hejiacun, Xi'an, Shaanxi
Province, in 1970.

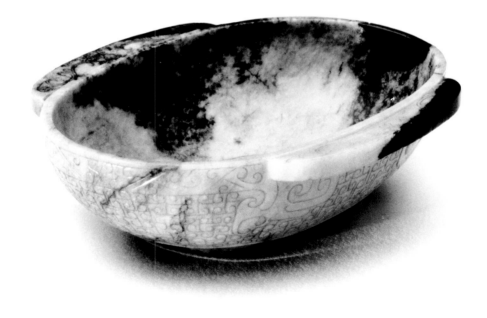

66 Scabbard Chape

Han dynasty, 3d–2d centuries B.C.
height 4.1, width 5.6, depth 1.5 cm
(1⅝ × 2³⁄₁₆ × ⁹⁄₁₆ in)
S87.0598

Sword and scabbard ornaments fashioned of jade appear to have been used in China beginning about the eighth century B.C. Those jade ornaments included the sword pommel and guard and the scabbard slide and chape. Particularly elaborate sets of jade sword and scabbard fittings were made during the Han dynasty.

The flattened, trapezoidal scabbard chape in the Sackler Gallery is thick at the center and tapers to thin, blunt edges at the sides. Symmetrical in its basic decoration, the tan, totally altered jade surface is covered with a series of subtly interrelated curls. The curls vary in their horizontal and vertical arrangement; some are presented as incised lines, others are modeled in low relief, and still others are indicated by narrow, convex ridges. Interlocking curls and striated leaf motifs decorate the bottom surface of the jade. Signs of wear appear on the surface of the chape, the most conspicuous being the chips missing from the corners. A single, shallow vertical hole has been drilled at the center of the upper lenticular surface. The hole would have permitted the chape to be secured at the end of a lacquered wooden sword scabbard.

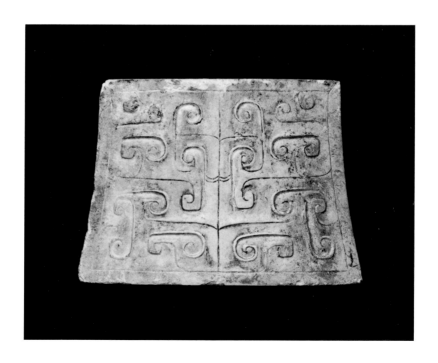

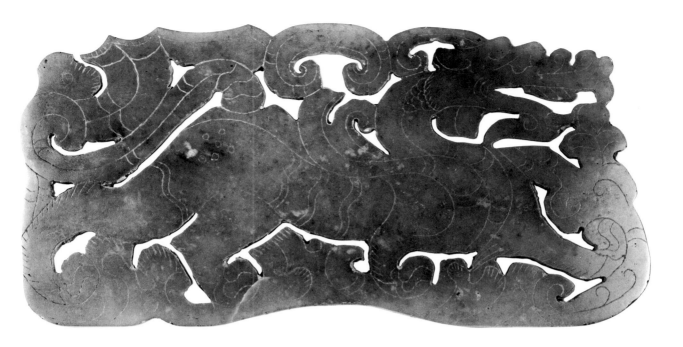

67 *Chimera Plaque*

Han dynasty, 2d–1st centuries B.C.
height 9.4, width 18.7, depth .7 cm
(3 11/16 × 7 3/8 × 1/4 in)
s87.0683

According to Chinese lore, the chimera, or *bixie*, is a fabulous creature with the body of a lion, head of a dragon, and wings of a phoenix. Large, three-dimensional stone carvings of chimera were frequently placed before temples or shrines as guardians. Smaller jade depictions of the chimera preserve the creature's characteristic ferocity and energy without any loss of monumentality.

As is typical of Chinese *bixie*, this one presents the chimera in a striding, energetic pose. The undulating movement of the body and the firm placement of the four legs suggest extraordinary strength. The individual forms were defined by joining a series of perforations in the flat jade surface. Details of the pointed head and curling horn, as well as the representation of striped fur, are indicated by incised lines. The landscape through which the *bixie* moves is evoked by the stylized mountains and plants along the bottom and sides of the plaque. Both sides of the trapezoidal polished jade plaque are decorated.

It is possible that the Sackler *bixie* formed part of a screen similar to the Han dynasty example found in Tomb No. 43 at Ding Xian, Hebei Province, in 1969. The jade might also have been set into a gilded bronze headrest of the sort included among the princely objects in the Han tombs at Mancheng, Hebei Province.

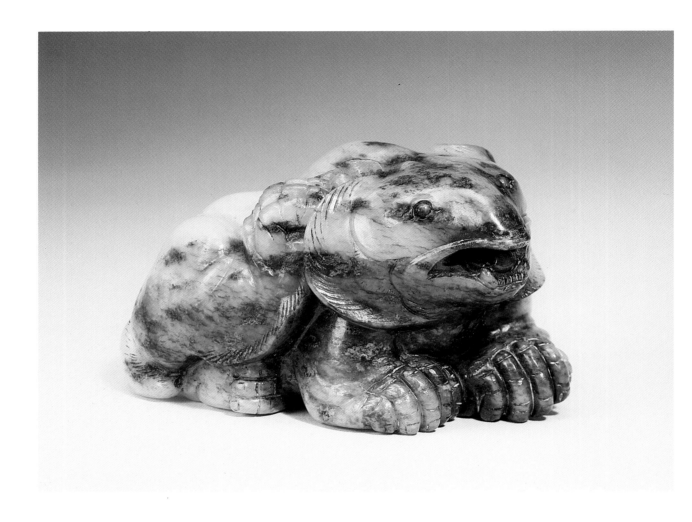

68 Bear

Han dynasty, 1st century B.C.—1st century A.D.
height 4.9, width 9.6, depth 5 cm
(2 × 3¾ × 2 in)
S87.0025

The bear is raising one leg to scratch its ear. Although the various portions of the bear are presented as simple, geometric forms, the artist's attention to specific details in modeling the head and paws stresses the most characteristic features of the animal. Small, deeply set eyes and bared fangs are framed by a wide, flaring ruff. The bear's claws are clearly defined, and the individual pads on the undersides of the feet are precisely modeled. To suggest the animal's massive bulk, the artist polished the mottled white stone to a high luster; there are occasional striations to indicate fur.

The date of the Sackler bear is based on stylistic comparison with a jade bear unearthed at Xianyang Xian, Shaanxi Province, in 1972. Although the excavated bear is slightly smaller than the Sackler example, the rendering of the general form and specific details suggests that they are roughly contemporaneous. Another jade bear presented in the same informal pose as the Sackler piece is in the British Museum.

Bears were frequently depicted by ancient Chinese artists. Traditionally the bear was regarded in China as being a good omen for male offspring because of its association with strength and endurance. In some cases the bears are shown in remarkably animated poses. A late Eastern Zhou bronze in the Freer Gallery of Art presents a bear balancing precariously atop a pole held by a juggler.

69 Winged Chimera

Han dynasty,
1st century B.C.–1st century A.D.
height 8.1, width 13.9, depth 3.8 cm
(3³⁄₁₆ × 5½ × 1½ in)
S87.0026

The chimera, or *bixie*, strides forward, its powerful chest and muscular legs emphasizing the sense of swift, unimpeded movement. Boldly articulated wings rise from the creature's front haunches and fold back onto its flanks without interrupting the formal relationships of the overall composition. A long trifid tail, decorated by a median line, curls backward to rest on the remarkably long, outstretched hind leg. Fine hatching on the surface of the chimera indicates the texture of its sleek pelt. The figure of an immortal, its long hair streaming in the wind, rides on the back of the chimera. Grasping a length of the long, curling mane to maintain its balance, the immortal gives tangible evidence of its intimate union with the mythological beast.

Several jades that can be related to the Sackler chimera in size and style were unearthed at Xian-yang Xian, Shaanxi Province, in 1966 and 1972. The quality of the workmanship of those jades and, by extension, the Sackler *bixie*, suggests they were originally commissioned by members of the Han nobility. A number of Han dynasty imperial tombs are located in the same area.

There are different points of view regarding the origins of the chimera in China. It remains uncertain whether these fantastic beasts that became so popular in Chinese mythology were based on Western models or were developed by indigenous artists on the basis of descriptions in Chinese texts.

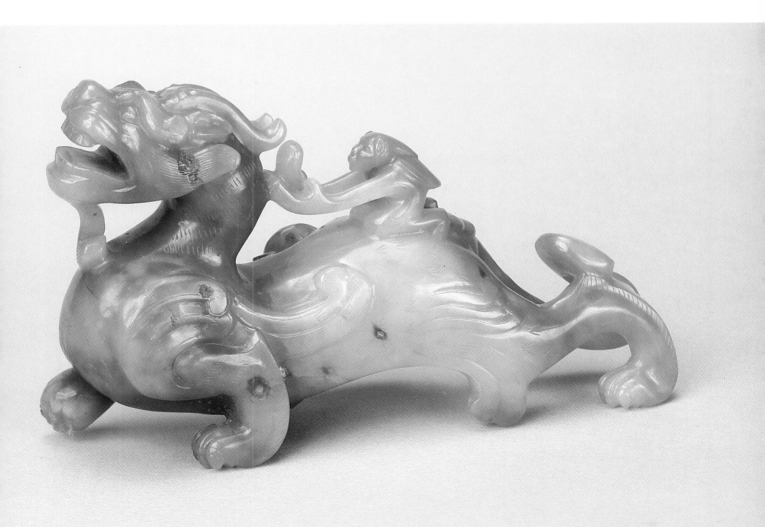

70 *Iron Sword with Jade Guard*

Han dynasty, 1st–2d centuries A.D.
height 44.5, width of blade 3.2, width of
guard 5.4, depth of guard 2.2 cm
(17½ × 1¼ × 2⅛ × ¹³⁄₁₆ in)
s87.0697

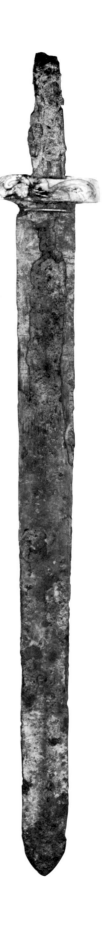

The iron sword blade and the tang are heavily cor-
roded. Some traces of wood and textile impressions
are readily visible on the surface of the blade. The
jade guard, fashioned of tan nephrite, is decorated
on each side with a striding dragon. The dragons'
sinuous bodies and tails form double S-curves, and
their legs are presented in striding positions. Iron
oxide stains appear on the jade guard.

The long iron sword was introduced in China
during the late Eastern Zhou dynasty. Although
never as strong or durable as the shorter, more
costly bronze weapons, iron swords were cast in re-
markably large numbers. The victories that enabled
the Qin armies to unite all of the smaller Chinese
contending states by 221 B.C. was, to a large degree,
a result of the use of the long iron swords. By the
succeeding Han dynasty, the iron sword, which usu-
ally measured approximately one meter (3.3 feet) in
length, had become the standard weapon used for
combat. The Han dynasty jade fittings that embel-
lished iron swords and their sheaths are among the
finest made in ancient China.

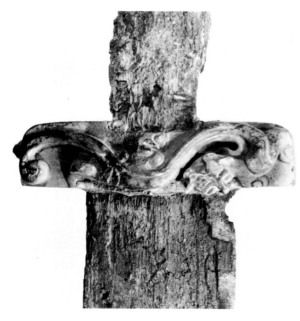

detail of jade guard

71 *Coiled Chimera*

Han dynasty–Six Dynasties period,
2d–5th centuries A.D.
height 3.6, width 10, depth 5.6 cm
($1\frac{7}{16} \times 3\frac{15}{16} \times 2\frac{3}{16}$ in)
s87.0785

Ingeniously designed to conform to the shape of an
essentially triangular stone, the chimera, or *bixie*, is
presented as a series of intertwined, coiling bands.
The large, square head is dominated by the gaping
mouth, striated beard, and curving horns. In a tour
de force of technique and composition, the Chinese
artist arranged the hind portion of the chimera as
two tightly curling bands. The larger of the two
bands, which ends in a concentric spiral and is em-
bellished with abstract incised designs, complements
the massive head and forequarters. The underside of
the chimera is defined by pairs of curved lines sepa-
rated by a central spine. The creature's footpads and
claws are indicated by curved planes. Irregular areas
of brown accent the chimera's head and portions of
its body.

Although the Sackler coiled chimera is clearly in-
debted to the intricately entwined jade creatures of
Eastern Zhou, the later artist replaced the flat sil-
houettes of the earlier period with three-dimensional
forms in which the elements of the sculptural com-
position are organized to take full advantage of the
openwork patterns. Images of this type exerted an
influence upon the large stone guardian figures
carved during the Six Dynasties period.

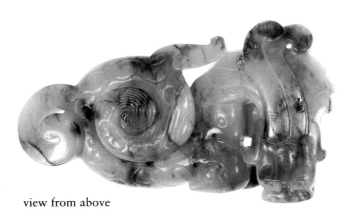

view from above

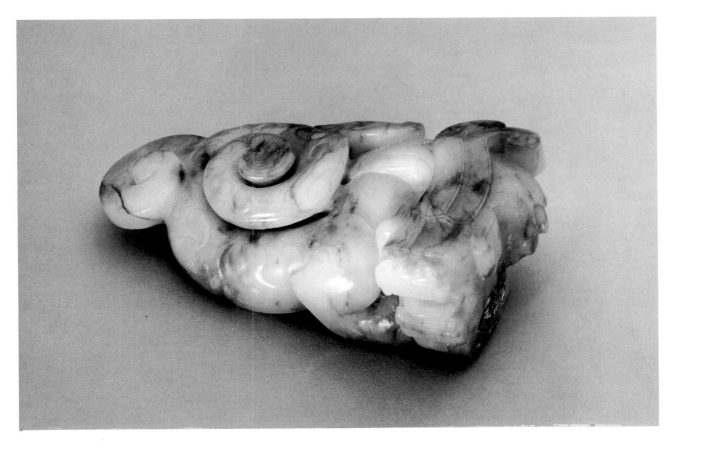

72 Water Dropper

Six Dynasties period, 3d–4th centuries A.D.
height 5.5, width 16.2, depth 7.6 cm
(2³⁄₁₆ × 6³⁄₈ × 3 in)
S87.0796

In spite of its fierce appearance, intensified by the
large teeth and curling horns, the fantastic creature
holds the fragile oval cup in its mouth with a deli-
cacy that suggests a remarkably benign tempera-
ment. The circular opening on the animal's back en-
abled the owner of the jade to fill the interior
chamber with water. Small amounts of water could
then be allowed to flow through the small orifice in
the animal's mouth into the oval cup. A jade of this
size and complexity would have been an especially
prized object on the desk of a Chinese scholar,
where it would have provided the water necessary to
mix with ground ink for writing calligraphy. Both
the shape of the striding animal and the oval
"winged cup," or *yushang*, have parallels in jades
dating from the preceding Han dynasty. The combi-
nation of the two elements to form a secular, func-
tional object for a scholar's desk is a reflection of
antiquarian interests that were already well estab-
lished in China during the Six Dynasties period.

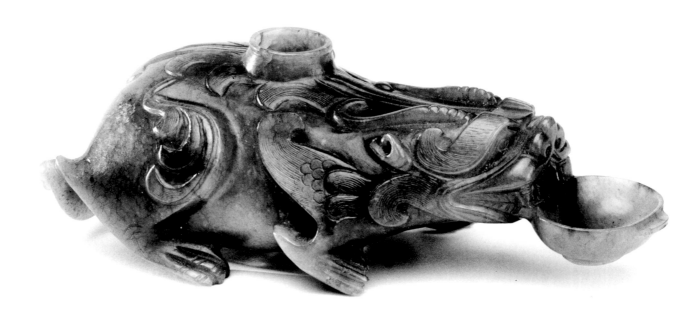

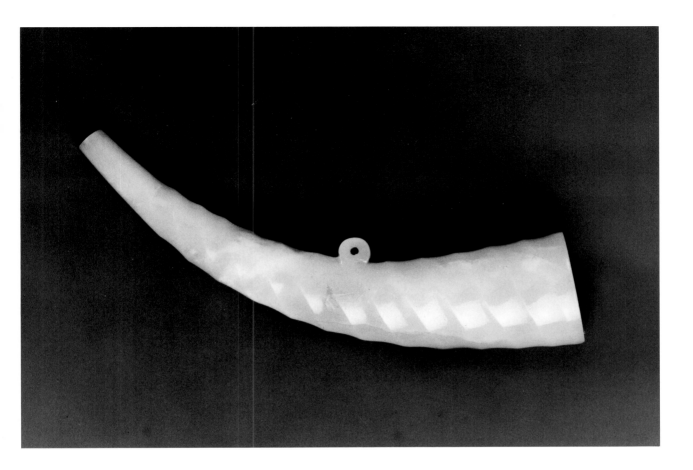

73 Horn

Six Dynasties period, 4th–5th centuries A.D.
height 3, width 14, depth 2.6 cm
(1³⁄₁₆ × 5½ × 1 in)
s87.0801

Fashioned in the shape of a miniature trumpet, the surface of the white jade is encircled with oblique fluting. Two perforated disks placed side by side in the middle of the horn apparently were used to suspend the jade as an ornament.

Chinese artists have embellished the surfaces of jades with fluting at least since the Shang dynasty. During the Warring States period flattened jade rings were decorated with a precise series of narrow flutes that were defined so finely as to appear like twisted cords. This type of jade decoration requires especially skilled technique. As is the case with this miniature horn, fluted motifs usually are worked into jade surfaces to the exclusion of any other decoration.

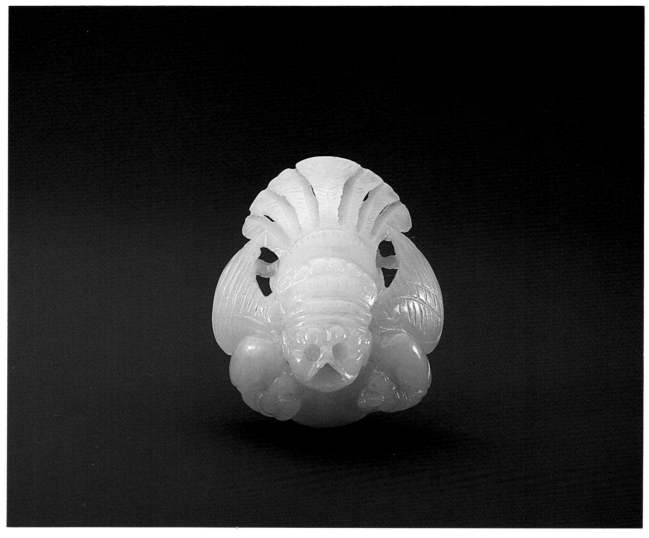

a

74 *Ritual Ornaments*

Tang dynasty, 7th–10th centuries
(a) height 5, width 5.1, depth 2.4 cm
(1 ¹⁵⁄₁₆ × 2 × ¹⁵⁄₁₆ in)
s87.0774
(b) height 4.8, width 4, depth 2.4 cm
(1 ⅞ × 1 ⁹⁄₁₆ × ¹⁵⁄₁₆ in)
s87.0806

On both jades a creature with a human face is surrounded by unfurled wings. The facial features are precisely defined in white jade, and the red stones set into the eye sockets on one of the pieces introduce a dramatic tonal contrast and direct attention to the eyes. Curvilinear headbands interrupt the striated hair patterns. On one jade, flowing ribbons emerge from beneath the head and turn backward onto the wings, where they intertwine with a narrow, striated ring. The feather patterns are indicated by linear striations. Circular rings hang from the ears. Small, cupped hands appear beneath the human heads. Perforations on the backs of the ornaments presumably were used to attach them to another surface.

One scholar has suggested that these unusual jades were intended as hat ornaments and proposes a Tang date for an entire group of similar pieces. Other scholars believe that the faces on such jades represent shamans and that the ornaments probably were worn on headdresses by shamans or by a certain class of Daoist priests in ritual dress.

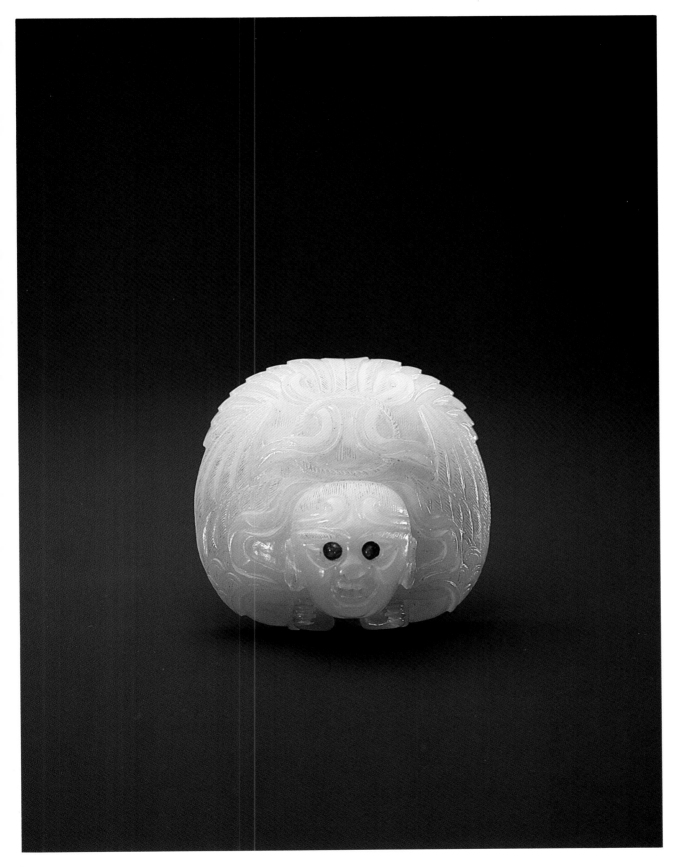

b

75 Hound

Tang dynasty, 7th–10th centuries
height 3.9, width 8.4, depth 2.5 cm
(1½ × 3⁵/₁₆ × 1 in)
s87.0024

Although the dog is reclining with its paws neatly
drawn together, the animal remains tense and alert.
That mood of anticipation is heightened because the
artist has presented the dog with its head raised and
staring intently forward. The elegance of the ani-
mal's pose is captured with a minimum of detail.
Aside from the facial features, which are rendered
with remarkable precision, the artist focused atten-
tion on the curvilinear patterns established by the
long ears and the slightly raised ridge of the spine,
which joins with the spiraling tail. An oval-shaped
bell hanging from the collar affixed around the dog's
neck refers to the special status enjoyed by exotic
animals of this kind among the Chinese nobility of
the Tang dynasty.

Before beginning to work on a specific piece of
jade, Chinese artists studied the original shape of
the stone and considered the feasibility of including
any irregularities of color as part of the final compo-
sition. In the case of this reclining dog, it is obvious
that the occurrence of the mottled black markings,
which provide such dramatic accents to the overall
form, resulted from careful planning by the artist.

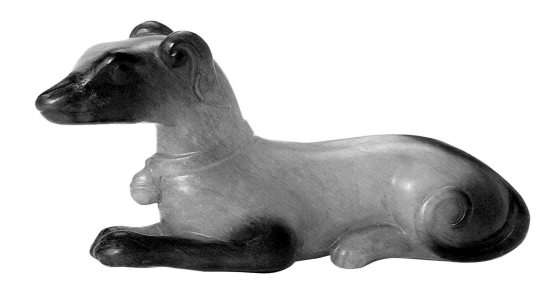

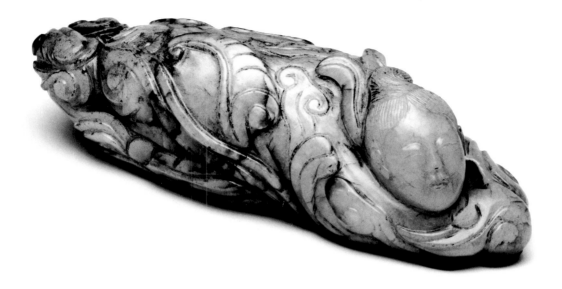

76 *Apsaras*

Tang dynasty, 8th–10th centuries
height 3.1, width 9.8, depth 3.4 cm
(1¼ × 3⅞ × 1⁵⁄₁₆ in)
s87.0814

Only the appearance of the impassive female head
hints at the subject of this jade. All other elements
of the composition are highly stylized, abstract mo-
tifs that follow closely the original, ovoid shape of
the stone. Both the arms and hands of the figure are
covered by the curvilinear draperies that swirl back-
ward to envelop the entire form. Merging with the
draperies are the leaf-shaped wings. Beneath the fig-
ure are stylized clouds on which the apsaras is borne
aloft, further imbuing the work with a sense of
buoyant movement. A small, circular perforation
beneath the head permitted the jade to be sus-
pended.

Figures like this usually are identified as Buddhist
apsaras, or heavenly beings, but some uncertainty
remains about their origins. Several jades depicting
figures swathed in flowing scarves and stylized
clouds have been found in sites dated to the tenth to
the thirteenth century. It is possible that those im-
ages were not specifically associated with Buddhism,
but rather affiliated with native Chinese shamanism
or Daoism.

77 Figure of a Foreigner

Tang dynasty, 8th–10th centuries
height 6.3, width 5.9, depth 3.5 cm
(2½ × 2⁵⁄₁₆ × 1³⁄₈ in)
s87.0805

Foreigners are frequently portrayed in Chinese art dating from the Tang dynasty. During that period the capital at Chang'an (modern Xi'an) was one of the greatest cities of the world, and visitors, including merchants, pilgrims, scholars, musicians, and dancers, came there from the far corners of the earth. This small jade figure provides eloquent proof of the variety of ethnic types and the richness of art treasures that are described so vividly in Chinese literature from the Tang dynasty.

The muscular figure squats as if waiting to present the ornamental vase that he holds aloft and to one side. An ornate headband keeps his carefully arranged hair in place and frames his expressive facial features. The arms, torso, and legs are carefully defined, emphasizing the figure's physical strength. A sense of imminent action is conveyed by the drapery folds, which are modeled as if being lifted in a strong breeze. A circular perforation in the top of the vase that the figure holds so firmly in both hands probably supported a stick of incense. The fragment of a metal pin remains in place on the sole of one foot; there is a small perforation in the other foot. Evidently the figure was attached to a base that is now lost. This squatting foreigner may have been part of a larger ensemble, perhaps a group of donors presenting gifts to a votive image.

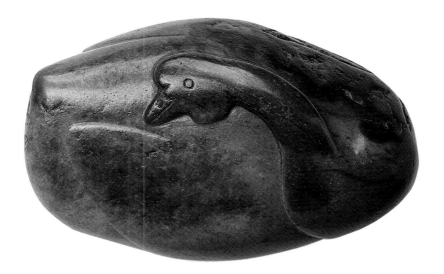

view of bottom

78 Goose

Song dynasty, 10th–13th centuries
height 2.8, width 9.2, depth 6 cm
(1⅛ × 3⅝ × 2⅜ in)
s87.0028

Chinese connoisseurs have always had particular affection for those jade pieces in which the artist retains the basic shape of the original stone, adding as little modeling as possible to achieve the final form. Another important consideration in evaluating the work is the artist's ability to incorporate into the composition any coloristic variations in the jade.

In this representation of a goose, all the disparate parts of the bird's body have been ingeniously organized within a simple, geometric form. Depicted as though at rest, the goose turns its long neck and head back onto its plump body; details such as the beak and eye are tersely modeled. Larger forms, including the bird's furled wings, are defined by a single incised line. Special attention was given to the articulation of the two webbed feet, which are presented in low relief on the underside of the jade.

Further enriching the composition are the irregular areas of warm brown color that appear on the goose's chest, neck, and head, as well as on the smooth, convex surface of the wings. Both the simplicity of form and the richness of color emphasize the tactile qualities of the jade; it is precisely these aspects of the piece that make it so appealing.

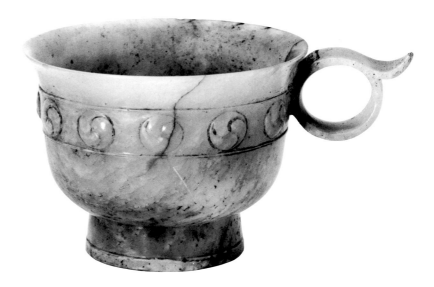

79 *Cup*

Song dynasty, 11th–12th centuries
height 5.8, width 10.3, depth 7.6 cm
(2¼ × 4¹/₁₆ × 3 in)
s87.0727

This circular cup has a tapered, flaring lip and stands on a high, conical foot. There is a narrow raised band at the bottom edge of the foot. The single ring handle is embellished with a pointed thumb piece. On the body of the cup the horizontal band of decoration, which consists of tripartite, raised whorls, is enclosed above and below by a single raised thread line.

The formal relationships between the cup, base, and handle of this jade vessel suggest that a metal prototype may have been available to the artist. The simple, elegant shape and restrained decoration are generally reminiscent of silver cups made during the Tang dynasty.

80 Vase

Song dynasty, 12th–13th centuries
height 12.1, width 6, depth 4.6 cm
(4¾ × 2⅜ × 1⅞ in)
s87.0826

Archaism, which plays an influential role in all aspects of Chinese art, is especially important to Song dynasty jades. An outstanding example of archaism at its best is this small, oval-shaped vase. The knotted cord motifs that decorate the surface of the vase were derived from designs found on a number of late Eastern Zhou bronze vessels said to have been found at Liyu, Shanxi Province. A pair of elephant-mask handles appears on the vase, linking the three double strands of knotted cords. The modeling of the masks is reminiscent of three-dimensional representations of elephants that are also dated to the Song dynasty. The simple shape of the jade vase and restrained use of the cord design are in keeping with modern knowledge of Song dynasty antiquarianism. Apparently the careful scholarship of that period had a profound influence on the many archaistic vessels that were produced in a wide variety of materials, and Song archaistic vessels remained remarkably faithful to the original prototypes.

White jade seems always to have been highly prized in China, especially during the Song dynasty. A number of small objects fashioned of white jade are traditionally dated to the Song period. The semitranslucent surfaces of those jades contrast with the more opaque appearance of those "mutton fat" objects made during the Qing dynasty.

81 Bird Staff Finial

Song dynasty, 12th–13th centuries
height 5.1, width 8, depth 4.2 cm
(2 × 3⅛ × 1⅝ in)
s87.0794

According to tradition during the Han dynasty, men who had reached the age of seventy were given a staff decorated with bird-shaped finials. There is no certainty, however, that any of the birds on the staffs made during the Han dynasty were made of jade. It has been suggested that the custom of affixing jade birds to staffs of this type may have begun during the Song dynasty (960–1279), when there was a marked interest in antiquarianism.

The jade bird in the Sackler Gallery, which is presented as a simple, compact form, is decorated with finely incised wings and tail feathers. Curling plumes embellishing each of the wings are further enhanced by small circles. Similar circles appear on the front section of the wings. Incised C-shaped scrolls decorate the areas on the bird's back and the area beneath the tail. Narrow bands of hatching appear on the rounded chest. Dark brown and black markings on the head, wings, and tail contrast with the lighter color on the body. There is a large circular depression bordered by a beveled rim on the base of the finial.

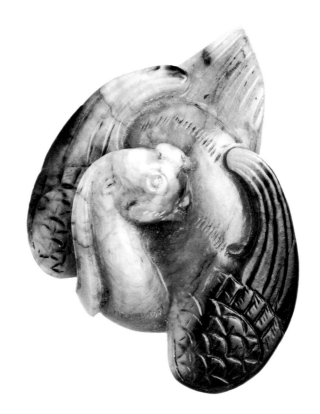

82 Bird Pendant

Song–Yuan dynasties,
12th–14th centuries
height 6.4, width 4.3, depth 2.2 cm
(2½ × 1¹¹⁄₁₆ × ⅞ in)
s87.0807

This compact composition presents a bird with
wings outspread; the tips of the wings curve inward
to frame the bird's body and tail. Incised lines de-
scribe the different types of plumage on the wings,
while a series of short strokes suggest the finer
feathers on the body. The triangular tail is deeply
grooved.

The graceful, curving lines of the bird's wings are
repeated by the elongated neck and the plume,
which arch back onto the body. Details such as the
beak, eye, ear, and crest are precisely defined. On
the underside of the jade the bird's legs and claws
are indicated in low relief. A V-shaped perforation
between the legs permitted the bird to be secured to
another material or to be suspended as a pendant.

Birds fashioned of jade appeared in China as early
as the Late Neolithic period. Moreover, depictions
of those early birds vary markedly, reflecting the dif-
ferent aesthetic and ritual emphases of the Late
Neolithic cultures in China. Birds continued to play
an important role in ritual jades through the suc-
ceeding Shang, Zhou, and Han dynasties. Although
it becomes increasingly difficult in the post-archaic
periods (after the Han dynasty) to determine
whether the function of the jades was ritual or secu-
lar, birds remain an important artistic motif
throughout Chinese history.

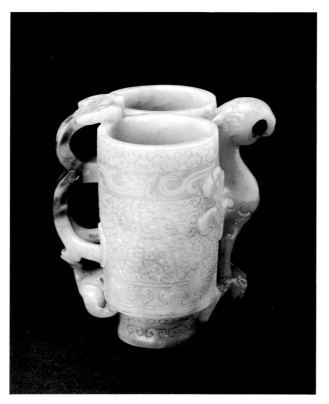

side view

back view

83 *Champion Vase*

Song–Yuan dynasties,
12th–14th centuries
height 8.9, width 8.8, depth 8.4 cm
(3½ × 3⁷⁄₁₆ × 3⁵⁄₁₆ in)
S87.0725

Consisting of two cylinders joined at the base, this vase is supported by an animal, whose bifid tail emerges on the opposite side of the ensemble. A bird with outspread wings stands atop the animal head; an extension of the wings forms the handle of the vessel. The surfaces of the two cylinders are embellished with archaistic spiral and plant motifs that first appeared in China during the Zhou dynasty.

Vessels of this type are referred to as "champion" or "hero" vases because of a rebus on the Chinese names for falcon and bear—the two creatures that supposedly play such a conspicuous role in the composition. As is the case with the Sackler example, however, these creatures usually are so schematically modeled that it is uncertain whether they are actually meant to be a falcon and a bear. In all probability, this interpretation of the decoration and

the terms "champion" or "hero" vase are not of long standing.

A gilded bronze cup formed by two cylinders and linked by a bird standing atop a feline was found in a second century B.C. Han-period tomb in 1968. Other examples, made of pottery and jade, have been unearthed in tombs dating from the Han dynasty. This unusual shape was known in China at least as early as Han times and continued to be made for over a thousand years.

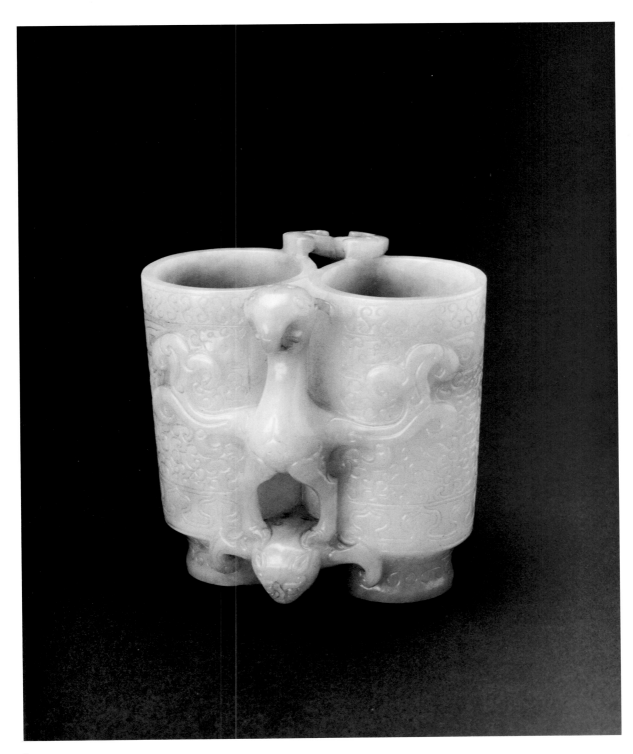

front view

84 Bird

Song–Yuan dynasties,
13th–14th centuries
height 4.3, width 2.9, depth .9 cm
(1¹¹⁄₁₆ × 1⅛ × ⅜ in)
s87.0752

Fashioned of white jade, the bird is presented with head erect and in profile. The wings and tail are arched dramatically, and the texture and markings of the feathers are clearly indicated by incised diagonal lines. The curvilinear elements of the various segments of the bird are echoed in the stylized clouds along the right edge of the composition.

The elaborate treatment of the bird's plumage and the attention given to the tail are traditionally associated with Tang dynasty jades.

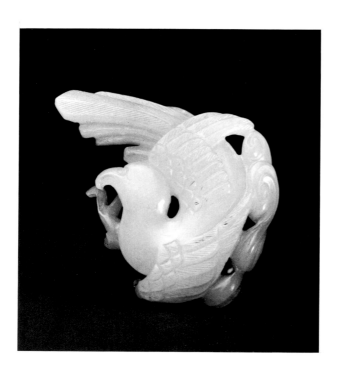

85 Dragon Finial

Yuan dynasty, 13th–14th centuries
height 6.9, width 24.3, depth 5.1 cm
(2¾ × 9⁹⁄₁₆ × 2 in)
S87.0819

This large, green jade head of a dragon is carved in the round. The vitality of the powerful head is enhanced by the undulating movement that characterizes each element of the composition. Curved tusks project upward from the gaping mouth, echoing the arch of the extended snout, which presses back against the large, flaring nostrils and deeply inset eyes. Long, striated eyebrows flow backward over the skull toward the pair of bifurcated antlers and, ultimately, to the complex mane. The upward sweep of the farthest extremities of the mane provides a complementary balance to the dragon's formidable snout.

There is a large oval perforation on the underside of the jade, flanked by two smaller holes. These openings probably would have enabled the jade dragon to be mounted as a finial, where it would have formed an imposing standard. Yet another perforation at the mane portion of the jade may have been used to attach a streamer. Architectural comparisons for this image are provided by the acroteria that decorated the ridges of traditional Chinese buildings.

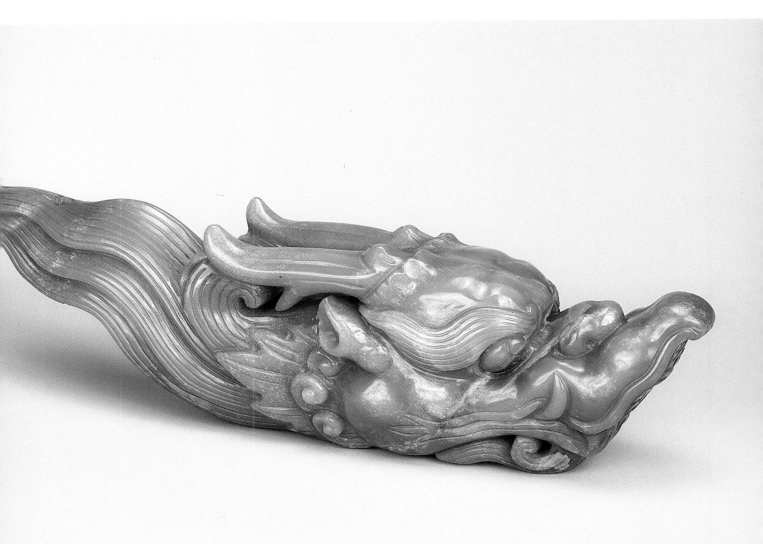

86 Ring Ornament

Yuan–Ming dynasties,
13th–17th centuries
height 11.2, width 11.4, depth 1.1 cm
(4⅜ × 4½ × ⁷⁄₁₆ in)
s87.0767

A small boy, whose youth is indicated in traditional Chinese fashion by the way in which his hair is arranged in topknots on either side of his head, holds a ring in each hand. Wearing only a loincloth and a scarf, the boy is presented in an animated stance atop stylized clouds. These stylized clouds are indicative of a late Yuan-early Ming date. A serpentine dragon confronting the boy forms the other half of the circular composition. The dragon's body is seen from above, with its muscular legs placed firmly on clouds and with a double outline flowing rhythmically from the coiling tail, along the spine, and ending in the large, horned head. The dragon holds a jewel in the paw that is closest to the boy.

Although the exact relationship between the boy and the dragon remains unclear, other versions of this remarkable composition are known. A jade ring in the British Museum, dated to the eleventh through the twelfth century, presents the boy and the dragon in a more intimate relationship. The boy is winged, and his hair rises in an unusual curling tuft from the top of his head. More unusual is the fact that the boy stands on top of the tail of the dragon and holds the jewel in his hand. The imagery of the boy and the dragon might be based on one of the many stories in Chinese mythology that describe the spiritual communion between immortals and dragons. Another theory is that the rings held by the youth might identify him as Nazha, one of the legendary manifestations of Vaisravana, a heavenly king. Nazha is credited with slaying the Dragon King of the Eastern Seas.

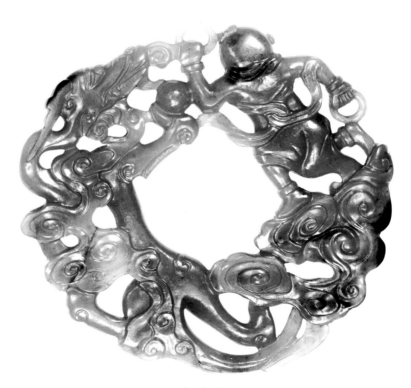

back view

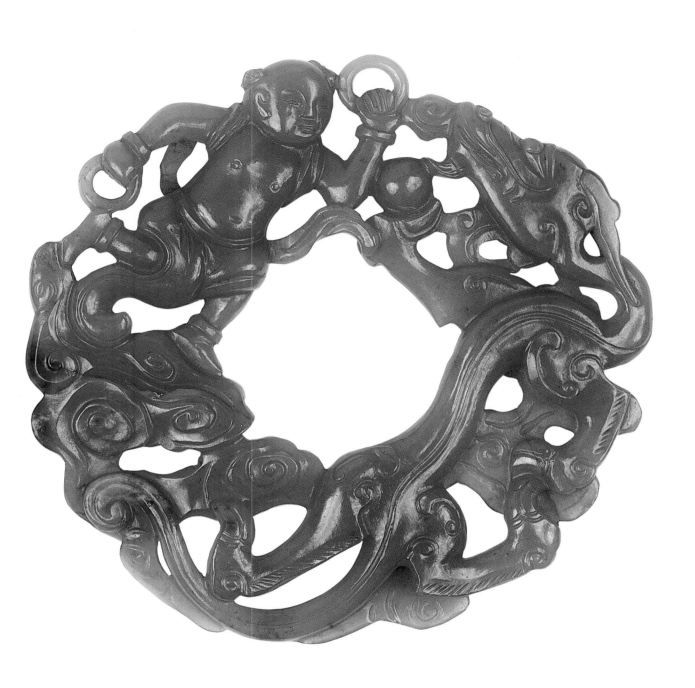

87 Figure

Yuan–Ming dynasties,
13th–17th centuries
height 5.4, width 2.8, depth 1.2 cm
(2⅛ × 1⅛ × ½ in)
s87.0792

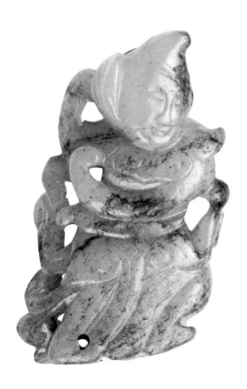

This small jade figure, carved in the round, is noteworthy for the extreme torsion of its posture; both arms, which are raised to one side, serve as a counterbalance to the direction of the head and body. The pose, suggesting that the figure might be in the midst of a dance, is complemented by an elaborate costume. The figure is wearing a pointed cap and a full-length robe that is further embellished with an elaborate collar and girdle. A diamond pattern etched into the surface of the robe apparently is based on embroidered textile motifs. Projecting from one side of the composition are curvilinear designs formed by looped drapery sashes. The unusual stance of the figure and the exotic costume have prompted some scholars to suggest that the jade may depict a shaman. A perforation runs vertically from the top of the jade to the bottom; there is a small perforation on the lower right edge of the robe.

88 Elephant

Ming dynasty, 14th–17th centuries
height 5.3, width 11.8, depth 7.6 cm
(2⅛ × 4⅝ × 3 in)
s87.0825

This large jade elephant is presented in an informal, reclining pose. Its head is lowered and turned back against the massive body. The curling trunk extends between the crossed tusks to rest beside the animal's cheek and front leg. The rear legs are drawn forward toward the head, lending an even greater sense of bulk to the sculpture. With remarkable attention to detail, probably based on the study of an actual elephant, the Chinese artist placed special emphasis on a few characteristic features, such as the pointed tusks, twisted trunk, small deeply set eyes, and thin heavily veined ears. The legs folded beneath the body are presented in summary fashion, although the toenails are noteworthy for the precision of their execution. Against those few, carefully defined features the monumental, highly polished bulk of the elephant is even more imposing. At the same time, there is a sense of playfulness and wit evident in the presentation of the animal that also surfaces in some Chinese ink paintings of the elephants associated with the Buddhist deity Puxian. Traditionally the elephant is regarded in China as being symbolic of strength, sagacity, and prudence.

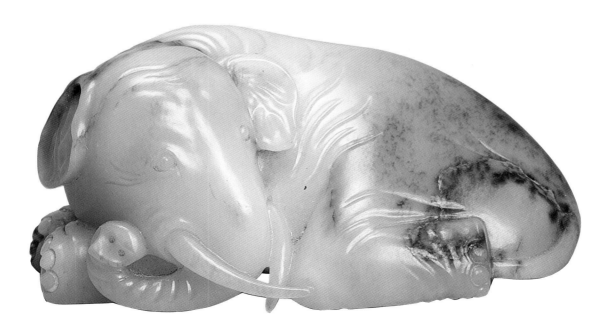

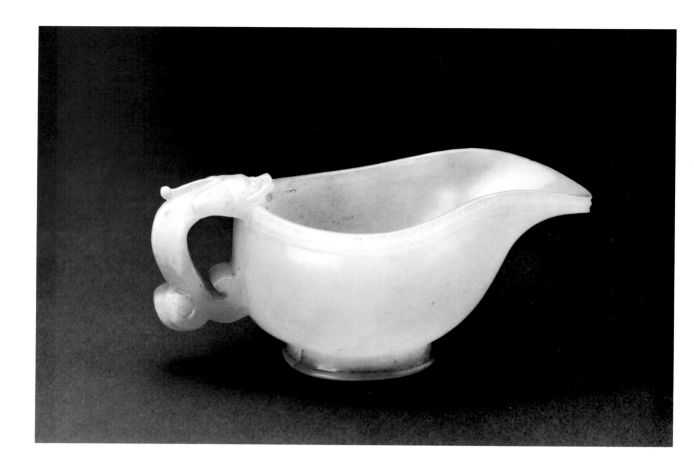

89 *Libation Cup*

Ming dynasty, 16th–17th centuries
height 4.7, width 10.5, depth 5.6 cm
(1⅞ × 4⅛ × 2³⁄₁₆ in)
s87.0726

This oval libation cup of lightly colored jade has an
extended spout and grooved rim. A similar grooved
decoration appears on the splayed foot. Such details
are characteristic features of Ming dynasty jade
carving. A curving dragon forms the handle of the
libation cup; the single-horned dragon grasps the
rim of the vessel in its open mouth, while one sec-
tion of the bifurcated tail joins the body of the
piece.

Information provided by archaeological finds in
China has demonstrated that during the Ming dy-
nasty jade artisans in the southeastern provinces of
Jiangsu, Zhejiang, and Jiangxi preferred to work
with white or tan nephrite. Their work contrasts
with the contemporary northern preference for dark
green jadeite and vessels of sturdier proportions.

90 *Double Chimera*

Qing dynasty, 17th–18th centuries
height 5.6, width 8.3, depth 8.2 cm
(2¼ × 3¼ × 3³⁄₁₆ in)
S87.0824

The two chimeras, or *bixie*, are shown oppo-
site one another, head to tail, with their heads
turned so that the muzzle of each rests on the hind-
quarters of the other. The tightly organized compo-
sition enabled the artist to make full use of the jade
available. The outer, brownish "skin" visible on
portions of the animals' bodies indicates the gener-
ally rectangular shape of the original jade stone.
One of the creatures has a pair of horns stretching
backward along its arched neck; the other has
shorter, striated horns arranged across its forehead.
Sharply ridged spines, articulated by precisely curv-
ing lines, emphasize the elegant torsion of the two
chimeras. A series of vertical rounded planes reveals
an impressive understanding of zoological muscula-
ture. More fanciful are the flat, stylized wings that
project from the animals' shoulders and curling
tails. The underside of the legs is rendered with only
a few details. All of the surfaces of this remarkable
pair of chimeras are polished to a high luster.

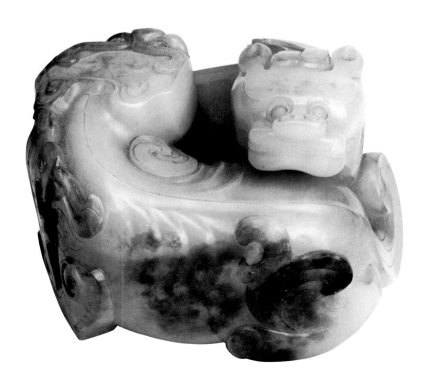

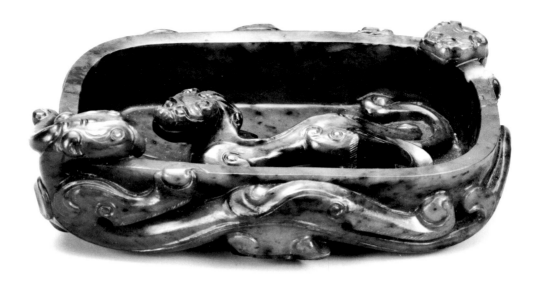

91 *Brush Washer*

Qing dynasty, 18th century
height 3, width 9.8, depth 7.1 cm
(1³/₁₆ × 3⁷/₈ × 2³/₄ in)
inscription
s87.0773

The smooth, precisely finished contours of this rectangular vessel form a sharp contrast with the sinuous bodies of the dragons that appear on the interior and exterior. Standing inside the brush washer is a single-horned dragon, its head raised and its legs in an aggressive stance. The undulating rhythm that lends further animation to the dragon is accentuated by the coiling ends of the bifurcated tail. On the outside of the vessel are two serpentine creatures; one of them has a crested birdlike head, and the other is feline. The bodies of the two creatures extend along the sides of the brush washer, while their heads and front paws project over the flat upper surface. Two characters, *yong bao* (eternally treasure), written in seal script, appear on the underside of the vessel.

In spite of its modest scale, this elegantly finished jade brush washer belongs to a tradition that can be traced back at least to the Yuan dynasty, to the legendary large black jade wine bowl that is preserved in the Tuancheng, or "Round Fort," a walled enclosure adjoining the Beihai Park in Beijing. Measuring approximately 494 centimeters (about 16 feet) in circumference, that colossal jade wine bowl is believed to date from the Yuan dynasty. According to an inscription added by the Qianlong emperor after

he acquired the treasure in 1746, the jade had formerly been used by Daoist monks as a vegetable container. A complex design of waves and dragons covers the surface of the large black jade wine bowl.

92 *Budai*

Qing dynasty, 18th century
height 10.5, width 7.3, depth 6.1 cm
(4⅛ × 2⅞ × 2⅜ in)
s87.0769

The rotund body, friendly appearance, and large cloth bag identify Budai, the "cloth bag monk" of Chinese Buddhism. According to tradition, Budai was an eccentric priest who lived during the latter part of the Tang dynasty and was the last incarnation of the bodhisattva Maitreya. This popular deity is sometimes shown holding a rosary and accompanied by children. Budai's cloth bag is said to contain riches of all kinds. This benevolent Buddhist personality is particularly revered in Japan, where he is known as Hotei.

During the Qing dynasty, jade carving was particularly important. The artists continued to have a predilection for fashioning their compositions in ways that would stress the shapes of the original pebbles. On occasion, Qing artists would stain the outer portions of the pieces to simulate the brown "skin" that was so characteristic of many earlier jades. The rounded, smoothly polished planes of the Sackler Budai reflect concern with retaining the contours of the jade pebble. The darker brown tonalities are the result of natural variations in the jade. There is a cylindrical aperture in the base of the jade that enabled it to be supported securely.

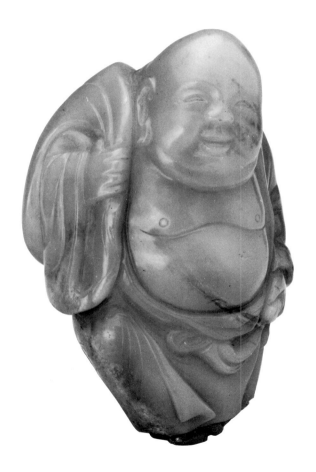

Bronze

CHINA'S BRONZE AGE spanned a period of more than a thousand years. The bronze vessels made during that millennium are characterized by a degree of aesthetic and technical perfection that remains unequaled. The bronzes were prized by the Chinese during the Bronze Age because of their importance in ritual ceremonies and as emblems of political authority. Most bronze vessels were entombed with the dead. But many appear to have been buried as offerings to natural spirits, such as those associated with rivers and mountains, while other bronzes were placed in treasure caches, evidently in times of turmoil.

When those same bronze vessels were unearthed during succeeding generations—after the Bronze Age had ended—they were revered as harbingers of auspicious events and collected for a variety of reasons; as early as the Han dynasty, the discovery of a single bronze was considered worthy of mention in the official Chinese histories. Most important for the Chinese, the bronze vessels were a tangible link with remote antiquity. And it is not surprising that those vessels that carried inscriptions referring to people, places, and events that could be identified with or could verify statements in classical texts were especially esteemed.

But at all times, bronzes carried high intrinsic value. The extraordinary elegance of form and decoration, as well as the historical information provided by the inscriptions, have intrigued generations of scholars in East and West. As emblems of a culture that has continued for more than five thousand years, these bronze vessels epitomize Chinese technical excellence and artistic genius.

Many of the precise details of the rituals and exactly how they dominated the lives of the Shang dynasty (ca. 1700–ca. 1050 B.C.) rulers are uncertain, but there is general agreement that these bronze vessels were used in ceremonies to ensure harmony with the spirits of deceased ancestors. The preservation of these objects is due to the fact that they were buried,

for although bronze vessels dignified the lives of notable individuals, they were also prominent among the grave goods placed in the tombs of royalty and members of the ruling class. Jade objects were often included as well to indicate social rank and, especially during later periods, symbolically to preserve the body.

Throughout Chinese history, bronze artists regularly interpreted and transformed the canons initially established by the archaic vessels, a process known as archaism. Freed from the guiding constraints of compelling ritual traditions and the attendant aesthetic dictates of Shang and Zhou dynasty (ca. 1050–221 B.C.) traditions, later Chinese artists explored subtle variations in the archaic shapes and emphasized those decorative details that, for various reasons, had specific appeal. Regardless of how pronounced those variations might be, however, the obvious influence of the original prototypes and rich cultural associations that, inevitably, were embodied in the later archaistic bronzes have exerted an almost palpable control over China's awareness of its earliest documented historical periods.

During the Shang and Western Zhou periods, the Chinese produced bronzes according to methods that differed greatly from those used in ancient Mesopotamia and Greece. Instead of cold-working the alloy to create shapes and decoration, the Chinese relied instead on a piece-mold casting process, employing clay mold sections assembled around a clay core. The mold sections contained the negative image of the desired vessel's contour and surface ornament, either carved directly into the clay or transferred from a clay model. Therefore, after the molten alloy, composed primarily of tin and copper, was poured into the mold assembly and allowed to cool, the resulting vessel required no further work beyond minor finishing.

Bronze vessels were cast in a variety of shapes, many of them based on pottery forms inherited from the preceding Late Neolithic era (ca. 5000–ca. 1700 B.C.). Shang vessel types included food cookers (*ding*, *li*, and *xian*), ritual food containers (*yu* and *gui*), wine containers (*hu*, *he*, *guang*, *pou*, *zhi*, *you*, *gu*, *zun*, *fangyi*, and *lei*), wine warmers (*jia* and *jue*), and water basins (*pan*). In later times some shapes disappeared and others were introduced, such as *fu* (food vessel), *yi* (liquid container), and *ying* (water vessel), as shown in the figure, pp. 142–43.

The most prevalent decorative motif of the age is the *taotie*, a ferocious mask with large eyes and with shapes that suggest horns, fangs, and ears; usually *taotie* have no lower jaw (see detail, no. 105). The precise meaning of this popular motif, which became prominent during the Shang dynasty, is unknown, but it became increasingly well defined and sculptural in form during the period. In the succeeding Zhou dynasty, the *taotie* became less important. The masks gradually dissolved into separate elements and eventually disappeared.

The decoration of bronzes underwent extensive evolution, starting with the narrow bands of geometric decor found on the earliest examples (no. 93). By the late Shang period (thirteenth to eleventh century B.C.) ornamentation was likely to cover the entire vessel with complex patterns, including elements in rounded relief (no. 108). Crisply executed motifs like *taotie*, dragons, serpents, cicadas, birds, and a host of other animal forms appeared at regular intervals around the vessel, often against a background of squared spirals—the *leiwen*, or "thunder pattern."

Vessel type	FOOD						WATER		
	ding 鼎	li 鬲	xian 甗	fu 簠	yu 盂	gui 簋	yi 匜	pan 盤	ying 鑒

During the Western Zhou period (ca. 1050–771 B.C.) the repertoire of ornamental motifs gradually changed. Long-tailed birds were prominent on vessels from the initial phase of this period, while repetitive band patterns became important during the later years (nos. 125, 137, 138). In the Eastern Zhou period (770–221 B.C.), these band patterns developed into exquisitely detailed, abstract curls organized in interlocking units densely covering the surface of the vessels (nos. 139, 142). These fine and uniform designs were probably impressed with a master stamp into the piece molds. For extremely ornate curl patterns in relief, found on certain vessels from the Eastern Zhou period, the lost-wax method may have been used in preparing the molds. In the lost-wax process, a model of the desired form is created using wax, and the clay mold is shaped around the model. When the clay mold is fired, the wax melts and runs out, leaving a cavity to be filled by the molten bronze during casting.

Techniques for inlaying gold, silver, copper, and semiprecious stones into bronze were perfected during the Warring States period (480–221 B.C.), permitting surface decoration of contrasting color and frequently accentuating the linear vitality of ornamental motifs (no. 140). Using inlay and other cold-working processes such as engraving, artisans depicted not only geometrical motifs but also stylized landscapes and hunting scenes, a development that continued in the Han dynasty (no. 155).

壼	he 盉	guang 觥	pou 瓿	zhi 觶	you 卣	gu 觚	jia 斝	jue 爵	zun 尊	fangyi 方彝	lei 罍

Inscriptions in archaic script were cast into a number of the vessels presented in this volume. The earliest inscriptions, dating from the Anyang period (ca. 1300–ca. 1050 B.C.), consist of simple pictographs, later developing into terse ancestor dedications (nos. 95, 96). By the Western Zhou period, the texts were becoming much longer, sometimes recording valuable historical information (no. 125). Chinese connoisseurs have traditionally prized vessels bearing important or beautifully written inscriptions above uninscribed vessels. They also preferred vessels with a rich, even patina, the dark green or blue surface corrosion caused by chemical reactions during burial in the earth.

Other objects in addition to vessels were made of bronze, including weapons and chariot fittings during the Shang and Zhou periods. Archaeological discoveries show that bronze mirrors were also made at least as early as the Shang dynasty. Mirrors, however, occur in large numbers only after the fourth century B.C.

The surpassing beauty and complexity of Chinese bronzes ensure that they will continue to be treasured throughout the world as embodiments of history, culture, and art.

THOMAS LAWTON

93 Lei

Ritual Wine Container
Shang dynasty, ca. 15th century B.C.
height 27.7, diameter 21.8 cm
($10^{15}/_{16}$ × $8^{5}/_{8}$ in)
S87.0022

Widely recognized as one of the earliest Chinese bronze ritual vessels in the Sackler Gallery, this *lei* is also possibly the oldest of its type on record. The decoration cast in relief was executed in the simplest technique, that is, by incisions in the mold. The designs consist of a wide horizontal band of three symmetrically arranged *taotie* masks bordered above and below by rows of circles. The masks, which appear beneath the sharply articulated shoulder, consist of pairs of protruding round eyes surrounded by an abstract pattern of raised lines. A narrower band of decoration, also organized around pairs of raised eyes, appears on the shoulder of the *lei*. Horizontal bowstrings encircle the attenuated neck and high footrim of the vessel. Vertical scars appear three times around the circumference of the *lei*, clearly indicating the points at which the piece-mold assembly was joined.

The sophistication of the *taotie* decoration on the Sackler *lei* contrasts with the relative crudeness of the bronze casting itself. These same designs, executed in remarkably elegant raised thread relief and appearing on jade ritual objects dated to the Late Neolithic and early Shang periods, have prompted the suggestion that Chinese bronze casters may have been influenced by the decoration of the considerably earlier stone-working industry.

Note
Max Loehr, writing in 1968, described this *lei* as "the oldest of its type on record." See *Ritual Vessels of Bronze Age China,* New York, 1968.

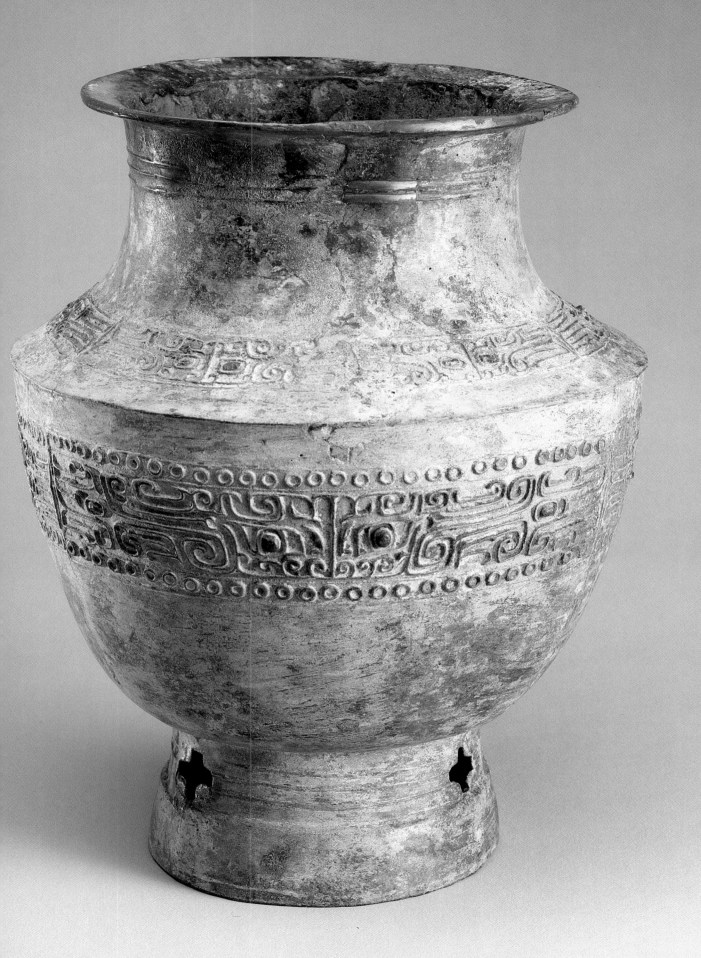

94 *Jia*

Ritual Wine Container
Shang dynasty, 15th–14th centuries B.C.
height 21.9, width 14.5, depth 16 cm
(8⅝ × 5¹¹⁄₁₆ × 6⁵⁄₁₆ in)
S87.0041

In this early form of the *jia*, which originally would
have been used for heating and serving ritual liba-
tions, the individual elements of the vessel are
clearly demarcated. The round body has a flat bot-
tom and stands on three tapered legs of triangular
cross section. A large, arched handle links the flar-
ing upper section of the vessel with the rounded
lower section. A horizontal register embellishes the
body of the Sackler *jia*. The register consists of a
highly stylized dragon motif dominated by a pro-
truding oval eye, repeated three times. The length of
the individual sections of this horizontal decorative
register coincides with the placement of the three
legs and handle. In turn the placement of each of
these formal elements was determined by the junc-
tures of the piece-mold assembly used to cast the *jia*.
During this early phase of Chinese bronze casting,
that assemblage technique demanded the interrup-
tion of the decorative register in the space immedi-
ately beneath the handle. Two unusually tall posts
rising from the lip of the *jia* are fitted with umbrella-
shaped caps. The inner lip of the vessel is thicker
than the remaining wall of the *jia*; this unusual fea-
ture, especially curious on a bronze that has been
cast, has caused some specialists to suggest that the
detail may derive from an earlier, wrought-metal
tradition.

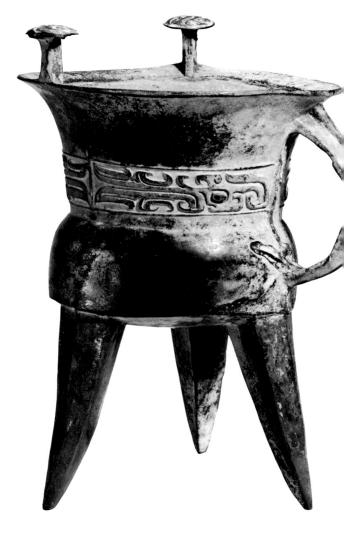

95 *Jia*

Ritual Wine Container
Shang dynasty, 13th century B.C.
height 25.2, width 17.7, depth 19.6 cm
(9¹⁵⁄₁₆ × 7 × 7¾ in)
inscription
s87.0060

Each element of this unusual *jia* is in subtle relationship to every other. The vessel reflects the remarkable aesthetic refinement of Shang dynasty bronze artisans. Contrasting concave and convex contours, established on the body of the *jia*, are repeated in the tall flaring cones that cap the two columns rising from the lip of the vessel and in the curved handle and the three splayed legs. The decoration on the exterior of the vessel is executed in intaglio, with only the eyes of the *taotie* masks projecting in relief.

Cast on the interior bottom of the *jia* is a single character, usually read *zheng*. That character, which appears on a number of Shang dynasty bronzes, probably is a clan sign.

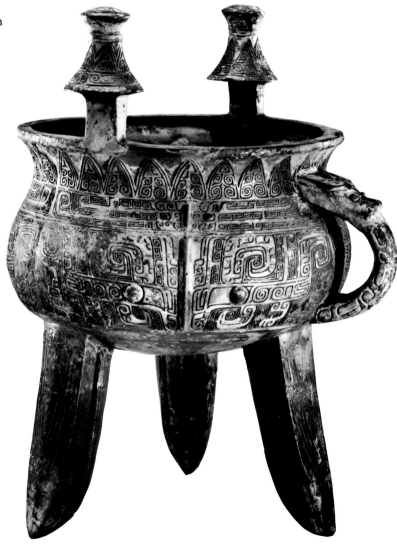

96 *Fuding Jue*

Ritual Drinking Vessel
Shang dynasty, 13th–12th centuries B.C.
height 21, width 18, depth 9.1 cm
(8¼ × 7⅛ × 3⁹⁄₁₆ in)
inscription
s87.0053

Dramatic proof of the richness of funerary furniture among Shang dynasty nobility came in 1976 with the excavation of Tomb No. 5 at Anyang, Henan Province. Scholars are generally agreed that Tomb No. 5 belonged to Fuhao, a consort of Wuding, one of the last Shang kings, who ruled ca. 1200 B.C. Tomb No. 5 was the first Shang royal tomb to yield its contents intact, all of the previous royal tombs at Anyang having been looted by grave robbers in the course of the past three millennia. Among the almost 2,000 pieces of funerary furniture from Tomb No. 5, there were more than 200 bronze ritual vessels. Forty of those vessels were *jue*, several of which are closely related in size, shape, and decoration to the *Fuding jue* in the Sackler Gallery.

The ovoid body of the *Fuding jue* tapers toward the flaring rim and pouring spout and is supported by three triangular, splayed, pointed legs. Two short columns fitted with umbrella-shaped caps project from the inner portion of the elongated pouring spout. Decoration on the surface of the *jue* is limited to the animal head on the crest of the single curved handle and the horizontal band of *taotie* masks around the body of the vessel. Narrow, vertical flanges divide the individual sections of the *taotie*.

The inscription cast beneath the handle consists of a pictograph, probably a clan sign, and the dedication to Fuding (Father Ding).

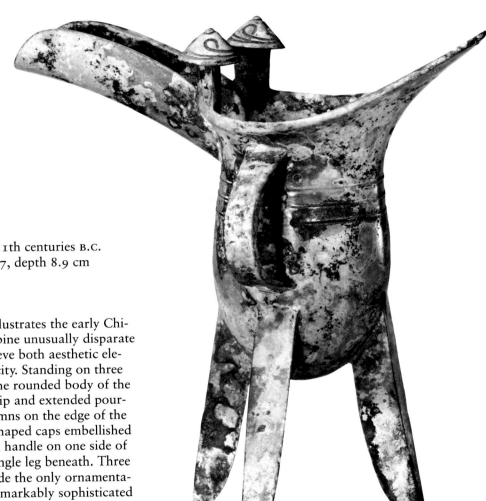

97 *Jue*

Ritual Drinking Vessel
Shang dynasty, 12th–11th centuries B.C.
height 18.7, width 16.7, depth 8.9 cm
(7³⁄₈ × 6⁹⁄₁₆ × 3½ in)
s87.0040

This bronze *jue* splendidly illustrates the early Chinese artisan's ability to combine unusually disparate formal elements and to achieve both aesthetic elegance and functional simplicity. Standing on three tapered blade-shaped legs, the rounded body of the *jue* rises to meet the flaring lip and extended pouring spout. Two upright columns on the edge of the pouring spout end in cone-shaped caps embellished with spiral whorls. A curved handle on one side of the *jue* is aligned with the single leg beneath. Three horizontal bowstrings provide the only ornamentation on the surface of this remarkably sophisticated bronze vessel.

Archaeological finds in China have yielded bronze *jue* that can be dated to the first half of the second millennium B.C. These early Shang dynasty prototypes of the Sackler *jue* are characterized by extremely attenuated forms that reflect a sophistication noteworthy in such early metal vessels. The clear demarcation of the forms that is so conspicuous a feature of those earliest bronze *jue* was dictated, in part, by the piece-mold technique used in the casting. That preoccupation with accommodating form to technique is replaced, in the Sackler *jue*, with an overriding concern for unity of design.

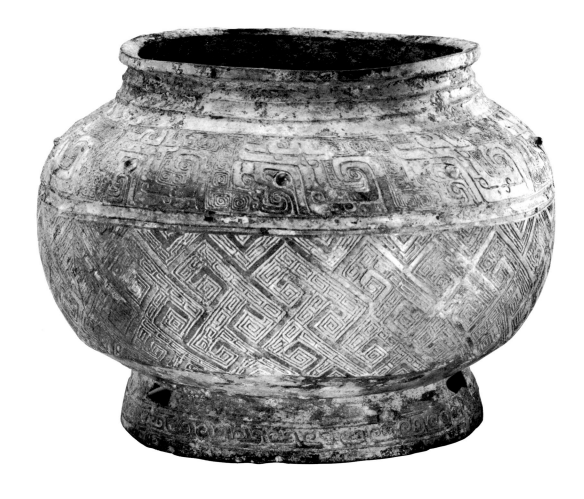

98 *Pou*

Ritual Wine Container
Shang dynasty, 13th century B.C.
height 17.1, diameter 22.6 cm
(6¾ × 8¹⁵/₁₆ in)
s87.0043

Many early Chinese bronze ritual vessels display close relationships with contemporary pottery pieces. Since the bronze-casting techniques used in China during the Shang dynasty required a continuing supply of large numbers of precisely formed pottery molds, bronze casters and potters of necessity had to coordinate their efforts. Given that collaboration, it is not surprising that the shapes and designs of ancient bronze vessels frequently are similar to ceramic traditions. At the same time, it is remarkable that the Chinese bronze casters so quickly developed shapes and motifs that are obviously the products of a cast-metal tradition. Those metal

shapes and designs, in turn, eventually exerted considerable influence upon contemporary pottery.

The *pou* in the Sackler Gallery has a full, round body and short neck and is seated on a high conical foot. This simple rounded shape is directly related to Shang dynasty pottery prototypes. On the horizontal frieze around the shoulder of the *pou*, a band of stylized dragons all face left on a ground of *lei-wen* (see Glossary). The protruding, conical eyes of these dragons are the only elements in the overall design to project above the surface of the vessel. A narrow band of barbed spirals slanting to the left on the base of the vessel echoes the direction established by the stylized dragons. The wide, lower frieze on the Sackler *pou* presents a series of intersecting hooked T-shaped motifs arranged diagonally. A number of Shang dynasty gray pottery and white pottery pieces are decorated with similar intersecting hooked T-shaped motifs. Whether that pattern was first introduced by potters or by bronze artisans is uncertain.

99 *Gu*

Ritual Drinking Vessel
Shang dynasty, 13th century B.C.
height 24.8, diameter 14.9 cm
(9¾ × 5¹³⁄₁₆ in)
S87.0054

On the basis of archaeologically attested bronze vessels, it is possible to trace the stylistic development of the *gu*, or ritual beaker, from the squat, simply shaped vessels that date from the early Shang period, to the tall, elegantly proportioned examples crafted during the final years of the dynasty. *Gu* are among the earliest Chinese bronze ritual vessels. Examples unearthed at the important Shang site of Zhengzhou, Henan Province, can be dated to the middle of the second millennium B.C.

The proportions and decoration of the Sackler *gu* reflect a series of significant refinements on the earliest bronze examples known. The vessel, which has a slender, clearly demarcated waist and flaring mouth, rises from a hollow, splayed foot. Decoration is restricted to the waist and foot of the *gu*, and the horizontal transition between each of these segments is clearly defined by a series of raised, horizontal bowstrings. The ornamental frieze on the splayed foot consists of a band of precisely articulated spirals, all of which turn in the same direction. In each trapezoidal space between the band are spirals and quills centered on a protruding eye. The smooth surface of the hooked canthus serves to emphasize each of these eyes. In contrast to the asymmetry of the designs on the foot of the Sackler *gu*, the protruding eyes, as well as the intaglio spirals and quills on the waist, are arranged symmetrically on either side of the vertical ridge. This balanced configuration presents the ubiquitous *taotie* in its more characteristic form. An olive-green patina, with irregular darker accretions, covers the entire surface of the Sackler *gu*.

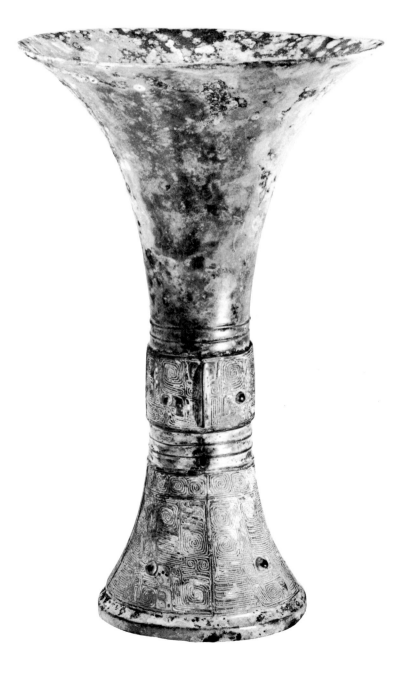

100 *Gu*

Ritual Drinking Vessel
Shang dynasty, 13th century B.C.
height 29.6, diameter 16.5 cm
(11⅝ × 6½ in)
inscription
s87.0042

Among the more than two hundred bronze ritual
vessels discovered in Tomb No. 5 at Anyang were
fifty-three *gu*. Several of those *gu* are closely related
to the Sackler example in size, shape, and decora-
tion. On the basis of that relationship, it is possible
to date the Sackler *gu* to ca. 1200 B.C. and to sug-
gest that it probably was cast at a foundry in the
Anyang area.

The tall, attenuated form of the Sackler *gu* was
the result of the Shang bronze artisan's continuing
refinement of the squat proportions that were char-
acteristic of the earliest examples known. Certainly
the slender waist, flaring mouth, and hollow,
splayed foot are features that were associated with
the *gu* from the beginning. But the subtle relation-
ship of those parts and the refined decoration on
their surfaces on examples like the Sackler *gu* reveal
a sophistication that is unparalleled in the period.

The delicately wrought flanges that separate the
taotie masks on the foot and middle section of the
gu do not continue onto the mouth. This further
stylistic development would unite all three portions
of the vessel more emphatically than is the case on
the Sackler example, although the designs on the
elongated triangular blades at the top of the bronze
are in keeping with the overall decorative program.

The two pictographs—*ju* (to raise), and *ji*, one of
the cyclical characters that designates the ten days
in the Shang week—are cast inside the base of the
vessel.

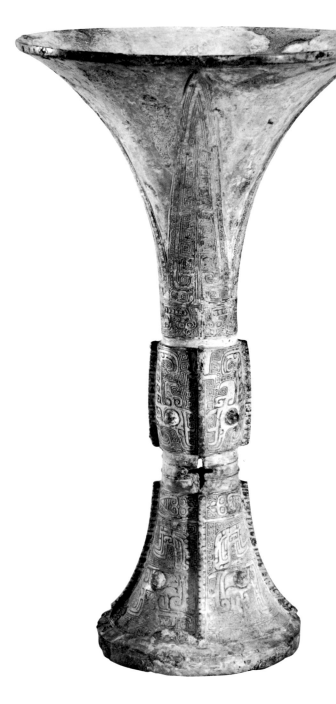

101 *Zuyi Jiao*

Ritual Drinking Vessel
Shang dynasty, 11th century B.C.
height 23.9, width 18.6, depth 10.9 cm
(9⅜ × 7⁵⁄₁₆ × 4⁵⁄₁₆ in)
inscription
S87.0046

Among the most elegant and graceful of all Shang dynasty bronze ritual vessels, the *jiao* closely resembles the *jue*. The major difference between the two is that the *jiao* does not have the pouring spout and capped posts on the lip that are characteristic features of the *jue*. Both types of ritual drinking vessels frequently bear short inscriptions in the vertical space beneath the handle. In the case of the Sackler *jiao*, the inscription provides the name Zuyi, or "Grandfather Yi," the person to whose memory the bronze was cast.

Taotie masks form the main decorative motif on the horizontal register that encircles the *jiao*. Two of these masks are centered on opposite sides of the vessel. Each mask is divided—on one side by the curved handle, on the other by a vertical flange. Above the vertical flange and on the crest of the handle are animal heads modeled in high relief. The intaglio masks are an unusual feature in the decor of the Sackler *jiao;* they are enclosed within elongated triangular shapes that follow the outer edges of the three slightly splayed legs. The glossy black surface of the bronze is further enhanced by irregular areas of rich green encrustation.

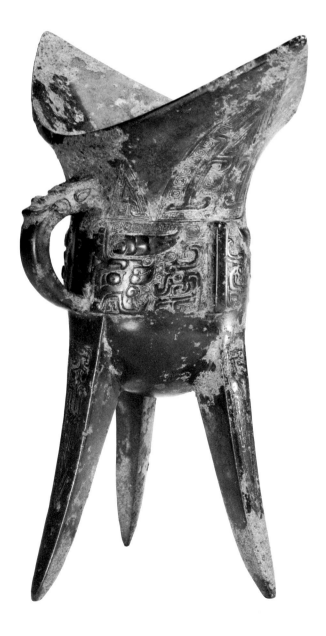

102 *Fangyi*

Ritual Wine Container
Shang dynasty, 13th century B.C.
height 18.4, width 11.1, depth 8.1 cm
(7¼ × 4⅜ × 3³⁄₁₆ in)
inscription
s87.0034a,b

The architectonic character of Shang dynasty bronze vessels is especially apparent in the structure and decoration of those wine containers known as *fangyi* (square vessels). The basic geometric form of *fangyi* has caused some scholars to suggest that the bronze examples might conceivably have evolved from wooden prototypes.

The Sackler *fangyi*, which is an early example of this type of ritual wine container, is rectangular in shape and fitted with a roof-like lid. The knob in the center of the lid is shaped like a miniature hip roof. Flanges in flat relief reinforce all of the corners of the vessel and its lid, interrupted only by the plain, narrow horizontal bands that establish the tripartite division of the vessel. Rounded, convex, vertical ridges accent the *taotie* masks on the vessel and lid. The narrow friezes, embellished with pairs of facing birds and dragons, are shown against a precisely cast, intaglio *leiwen* (thunder pattern) ground. The curved opening in the center of the base of the vessel, a characteristic feature of Shang dynasty *fangyi*, may have resulted from the way in which the piece molds were assembled when the bronze was cast.

Inside the vessel and the lid is an inscription that has been interpreted as consisting of the characters *ge* (dagger-ax), *bei* (north), and *dan* (single).

103 *Ge Fangyi*

Ritual Wine Container
Shang dynasty, 12th century B.C.
height 25.6, width 16.9, depth 13.4 cm
(10¹⁄₁₆ × 6⅝ × 5⁵⁄₁₆ in)
inscription
s87.0038a,b

The *Ge fangyi* in the Sackler Gallery provides a classic example of a late Shang dynasty wine container. Heavy, scored flanges emphasize the corners and the central axis of each plane of the vessel and of its lid. The only breaks in the vertical flanges coincide with the plain, narrow, horizontal bands that separate the decoration into clearly defined registers. In the center on each side at the foot of the Sackler bronze is the characteristic curved opening of Shang dynasty *fangyi*. The robust decoration, cast in high relief, complements the energy of the flanges. The major elements in the decoration are the *taotie* masks on the lid and central frieze of the vessel, consisting of large, circular eyes, gaping mouths, and curvilinear horns. These masks are clearly distinguished from the ground by an extremely finely cast *leiwen* pattern. The *taotie* masks on the lid of the Sackler *Ge fangyi* are arranged so that they appear right-side up when seen from above. The knob in the center of the lid repeats, in miniature, the shape of the lid itself. Confronting dragons appear in the horizontal register at the top of the vessel. A variant form of these dragons occurs along the four sides of the foot.

The single pictograph *ge* (dagger-ax), possibly a clan sign, is cast inside the lid and on the floor of this *fangyi*.

lid

vessel

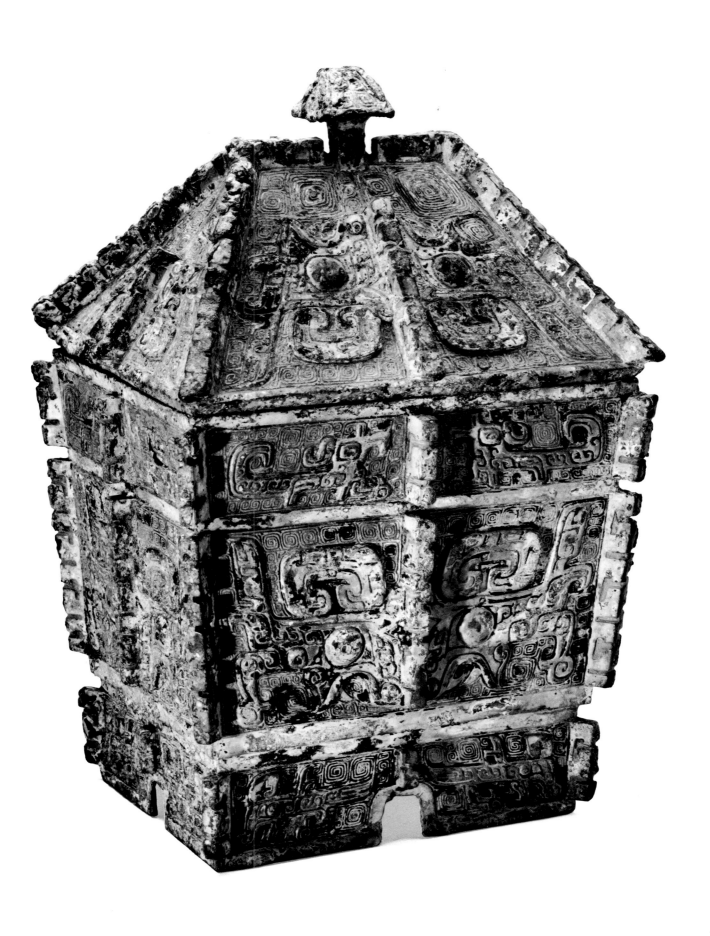

104 *Hu*

Ritual Wine Container
Shang dynasty, 13th century B.C.
height 34.8, width 24.2, depth 18.9 cm
(13¹¹⁄₁₆ × 9⁹⁄₁₆ × 7⁷⁄₈ in)
s87.0056

Dignified and formal in shape and decoration, this *hu* is an excellent example of early Anyang period (see Glossary) bronze casting. The *hu*, which is oval in cross section, rises from a low, conical foot. The elegant silhouette established by the outward curve and upward sweep of the vessel is interrupted only by two vertical lugs, presented as animal heads with large round eyes. Refinement in every detail of the Sackler *hu* is exemplified by the way the Chinese bronze artisan aligned these two vertical lugs with the uppermost horizontal design register, which includes two bowstrings and a narrow band of *leiwen* pattern. The two broad horizontal registers that dominate the surfaces of the *hu* are decorated with *taotie* masks. Raised rounded eyes and vertical flanges accent these masks; all other elements in the decoration are flush with the surface of the vessel. To differentiate between figure and ground, the artisan included a finely cast *leiwen* motif. The surface of the Sackler *hu* is grayish in color with some green encrustation.

Note
In his study of Anyang bronzes, Max Loehr assigned vessels of this type to Style IV (see Bibliography).

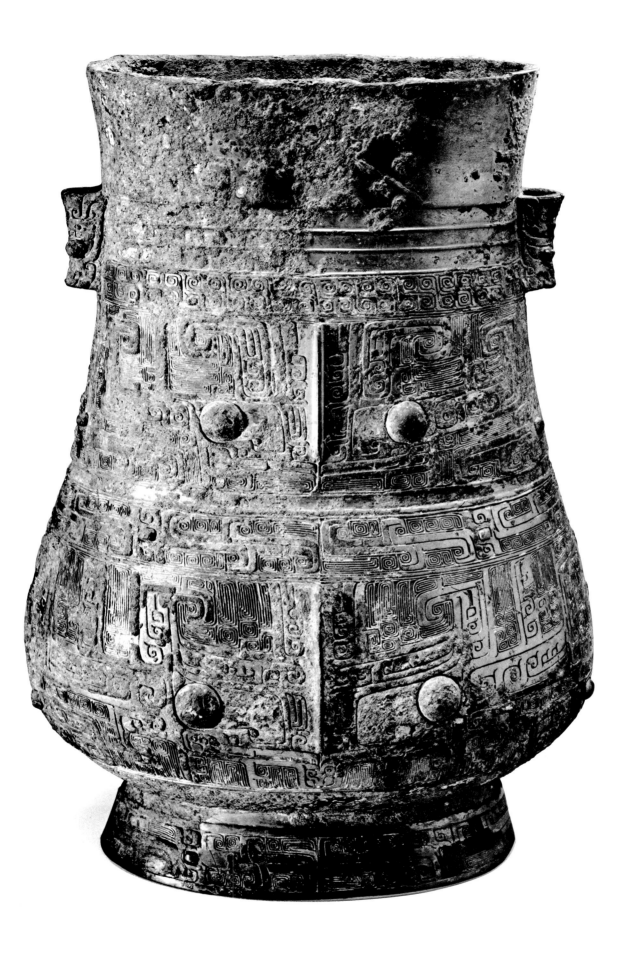

105 *Guang*

Ritual Wine Server
Shang dynasty, 12th century B.C.
height 17.8, width 19.2, depth 8.7 cm
(7 × 7⁹⁄₁₆ × 3⁷⁄₁₆ in)
s87.0279a,b

In decorating the surfaces of *guang*, Chinese bronze artisans were especially inventive. The creatures on the lid of the Sackler *guang*, for example, immediately establish the hybrid character of the piece. Dominating the front of the lid is a dragon with bottle horns and gaping fangs, though the dragon's bulbous eyes and flat, projecting ears are less imposing. At the opposite end of the lid is an owl, whose identity is revealed by its large ears and pointed beak. A dragon and an owl are frequently paired on the covers of Shang dynasty *guang*. Occasionally,

the bodies of these two creatures are presented in detail, sometimes extending down onto the surfaces of the *guang* itself. On the Sackler *guang*, however, the main areas of the vessel are dominated by late Shang-style *taotie* masks and *kui* dragons (see Glossary). Each of these motifs is clearly articulated and separated from the ground by a meticulously cast *leiwen* pattern. Raised vertical flanges at the front and on the sides of the vessel define the positions of the molds used in casting the *guang*.

The curving handle of the Sackler *guang* illustrates yet another aspect of late Shang dynasty ingenuity. A stylized bovine mask decorates the top of the handle, while a bird's head, wings, and body form the pendant portion. Particularly noteworthy is the fact that these disparate decorative elements have been carefully combined without any loss of the functional aspects of the handle.

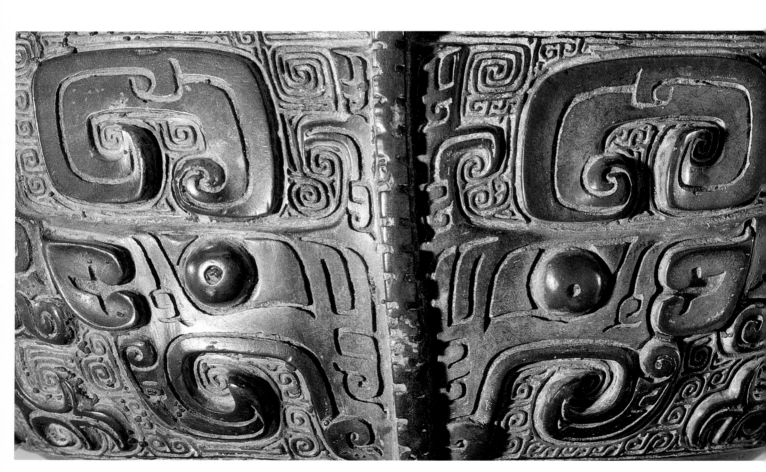

taotie mask

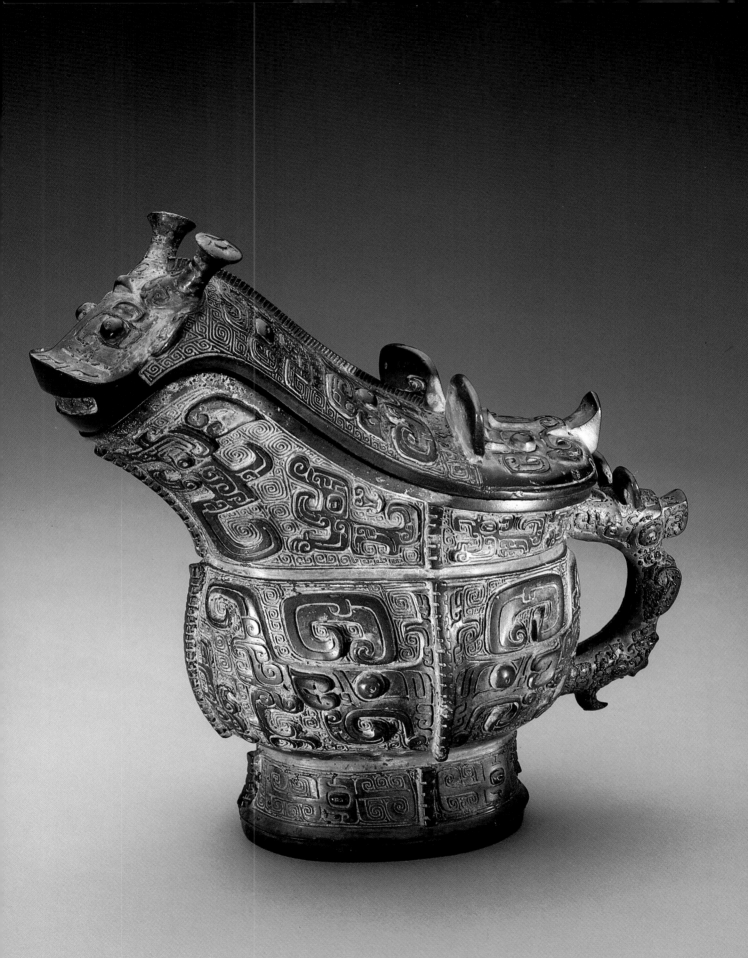

106 *You*

Ritual Wine Container
Shang dynasty, 13th century B.C.
height 30.1, width 12.2, depth 12.5 cm
(11⅞ × 4¾ × 4⅞ in)
inscription
s87.0023a,b

This elegant, exceptionally finely cast vessel can be assigned pride of place among the Chinese ritual bronzes in the Sackler Gallery. The rounded body of the *you* rises from a high, cone-shaped base and curves inward to form an elongated neck before flaring out to meet the circular lip. The domed lid continues the sweeping curvilinear silhouette of the vessel that is then repeated, in reverse, by the contours of the bail handle.

Two large circular eyes linked by a pointed beak establish the bird on the lower portion of each side of the Sackler *you* as an owl. The owl's wings, chest, and horns, all embellished with a meticulously cast imbricated feather pattern, vigorously convey the spirit of the bird. Displaying an unusual lack of concern for the integrity of each segment of the vessel, the artisan included the owl's legs by letting them intrude into the spiral band on the footrim. Even this noteworthy variation in Shang design is accomplished with remarkable sensitivity; each clawed foot occupies the space allotted to one of the spirals and observes the same baseline. Dragons placed vertically on either side of the owl's eyes provide a transition to the design registers on the neck of the Sackler *you*. Pairs of symmetrically arranged birds seen in profile appear beneath the curiously dismembered *taotie* masks. The bird motif is echoed by the head modeled in relief on the lid of the *you*. A short link fashioned of a cicada and two rings, now incomplete, originally joined the lid with a circular loop projecting from one side of the bail handle. *Taotie*

masks fitted with pairs of bottle horns serve as finials for the ends of the handle.

A two-character inscription, probably a clan sign, is cast inside the base of the Sackler *you*.

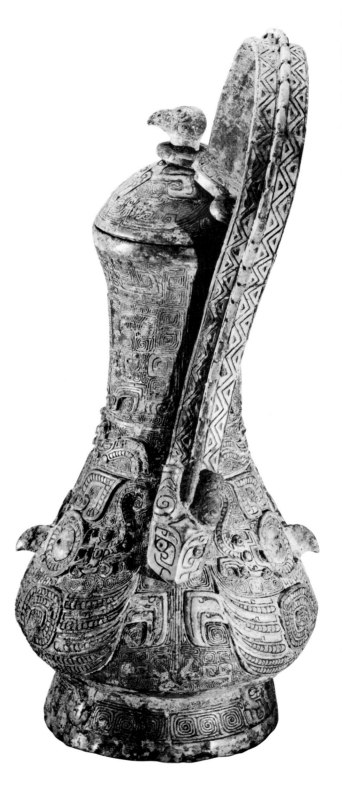

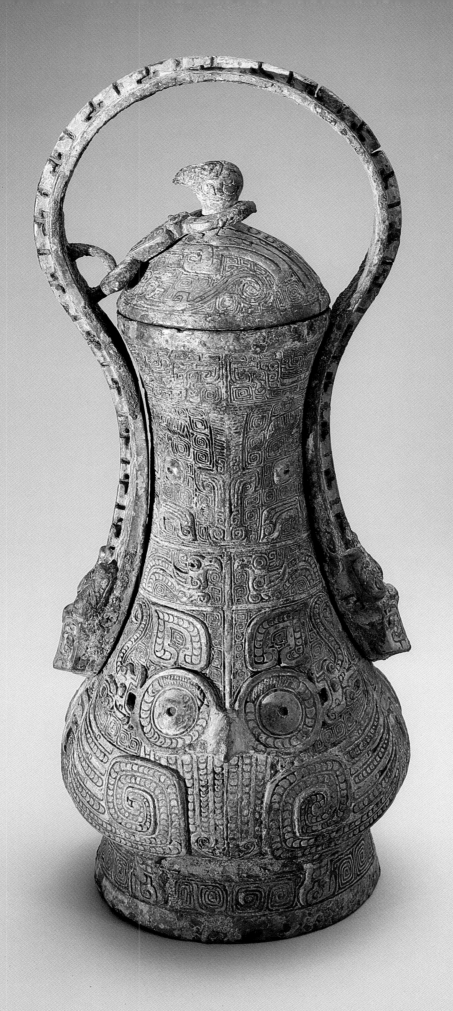

107 *You*

Ritual Wine Container
Shang dynasty, 12th–11th centuries B.C.
height 23.2, width 13.4, depth 11 cm
(9⅛ × 5¼ × 4⁵⁄₁₆ in)
s87.0063a,b

Small in size and jewel-like in detail, this bronze *you* suggests the high degree of technical and aesthetic refinement of late Shang dynasty bronze artisans. The unusually attenuated proportions of the *you* are further emphasized by the succession of narrow, horizontal registers that divide the surface of the vessel. Each of these narrow registers, however, is contained within the tripartite division—vase, body, and neck—that is characteristic of most Shang dynasty bronze ritual vessels.

The foot of the Sackler *you* is raised on a slightly receding vertical base, thereby giving additional prominence to the flaring ledge. Dominating the body, as well as the rest of the vessel, is the wide register decorated with boldly modeled *taotie* masks. These *taotie* masks are executed using sculptural elements, ranging from the protruding oval eyes to the raised edges of the mouth and horns and the flat bands of the stylized tails. The sunken lineament on the individual portions of these *taotie* contrasts with the more densely curled *leiwen* pattern that serves as a ground. A variant form of these *taotie* masks decorates the lid of the vessel.

Augmenting the sculptural character of this *you* are the sturdy vertical flanges that divide the vessel into quadrants. Narrow, plain horizontal bands, like the vigorously defined vertical flanges, identify the divisions of the piece molds used during the casting process. The only interruption in these divisions occurs on the lower, curved section of the neck, where bovine animal masks and two handle loops replace the geometric flanges. The animal masks fitted with bottle horns that project from the ends of the bail handle echo the spiky silhouette of the Sackler *you*.

A *you* in the Nelson Gallery of Art, Kansas City, Missouri, is identical to the Sackler bronze in shape and decoration. The Nelson Gallery *you*, which measures 26 centimeters (10¼ inches) in height, is the larger vessel.

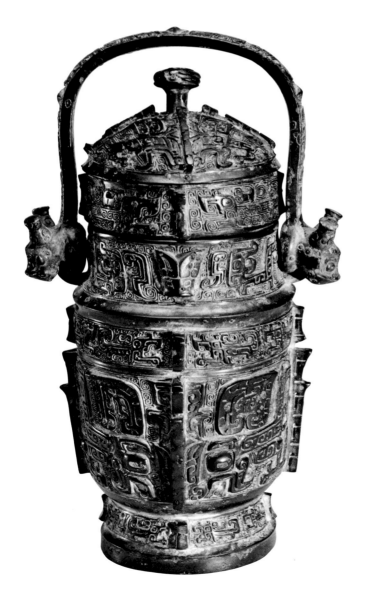

108 *Zun*

Ritual Wine Container
Shang dynasty, 13th century B.C.
height 30.2, diameter 29.1 cm
(11⅞ × 11⁷⁄₁₆ in)
inscription
s87.0045

In its form and proportions this *zun*, or beaker, is a representative example of a fully evolved Shang dynasty bronze vessel from foundries in the Anyang area of Henan Province. These vessels are characterized by clearly defined component parts that join each other at precisely articulated angles. The Sackler *zun*, for example, stands on a high conical foot; the rounded body of the vessel curves upward to join a narrow slanting shoulder that is decorated with three bovine animal heads in high relief. The placement of these animal heads stresses the demarcation between the body and the neck of the *zun*. Dominating the entire vessel is the flaring trumpet-shaped mouth, which rises dramatically from the shoulder. A series of rising blades further emphasizes the form of the flaring mouth, while horizontal bands of intaglio decoration cover the shoulder, body, and foot of the vessel.

A bronze *zun* of virtually the same size, shape, and decoration as the Sackler example was among the rich assemblage of funerary objects in the celebrated Shang dynasty Tomb No. 5, excavated at Anyang. The quality and quantity of objects from that tomb, which escaped detection by grave robbers for more than 3,000 years, testify to the royal status of the occupant. The objects in Tomb No. 5 and, by extension, the Sackler *zun* can be dated ca. 1200 B.C.

Cast inside the Sackler *zun* is a two-character inscription: the character for "mother" and the *yaxing* cruciform (see Glossary).

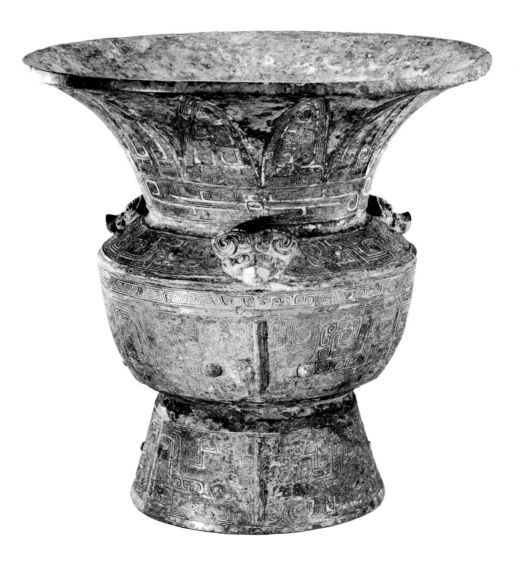

109 *Zun*

Ritual Wine Container
Shang dynasty, 12th century B.C.
height 33.3, diameter 21.4 cm
(13⅛ × 8⁷⁄₁₆ in)
inscription
s87.0052

Imposing in its majestic formality, this *zun* rests on a conical foot that flares strongly at its molded base. The middle section of the vessel is moderately convex, and the upper portion of the *zun* curves outward to provide a dramatic climax in the overall silhouette. Boldly articulated flanges divide the two lower sections of the *zun* into quadrants. Although the flanges do not continue onto the upper portion of the vessel, the four elongated blades that follow the flaring lip are centered above the vertical flanges in the middle register. Inside each of the elongated blades is a stylized, inverted *taotie*. The separation between the two lower sections of the *zun* is clearly established by a wide, recessed band decorated by two bowstrings and pierced on either side by large, cross-shaped apertures located below the bronze membrane that forms the actual bottom of the container. Presumably the *zun* was cast upside down, and pins passing through these cross-shaped openings supported a clay core inside the foot of the vessel. *Taotie* masks, composed of characteristically protruding eyes, gaping mouths, and curling horns, appear on the two lower registers. The casting of all the decorative elements on the *zun* is of exceptionally fine quality.

A pictograph, probably a clan sign, is cast inside the wall of the lower section of the *zun*.

166

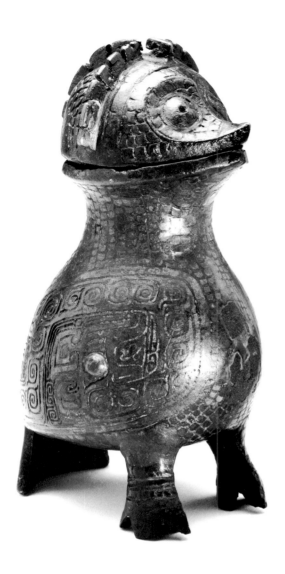

110 *Zun*

Ritual Wine Container
Shang dynasty, 12th–11th centuries B.C.
height 16.3, width 9.3, depth 7.4 cm
(6⅜ × 3¹¹⁄₁₆ × 2¹⁵⁄₁₆ in)
inscription
s87.0001a,b

This appealing bird-shaped ritual wine container was first mentioned in a Chinese text in 1885, when it was in the collection of the distinguished scholar-official Wang Yirong (1845–1900). Judging from the large circular eyes and the crests on either side of the head, the bird is surely an owl. The Shang dynasty artisan who made the *zun* evidently was concerned with suggesting plumage and general stance, while still working with formal elements appropriate to ritual functions. That formality is especially apparent in the stylized dragons that decorate the bird's wings, even though the piece as a whole conveys a sense of humor and whimsy.

Although Shang dynasty bronze ritual vessels are usually characterized by strict formality and abstract decoration, a number of extant pieces were modeled with impressive naturalism. Some Shang artisans created bird and animal forms that can be appreciated purely as sculpture and that reflect an admirable ability to observe nature and to capture the essence of a particular creature.

The two-character inscription found inside the vessel and the lid consists of a *yaxing* cruciform and an animal pictograph that has been identified by some Chinese scholars as a rabbit.

III *Zun*

Ritual Wine Container
Shang dynasty, 12th–11th centuries B.C.
height 18.7, width 21.4, depth 8.1 cm
(7⅜ × 8⁷⁄₁₆ × 3³⁄₁₆ in)
s87.0065a,b

Identification of this vessel as being in the form of an elephant depends upon the details of the massive, albeit fragmentary, head at the front of the lid. Although remnants of the two tusks remain, other characteristically elephantoid features like the large ears and curling trunk have been broken and lost. Nonetheless, the high rounded forehead and the two curling serpents ornamenting it are quite similar to comparable portions of two well-known Shang dynasty bronze elephant-shaped *zun*: one in the Freer Gallery of Art, the other found in Hunan Province in 1975 and residing in the Hunan Provincial Museum. On the Sackler vessel, a serpentine dragon appearing above the elephant head functions as a link between it and the stylized owl head at the opposite end of the lid.

There is little in the proportions of the body of the Sackler *zun* to suggest the massive, wrinkled bulk of an elephant. Rather, the artisan appears to have added the elephant-headed lid to a body that could just as easily have served a ram or water buffalo.

Raised curving planes on the front and rear haunches and the circular eye toward the front of the Sackler *zun* are the only intrusions into the overall, finely textured intaglio decorations. On the body of the *zun* unearthed in Hunan Province, which is embellished with decoration virtually identical to that on the Sackler piece, the significance of the curving planes and circular eye are immediately understandable. The circular eye belongs to a bird whose body is defined by the raised plane on the front haunch. In the same way, the large curving plane on the rear haunch actually represents the tail of a curious-looking horned beast that is stylistically related to, but separate from, the bird at the front of the Sackler *zun*.

Archaeological finds in China are providing information supporting the theory that late Shang and early Zhou dynasty bronze vessels in the form of naturalistically modeled animals should be associated with cultures in southern China. A similar provenance for the Sackler *zun* is also appropriate.

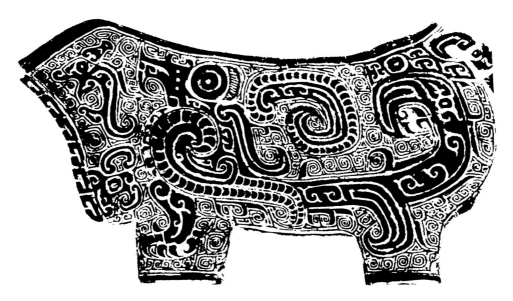

Rubbing of decoration on bronze *zun* unearthed in Hunan Province in 1975. From *Shang Zhou qingtong wenshi*, p. 175.

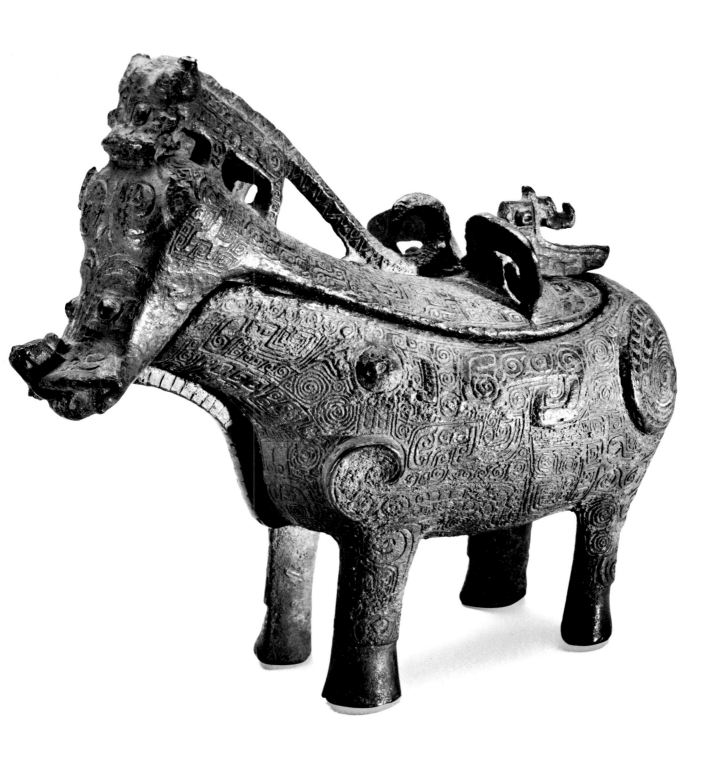

112 *Zun*

Ritual Wine Container
Shang dynasty, 11th century B.C.
height 35.1, width 24.2, depth 24.5
diameter 22.8 cm
(13⁹/₁₆ × 9⁹/₁₆ × 9⁵/₈ × 8¹⁵/₁₆ in)
inscription
s87.0035

Characteristic of one of the fully developed phases of the Anyang tradition is the appearance of motifs in relief, with the motifs rising above the ground spirals. This tall and stately *zun* is an excellent example of a Shang dynasty bronze decorated in that mature Anyang style.

The Sackler *zun* has a splayed conical foot, a clearly articulated middle section, and a flaring, trumpet-shaped mouth. Heavy, densely scored flanges divide the *zun* into quadrants, with the flanges at the top of the vessel becoming slightly wider before they project out beyond the edge of the circular lip. Two cross-shaped perforations in the narrow horizontal band separating the foot from the middle section of the vessel apparently were caused by the way in which the piece molds were assembled when the bronze was cast.

The main decoration on the two lower sections of the *zun* are *taotie* modeled in relief on a *leiwen* ground. The mouth of the vessel is embellished with rising, triangular blades that are centered on the four vertical flanges. The blades are filled with *taotie* masks facing upward. A narrow horizontal band of

squares joined by crescents completes the decorative program.

A single, unidentified pictograph of the type found on many Shang dynasty bronze vessels is cast inside the *zun*.

Note
In his study of Anyang bronzes, Max Loehr assigned vessels of this type to Style V (see Bibliography).

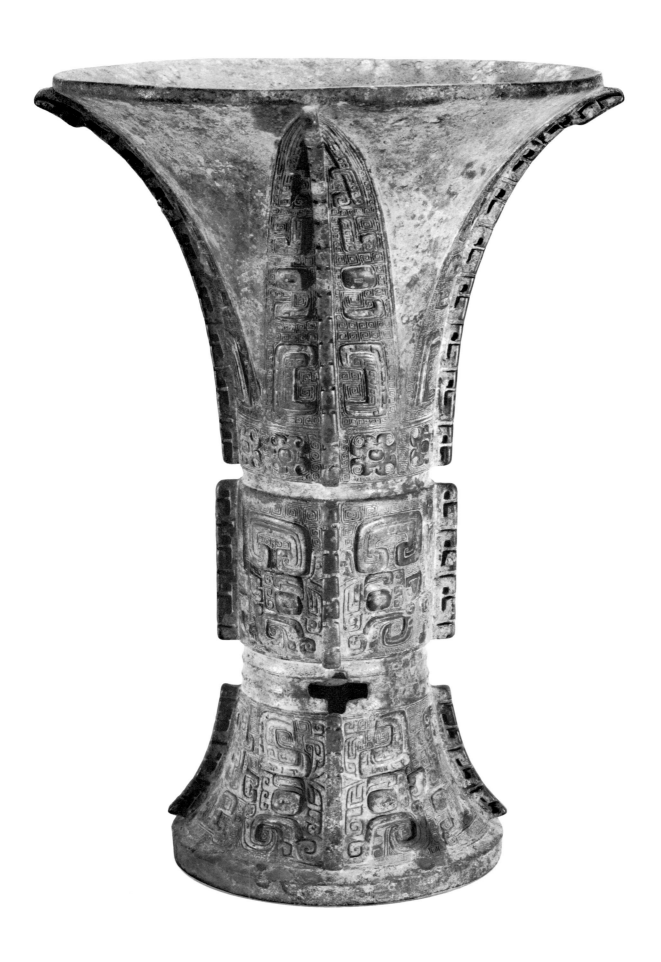

113 *Fuji Zun*

Ritual Wine Container
Shang dynasty, 11th century B.C.
height 30, diameter 20.7 cm
(11¹³/₁₆ × 8³/₁₆ in)
inscription
s87.0066

As is usually the case with Shang dynasty bronze vessels, the body of this *zun* is clearly demarcated into distinct sections. The slightly tapered base is separated from the convex middle portion of the *zun* by a narrow horizontal band embellished by a single bowstring. A similar horizontal band appears between the middle portion of the *zun* and the trumpet-shaped mouth. Sturdy flanges further divide the two lower portions of the Sackler *zun* into vertical quadrants.

The decoration of the base and middle portions of the bronze is remarkable in that the *taotie* masks on each of these sections are so different. The lower masks, with their protruding oval eyes, pointed fangs, and curling ears, are characteristic of a late Shang dynasty-style *taotie* mask. By contrast, the masks on the middle portion of the *zun* are startlingly different. The coherence of the individual parts of the traditional *taotie* has been abandoned, and the ferocious, irregularly shaped mouths are borrowed from an earlier, briefly tried style. That same mouth, again framed by rounded, convex lines, appears at the bottom section of each of the triangular blades that ornament the surface of the flaring lip. This unusual mouth formation appears on a vessel dated earlier than the Sackler piece—a bronze *pou* (ritual wine container) unearthed at Taixicun, Gaocheng Xian, Hubei Province, in 1972.

The pictograph cast inside the *zun* is a clan sign of the type found on many other Shang dynasty vessels. During the nineteenth century this *zun* resided in the collection of the distinguished Chinese connoisseur Pan Zuyin (1830–90).

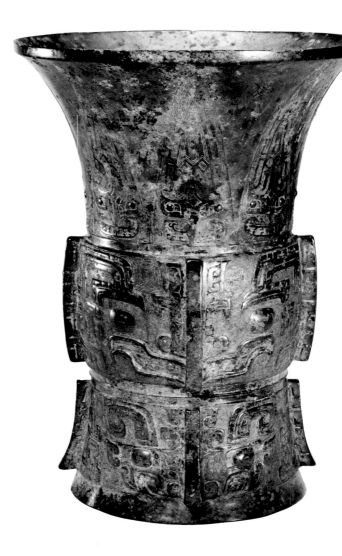

114 *Fuji Zun*

Ritual Wine Container
late Shang–early Western Zhou dynasties,
11th century B.C.
height 26.3, diameter 21.1 cm
(10⅜ × 8⁵⁄₁₆ in)
inscription
S87.0330

Reference to archaic prototypes by artists working at a later date is known as archaism and is a constantly recurring aspect of Chinese art. What is particularly remarkable about archaism in China is that it developed at such an early date and continued to exert a strong influence on Chinese art for more than three millennia.

According to a theory first formulated in 1953 by Max Loehr, the decoration on Shang dynasty bronze vessels developed from simple relief designs into more complex motifs that, by the end of the dynasty, were presented in varying layers of relief against a clearly defined ground.

The *Fuji zun* is an excellent example of a ritual bronze cast during the years spanning the end of Shang and beginning of Zhou, when some bronze artisans were influenced by the decorative traditions of a preceding generation. Those archaistic elements are most clearly apparent in the frieze that encircles the flaring body of the *Fuji zun*. The *taotie* masks, defined by pairs of oval, protruding eyes separated by a vertical ridge, are presented with ears, noses, fangs, and horns that merge imperceptibly with the ground formed by a series of tight curls. The narrow borders of raised circles and pairs of bowstrings also are design elements that can be found on earlier vessels, representative examples of which are in the Sackler Gallery (nos. 93, 97).

The inscription cast inside this *zun* consists of a pictograph, presumably a clan sign, and the two characters, *Fuji* (Father Ji).

Note
Although Max Loehr's stylistic sequence of simple relief designs to more complex motifs has proved to be correct, information from archaeological finds after 1949 has shown that there were many variations within the "five styles" that Loehr identified (see Bibliography).

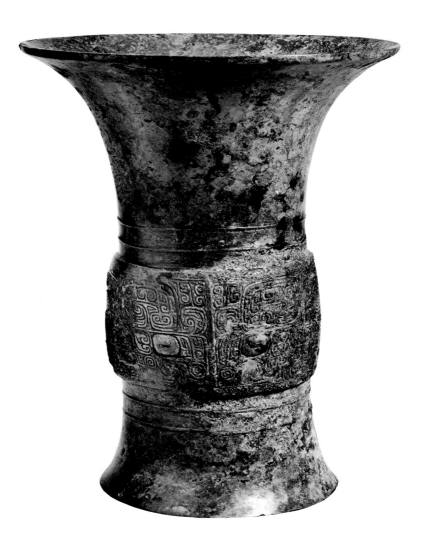

115 *Zhong*

Ritual Bell
Shang dynasty, 12th century B.C.
height 31, width 24.8, depth 15.2 cm
(12³⁄₁₆ × 9¾ × 6 in)
s87.0010

The Sackler *zhong* (bell) is especially important for understanding regional bronze styles in China. Information provided by archaeological finds after 1949 in China has augmented awareness of those different regional styles and made identification of them more certain.

Unfortunately, there is no documentation to suggest a specific provenance for this small bronze bell. When it was first described in 1924, the bell was recognized as representing an "archaic style" and, with considerable precision for that time, was dated to the Xia or Shang dynasties (the Xia period was ca. the nineteenth to the sixteenth century B.C.). In that early publication the vertical flanges on either side of the bell were cited as badly damaged and portions of the curving projections as missing. All of these losses have been restored during the intervening years.

The Sackler bell was likely derived from the much smaller bronze harness bells cast in northern China during the Shang dynasty. The two crested birds that flank the suspension loop of the bell, the outlandish hooked flanges, and the simplified handling of the *taotie* mask are features that suggest the piece may have been cast in Hunan Province. The Sackler bell probably dates from a time contemporary with the late Anyang period, when the Hunan bronze-casting industry began to exhibit a spirit of independent creativity.

Note
See Virginia C. Kane's pioneering article, "The Independent Bronze Industries in the South of China Contemporary with the Shang and Western Chou Dynasties," *Archives of Asian Art*, 28 (1974–75), pp. 77–107.

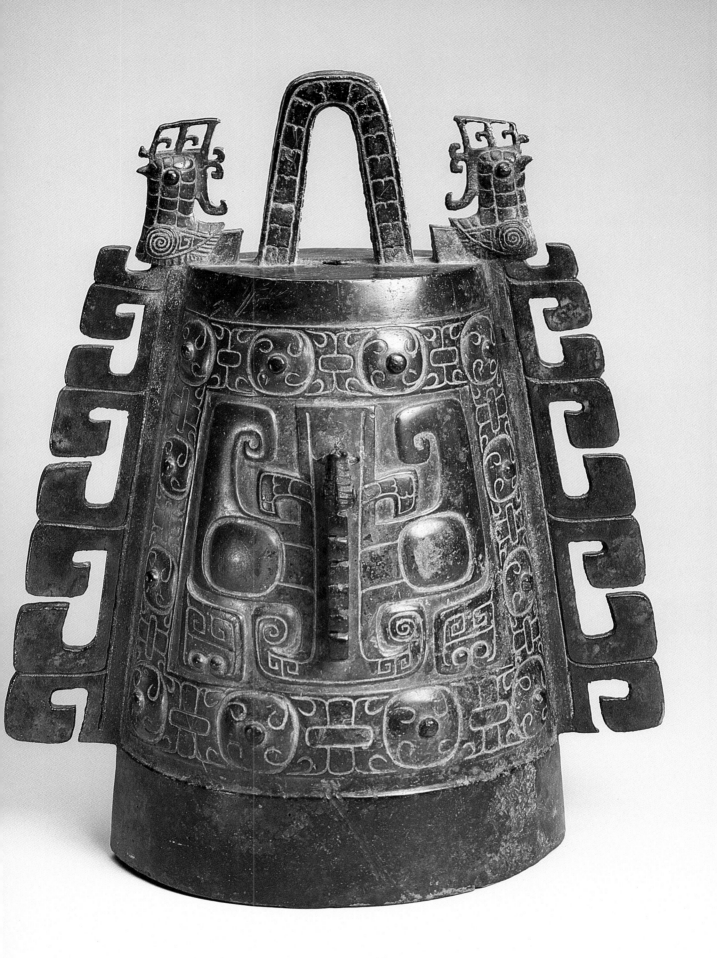

116 *Ding*

Ritual Cooking Vessel
Shang dynasty, 15th–14th centuries B.C.
height 20.8, width 17.4, depth 17.3,
diameter 17 cm
(8 3/16 × 6 13/16 × 6 13/16 × 6 11/16 in)
s87.0050

This *ding*, or tripod, stands on three flat legs, note-worthy for their cusped outer contours and bold intaglio decoration. The bottom tip of each leg has been repaired. The position of each of the legs coincides with a vertical seam, continuing up onto the bowl of the tripod, marking the junction of the piece-mold assembly at the time the vessel was cast. A comparable relationship between the piece molds

and the decoration is evident in the three horizontal *taotie* masks and the rows of small circles that border them; these design elements are neatly contained within the spaces demarcated by the vertical scars left by the joining of the molds. The only prominent elements of these *taotie* masks are the protruding oval eyes. Two small loop handles stand on the everted rim.

All of the features of this tripod are recognized as indicative of the vessel's early date; the position of such bronzes has been verified through archaeological finds, particularly since 1972.

Note
In his study of Anyang bronzes, Max Loehr assigned vessels of this type to Style II (see Bibliography).

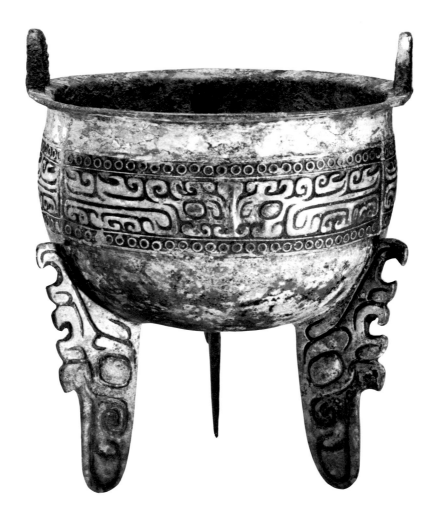

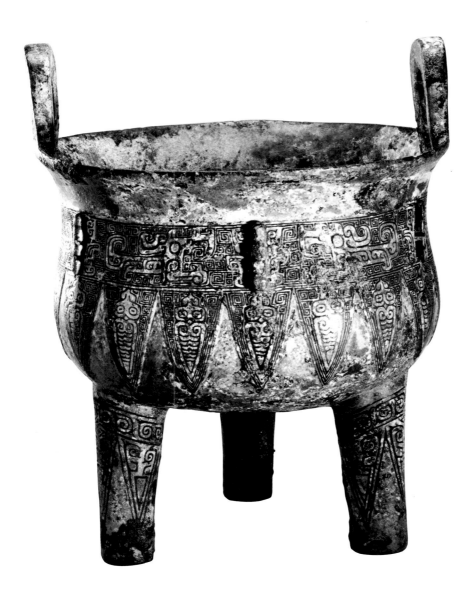

117 *Ding*

Ritual Cooking Vessel
Shang dynasty, 12th century B.C.
height 30.2, width 25.8, depth 25.6 cm
(11⅞ × 10⅛ × 10 1/16 in)
s87.0062

The deep, globular body of this *ding* has a contracted neck and flaring rim. Three sturdy, cylindrical legs are placed in a nearly perpendicular position close to the outer edges of the vessel; two simple curved handles rise from the rim. The outer surface of each of the handles is decorated with a dragon cast in intaglio. A frieze of six dragons on a *leiwen* ground that encircles the Sackler *ding* is interrupted by short vertical flanges. Pendant from the lower border of the frieze are blade-shaped panels, each containing a stylized cicada. Similarly shaped panels, although containing more simply rendered motifs, are arranged around each of the legs. The precision of the individual patterns is made even more visible because black paste fills the intaglio portions of the decoration.

A large bronze *ding* measuring sixty-four centimeters (twenty-five inches) in height and having the same general shape as this one was unearthed from a Shang dynasty sacrificial pit at Anyang, Henan Province, in 1976. The Anyang *ding* is fitted with a simple, flat lid having two notches at the sides to ensure that it rests snugly around the two handles. It is conceivable that this Sackler bronze originally had a similar lid.

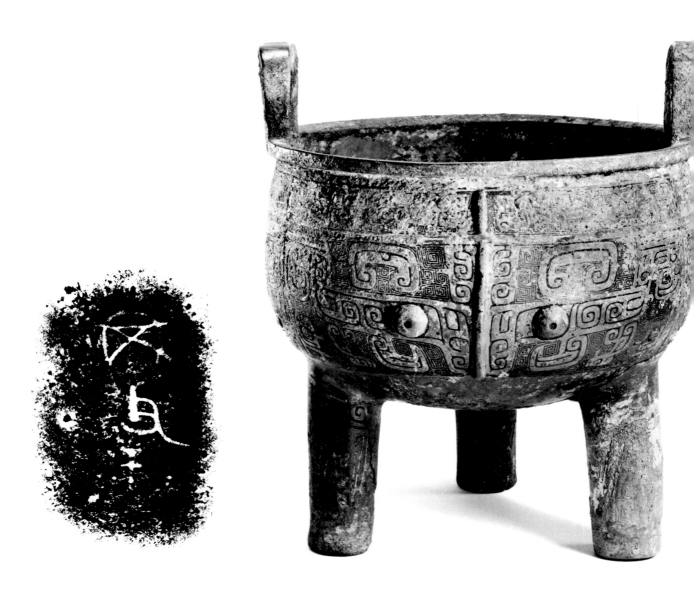

118 *Fuxin Ding*

Ritual Cooking Vessel
Shang dynasty, 12th–11th centuries B.C.
height 23.2, width 18.2, depth 17.6 cm
(9⅛ × 7³⁄₁₆ × 6¹⁵⁄₁₆ in)
inscription
s87.0048

The outspoken vigor of the *Fuxin ding* results from an especially successful combination of shape and decoration. The tautly rounded bowl of the *ding* is supported by sturdy, cylindrical legs that are set at a slight angle. Upright, loop handles rise vertically from the narrow, everted rim. The main horizontal decorative frieze presents *taotie* masks that are unusually large in scale and dominated by large, circular, protruding eyes. The other elements of the *taotie* are rendered in flat relief and silhouetted against a precisely cast *leiwen* ground. A narrower band of decoration beneath the rim of the *Fuxin ding* is filled with crested dragons. Pendant triangles, cast in intaglio, appear on the three legs.

The three-character inscription inside the tripod contains the name Fuxin, "Father Xin," and a pictograph that has traditionally been rendered as *ju* (to raise).

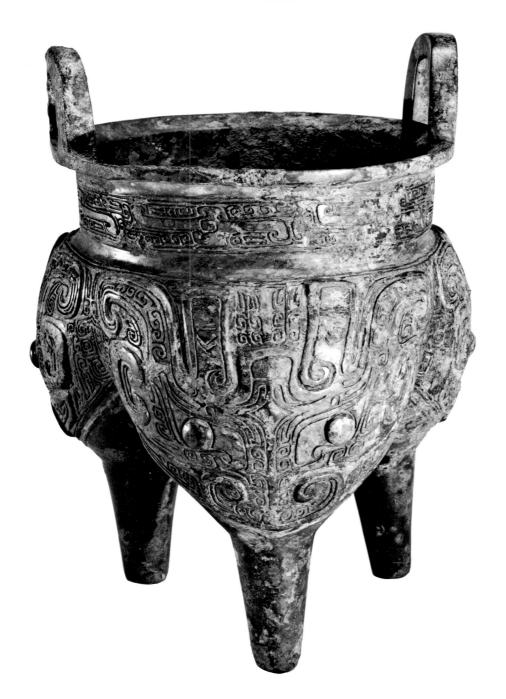

119 *Li*

Ritual Cooking Vessel
Shang dynasty, 13th century B.C.
height 28.9, width 21, depth 20.4 cm
(11⅜ × 8¼ × 8 in)
s87.0064

The bowl of this *li* is formed by a subtle fusion of the swelling, convex lobes above each of the three tapering legs. By constricting the wide, circular neck band, the artisan further emphasized the rounded contours of the lower portion of the *li*. Two plain curving handles project from the narrow everted lip. The *taotie* masks with unusually large, curling horns and snouts, which decorate the three lobes of the vessel, appear more sculptural in form because of the rounded surfaces on which they are cast. Although some elements of the *taotie* are slightly raised above the *leiwen* ground, most of the modeling is restricted to a shallow depth. During later periods, some bronze artisans introduced spectacular, three-dimensional sculptural elements, such as large, curving horns, on the masks that ornament the lobes of *li* tripods. These elements lend a further, unexpected ferocity to the overall appearance of the vessels, which would presumably ward off evil forces.

120 *Yu*

Ritual Food Container
Shang dynasty, 13th century B.C.
height 14.2, diameter 23.3 cm
(5⁹⁄₁₆ × 9³⁄₁₆ in)
inscription
S87.0059

This round *yu* has no handles and rests on a high, flaring footrim. The upper, bowl-shaped portion of the vessel curves inward before meeting the narrow everted lip. Crisply cast intaglio decoration occurs on the footrim and on the bowl. Squared vertical flanges interrupt the bands of rounded, barbed spirals on the footrim. Less precisely articulated, central ridges appear between the pairs of raised circular eyes that define the *taotie* masks on the widest register of the vessel. The other elements of the *taotie*—horns, body, and quills—are presented in flat relief. Immediately above the *taotie* is a narrow band of diagonals and curls. Centered on each of the vertical flanges is a projecting oval eye. By introducing smaller scale *leiwen* designs, also in flat relief, into the widest band of decoration, the artisan clearly established the relationship between figure and ground.

The distinction between *yu* and *gui*, both bronze bowl-shaped food containers, remains problematic. Several vessels are specifically identified in their inscriptions as *yu*. Nonetheless, some bronzes of the same shape as the Sackler example have been designated as *gui*.

Cast inside the center of the Sackler *yu* is a pictograph that can be interpreted as a clan sign.

Note
In his study of Anyang bronzes, Max Loehr assigned vessels decorated in this manner to Style IV (see Bibliography).

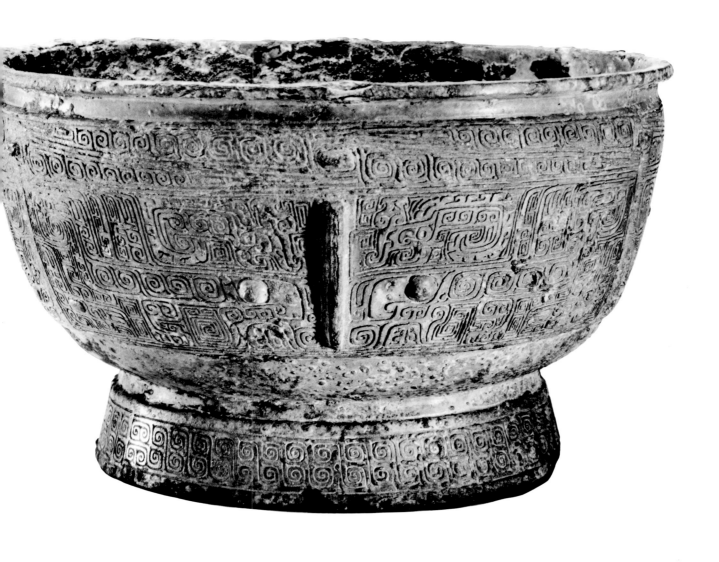

121 *Wuchen Gui*

Ritual Food Container
Shang dynasty, 12th–11th centuries B.C.
height 16.2, width 29.2, depth 21.6 cm
(6⅜ × 11½ × 8½ in)
inscription
S87.0051

The refined shape and restrained decoration of this ritual vessel reflect the highest level of achievement in Shang dynasty bronze casting. Set on a high, slightly flaring footrim, the vessel itself is decorated with a wide band of vertical ribbing that is enclosed by horizontal registers of whorl, star, and dragon motifs in relief. Even the rounded contours of the animal masks and stylized birds that ornament the two handles are characterized by an air of elegant restraint. A glossy black patina of exceptional beauty distinguishes the surface of the *gui*.

In spite of the subtlety that is apparent in every element of the *Wuchen gui*, it is the unusually long inscription cast inside the vessel that has occupied the attention of generations of scholars. As was frequently the case with catalogs of bronzes compiled during the late Qing dynasty, emphasis was placed on assembling rubbings of the inscriptions and on deciphering their content, while the vessels themselves usually were not discussed at all. So it is not surprising that none of the authors of the various Chinese texts in which the *Wuchen gui* is mentioned provides a drawing of the vessel or describes its shape or decoration. Undoubtedly, the thirty-six-character inscription is one of the most important dating from the late Shang period. Its significance derives from the fact that it contains a reference to a sacrifice in honor of a deceased royal consort, designated as "Grandmother Wu," in the twentieth year of a king's reign. It is worthy of note that the inscription in the Sackler bronze provides evidence that the cyclical day, *wuchen*, corresponds to the posthumous name of Grandmother Wu, to whom the sacrifice was addressed. The precise identity of the Shang ruler making the sacrifice remains uncertain, but scholars generally agree that it was one of the last two rulers of the dynasty.

Inlaid on the bottom of the base of the *Wuchen gui* is the four-character seal of the late-Qing dynasty official Jin Futing, one of the former owners of the vessel.

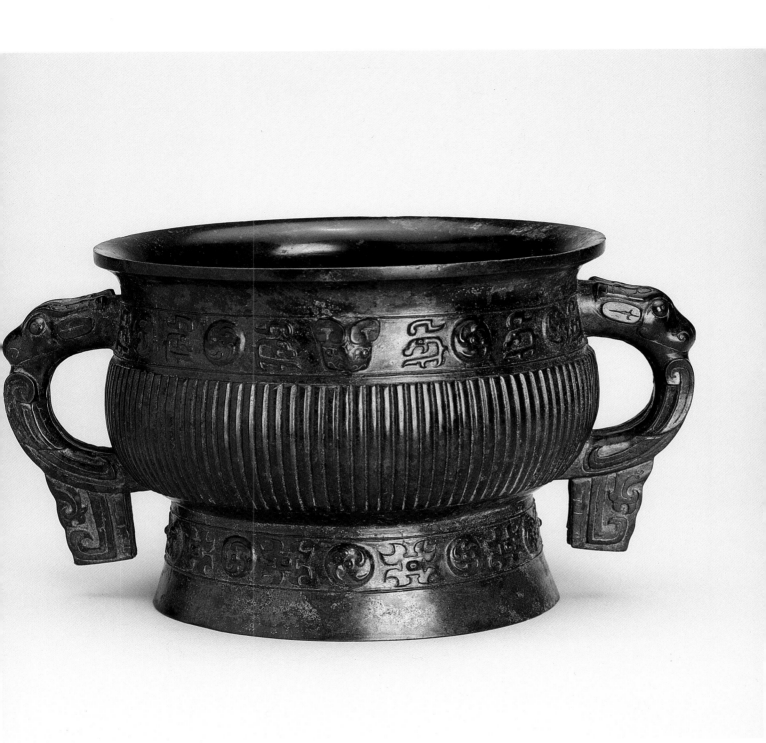

122 *Ding*

Ritual Cooking Vessel
Western Zhou dynasty, 11th century B.C.
height 22.9, width 20, depth 20.8 cm
(9 × 7⅞ × 8³⁄₁₆ in)
S87.0037

The subtle curves of the body and legs of this *ding* are virtually obscured by the projecting handles and flanges. Yet even those bold architectonic elements have been added to the basic form with careful regard to the underlying structure. The gentle inward cant of the two handles and the relationship between the horizontal ornamental bands and the hooks on the vertical flanges reflect an aesthetic quite unlike that seen on Chinese bronze ritual vessels made at Anyang during the preceding Shang dynasty. Even decorative motifs like the elongated dragons, vertical ribbing, pendant triangular design, and *taotie* masks that appear on the body and legs of the Sackler *ding* result in a totally different ap-

pearance for this most traditional of bronze ritual vessels. All these features should be understood as regional variations introduced by bronze artisans working in northwestern China during the early years of the Western Zhou period. Stylistically related bronze vessels can be associated with archaeologically attested sites in present-day Shaanxi Province, the seat of Zhou power both before and after the Zhou conquest of Shang ca. 1050 B.C.

Note
Further support of a Shaanxi provenance for the Sackler bronze is provided by Chen Mengjia in his discussion of a large *ding* in the Brundage collection in San Francisco, *In Shu seidoki bunrui zuroku* (A Corpus of Chinese Bronzes in American Collections), Tokyo, 1977. According to Chen Mengjia, the Brundage vessel was one of four *ding*, related in decor but differing in size, that were found near Baoji, Shaanxi Province, in 1929. Both the Sackler *ding* and a very similar *ding* in the Palace Museum, Beijing, can be assigned tentatively to the group of bronzes described by Chen Mengjia.

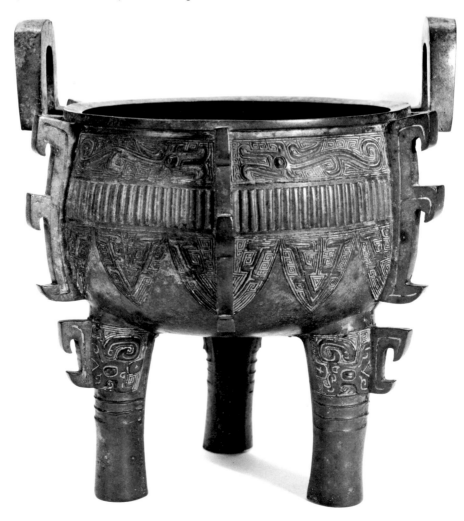

123 *Fugeng Li Ding*

Ritual Cooking Vessel
Western Zhou dynasty, 11th century B.C.
height 21.3, width 16.9, depth 16.9 cm
(8⅜ × 6¹¹⁄₁₆ × 6¹¹⁄₁₆ in)
inscription
s87.0303

This *li ding* has the distinction of having been part of the Qing dynasty imperial collection. A woodblock illustration and a discussion of the Sackler bronze appear in *Xiqing gujian*, the first catalog of ancient Chinese bronze vessels commissioned by the Qianlong emperor (reigned 1736–95) in 1749. Wu Dacheng (1835–1902) included a rubbing of the inscription taken directly from the bronze in his catalog published in 1896, indicating that in all probability this *li ding* was among the objects that left the imperial collection in Beijing in 1860, during the looting of the Yuanmingyuan, the "Old Summer Palace," by French and British troops.

The *li ding* has three comparatively long, cylindrical legs that taper slightly toward the bottom. The bowl, which is slightly convex and has three distinct lobes, is topped by an everted rim from which two loop handles rise. A *taotie* mask decorates each of the three lobes. The modeling of those masks, together with refinements in the proportions of the various parts of the vessel, are indicative of Western Zhou aesthetic preferences. Particularly noteworthy is the lustrous black patina that covers the vessel.

Cast inside the *li ding* is a three-character inscription that includes the pictograph *yang* (sheep) and reference to "Father Keng," the particular deceased ancestor for whom the vessel was made. In posthumous designations of this type, the character *keng* apparently refers to the day in the Shang ten-day week on which the spirit of Father Keng could expect to receive offerings of food and wine.

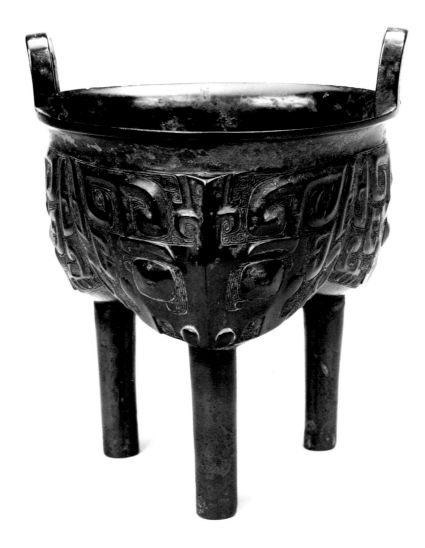

124 *Gui*

Ritual Food Container
Western Zhou dynasty, 11th century B.C.
height 34.6, width 29.7, depth 21.5 cm
(13⅝ × 11¹¹⁄₁₆ × 8½ in)
s87.0003a,b

Ever since it appeared on the antique market in
northern China in the early twentieth century, this
gui has intrigued scholars. The *gui* is fitted with a
domed lid and has a square base that was cast as an
integral part of the vessel. There are two curved
handles, ornamented with bovine masks modeled in
high relief and further embellished with vertical rec-
tangular pendants. The shape of the Sackler *gui* is
not unusual for an early Western Zhou vessel, but
the decoration, consisting of birds, is noteworthy
for its flamboyance and originality.

The birds are cast in low relief on the surface of
the vessel, as well as on the lid and the base. There
are two distinctly different kinds of birds. The
smaller variety on the foot and neck of the *gui* is
presented in unadulterated Shang dynasty style,
with short crests and full-size wings. By contrast,
the large, dominant, spiky birds are more striking.
These birds consist of a head, crest, and tail only;
their wings have been reduced to a few concentric
curves below the head. Moreover, their crests and
tails are so assimilated that they appear to be parts
of a pattern rather than an integral part of the bird
itself. There are no parallels for this type of bird
decoration on Chinese bronzes known to have been
made at Anyang, Henan Province. This spiky bird
motif on the Sackler *gui* is rare; fewer than six
bronze vessels presently known are like it.

The Sackler *gui* is traditionally said to have been
found together with a group of unusual bronzes on
the basis of a photograph purportedly taken in the
first decade of the twentieth century when the set of
vessels was unearthed at Baoji, Shaanxi Province.
On the basis of what is known about bronze vessels
cast in that region prior to and just following the
Zhou rulers' conquest of the Shang, it is almost cer-
tain that the bird decoration on the Sackler *gui* rep-
resents a regional bronze style and that the *gui* itself
was cast in a foundry in the area of Baoji during the
eleventh century B.C.

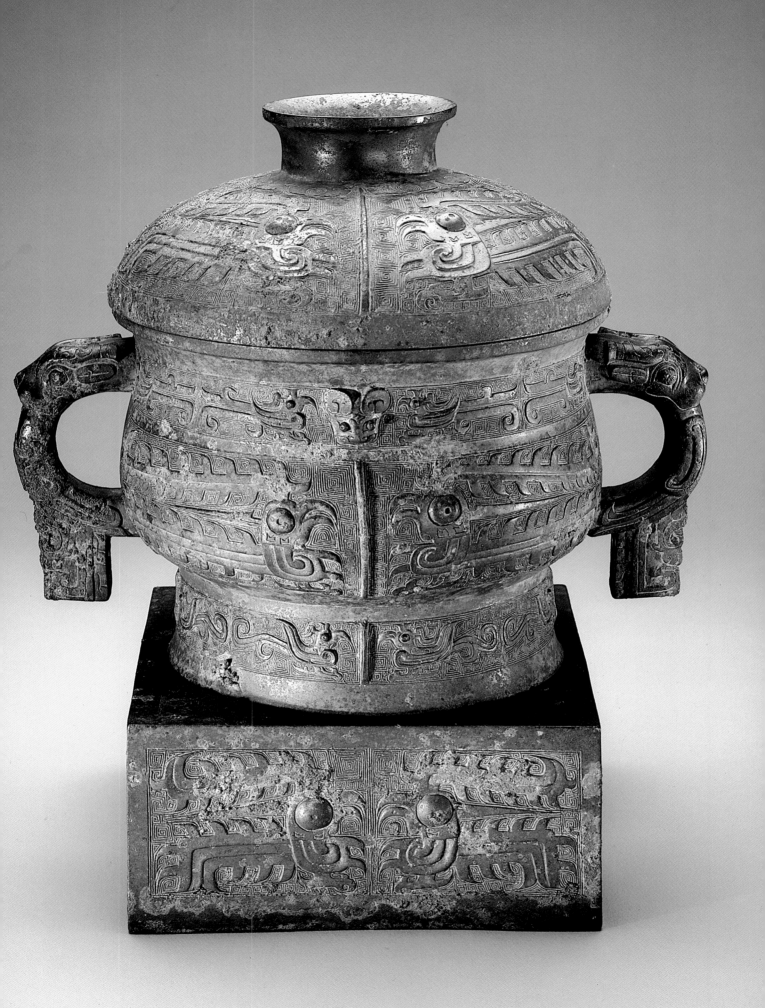

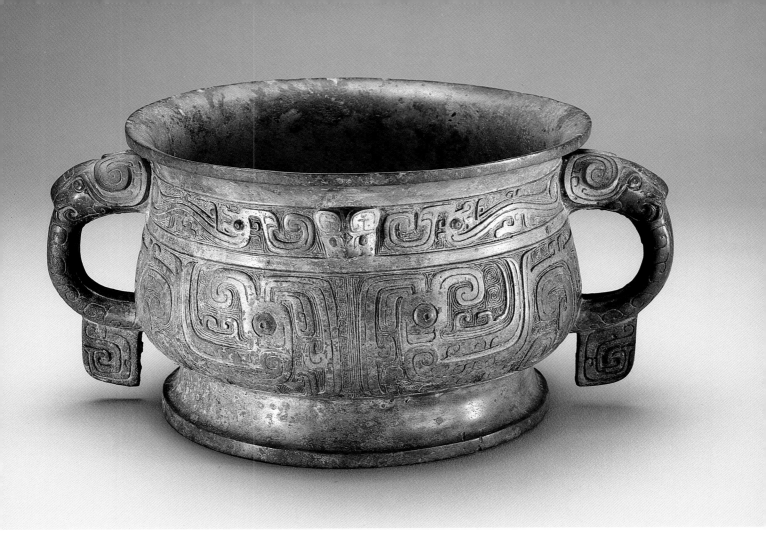

125 *Jing Gui*

Ritual Food Container
Western Zhou dynasty, 10th century B.C.
height 15.5, width 32.1, depth 23.5 cm
(6⅛ × 12⅝ × 9¼ in)
inscription
s87.0329

During the eighteenth century the *Jing gui* was in
the Qing imperial collection and, together with
more than 1,300 other bronze vessels, was included
in *Xiqing gujian*, the first of the bronze catalogs
commissioned by the Qianlong emperor (reigned
1736–95). By the end of the nineteenth century, pri-
vate Chinese collectors possessed the *Jing gui*, sup-
porting the theory that the bronze was among impe-
rial treasures taken when French and British troops
sacked the Yuanmingyuan, the "Old Summer Pal-
ace," in 1860.

The *Jing gui* stands on a conical footrim. The
body of the vessel has curved sides and a flaring
mouth. Both handles, which are rounded in section
and covered with intaglio spirals, are surmounted
with bovine heads modeled in high relief. There are
two bands of decoration on the *gui* itself, contrast-
ing with the plain foot. The main horizontal zone
encircles the lower section of the body and depicts
two pairs of addorsed birds with their heads turned.
The bodies of the birds and their beaks, crests, and
tails appear as a series of broad curving bands. The
large, circular, protruding eyes serve as a focus for
each of the birds. A narrower horizontal frieze, just
beneath the lip of the *gui*, presents elongated drag-
ons arranged on either side of a sculpted animal
head.

Generations of scholars have studied the ninety-
character inscription cast inside the *Jing gui*. Ac-
cording to that inscription, a person named Jing was
rewarded by the Zhou king for his skill as an archer.
To record that royal gift, Jing had the *gui* cast with
a dedication to his mother and an expression of the
hope that his descendants would continue to use it
for 10,000 years. Several other contemporary
bronze vessels carry inscriptions that mention Jing.
In each case Jing's exceptional abilities as an archer
are recorded, together with the royal gifts presented
in recognition of his accomplishments.

126 *Ding*

Ritual Cooking Vessel
Western Zhou dynasty, 11th century B.C.
height 28.5, width 23.1, depth 23.4 cm
(11³⁄₁₆ × 9¹⁄₁₆ × 9³⁄₁₆ in)
inscription
s87.0328

Sturdily proportioned, with three plain legs joining
the outer edges of the rounded body, the Sackler
ding is fitted with a pair of curved handles. A nar-
row, horizontal band of decoration below the
everted lip is the only embellishment on the vessel.
That band is further divided into three contiguous
registers, with pairs of oval eyes and pointed canthi
symmetrically arranged on either side of a vertical
separation that establishes a terse *taotie* mask.

Of particular importance is the three-character in-
scription cast just below the rim on the interior wall
of the vessel. The three characters—*ba*, *wu*, and
yi—are those for the numerals eight, five, and one.
Research in China has established the significance of
these numbers in bronze inscriptions and their rela-
tionship to similar characters found on Chinese
oracle bones and pottery. According to these theo-
ries, numbers of the type found on the Sackler *ding*
are based on the trigrams (see Glossary) in the *Yi-
jing* (Book of Changes). Proponents of these theories
believe the trigrams were related to divination prac-
ticed before a city was founded in ancient China.
Possibly the name of the city was related to the divi-
nation, and that same name may also have been
used as a clan sign or insignia by the clan associated
with the city.

The three numbers found on the Sackler *ding* can
be equated with *dui*, the fifty-eighth trigram from
the *Yijing*. The numbers on that trigram—eight,
five, and one—also appear on a bronze ritual *gui*; in
that case the numbers occur at the end of the in-
scription. In both of these instances, the numbers
can be understood as clan signs or insignia of the
people who commissioned the bronze vessels.

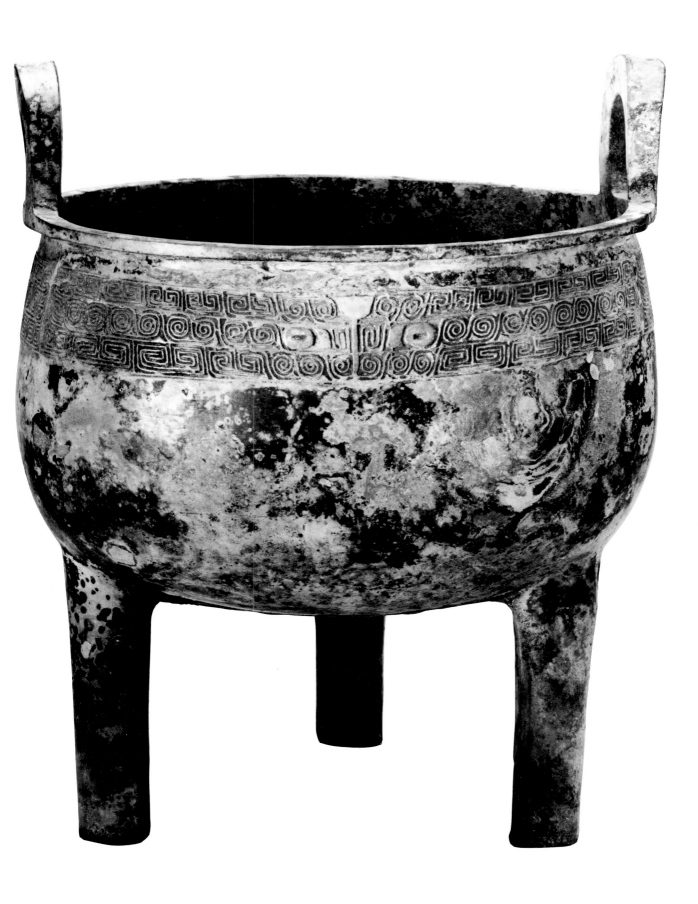

127 *Gui*

Ritual Food Container
Western Zhou dynasty, 10th century B.C.
height 15.5, width 30.8, depth 21 cm
(6⅛ × 12⅛ × 8¼ in)
inscription
s87.0055

In contrast to the ferocious *taotie* masks and serpentine dragons that dominate the surfaces of Shang dynasty bronze ritual vessels, the decoration on Western Zhou bronzes yields to elegant, highly stylized, peacock-like birds. The earliest representations of Western Zhou birds established a basic silhouette, with the heads turned backward and accented by protruding circular eyes. It is the bold, concentrically curving bands derived from the elongated plumes, tails, and wings of these birds that became increasingly important during the early decades of Western Zhou. These curving bands gradually became more abstract and standardized in width, until only a large protruding eye and two concentrically curving bands remained of the richly detailed flamboyant birds that marked the beginning of the tradition (no. 125).

The birds on the Sackler *gui* already reflect some standardization of the component elements. The enlarged, circular eyes obscure all other facial details, and the curvilinear bands indicating the various parts of the body are of approximately the same width. A comparable degree of stylization can be seen in the birds assembled in the two horizontal bands on the foot and beneath the neck of the *gui*. The birds that form the two handles on either side of the vessel still retain some of the original complexity. An imbricated feather pattern, supported by a series of curvilinear bands and a curling crest lend these birds a freshness derived from the unexpected juxtaposition of such disparate motifs.

Cast inside the *gui* is a four-character inscription that can be translated "made this precious sacral vessel."

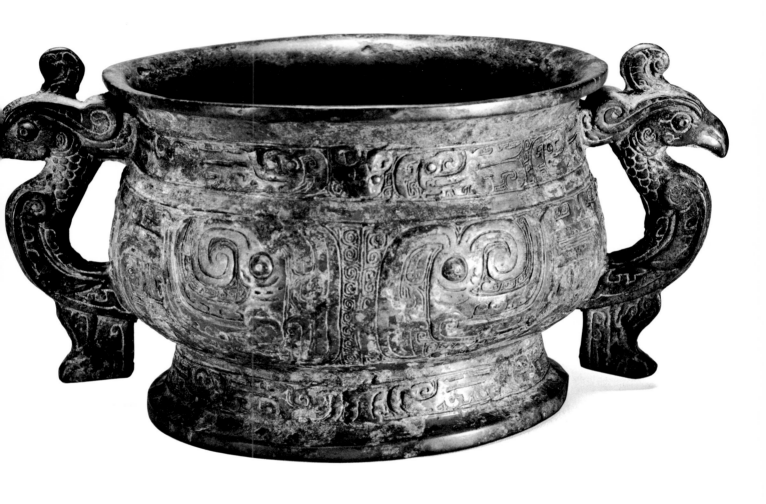

128 *Zun*

Ritual Wine Container
Western Zhou dynasty, 10th century B.C.
height 30.4, width 47, depth 18.4 cm
(12 × 18½ × 7¼ in)
S87.0044

Bronze vessels made during the Shang and Zhou dynasties usually are formal in shape and decorated with elaborately stylized motifs that were regarded as essential to the efficacy of those ritual activities that dominated the lives of the rulers and their immediate family members. In contrast to those symmetrical, architectonic bronze vessels are those few pieces, like the Sackler *zun*, in which the artist depicts an animal with obvious appreciation of the creature's most characteristic features.

The Sackler *zun* is almost certainly a rhinoceros, and the artisan exploits the massive bulk of that animal by contrasting the boldly modeled portions of the body with the four delicate legs. The rhinoceros' head, like the body, is presented with major emphasis on a profile view. Nonetheless, the thin ears, heavy jowls, round eyes, and long snout are characterized by the direct candor of the artist's articulation of form. By omitting those decorative motifs usually cast into the surfaces of Zhou dynasty bronze vessels, the artisan further heightens the sense of naturalism. The lid that originally covered the oval aperture on the rhinoceros' back is lost. The open snout indicates that the vessel originally was used to contain and pour wine.

A bronze animal *zun* unearthed in 1975 from Tomb No. 2 at Rujiazhuang, near Baoji, Shaanxi Province, is similar in style and size to the Sackler example. The Sackler *zun* may also have been cast in what is now Shaanxi Province.

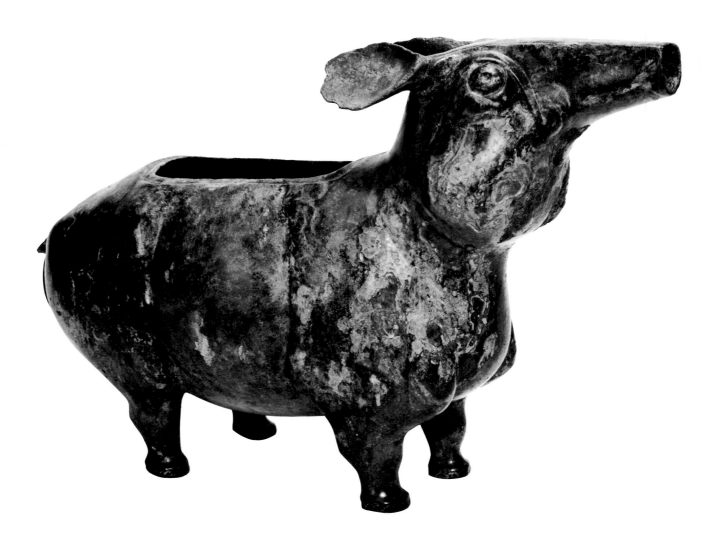

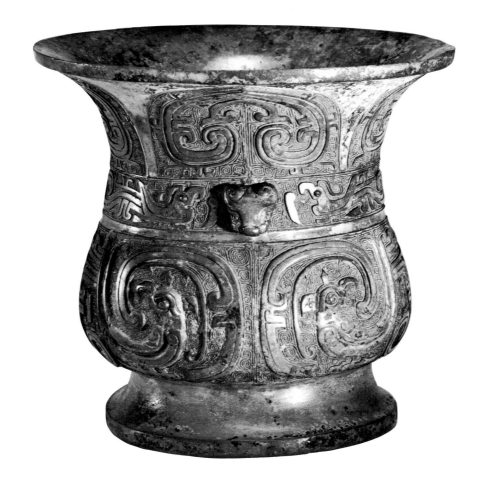

129 *Zun*

Ritual Wine Container
Western Zhou dynasty, 10th century B.C.
height 16.7, diameter 17 cm
(6⅝ × 6¹¹⁄₁₆ in)
inscription
s87.0058

The Sackler *zun* rises from a gently splayed foot; the curving silhouette of the body ends in a widely flaring mouth. Ornamentation on the surface of the vessel is arranged in three clearly demarcated registers. Dominating the vessel are the two pairs of addorsed birds with their heads turned. Curvilinear bands of contrasting width emerge from the wings and tails to enclose each of the birds in a series of vigorously defined circular contours. The relationship between the figure and ground is defined by the meticulously cast intaglio *leiwen* motif. Above this register is a narrow band of long-tailed birds. Broad ogival leaves, separated by smooth gussets, appear on the

flaring upper surface of the *zun*. Each of the ogives is embellished with broad, grooved bands that echo the outer contours. Although it is difficult to identify the ultimate source of these motifs, their general shape suggests that they might have been based on birds of the type depicted in the lowest register of the *zun*. A small animal head modeled in high relief appears in the center of the narrow register, immediately above the pair of confronting birds.

The long-tailed birds in the narrow register of the Sackler *zun* are reminiscent of the birds on Shang dynasty vessels; at the same time the swirling bands that encircle the larger birds on the bronze reflect a new development in the decoration of Western Zhou vessels. The birds became increasingly abstract until, by the end of the Western Zhou period, all that remained of these dynamic images were small, completely abstract curving bands centered on a raised eye.

Cast inside the Sackler *zun* is a four-character inscription that can be rendered "made this precious sacral vessel."

130 *Bohuan You*

Ritual Wine Container
Western Zhou dynasty,
11th–10th centuries B.C.
height 38.1, width 30.1, depth 23 cm
(15 × 11¹³/₁₆ × 9¹/₁₆ in)
inscription
s87.0333a,b

The silhouette of the *Bohuan you* is dominated by spiky hooked flanges that divide the oval container into quadrants. Standing on a high, raised foot, the *you* curves outward and then narrows at the neck to join the domed lid. *Taotie* masks and dragons depicted in rounded relief against a plain ground contribute still further to the stark boldness of the vessel. The bail handle, which swings over the short axis, is attached to projecting rings and embellished with ram heads modeled in high relief. All of these features suggest that the *Bohuan you* was the product of a foundry in present-day Shaanxi Province.

The inscription cast inside the vessel and lid of this *you* states that Bohuan made the precious sacral vessel on behalf of his house. At the end of the inscription, inside the vessel itself, there is an additional pictograph, probably a clan sign. The Sackler *Bohuan you* is one of a pair. The second *you*, formerly in the collection of Edward T. Chow, is smaller, and the arrangements of the inscriptions that appear in these two *Bohuan you* differ. The columns of characters in the Sackler bronze should be read from left to right, while those in the other *you* should be read from right to left. In addition, in the Sackler bronze the character *zuo* (to make) is written upside down. During the nineteenth century the Sackler vessel was owned by such famous Chinese connoisseurs as Chen Jieqi and Liu Tizhi.

Note
Chen Mengjia discusses the two *Bohuan you* in *In Shu seidoki bunrui zuroku* (A Corpus of Chinese Bronzes in American Collections), Tokyo, 1977.

lid

vessel

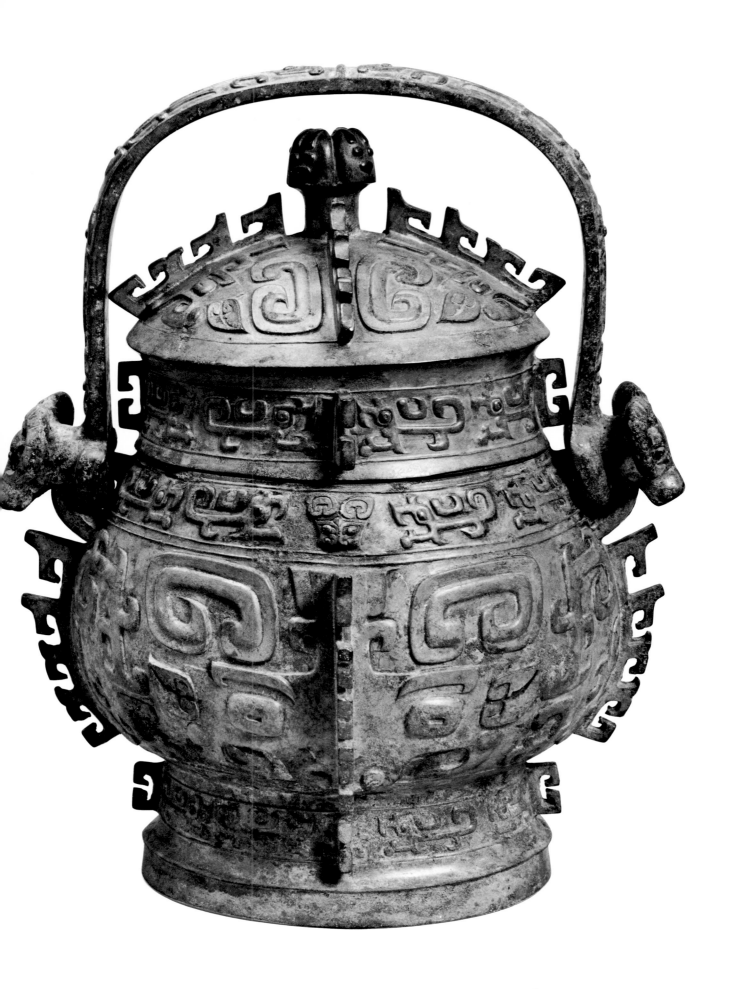

131 *Fuding You*

Ritual Wine Container
Western Zhou dynasty, 10th century B.C.
height 28, width 22.9, depth 17.2 cm
(11 × 9 × 6¾ in)
inscription
s87.0047a,b

During the early years of the Western Zhou period, bronze casters frequently decorated vessels with motifs based on earlier Shang traditions but transformed them in ways that reveal a completely new point of view. In the case of the *Fuding you,* the shape of the vessel and the embellishment of many of the decorative motifs are characteristic of that transitional period in the history of Chinese bronze production.

The container, which is ovoid in cross section, has a high, domed lid and a silhouette punctuated by spurred flanges. Standing on a flaring base, the body of the *you* swells outward and then curves inward to meet the collar of the lid. A sharply demarcated ridge separates the collar from the domed lid, which is surmounted with a conical knob. Projecting from both sides of the *you* are plain rings to which are attached the ends of the curved bail handle, which in turn are decorated with animal masks in high relief. The spurred vertical flanges divide the vessel and lid into quadrants. Dominating the main decorative frieze on the *Fuding you* are flamboyant *taotie* masks, which display undulating horns ornamented with elaborately curved hooks and prongs that have no counterpart on Shang dynasty ritual bronzes.

During the nineteenth century, the *Fuding you* was owned by the Chinese connoisseur Cao Zaikui (1782–1852), who included it in his catalog published in 1840.

A four-character inscription is cast inside the lid and vessel. The same inscription appears inside a *you* in the Nelson Gallery of Art, Kansas City, Missouri. It is noteworthy that the Nelson Gallery bronze is decorated in a much more austere style than the Sackler piece, illustrating the variation to be found in ritual vessels cast during the early years of the Western Zhou period.

lid

vessel

198

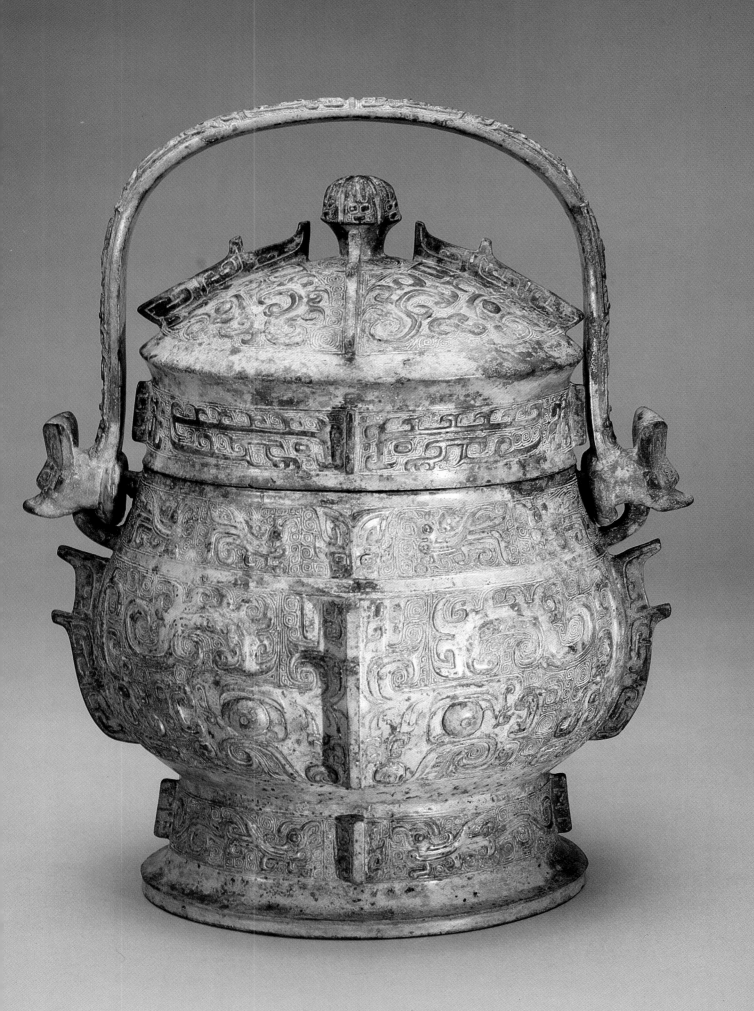

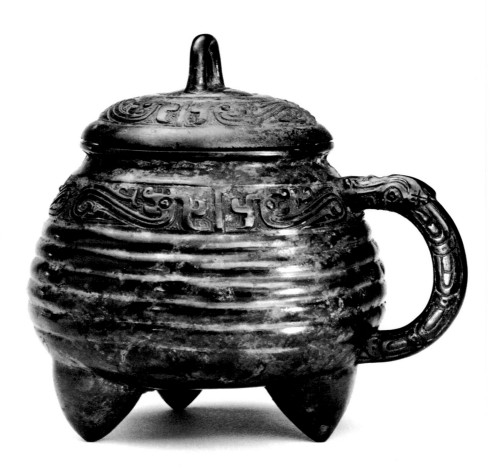

132 *Ying*

Ritual Water Container
Western Zhou dynasty, 10th century B.C.
height 14.3, width 12.2, depth 15.1 cm
(5⅝ × 4¹³/₁₆ × 5¹⁵/₁₆ in)
s87.0334a,b

As archaeological excavations in China continue to yield impressively large numbers of bronze ritual vessels, specialists are modifying some earlier concepts. For instance, it is evident that throughout the Shang and Zhou dynasties, artisans were making bronze vessels in a wider variety of shapes and experimenting with a more diverse range of decorative motifs than had been assumed. This small ritual water container is an example of how Chinese artisans combined different elements to arrive at an unusual and unexpected solution.

The round bronze jar with its circular, domed lid is supported by three pointed, bulbous legs. The shape of the legs obviously is indebted to pottery traditions. A horizontal frieze of decoration presenting a series of reclining dragons encircles the vessel.

Identical dragons appear on the lid, surrounding the plain loop handle. The placement and proportions of the curved handle at the side of the vessel, decorated with an animal head and intaglio scale patterns, is yet another instance of the artisan's refinement of each element, regardless of how minor, to achieve a totally harmonious form.

Particularly noteworthy are the five rounded, horizontal bands that enrich the lower portion of the vessel. These bands prefigure the concave fluting, or *wawen* (tile pattern), that was to be a persistent decorative element in the later Western Zhou period. The rounded horizontal bands seen on the Sackler vessel also continued to be employed during the Western Zhou period. Several *gui* from the hoard of late Western Zhou bronze vessels found at Qijiacun, Fufeng Xian, in 1960 are decorated with this same unusual pattern. Another *gui*, formerly owned by the Manchu official-connoisseur Duanfang (1861–1911), is in the collection of the Nelson Gallery of Art, Kansas City, Missouri. The handles of the Nelson Gallery *gui* are decorated with the same intaglio scale motif seen on the Sackler bronze.

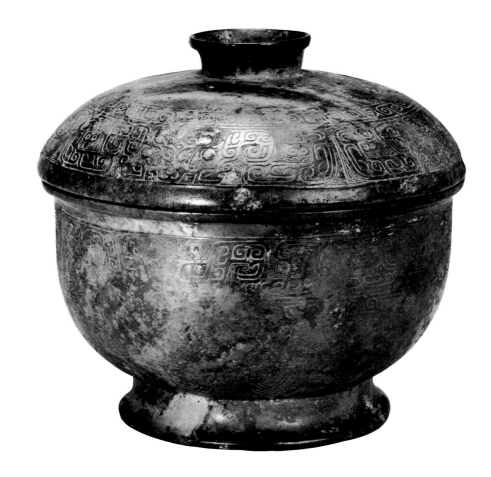

133 *Yu*

Ritual Food Container
Western Zhou dynasty,
11th–10th centuries B.C.
height 18.6, diameter 19.3 cm
(7⁵⁄₁₆ × 7⁵⁄₈ in)
inscription
s87.0361a,b

The unassuming size and simple shape of this *yu* take on greater importance in light of archaeological information concerning regional bronze styles in China. Two bands of intaglio decoration embellishing the lid and the vessel present a series of *taotie* masks, the ubiquitous motif on bronze vessels during the preceding Shang dynasty. But the representation of the *taotie* masks on the Sackler *yu,* and the juxtaposition of these masks with serpents, is extremely unusual.

An explanation for the rare aspects of this bronze *yu* can be found in the five-character inscription cast inside the vessel and its lid. According to the inscription, the bronze was made by a marquis of Yan, the ruler of a fief that, during the Western Zhou period, encompassed the area of northern China around modern Beijing. Archaeological excavations have shown that close political and cultural relationships were maintained between the State of Yan and portions of modern Liaoning Province. A number of bronze ritual vessels associated with the State of Yan, some of them with inscriptions specifically mentioning a marquis of Yan, have been unearthed in these regions. In their shapes and in their decoration, the bronzes associated with the State of Yan reflect an aesthetic quite different from that seen in other parts of northern China. Especially interesting is the fact that many of the bronzes associated with the State of Yan are decorated with strikingly different designs, supporting the concept that a single patron or a single clan could and would commission bronze vessels decorated with a wide variety of styles.

There is an identical bronze *yu,* bearing the same five-character inscription, in the Metropolitan Museum of Art, New York.

134 *Xian*

Ritual Cooking Vessel
Western Zhou dynasty,
11th–10th centuries B.C.
height 43.6, width 27.9, depth 27.9 cm
(17³⁄₁₆ × 11 × 11 in)
inscription
s87.0352a,b

The essentially functional aspects of archaic Chinese bronze vessels are clearly apparent in the *xian*, which served as a kind of steamer. A thin, perforated bronze disk placed inside the *xian* at the point where the waist is most constricted permitted steam to rise from the lower, tripod portion and heat the contents in the upper section of the vessel. The smooth surface of that trilobed bottom reservoir, which is formed by the joining of the three sturdy legs, is decorated with three bovine masks, all presented with bold simplicity. In sharp contrast to the sleek, polished forms dominating the lower portion of the *xian* are the densely rendered, detailed intaglio motifs on the basin at the top of the vessel. A narrow horizontal frieze just beneath the everted lip presents *taotie* masks dominated by round, projecting eyes. Borders filled with raised circles enclose the *taotie* frieze, and triangular forms arranged beneath are centered on the vertical flanges that accent the *taotie* masks. The triangular pendants, in turn, enclose V-shaped bands that provide a repetition of their outer conformations, silhouetted against a finely cast *leiwen* ground. Squared loop handles in a twisted rope motif rise from the lip of the *xian*.

The difference between the decoration on the upper and lower portions of the *xian* reflects the aesthetic innovations of the early Western Zhou period. The *taotie* and triangular pendants on the upper section of the vessel are reminiscent of Shang traditions, while the rounded, bold, bovine heads are harbingers of the direction taken during the first decades of the Zhou dynasty.

A two-character inscription is cast inside the *xian* just below the rim.

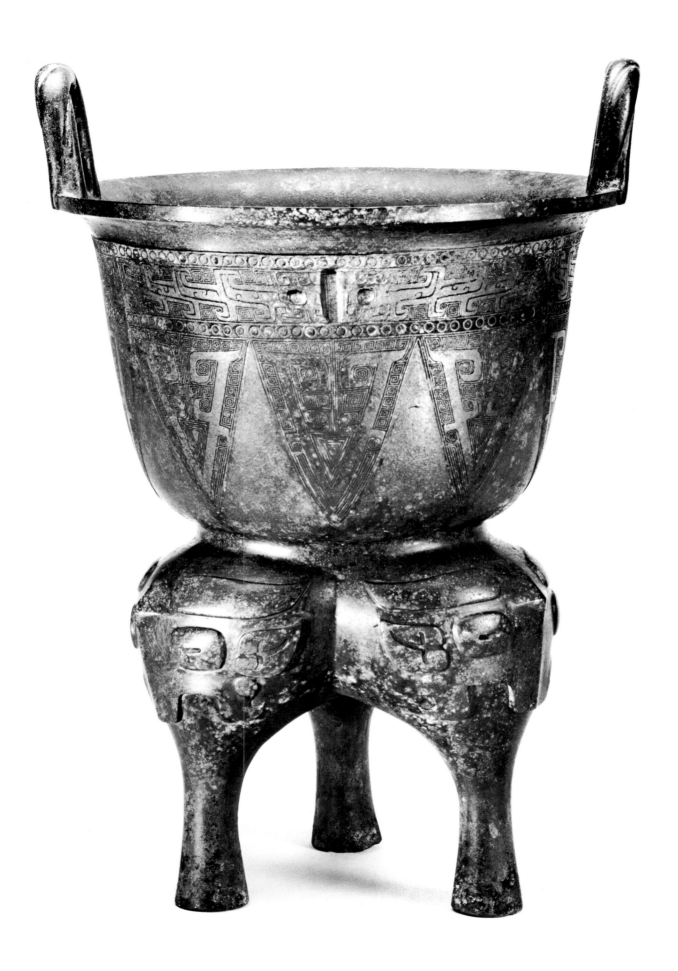

135 *Yuantong*

Cylinder
Western Zhou dynasty, 10th century B.C.
height 27.6, diameter 16.6 cm
(10⅞ × 6⁹⁄₁₆ in)
inscription
s87.0327

The precise function of the Sackler bronze *yuantong* remains open to speculation. Although the tall, smooth shape with flaring ends is similar in style to several traditional Chinese ritual vessels, both ends of the cylinder are open, making it impossible for the piece to have been used as a container. Further, there is no indication that either end of the cylinder was ever fitted with a base or lid. At the same time, a four-character inscription, "Shu made this precious sacral vessel," cast inside the cylinder follows a practice normally associated with ritual vessels. The inscription appears inside the wider of the two openings, so that end is probably the bottom of the cylinder. It is conceivable that the Sackler cylinder served as the base or support for another bronze vessel.

Each end of the Sackler cylinder is decorated with narrow, horizontal bands of stylized double-headed dragons and a series of blades. The blades encircling the upper end of the cylinder are narrow and elongated, and pairs of round, projecting eyes and curling horns identify the forms as dragons. A variation of that same stylized dragon, also presented as facing paired units, appears in the wider, more blunt forms at the bottom of the piece.

Note
Chen Mengjia includes the Sackler cylinder in his magisterial *In Shu seidoki bunrui zuroku* (A Corpus of Chinese Bronzes in American Collections), Tokyo, 1977. After noting the unusual shape of the piece, Chen Mengjia explains that he included the bronze among the ritual *zun* because that is the vessel type it most resembles.

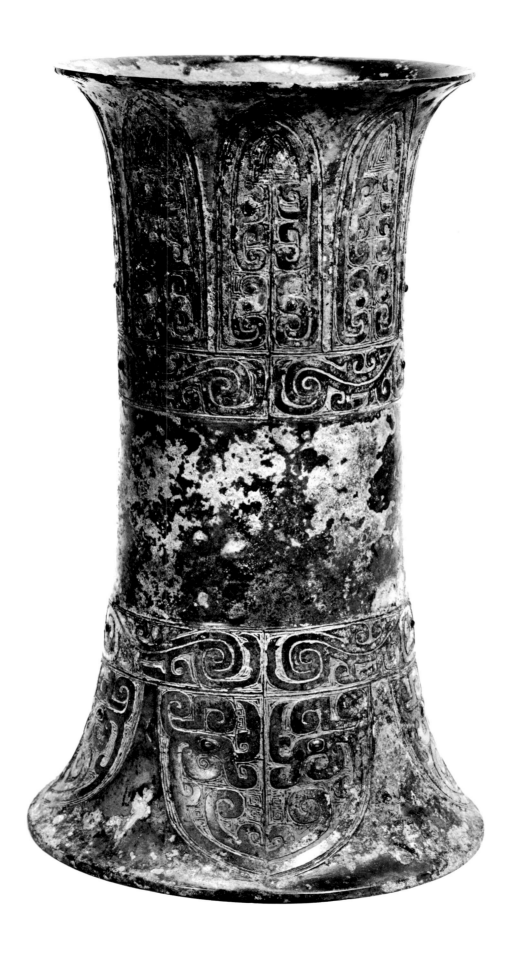

136 Bo

Ritual Bell
Western Zhou dynasty,
10th–9th centuries B.C.
height 42, width 35.2, depth 27.5 cm
(16⁹⁄₁₆ × 13⁷⁄₈ × 10¹³⁄₁₆ in)
S87.0036

In shape and decoration the Sackler bell is related to examples in the Shanghai Museum, the Hunan Provincial Museum, and the Sumitomo collection in Kyoto, Japan. Among the unusual features of the ornamentation on these bells are the *taotie* masks formed by broad, curvilinear bands and dominated by protruding oval eyes. Pairs of feline-shaped, vertical flanges divide the bells along their wide axes. The *taotie* masks on both faces of each of these oval bells are divided by hooked flanges that in turn are surmounted by crested birds. Each of these bells is fitted with a simple, curved suspension hook.

It has been suggested that the Sackler bell is part of a series of loop-suspended bells of southern workmanship. Specific features, such as the *taotie* and flanges, could be indicative of bronzes made in present-day Hunan Province. The possibility of stylistic affiliations with bronzes cast in what is now Shaanxi Province has also been raised, thus leaving the final question of origin unresolved.

Note
See Virginia C. Kane's discussion in "The Independent Bronze Industries in the South of China Contemporary with the Shang and Western Chou Dynasties," *Archives of Asian Art*, 28 (1974–75), p. 86. Robert W. Bagley raises the question of stylistic affiliations with bronzes cast in Shaanxi in *The Great Bronze Age of China*, New York, 1980, p. 245.

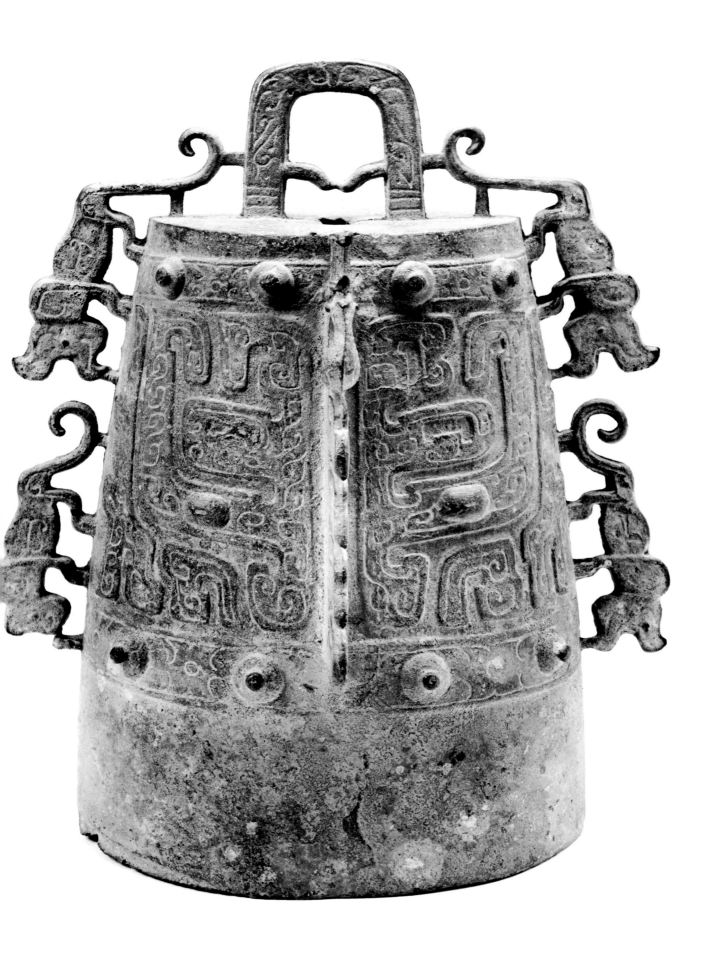

137 *Hu*

Ritual Wine Container
Eastern Zhou dynasty,
Spring and Autumn period,
8th century B.C.
height 41, width 28.5, depth 29.5 cm
(16⅛ × 11³⁄₁₆ × 11⅝ in)
S87.0049

Both the size and the shape of this *hu* are remarkable. They represent innovations made by Chinese bronze artisans during the Eastern Zhou period, when increasingly greater emphasis was placed upon overall decorative motifs. Although the origins of most of those motifs can be traced to the zoomorphic forms that were so prevalent in bronze decoration during the preceding Western Zhou period, those forms became progressively more abstract and smaller in proportion from the eighth century B.C. onward. For example, the scale patterns on the surface of the Sackler *hu* had their beginnings in bold wave patterns that embellished bronze vessels while ignoring the traditional limitations initially governed by the piece-mold technique. The introduction of wave patterns might seem to be of minor importance, but in fact it had great impact on the decoration of later Chinese ritual bronze vessels.

On occasion, individual scales of the type on the Sackler *hu* were modeled in low relief and overlapped one another, thereby further enriching the surface. In the case of the Sackler *hu*, however, all of the scales are flat and there is no overlapping, although the position of the individual units within each horizontal register is staggered to suggest an imbricated arrangement. The only other variations are those provided by a gradation in the width of the individual registers and by the pairs of interior lines that repeat the outer contours of each scale. A narrow, plain horizontal band separates the three upper rows of decoration from those on the bottom of the *hu*. A narrowly recessed rough-textured ground provides a further contrast to the smooth bronze surface. Two vertical lugs on the shoulder of the *hu* and a simple ring near the base are the only additions to the bold-scale pattern that dominates the Sackler *hu*.

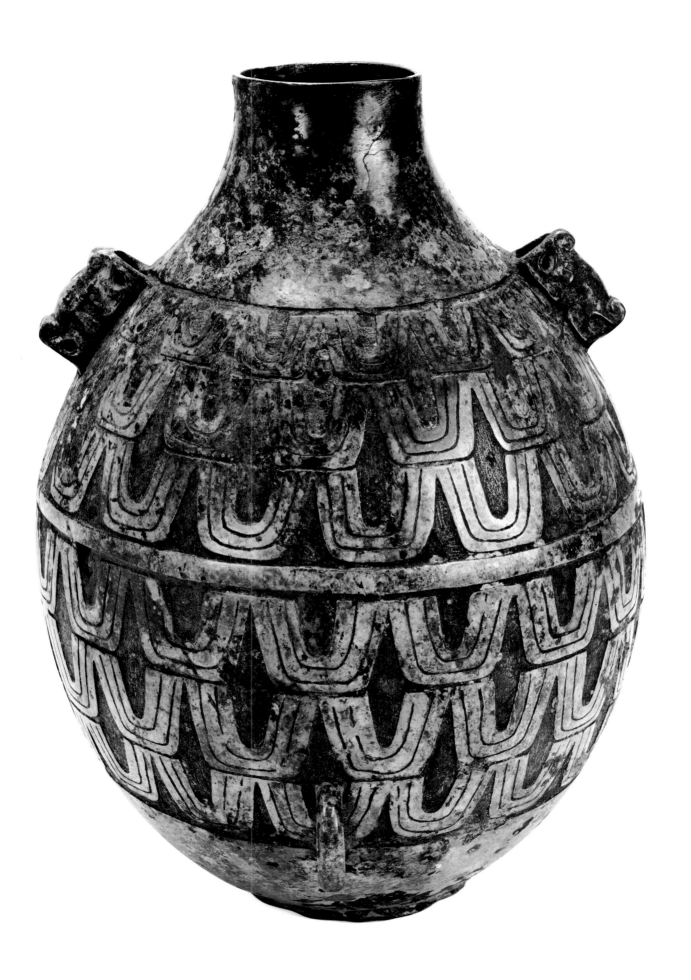

138 *Fanghu*

Ritual Wine Container
late Western Zhou–early Eastern Zhou
dynasties, 8th century B.C.
height 74, width 43, depth 36.8 cm
(29⅛ × 16¹⁵⁄₁₆ × 14½ in)
s87.0002a,b

In its imposing size and bold decoration this *fanghu* provides eloquent testimony to the technical achievements of Chinese bronze artisans during the early eighth century B.C. The monumental vessel is supported by a broad flaring base; the body curves outward and then tapers toward the tall, straight neck. Surmounting the lid is a feline creature surrounded by a reticulated wave pattern. Two sturdy loops projecting from the wall of the vessel at a point corresponding to the edges of a horizontal band support pendant rings. These loops are ornamented with animal heads in relief, having circular eyes, curled muzzles, and cone-shaped horns. The decoration on the surface of the *fanghu* is arranged in registers of varying width, with vertical divisions clearly indicated at the center of each side. Broad, concave undulating bands ending in stylized dragon heads are further accented by a regularly repeated series of intaglio lines. The introduction of the wave pattern was an important influence in the decoration of Chinese bronze ritual vessels during the Eastern Zhou dynasty; the individual units derived from the boldly articulated dragons became increasingly small in scale during the succeeding centuries (nos. 142, 147, 149, 152).

The Sackler *fanghu* is one of a pair, originally in the Vignier collection, Paris. The other vessel is in the Musée Guimet, Paris.

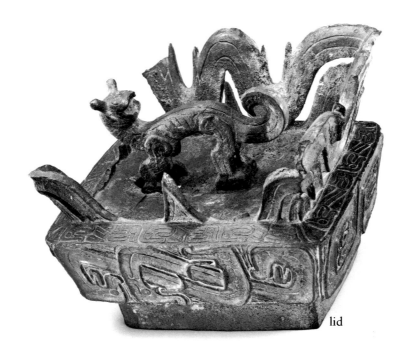

lid

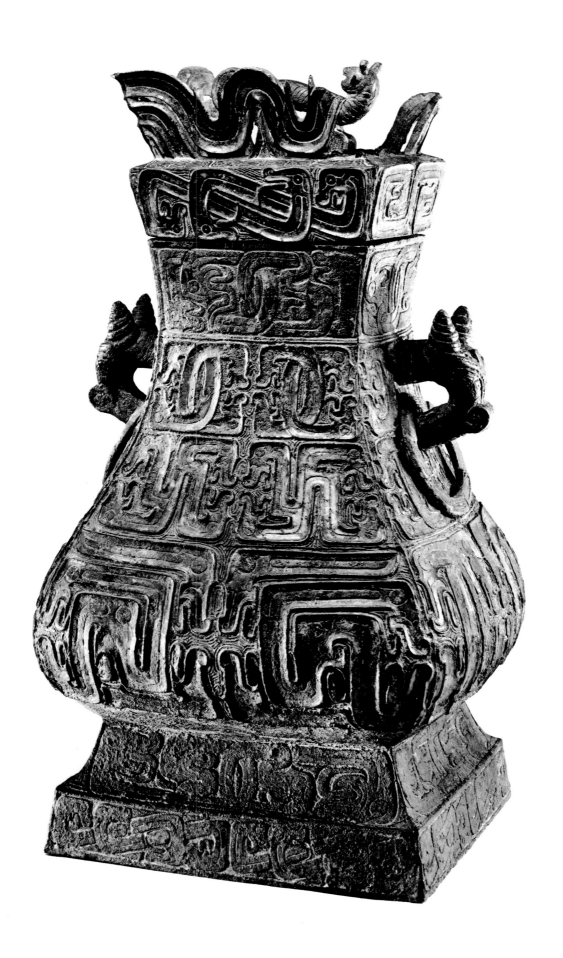

139 *Hu*

Ritual Wine Container
Eastern Zhou dynasty,
Spring and Autumn period, 6th century B.C.
height 38, width 13.4, depth 15.2 cm
($14^{15}/_{16} \times 5^{5}/_{16} \times 6$ in)
s87.0325a,b

Among archaeological finds after 1949 in China, there is evidence that gourds were used for a variety of utilitarian purposes as early as the Late Neolithic period. By the sixth century B.C., when casting this ritual bronze of a type sometimes referred to as a *hu hu*, or gourd container, the Chinese artisan knew that the subtle reference to the asymmetrical shape of a natural gourd would be recognized as an especially sophisticated use of precious bronze.

Rising from a flat base, the walls of the *hu* curve outward and then converge to form a narrow, elongated neck. The conical lid, enriched by a stylized bird whose circular mouth serves as a pouring spout, is modeled with the same refined simplicity apparent in every facet of the Sackler *hu*. A curved handle is secured to the body of the vessel by two projecting loops; the chain that originally linked the lid with the handle is missing.

As is typical of the known "gourd containers," all of which date from the Eastern Zhou period, a series of horizontal bands decorates the surface of the Sackler vessel. The three horizontal bands of miniature interlaced patterns can be related to that mode of embellishment usually designated as Xinzheng style, on the basis of the decoration found on bronzes unearthed at Xinzheng, Henan Province, in 1923. On the Sackler *hu* the arrangement of these bands, which vary in width, further emphasizes the subdued elegance of the unusual shape of this sixth century B.C. bronze vessel.

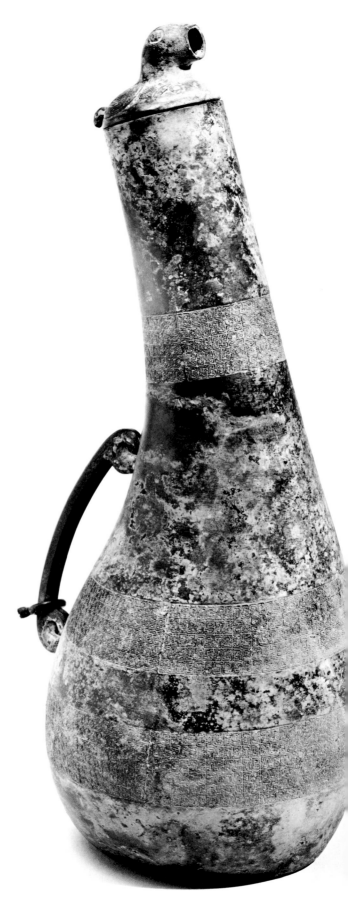

140 *Hu*

Ritual Wine Container
Eastern Zhou dynasty,
Warring States period, 3d century B.C.
height 12.8, width 9.1, depth 9 cm
(5 × 3⁹⁄₁₆ × 3½ in)
s87.0896

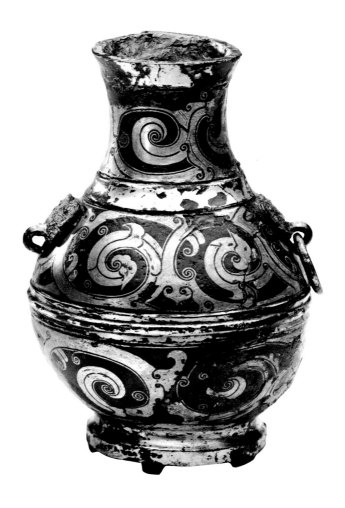

This small vessel sits on a low, gilded footrim. The body curves outward and then rises to a flaring neck. Gilded bands divide the Sackler *hu* into three horizontal registers; two of the bands are plain, and the third, at the widest part of the vessel, is further embellished with a rounded welt. Curvilinear inlaid silver scrolls arranged in three registers introduce a dramatic coloristic and formal contrast to the stable gilded bands. Only an occasional stylized bird head at the end of one of the silver scrolls suggests any reference to natural forms; otherwise, the artistic vocabulary is entirely abstract. The Chinese artisan intensified the vigor of the wide silver scrolls—and the smaller curls as well—by having them emerge from the horizontal gilded bands.

A remarkable technique was used in decorating this *hu*. Silver wire hammered into shallow cast depressions on the surface of the vessel was flattened into strips about one tenth centimeter wide. Some of the silver inlay in the longer loops of the design was formed by combining as many as seven parallel strips. Those multiple strips of silver wire were hammered together so tightly that they give the appearance of being sheets of silver.

It has been suggested that the two small masks attached to the sides of the vessel may be later additions. A small *hu* quite similar to the Sackler vessel in size and decoration is in the Art Institute of Chicago.

The Warring States period was marked by a series of innovations in the decoration of bronze vessels. Metal inlay techniques provided an alternate method for enriching the surfaces of the vessels, and the designs, which apparently were influenced in their jewel-like delicacy by lacquer and textile traditions in the south of China, reached their apogee in the fifth through the third century B.C.

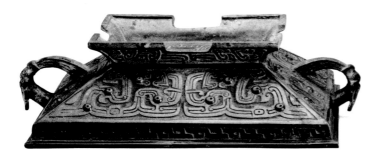 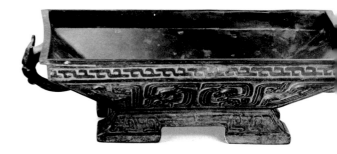

141 *Fu*

Ritual Food Container
Eastern Zhou dynasty,
Spring and Autumn period,
early 8th century B.C.
height 21.5, width 37.5, depth 25.1 cm
(8⁷⁄₁₆ × 14¾ × 9⅞ in)
s87.0314a,b

Fu did not appear until the Eastern Zhou period, coming late in the evolution of bronze vessels. They continued to be made throughout that period, although after the fifth century B.C., production seems to have been limited to foundries in the southern part of China. Although the Sackler *fu* is not inscribed, it is clear from the inscriptions on a number of contemporary examples that *fu*, like other bronzes made over long periods of time, also were commissioned for a variety of reasons. On some occasions, the name of the person who commissioned the *fu* is included in the inscription; sometimes the inscription only records the name of the person for whom it was made. The latter type of inscription also mentions deceased ancestors. In addition, there are several instances in which the inscriptions note that a *fu* was intended to be part of a dowry.

The Sackler *fu* consists of two parts, a base and lid, that are virtually identical. Each part is rectangular and is fitted with four flaring projections. The projections serve both as legs and as decorative embellishments. Of course, when the lid was removed and placed upside down, it could also have been used as a container. A pair of curved handles, modeled in animal masks in high relief, appears at the longer ends of both sections of the *fu*. Stylized dragon and feline forms, accented with convex, circular eyes, decorate the sloping surfaces of the bronze. The abstract bands that decorate the narrow edges of the lid and base are considerably smaller in scale. In shape and design, the *fu* reflects the continuing ingenuity of the Chinese bronze artisans.

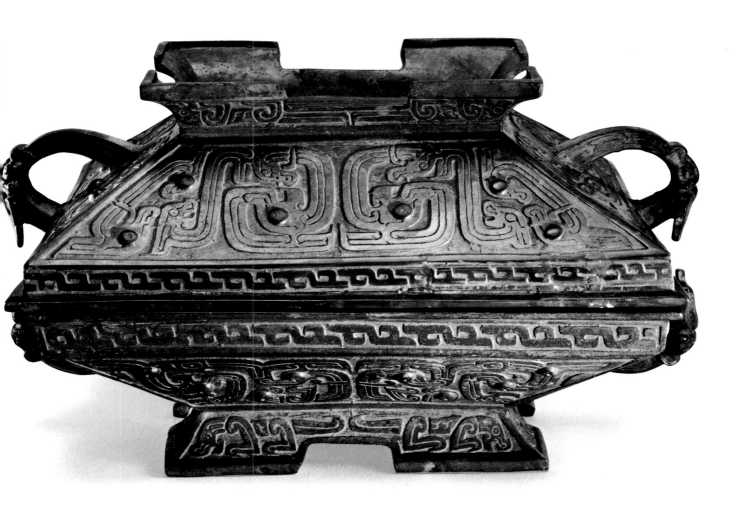

142 *Ding*

Ritual Cooking Vessel
Eastern Zhou dynasty,
Spring and Autumn period, 7th century B.C.
height 34.5, width 37, depth 30.7 cm
(13⁹⁄₁₆ × 14⁹⁄₁₆ × 12⅛ in)
inscription
S87.0326

The broad, shallow bowl of this *ding* is supported
by three cabriole legs set well beneath the outer con-
tours of the vessel. The contrasting convex and con-
cave silhouette of the three legs is repeated more
vigorously in the swelling bowl and abruptly everted
rim of the body of the Sackler *ding*. A final, exuber-
ant flourish to the outward thrust of the overall
shape of the vessel is provided by the two handles
that rise from the rim.

Bands of interlocked bird and dragon designs,
clearly separated by narrow horizontal ridges, ap-
pear on the body of the Sackler *ding*. These designs
are further embellished by a series of linear intaglio
motifs and circular protruding "eyes." In keeping
with their larger scale and central position, the *tao-
tie* masks in the lower decorative band assume the
dominant focus. All of these features of the Sackler
ding are associated with the Xinzheng style on the
basis of comparisons with the more than 100
bronzes accidentally found in 1923 when a local
farmer was sinking a well in a field at Xinzheng,
Henan Province. Although there is a considerable
range in the decorative styles represented on those
bronzes, the term "Xinzheng style" has become syn-
onymous with interlocked zoomorphic designs that
provide a uniform surface decoration.

There are a number of repairs on the surface of
the Sackler *ding*. The authenticity of the nine-
character inscription on the inside of the vessel re-
mains open to further study.

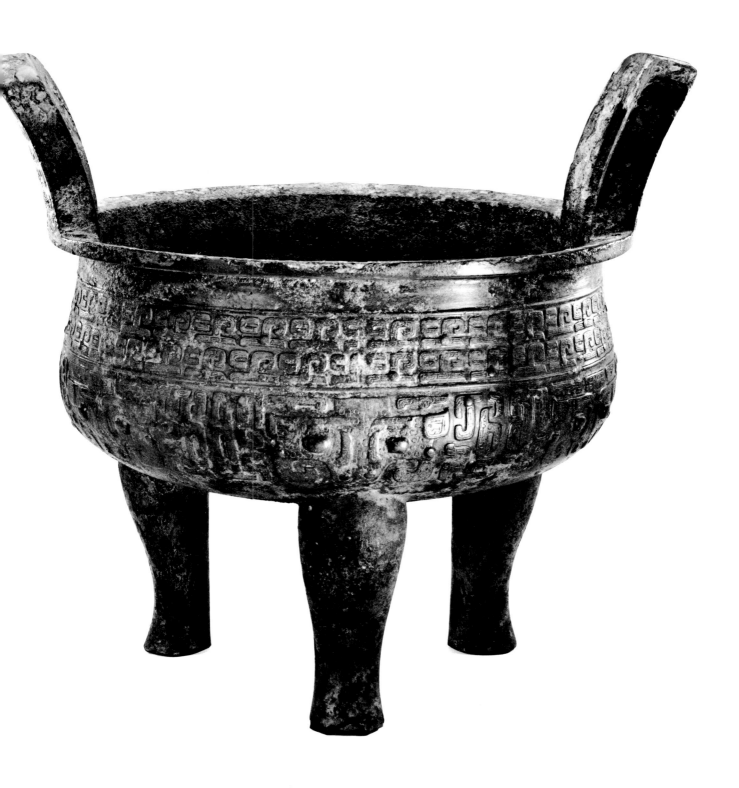

143 *Ding*

Ritual Cooking Vessel
Eastern Zhou dynasty,
Spring and Autumn period,
7th–6th centuries B.C.
height 59.5, width 76.5, depth 71.5 cm
(23⁷⁄₁₆ × 30⅛ × 21⅛ in)
s87.0067

Included among the large number of Eastern Zhou dynasty bronze vessels and bells unearthed at Xinzheng, Henan Province, in 1923 were several *ding* that are identical in shape and decoration to this example in the Sackler Gallery. Impressive in size, as well as in the boldness of their silhouettes, these *ding* from Xinzheng are eloquent reminders of the Chinese bronze artisan's ability to undertake large-scale casting projects successfully.

This massive *ding* stands on three squat, cabriole legs, decorated on their rounded tops with sculptured animal masks. The large hemispherical bowl rises from a flat bottom and curves upward toward the concave shoulder that joins the narrow everted lip. Two flamboyantly shaped handles emerge from opposite sides of the Sackler *ding*. In their sculptural vitality, these handles, which curve outward and back before arching outward again, reflect the exuberant taste of the rulers of the ancient State of Zheng. This degree of flamboyance and zest also reflects the influence of aesthetic preferences found in those areas under the cultural sway of the State of Chu in southern China.

In contrast to the boldness of the silhouette of the Sackler *ding* are the miniature size and geometric precision of the surface decoration. Small units, based on a highly stylized motif, are repeated to achieve an overall surface richness. The only interruptions in the horizontal registers of these decorative patterns are provided by the narrow, rounded bands just beneath the concave shoulder. A bovine head, surmounted by large curving horns, adorns the circular handle that projects between these narrow bands.

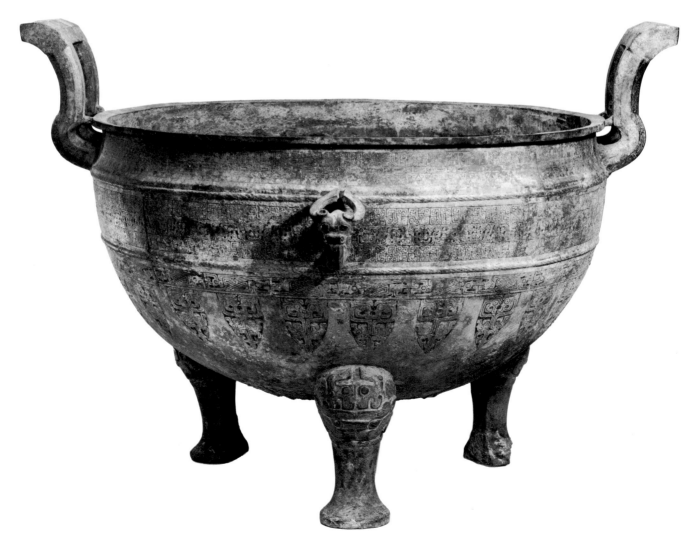

144 *Ding*

Ritual Cooking Vessel
Eastern Zhou dynasty,
Spring and Autumn period, 6th century B.C.
height 31.5, width 45, depth 38.8 cm
($12\frac{3}{8} \times 17\frac{3}{4} \times 15\frac{5}{16}$ in)
s87.0291a,b

The interlaced bands that decorate the surface of this covered *ding* are characteristic of a bronze style known as Liyu. That name derives from a village, Liyu, in modern Shanxi Province, where in 1923 the discovery of a cache of bronze vessels enabled scholars to achieve greater accuracy in the dating of Chinese bronze vessels. Some of the bronzes from Liyu were exhibited in Europe soon after their discovery, and Western scholars immediately recognized their exceptional quality. Indeed, one characteristic feature of bronze vessels associated with the Liyu tradition is the uniformly high technical excellence. The Sackler *ding*, with its flat relief and overlapping parts, suggests layers, but without any actual plastic relief. Further embellishing the interlaced bands on this vessel are the twisted braid pattern on the handles and the masks rendered in relief on the upper sections of the legs.

Note
Max Loehr proposed a sequence for the development of the Liyu style, which he believes spanned the period ca. 525–482 B.C. According to that chronology, the entire sequence developed during the late Spring and Autumn period and just preceded the Warring States period. The Sackler *ding* can be assigned to the second of Loehr's sequences and dated ca. 500 B.C. (see Bibliography).

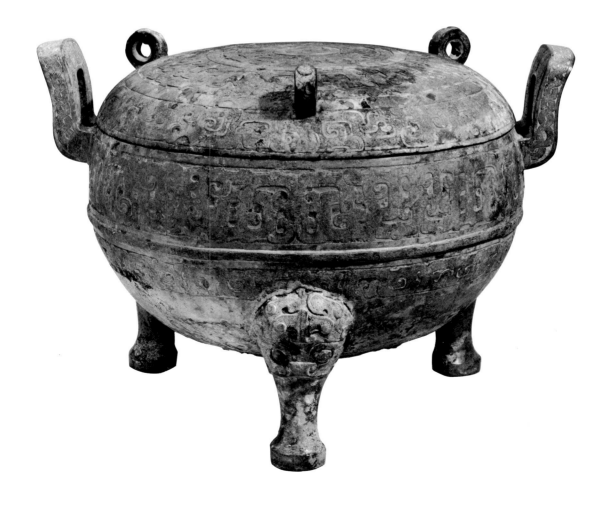

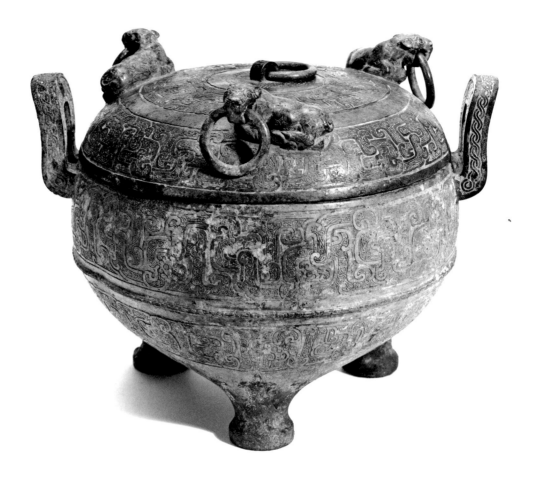

145 *Li Ding*

Ritual Cooking Vessel
Eastern Zhou dynasty,
Spring and Autumn period,
late 6th–early 5th centuries B.C.
height 16.5, width 20.5, depth 17.7 cm
(6½ × 8¹/₁₆ × 6¹⁵/₁₆ in)
s87.0039a,b

The bronze vessels decorated in the Liyu style are remarkable for the unusual combination of naturalistically sculpted, three-dimensional animal and bird forms and stylized interlaced animal bands rendered in low relief. Regardless of whether they were presenting naturalistically modeled forms or arranging the complex animal bands on the Liyu-type bronzes, Chinese artisans maintained an extraordinarily high degree of technical perfection. This *li ding* in the Sackler Gallery is an excellent example of that unusual combination of Liyu-style decorative features.

Three squat legs blend with the rounded contours of the *li ding*, the rounded cover completing the globular shape of the vessel. A narrow, convex, horizontal band decorated with a cowrie shell motif divides the upper and lower sections of the vessel. The friezes on either side of that narrow band of cowrie shell are decorated with an intricately textured series of flat interlaced bands. Smooth, plain strips frame each of the bands, thereby emphasizing the small spirals, striations, scales, and granulations that enrich the stylized creatures. These bands on the Sackler *li ding* do overlap and interlock, but there is no attempt to model any of the bands in three dimensions. Narrow design registers, also enhanced by flat, interlaced bands, appear on the cover of the *li ding*. A single loose ring supported by a small lug decorated with cowrie shells hangs in the center of the cover. Sturdy loop handles project from the lip on either side of the vessel. The narrow edges of these handles are embellished with a twisted cable motif. Three recumbent animals, arranged with their heads all facing in the same position, hold loose rings in their mouths.

146 *Pou*

Ritual Wine Container
Eastern Zhou dynasty,
Spring and Autumn period,
7th century B.C.
height 20.5, width 35.5, depth 30.5 cm
(8¹/₁₆ × 14 × 12 in)
s87.0277

This flat-bottomed vessel has a wide curving shoulder, short neck, and a narrow, everted mouth rim. Two small loop handles are cast onto the shoulder at opposite sides of the *pou*. Decorating the outer surface of the vessel is a low-relief design based on a stylized dragon. Each unit of the design is centered on the raised eye of a dragon. Other elements of the design, reduced to a series of curving bands and embellished with intaglio lines and dots, are all that remain of a recumbent dragon motif. The original motif emerged as an important decorative element

on Chinese bronze vessels in the eighth century B.C. Some variation is achieved in the overall decoration of the Sackler *pou* by placing inverted and mirror-image versions of the design unit side by side. An irregular pattern of raised dots formed by the eyes of the dragons further embellishes the surface of the *pou*.

Decoration on bronze vessels cast during the Eastern Zhou period reflects a preoccupation with motifs that sheath the surfaces with rich, low-relief patterns. Unlike bronze decoration dating from the preceding Shang and Western Zhou periods, when artisans observed the integrity of each portion of a particular vessel, Eastern Zhou artisans developed small-scale motifs that embellish the surfaces of their vessels without regard for transitions between the individual segments. An excellent example of this late Eastern Zhou aesthetic can be seen in the way the design units that sheath the Sackler *pou* continue without a break onto the two loop handles.

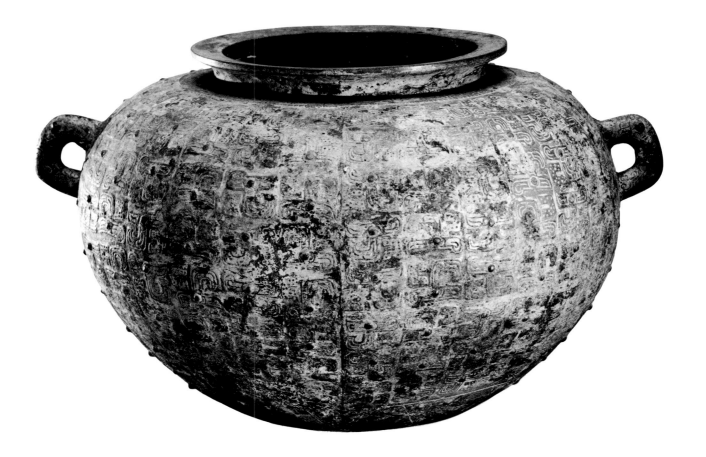

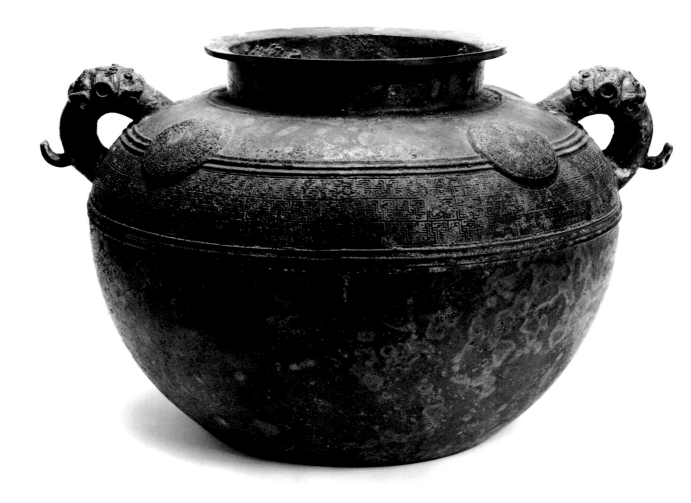

147 *Pou*

Ritual Wine Container
Eastern Zhou dynasty,
Spring and Autumn period,
late 7th–early 6th centuries B.C.
height 26.5, width 41.5, depth 35.4 cm
(10⁷/₁₆ × 16³/₈ × 13¹⁵/₁₆ in)
s87.0295

This impressive flat-bottomed *pou* with a wide, convex shoulder has a short, straight neck and a narrow, everted mouth rim. Two loop handles in the form of rampant dragons are cast onto the shoulder at opposite sides of the vessel. The restrained, elegant proportions of the *pou* are heightened by the refinement of the horizontal band of geometric decoration on the shoulder. Large relief medallions interrupt the upper border of that band of interlaced decoration; otherwise the small-scale pattern of the abstract animal bands is a subdued, unobtrusive textural addition to the surface of the bronze.

A large number of bronze vessels decorated with abstract interlaced animal bands were unearthed accidentally in 1923 at Xinzheng, Henan Province. The bronzes from Xinzheng were not homogeneous in style, indicating that the vessels from that excavation had been made over a long period. On the basis of the information provided by the Xinzheng bronzes, however, it was possible to identify a stylistic sequence based on the motif of interlaced dragons that gradually were reduced in scale to achieve a small rectangular unit that could be repeated over the entire surface of a vessel. It is this latter sequence in the Xinzheng stylistic development that appears on the Sackler *pou*.

Archaeological excavations at sites in a number of provinces, including Anhui and Hunan, have yielded many more bronzes decorated in the style formerly associated with Xinzheng. This information makes it clear that the interlaced dragon motif had wide distribution during the Eastern Zhou period. Vessels from some of these archaeologically attested sites also support the suggestion that the Sackler *pou* originally was fitted with a lid.

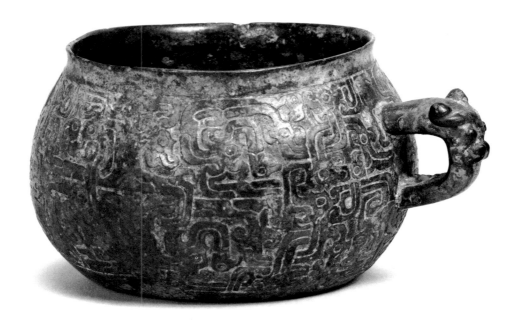

148 *Huo*

Ritual Vessel
Eastern Zhou dynasty,
Spring and Autumn period,
late 7th century B.C.
height 8, width 14.6, depth 12.7 cm
(3⅛ × 5¾ × 5 in)
s87.0299

The importance of this small bronze vessel is found in the decoration cast into its outer surface. Narrow, concave horizontal bands emphasize the flat bottom and the upper lip of the *huo*. Otherwise the only interruption to the wide band of interlaced decoration is the ring handle embellished with an animal mask in high relief. The overall decorative pattern on the *huo* is based on the repetition and interlacing of a double-headed bird and dragon motif to provide a rich textural surface. The individual bird and dragon heads are readily identifiable because of their characteristic eyes and crests. But the artisan was clearly more interested in the abstract qualities of this motif than in the definition of any single unit within the pattern. Although the flat bands do interlace, that interrelationship is suggested by intaglio lines only. None of the elements of the pattern is rendered in relief. That further refinement of the decorative patterns on Chinese bronze ritual vessels appeared later during the Eastern Zhou period.

149 *Zhong*

Ritual Bell
Eastern Zhou dynasty,
Spring and Autumn period,
7th–6th centuries B.C.
height 37, width 25.5, depth 21 cm
(14⁹⁄₁₆ × 10¹⁄₁₆ × 8¼ in)
s87.0302

Some aspects of this bronze *zhong*, such as poor casting and relatively crude design, are surprising, considering that it was purportedly unearthed in 1929 at Jincun, near Luoyang, Henan Province, where a number of sophisticated objects were found. Three bronze bells from another set found at Jincun at this same time are contemporaneous with the Sackler *zhong*; the decoration and casting technique suggest that all of those bells must have been cast in the same foundry.

The Sackler bell is oval in cross section, with a slightly curved silhouette ending in a flat bottom rim. A pair of addorsed birds, with heads turned, forms the sturdy suspension loop at the top of the *zhong*. The overall composition of the addorsed birds and the curvilinear intaglio motifs on the surfaces of the suspension loop are closely related to the depiction of the pair of dragons that appears in the lower section of the bell. A large, flat, plain circle in the center of this portion of the design is a curious intrusion into the decorative scheme. Rounded narrow bands divide the upper section of the bell into a series of horizontal and vertical planes. Narrow registers of attenuated, double-headed dragons occur between the rows of three bosses in the upper section of the bell. The feline faces and striated, coiled bodies that embellish the bosses provide yet another unusual decorative element.

Note
In his discussion of the large numbers of sophisticated objects said to have been found in the tombs at Jincun, William Charles White describes a chime of nine bells that includes the one in the Sackler Gallery; see *Tombs of Old Lo-yang*, Shanghai, 1934, plate CLXXII.

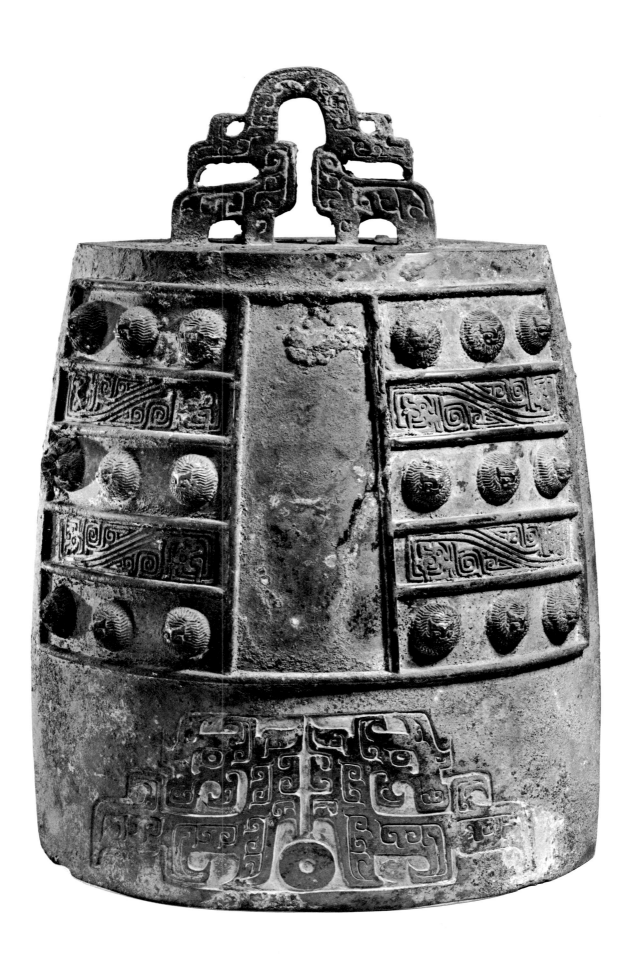

150 *Zhong*

Ritual Bell
Eastern Zhou dynasty,
Spring and Autumn period,
late 6th century B.C.
height 20.5, width 12.8, depth 10.4 cm
(8⅛ × 5 × 4⅛ in)
S87.0282

The small size and exquisite casting of this bell epitomize the technical skill and aesthetic refinement achieved by bronze artisans during the Eastern Zhou period. A pair of stylized creatures forms the support for the suspension loop at the top of the bell. Although these creatures can be identified as feline, their evenly textured bodies and curvilinear embellishments cannot be related to any specific animal. Only the oversized heads and exaggerated claws of the creatures retain particular references to natural forms.

The ovoid top of the bell and both of the convex vertical faces are decorated with a variety of stylized motifs. Each of the convex faces of the bell is divided into horizontal and vertical registers. In the spaces formed by that division are designs alternating between purely abstract motifs and horizontal rows of three bosses in the form of coiled serpents. The narrow vertical panel at the center of this portion of the bell is decorated with elegant floral motifs that, curiously, are asymmetrical in arrangement. The style of the panel marks the single exception to the symmetrical organization of the rest of the bell.

The Sackler *zhong* originally would have formed part of a chime of bells, each one varying in size. In China, chimes of bells were suspended from frames, usually fashioned of wood, and were played by being struck. Research on early Chinese musical instruments has revealed that a single Chinese bronze bell, like this one, produces different tones, depending on where on its lower section it is struck. On this Sackler bell, that lower portion is decorated with a trapezoidal panel of interlaced dragons.

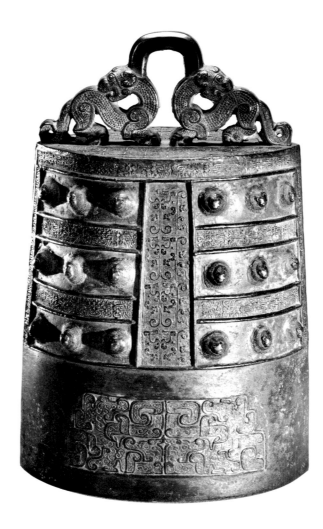

151 *Zhong*

Ritual Bell
Eastern Zhou dynasty,
Spring and Autumn period,
late 6th century B.C.
height 41, width 31, depth 24.4 cm
(16⅛ × 12³/₁₆ × 9⅝ in)
s87.0287

Technical virtuosity is immediately apparent in the
complex designs that cover the surfaces of this bell.
Two addorsed feline creatures supporting the sus-
pension loop on the top of the bell still retain their
zoomorphic identity, but the transition from their
curvilinear bodies to the abstract loop itself is barely
perceptible. Narrow raised bands separate the two
concave surfaces of the bell into a series of horizon-
tal and vertical planes. Groups of three bosses in the
form of coiled serpents appear in the wider of the
horizontal planes. Filling the narrower horizontal
planes, as well as the vertical panel in the center, is a
richly textured motif based on a stylized dragon
form. The repetition of that motif over such broad
areas results in the loss of the identity of any indi-
vidual element; rather, it is the rich overall texture
that dominates. A symmetrically designed trapezoi-
dal composition in the lower section of the bell in-
troduces interlaced band motifs that are larger in
scale and consequently easier to comprehend. A pair
of oval eyes at the center of the composition serves
as the radiating point for the angular textured
bands, some of which end in dragon heads. Individ-
ual elements within this composition are modeled in
high relief, thereby lending a further tactile richness
to the surface of the bell.

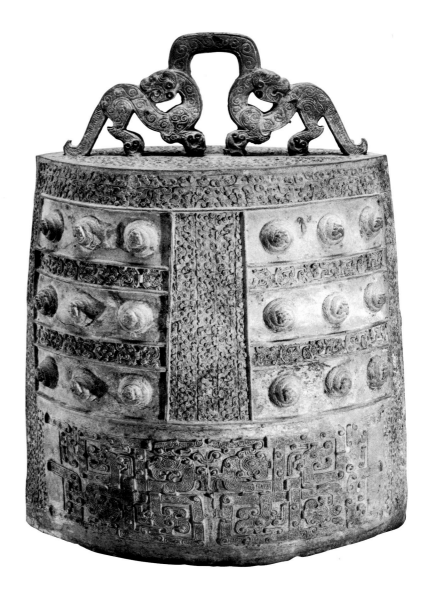

152 *Zhong*

Graduated Set of Six Ritual Bells
Eastern Zhou dynasty,
Spring and Autumn period,
6th century B.C.
(a) height 25.5, width 13, depth 10.3 cm
(10¹⁄₁₆ × 5⅛ × 4¹⁄₁₆ in)
s87.0004
(b) height 29, width 14.5, depth 11.7 cm
(11⁷⁄₁₆ × 5¹¹⁄₁₆ × 4⅝ in)
s87.0005
(c) height 31.5, width 16.5, depth 13 cm
(12⅜ × 6½ × 5⅛ in)
s87.0006
(d) height 35.5, width 18.2, depth 14.9 cm
(14 × 7⅛ × 5⅞ in)
s87.0007
(e) height 39, width 20, depth 16.6 cm
(15⅜ × 7⅞ × 6½ in)
s87.0008
(f) height 43, width 22.5, depth 17.8 cm
(16¹⁵⁄₁₆ × 8⅞ × 7 in)
s87.0009

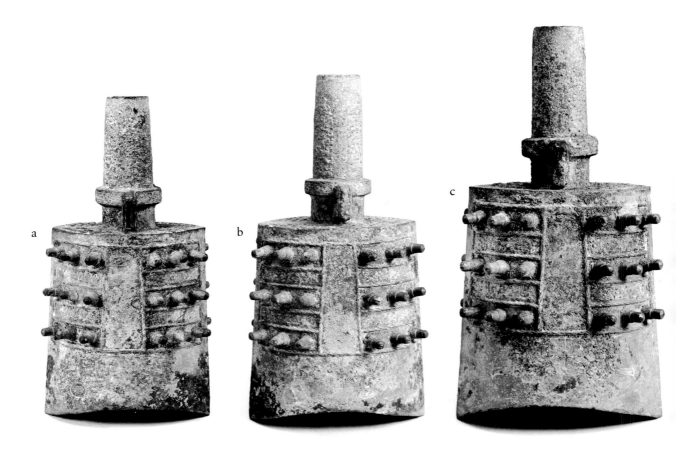

a b c

This set, or chime, of ancient Chinese bronze bells constitutes one of the rare intact series of graduated bells outside China. Although each of these bells differs in size, the overall shape and decoration remain virtually the same. The elliptical body of each bell tapers slightly toward the wider base, which is arched and culminates in two points at the outer edges. A tapered post rises from the flat surface at the top of each bell. Pointed blades ornamented with an overall pattern of miniature interlaced motifs decorate the surfaces of the posts. The projecting ring and loop at the lower end of these posts were used to suspend the bells. The position of the suspension loop means that the bells were designed to hang together on a wooden frame at an oblique angle. This type of clapperless bell would have been struck on the outside with a wooden hammer.

Narrow, raised, striated bands divide the main trapezoidal surfaces of each bell into horizontal and vertical registers. Rows of three elongated bosses arranged on either side of the central trapezoidal panel dominate the decoration of the bells. Narrower registers covered with interlaced motifs alternate between the rows of bosses. Centered on the lower section of each bell is a large-scale composition of striated interlaced bands based upon bird-headed serpents.

Archaeological finds in China are yielding valuable information that supplements traditional ideas about the development of Chinese music. One of the most dramatic discoveries was the tomb of Marquis Yi of the State of Zeng, which was unearthed in 1978 at Sui Xian, Hubei Province. Included among the more than 200 bronzes from that tomb is a set of sixty-four bells with lengthy inlaid gold inscriptions on their surfaces that have provided extensive new details about the terminology and performance of early Chinese music.

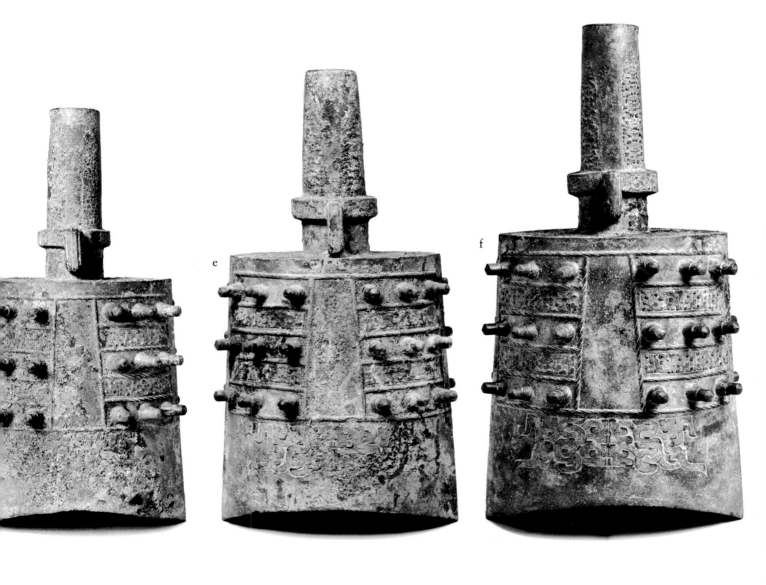

153 *Pair of Hu*

Ritual Wine Containers
Eastern Zhou dynasty,
Warring States period, 5th century B.C.
(a) height 46, width 32.1, depth 31.8 cm
(18⅛ × 12⅝ × 12½ in)
s87.0019
(b) height 46, width 32.1, depth 31.5 cm
(18⅛ × 12⅝ × 12⁷⁄₁₆ in)
s87.0011

This pair of bronze *hu* in the Sackler Gallery is
closely related in size, shape, and decoration to a *hu*
in the Grenville L. Winthrop collection in the Arthur
M. Sackler Museum, Harvard University. Each of
the three vessels has a low footrim decorated with
geometric patterns based on diagonals and curls.
The decoration on the surfaces of the *hu* is arranged
in seven horizontal registers alternating between
triple rows of small oval motifs derived from a
coiled bird or animal and bands based on an asym-
metrical stylized animal. Narrow plain horizontal
bands separate these alternating figured registers.
The restrained elegance of these *hu* results from the
subtlety of the intaglio decoration, which enriches
their surfaces but never intrudes on the overall sim-
plicity of the vessels' curving silhouettes. Ring
handles attached to lugs in the shape of *taotie* masks
appear on either side of the *hu*; four additional ring
handles adorn their necks. This aspect of bronze
decoration in the Warring States period reflects a
change in the relationship between figure and
ground. Although the principle of symmetry contin-
ued to prevail, the differentiation between figure and
ground that pertained during earlier periods (no.
104) was replaced by a greater interest in rich over-
all patterning. To achieve a more sumptuous visual
effect, artisans experimented with a wide variety of
complex motifs in which the clear definition be-
tween figure and ground was subordinated to a lux-
urious, even ostentatious, technical display.

Two bronze *hu* similar in size and shape to the
Sackler and Winthrop vessels were unearthed from
Tomb No. 1 at Zhaogu, Hui Xian, Henan Province,
in 1951. One of those *hu* is decorated with horizon-
tal bands embellished with motifs based on asym-
metrical stylized animals of the type already de-
scribed on the alternating registers of the Sackler
and Winthrop pieces.

detail of handle

Note
The editors of the Chinese archaeological report *Hui Xian
fajue baogao* assign Tomb No. 1 to the Warring States pe-
riod, a date that is consistent with the attribution of the
Sackler and Winthrop bronze vessels.

a left, b right

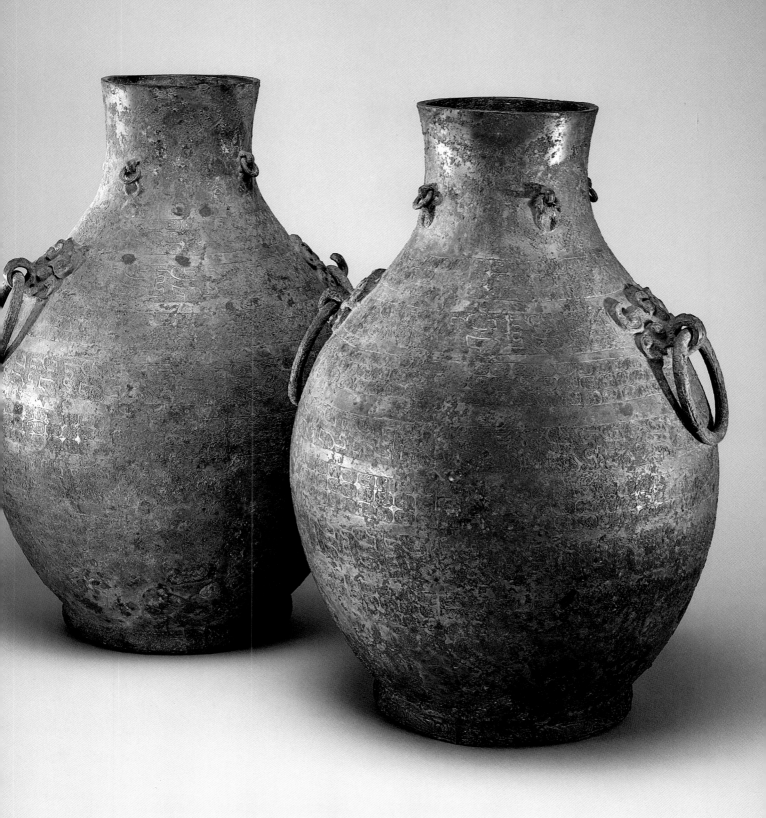

154 *Zhong*

Ritual Bell
Eastern Zhou dynasty,
Warring States period, 5th century B.C.
height 46.5, width 24, depth 7 cm
(18⁵⁄₁₆ × 9⁷⁄₁₆ × 6¹¹⁄₁₆ in)
s87.0285

This impressive bell is conchoidal in cross section, with the lower portion arching downward toward two points at either side. The tapered shaft that rises from the top of the bell is divided by four horizontal straps, one of which is round in profile and further embellished with a suspension ring in the form of a stylized animal head. The placement of the suspension ring indicates that this bell, and the others that formed the original chime, would have hung at an oblique angle. Slightly raised narrow convex bands separate the two large surfaces of the bell into a series of horizontal and vertical planes. Within those planes are arranged rows of three rounded bosses that alternate with narrower bands of richly textured interlaced animal designs. The interlaced animal designs are based on dragons, whose identity is revealed by protruding rounded eyes and curled muzzles. There is an ascending order of complexity in these animal designs, beginning with the relatively simple interlacing in the bands on the shaft and becoming more elaborate on those horizontal planes that alternate with the raised bosses. The Chinese artisan displays greatest ingenuity in the trapezoidal design on the lowest portion of the bell. A monster mask at the center of the composition is dominated by a pair of large eyes and a rounded snout. On either side of the mask are entwined richly decorated bands, some of which twist upward to end in claws; others end in abstract curls, thereby introducing a three-dimensional element to the design. At either edge of the trapezoidal plane, the artisan contrasted an abstract curvilinear form beneath a strikingly naturalistically feathered wing. Decorative units and textures of such remarkable complexity are characteristic of bronzes cast during the Warring States period and reflect a fondness for richly ornate surfaces.

Five other bells from this chime are known: the largest of the group, measuring 63.5 centimeters (25 inches) in height, is in the Brundage collection, San Francisco. The smallest bell, 22.6 centimeters (8⅞ inches) high, is in a private collection in Japan. The other three bells are in the Nelson Gallery of Art, Kansas City; the Pillsbury collection, Minneapolis Institute of Arts; and in a private collection in New York.

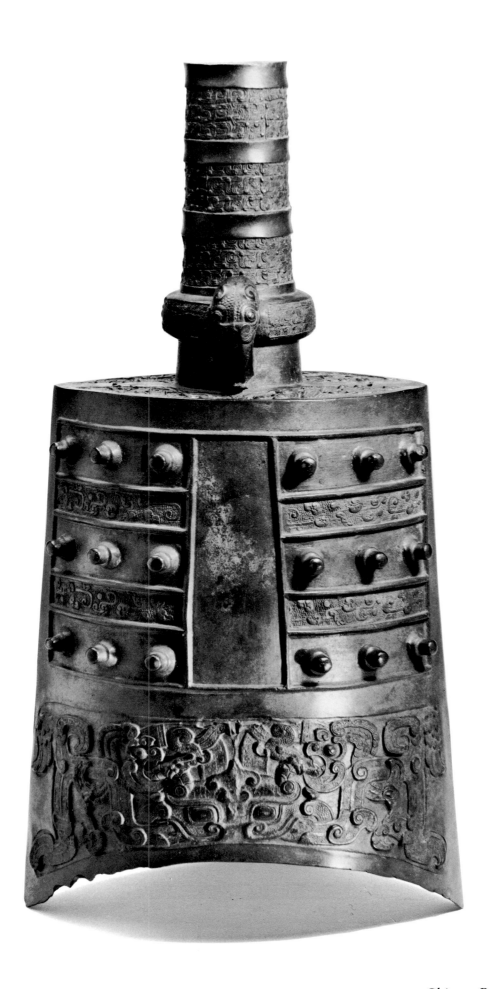

155 *Bianhu*

Ritual Vessel
Han dynasty, 1st century B.C.
height 27, width 27, depth 11.6 cm
(10⅝ × 10⅝ × 4⁹⁄₁₆ in)
s87.0014

The *bianhu*, a flat flask or canteen, was an innovation of the Eastern Zhou period. The shape apparently was introduced at some time around 400 B.C. and continued to be used into the Han dynasty. The Sackler *bianhu* is related to other bronze examples in its flat sides and flaring cylindrical neck, but features such as the square shape and separately cast feet are unusual. Chains attached to lugs on the lid and on the shoulders of the *bianhu* are further linked to a short curved handle embellished with dragon heads at either end. Incised in low relief onto the flat surfaces and extending up around the neck of the *bianhu* are representations of writhing birds and beasts, some of which can be identified as dragons and tigers. Several of these creatures appear on the upper surface of the lid. Low rounded mountain peaks along the edges of the composition suggest an ambiguous space within which the beasts are disporting themselves. These experiments in depicting landscape elements are early reflections of concern by Chinese artists, an interest that was to become paramount in succeeding centuries. By the beginning of the Han dynasty, few remnants of the earlier motifs derived from essentially ritual concerns remained in the bronze artisan's vocabulary. A variety of incised textures further enliven the surface of the Sackler bronze. Borders composed of incised diamond and triangular motifs are cut along the two feet, the lower edge, the neck, and the lid of the *bianhu*. All of these geometric motifs are executed with remarkable skill. Comparable designs occur on contemporary ceramic vessels based on bronze prototypes and unearthed in southern China. Bronze vessels decorated with these motifs may also be the product of southern foundries that reflect a regional stylistic preference.

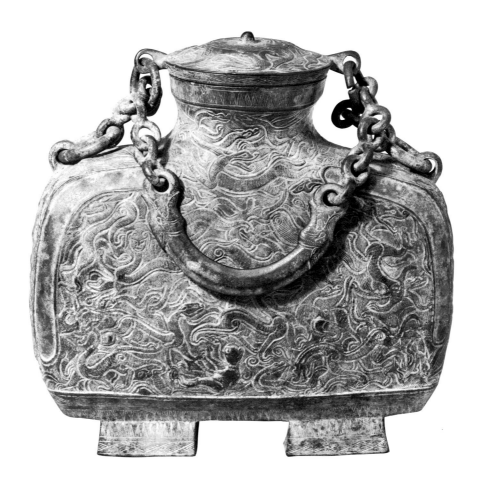

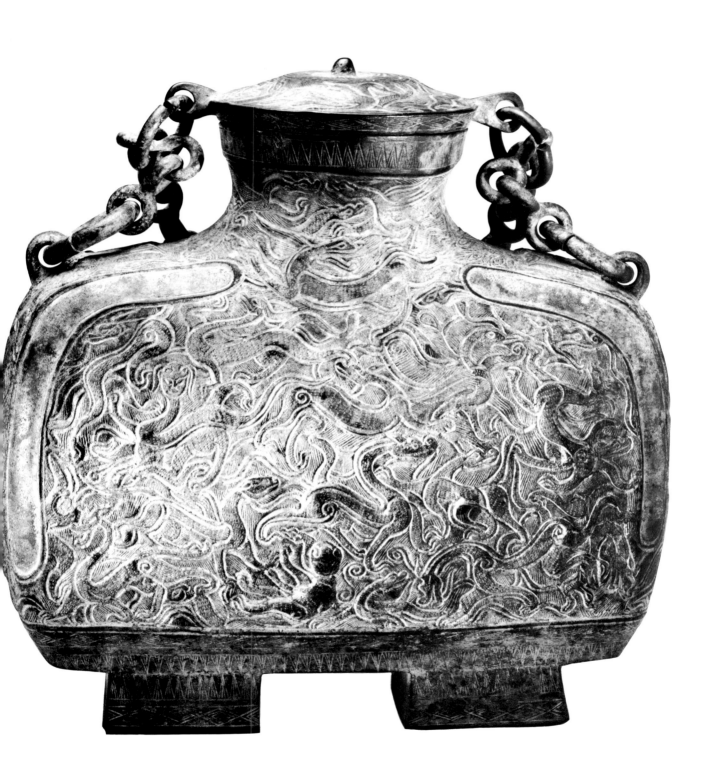

Garment Hooks

BRONZE, JADE, and iron garment hooks were generally used in ancient China to hold two pieces of a costume together, to secure a belt, or to suspend a sword or a knife. Many garment hooks are elaborately decorated, suggesting they were enjoyed as ornaments as well as for their practical value.

Apparently the earliest reference to a garment hook in a Chinese text occurs in a work dated to the third century B.C. It is noteworthy that Duke Huan (reigned 685–643 B.C.) wore a kind of hook while in battle, raising the possibility that it might have been of the type worn by nomadic mounted tribesmen. Garment hooks were probably introduced from outside China by such nomads. King Wuling (reigned 325–299 B.C.), for example, ruler of the State of Zhao, located in the area included in modern Shaanxi and western Hebei provinces, had many contacts with the nomads who frequented the northern borders of China. According to traditional accounts, King Wuling realized the value of developing a mobile cavalry to prevent incursions by foreign tribes from the north. In spite of the resistance of his people, in 307 B.C. the king decreed that his troops should adopt the more practical nomadic costume.

Several figurines from Warring States (480–221 B.C.) burials are shown wearing small hooks on belts at the waist. A specific type of garment hook depicting a human figure holding the hook portion of the piece, known in a fragmentary bronze example from a late Warring States tomb near Tianjin, Hebei Province, is also seen on one of the life-sized pottery figures from the Qin dynasty (221–206 B.C.) pits near the imperial mausoleum at Lintong, Shaanxi Province. A few of those ceramic warriors wear a simple hook at the waist. Perforations at both ends of a cloth belt accommodated the button at the back of the hook and the curving portion at the end of the hook itself.

A number of garment hooks have been found in burials dated to the middle (ca. 670–

570 B.C.) and late (ca. 570–481 B.C.) Spring and Autumn period. According to archaeological reports, most hooks of the early type were found beside the skull of the deceased, and later types were placed near the waist, raising questions as to their precise functions. Chinese garment hooks are found in an extraordinary range of sizes, further suggesting that they were not always used to secure belts.

A few hooks have been identified as supports for bronze swords. Those hooks, which belong to the culture of the State of Chu (during the Eastern Zhou period) presumably would have been worn with the hook downward rather than in the horizontal position of those attached to secure a belt.

Some other small metal hooks may also have been worn vertically on a belt to support small knives, pouches, or related personal paraphernalia. Evidence of extreme wear on some of those metal hooks makes it clear that they were subjected to heavy use. Small hooks have been found in tombs on the chest of the deceased. Their size and placement suggest that the hooks were meant to join the lapels of a garment. In other instances, hooks have been found near the head of the deceased and may have been part of an elaborate headdress.

Although it is unusual to find more than one or two examples in a single tomb, there are rare instances in which as many as six or seven were interred with a body. It would seem that the general practice of including a single hook in a tomb was followed throughout China, but there were also instances when larger quantities of hooks were amassed and buried with other funerary paraphernalia to enhance the prestige of the deceased.

THOMAS LAWTON

156 *Garment Hook*

Eastern Zhou dynasty,
Warring States period,
5th–4th centuries B.C.
height 20.1, width 1.3, depth 3.7 cm
(7¹⁵⁄₁₆ × ½ × 1⁷⁄₁₆ in)
s87.0439

The gold-sheathed hook of this slender, bow-shaped bronze garment hook is realistically modeled in the shape of a horned dragon supported by a crouching bear. A tear-shaped piece of turquoise is set into the forehead of the dragon. The main, rounded portion of the garment hook is divided by curvilinear gilded bands that are suggestive of fantastic creatures. Irregularly shaped turquoise chips fill the interstices between those bands. There are some minor losses in the gilded bands and turquoise chips. The back of the garment hook is lined with silver, as is the surface of the heavily corroded, round button that rises from the center.

A garment hook similar in size, shape, and decoration to the Sackler Gallery example is among the artifacts said to have been unearthed in the Eastern Zhou tombs at Jincun, near Luoyang, Henan Province, in the 1920s. Although the elegance and technique manifested in the Sackler garment hook suggest a Warring States period date for the piece, the Jincun provenance should remain tentative.

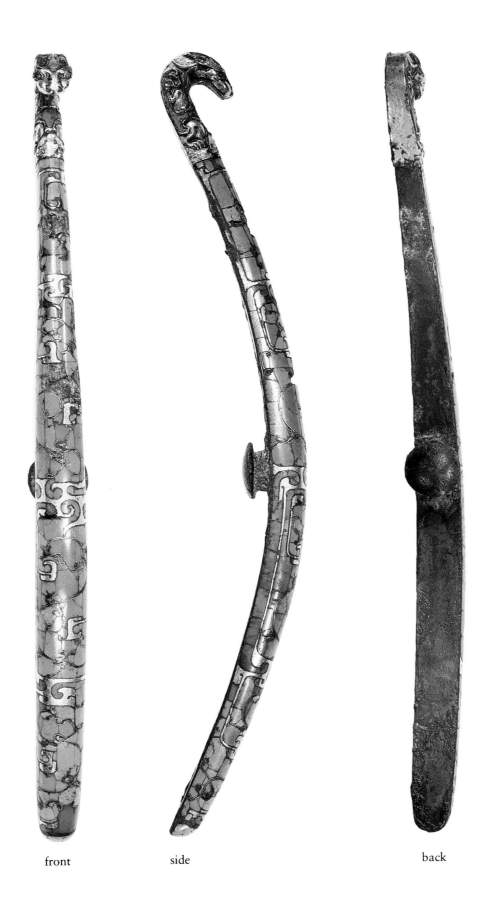

front side back

a

b

157 *Garment Hooks*

Eastern Zhou dynasty,
Warring States period,
5th–4th centuries B.C.
(a) height 19.4, width 3, depth 1.8 cm
(7⅝ × 1³/₁₆ × ¹¹/₁₆ in)
s87.0418
(b) height 23.2, width 4.2, depth 3.6 cm
(9⅛ × 1⅝ × 1⁷/₁₆ in)
s87.0435

These two garment hooks are of special importance because they are cast iron and embellished with gold and silver. Chinese artisans used iron for luxury items, such as garment hooks, as early as the Warring States period. It is indicative of their ingenuity and inventiveness that those artisans should combine iron, which earlier had been used principally to cast utilitarian farm implements, with precious metals like gold and silver.

In spite of the heavy corrosion of the iron surfaces of the two Sackler garment hooks, which obscures many details on the hook portions, some of the gold and silver designs inlaid along the surfaces are still visible. The small curls and diagonal bands are characteristic of inlay decoration on bronze vessels dating from the Warring States period.

Some indication of the original appearance of these two fragile, badly corroded, iron garment hooks is provided by the examples found in an imposing Warring States period tomb in Changtaiguan, Xianyang Xian, Henan Province, in 1956. Those iron hooks, like the bronze vessels unearthed at the same site, were found in pristine condition, without any corrosion or patina. The contrast between the different metals is extremely pleasing, and by studying those hooks from Changtaiguan, the appeal iron had for Chinese artisans who enjoyed experimenting with new and unusual materials can be readily understood.

158 *Garment Hook*

Eastern Zhou dynasty,
Warring States period,
5th–4th centuries B.C.
height 17.8, width 2.3, depth 3.7 cm
(7 × ¹⁵⁄₁₆ × 1⁷⁄₁₆ in)
s87.0413

Along its length, the surface of this garment hook is separated into three narrow facets. Inlaid gold and silver patterns based on contrasting diamonds and curls embellish the side facets. The center facet is inset with gold, silver, and turquoise. Some portions of the inlay are missing. A circular button inlaid with a whorl design projects from the wider end of the reverse of the garment hook.

Inventive shapes and technical finishes are characteristic of Chinese garment hooks produced during the Warring States period. The rich inlays and gilded surfaces reflect the Chinese artisan's concern for coloristic effects.

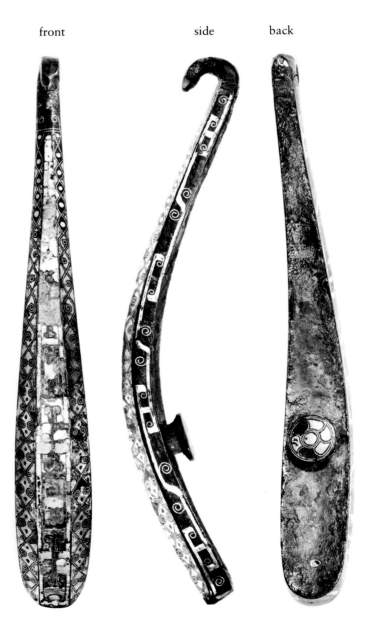

front side back

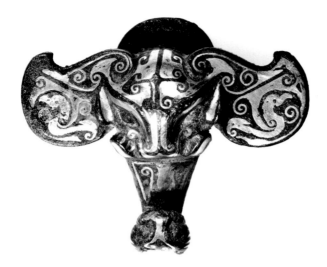

159 *Sword Hook*

Eastern Zhou dynasty,
Warring States period,
5th–4th centuries B.C.
height 4.2, width 4.8, depth 1.9 cm
(1⅝ × 1⅞ × ¾ in)
s87.0438

The surpassing technical finish and sumptuous inlay of this small hook give the utilitarian object the aura of jewelry. Although it is reasonable to assume that the hook did serve a functional purpose, it may have been meant for use on purely formal or ceremonial occasions.

The Sackler hook is fashioned in the shape of an elephant head, dominated by large, flat ears, while a curling trunk forms the hook itself. Smaller, pointed ears appear behind the elephant's eyes. A large, flat, circular button projects from the reverse surface of the hook. Gold and silver inlay patterns that include abstract spirals and volutes as well as stylized birds cover the surface of the hook.

The Sackler hook closely resembles several Warring States period examples unearthed in Hebei and Hunan provinces and identified in Chinese archaeological reports as supports for swords on the basis of their placement in tombs. Several of the hooks were actually associated with bronze swords when excavated. These sword hooks, which incidentally were excavated in areas known to be under the political and cultural domination of the ancient State of Chu, presumably were worn with the hook downward rather than in the horizontal position of those attached to secure a belt.

160 *Garment Hook*

Eastern Zhou dynasty,
Warring States period,
4th–3d centuries B.C.
height 24.8, width 9.4, depth 5.6 cm
(9¾ × 3¹¹⁄₁₆ × 2¼ in)
s87.0437

Although the size of this garment hook in the shape of a rhinoceros is remarkable, it does not equal the iron example unearthed in a late Eastern Zhou tomb in Hubei Province that is almost twice as long. It seems unlikely that pieces of such extravagant size were meant for practical use. More likely they were ostentatious luxury items, perhaps awarded in recognition of merit.

More important than size, however, is the sophisticated presentation of the rhinoceros that forms the major portion of the Sackler garment hook. The rhinoceros' clearly defined head, ear, horns, and body are decorated with a series of small-scale abstract designs inlaid with gold and silver. Only a portion of the inlay remains. Designs of this same type appear on bronze ritual vessels made during the Warring States period, where they overlay the surface and have no relationship to the natural forms suggested by the object.

Two rhinoceros-shaped garment hooks unearthed in a late-Eastern Zhou dynasty burial in Sichuan Province in 1956 provide additional information about the Sackler example. Comparison of these garment hooks makes it clear that the tip of the larger horn on the Sackler piece is incomplete.

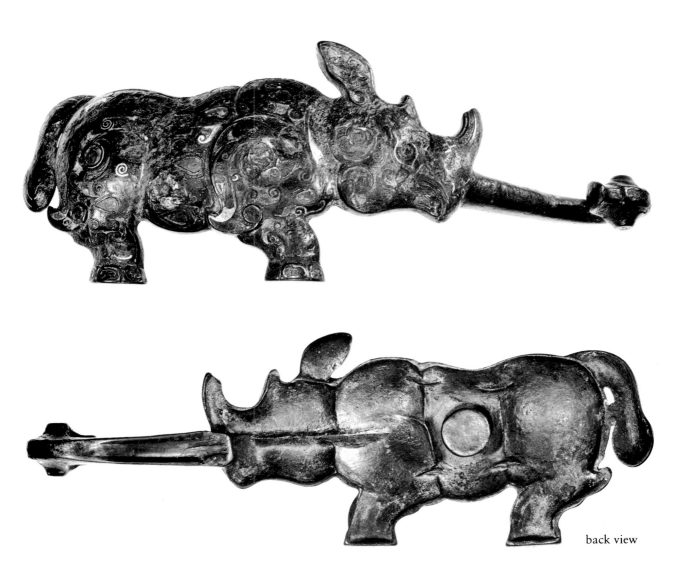

back view

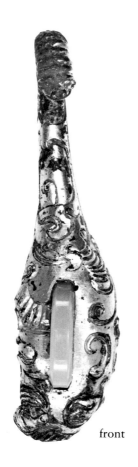

front

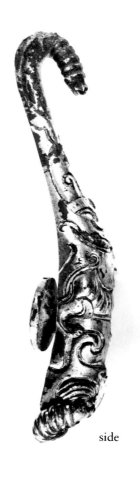

side

back

161 *Garment Hook*

Han dynasty, 3d–2d centuries B.C.
height 10.6, width 2.5, depth 2.9 cm
(4⅛ × 1 × 1⅛ in)
s87.0441

The curved hook portion of this gilded bronze piece
takes the form of a serpentine head emerging from a
series of fluted bands. A more complex arrangement
of that same type of fluting, although on a larger
scale, is repeated on the monster mask at the oppo-
site end of the garment hook. A human face appears
on the arched, central portion of the piece, perhaps
meant to echo the clawed legs that are firmly braced
against either side of an abstract curvilinear band. A
round button projects from the lower portion at the
back of the garment hook.

An oval disk of white jade, set on end, is inserted
into the central section of the garment hook. Al-
though it is not unusual to find Chinese gilded
bronze garment hooks embellished with jade, the
compositional effect of this jade disk is unexpectedly
dramatic.

244

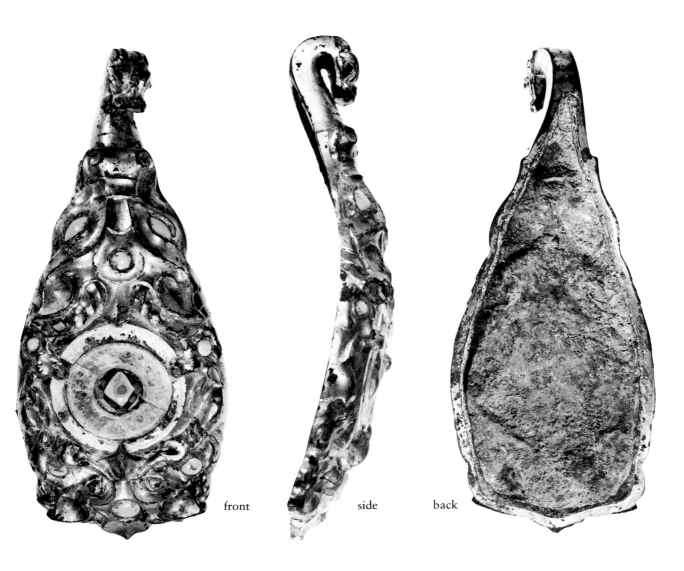

front side back

162 *Garment Hook*

Han dynasty, 3d–2d centuries B.C.
height 14.2, width 5.8, depth 2.9 cm
(5⁹⁄₁₆ × 2¼ × 1³⁄₁₆ in)
s87.0436

Gilded bronze designs cast in high relief present symmetrically intertwined animals over the entire face of this garment hook. At both ends of the body of the garment hook are large animal masks seen en face. Pieces of polished turquoise are inlaid into the animals' foreheads and, on the larger of the two masks, into the eyes. The heads of two deer-like creatures project onto the circular jade ring, which is further embellished with a glass bead. The surface of the jade ring is decorated with small, raised spirals. The hook terminates in a precisely modeled dragon head.

A gilded bronze garment hook inset with jade rings and glass was unearthed at Guweicun, Hui Xian, Henan Province. That garment hook is considerably larger than this example, but it displays the same boldness of decoration and the frenetic, undulating movement in the depiction of the fantastic creatures.

163 *Garment Hook*

Han dynasty,
2d century B.C.–2d century A.D.
height 11.8, width 3.7, depth 2 cm
(4⅝ × 1⁷⁄₁₆ × ¾ in)
s87.0434

The major portion of this remarkable garment hook is dominated by a human-headed figure with ele-phantoid ears, shrouded in a full-length garment, on which the rhythmic pattern of concentric drapery folds is indicated by raised fluting. Raising both arms, the figure grasps the symmetrically flowing bodies of a pair of serpents in tightly clenched fists. The body of the figure is dramatically arched in an S-curve and ends in a bushy tail, while the flexed legs serve as supports for the elongated bird at the opposite end of the garment hook. That bird stands with wings unfurled, its large head and beak form-ing the hook portion of the piece. There is a round button projecting from the reverse of the garment hook.

The iconography of this gilded bronze garment hook and those like it has evoked considerable in-terest among scholars. Suggestions about the iden-tity of the human-headed figure have included the Spirit of Thunder and the Queen Mother of the West, deities of ancient Chinese folklore. The ele-ment of fantasy so impressive in this piece also raises the possibility that it may have been made in southern China.

164 *Garment Hook*

Han dynasty, 2d–3d centuries A.D.
height 12.6, width 2.5, depth 2.5 cm
(4^{15}/$_{16}$ × 1 × 1 in)
S87.0447

This garment hook is one of the most ornate in the Sackler Gallery. With only slight variations in symmetry throughout the composition, the various forms merge into one another and are embellished with a variety of rich, coloristic materials that enhance the total visual effect. The hook itself is a stylized bird's head inset with turquoise chips. At the center of the composition is a fabulous creature that clasps a fish in its large talons. Both the monster and the fish are decorated with inlaid gold and silver

patterns. A tripartite foliate design at the extreme end of the hook balances the bird's head at the opposite end. A large circular button projects from the center of the back of the hook. There is a nine-character inscription incised into the back surface that refers to elements of the decorative motifs. Several other garment hooks of this same type (also inscribed) are known.

A garment hook of approximately the same size and form as the Sackler example was unearthed in a large-scale tomb near Nanjing in 1974. In the Chinese archaeological report, the editors comment on the unusual iconography of that garment hook. On the basis of the other contents of the tomb, particularly the glazed ceramics, the editors suggest that the burial should be assigned to the period around A.D. 265–80.

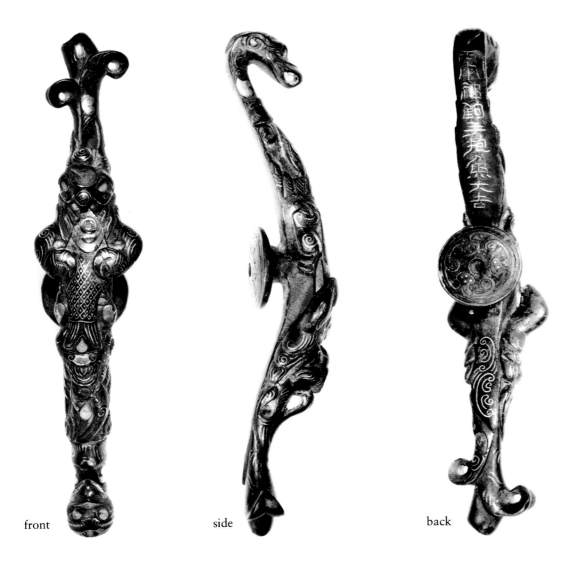

front side back

Lacquer

L ACQUER PREPARED from the sap of the lacquer tree has been used in China for coating and decorating objects made of wood and other materials since the Neolithic period. Remains of lacquer from a Late Neolithic site datable to the fourth millennium B.C. confirm the early discovery of this natural medium, which was to become one of the most important and distinctive in the arts of Asia.

The physical and aesthetic properties of natural lacquer combine excellent adhesion and resistance to moisture with a naturally glossy, durable finish that is amenable to a remarkable variety of decorative techniques, such as painting, engraving, carving, and inlay. Because of the beauty and durability imparted by lacquer to objects constructed of intrinsically fragile materials, such as wood, bamboo, and textiles, lacquer coating is useful for storage containers, for utensils and vessels employed in serving food, and for furniture.

Although several related species produce sap suitable for use as a varnish, the principal source of lacquer in China has been the natural sap of *Rhus verniciflua*, a native tree. The raw lacquer collected by cutting the bark is a latex that hardens to a glossy, dark brown finish that is impervious to liquids and exceptionally stable. Although raw lacquer is toxic to the skin and must be prepared and handled carefully, the superior protective and decorative qualities of cured lacquer have encouraged its continuous use and the expansion of its potential as an artistic medium.

Considerable skill, time, and care are required for the production of the finest lacquer objects. Consequently, they have enjoyed high status and were included in imperial tombs and among objects commissioned by patrons of elevated social rank. Although the highest quality lacquer objects tend to be the best preserved, it is likely that various levels of quality were produced in all periods. The names of most lacquerers remain unknown, but the names of a

few, specifically those who excelled in decorative techniques such as carving and inlay, are recorded in historical documents, a mark of the value of the best lacquer objects.

Fragmentary remains of lacquer objects datable to the thirteenth through the twelfth century B.C. from sites in the Shang dynasty capital, Anyang, indicate that decorative techniques in that early period already included painting in red and black lacquer and inlaying of mother-of-pearl. Lacquer painting in an expanded palette of colors appears as the dominant technique in the beautifully preserved objects from the tombs of Warring States period (480–221 B.C.) and Han dynasty (206 B.C–A.D. 220) rulers. Certain pigments mixed with lacquer yield vivid colors, such as red, yellow, green, and black, but additional colors, such as blue, pink, and ivory, can be produced by blending pigments with an oil medium and applying them to a lacquered surface (nos. 182, 183). Silver and gold can also be mixed with lacquer or applied as powder or foil to a lacquered surface.

In later periods, especially from the Song dynasty (960–1279) through the Qing dynasty (1644–1911), painted lacquer decoration was generally superseded by techniques of engraving, carving, or inlaying the lacquer surface. These techniques, which stress the plastic rather than the painterly qualities of the medium, flourished and evolved in China to a level never equaled in the history of lacquer art.

Qiangjin is a method that involves linear engraving in a relatively thin lacquer surface and filling the recesses with gold leaf (no. 170). This technique at its highest level of quality produces fine linear pictorial designs.

Carved lacquers require the application of many thin coats of lacquer to form a veneer up to several millimeters thick. It is estimated that the preparation of the lacquer piece for carving, which can involve hundreds of separate coats, might take one or more years to complete. The lacquer can then be carved with remarkable precision to create abstract or pictorial designs. The difficulty and expense involved in producing carved lacquer objects and furniture has always been so great that their use has been restricted until recently to the uppermost classes of Chinese society. The enduring Chinese appreciation of the beauty of relief decoration is paralleled in other media as diverse as jade, bronze, stone, and ceramics.

Extraordinary finesse also characterizes lacquers inlaid with mother-of-pearl, which employs thin pieces of iridescent shell in delicate, pictorial designs of minute scale. Closely related to this technique, and at times combined with it, is inlay of silver and gold foil.

The prevalent decorative motifs of Chinese lacquers range from simple geometric schemes to elaborate pictorial designs. Auspicious supernatural animals, such as the dragon, the phoenix, and the *qilin,* appear frequently on lacquers. Emblems of longevity, such as pine, bamboo, and plum, or the flowers of the four seasons also appear in lacquer decoration. Birds-and-flowers and natural landscapes similar to themes found in Chinese painting or scenes carrying literary allusions are also found in later Chinese lacquers.

The beauty and quality of Chinese lacquers were recognized not only in China but also in neighboring countries of East Asia, where Chinese lacquers were exported. Valuable pieces of Chinese lacquer encouraged the adoption of Chinese decorative techniques by lacquerers in Japan, Korea, and the Ryukyu Islands.

Research on Chinese lacquers in collections throughout the world and the new evidence being disclosed by archaeological excavations are constantly expanding our understanding of the quality and diversity of Chinese lacquer. The masterpieces of lacquer are among the finest achievements of Chinese craftspeople.

ANN YONEMURA

165 *Lobed Oblong Tray*

Southern Song dynasty, 1127–1279
black lacquer on wood
height 4, width 37, depth 14.5 cm
(1⁹⁄₁₆ × 14⁹⁄₁₆ × 5¹¹⁄₁₆ in)
s87.0364

The multilobed sides of this elongated tray flare upward to a flat rim with a narrow ridge along its outer edge. This kind of regular lobing is often described as resembling chrysanthemum petals. Supported by a thin footrim, the tray is formed of wood coated with layers of black lacquer that have aged to a rich, slightly variegated brown tone.

The beauty of undecorated or monochrome lacquers depends on the shape of the object. Although the simple technique of coating objects with black or red lacquer must have been used in China beginning soon after the discovery of this natural medium, monochrome lacquers from the Song dynasty (960–1279) have gained special admiration. Their graceful forms often reflect those of ceramics or metalware of the same period. Chinese archaeological excavations have yielded many undecorated lacquer pieces representing a range of types produced during the Song dynasty.

166 Carved Lacquer Circular Tray

Southern Song dynasty, 1127–1279
black, red, and yellow lacquer on wood
height 3.8, diameter 28.5 cm
(1½ × 11³⁄₁₆ in)
s87.0380

Filling the surface of this tray are carved designs of two birds with long plumage in a ground of peonies and other flowers. Around the underside of the rim are peony and chrysanthemum scrolls. Each motif is clearly defined without overlapping others. Details are carved into the individual elements, but the uppermost surfaces are relatively flat. This type of design is typical of Chinese carved lacquers attributed to the Song dynasty. Later carved lacquers tended toward more rounded relief carving.

The surface of the tray is covered with a thin layer of black lacquer, but the original red color is visible where the black lacquer has worn away. Two thin layers of bright yellow are evident among the red layers. It is possible that the tray was relacquered with black after exportation to Japan in order to adapt it for use in Buddhist ceremonies. Although this tray has undergone some modification and repair, it is an important early example of Chinese pictorial carved lacquer.

167 Carved Lacquer Circular Tray

Southern Song dynasty, 1127–1279
black, red, and yellow lacquer on wood
height 5.2, diameter 34.9 cm
(2¹⁄₁₆ × 13¾ in)
s87.0372

One of the earliest types of Chinese carved lacquer, described in later Chinese texts as *tixi*, is represented by this circular tray with a low footrim. In *tixi* pieces, the lacquer surface is built up of many superimposed thin layers of lacquer, forming distinct strata of contrasting colors. In this example, yellow and red alternate beneath a final layer of black. After the coats of colored lacquer were applied and individually hardened, the surface was carved with broad, V-shaped grooves. The underlying colored layers were exposed by the carving, producing a striking contrast to the black lacquer surface. The motifs of linear lobed and curved patterns are arranged symmetrically in relation to a square within the circular rim of the plate. The decorative motifs are similar to those found on excavated lacquer and metalwork from Southern Song tombs.

Carved lacquer trays showing this type of decoration are relatively rare. Of the few known pieces, this is the only one in the United States.

Note
For discussion of *tixi*, see Sir Harry Garner, *Chinese Lacquer*, London, 1979, pp. 71–73.

168 *Carved Lacquer Circular Tray*

Southern Song dynasty, 1127–1279
red, yellow, and black lacquer on wood
height 4.8, diameter 31.4 cm
(1⅞ × 12⅜ in)
s87.0396

One of the finest and best preserved of surviving Song dynasty carved lacquers, this work is the best example of that type in the Sackler Gallery. Carved with precision in low relief, two phoenixes with elaborate plumage fly in opposite directions among flowers. The flowers of the four seasons on the surface of the tray—winter plum blossoms, spring peonies, summer lotuses, and autumn chrysanthe-

mums—are repeated on the underside of the rim. The carved lacquer layer is predominantly red, with a single thin layer of black visible between the upper surface and the yellow lacquer ground. The tray has a footrim decorated with a simple, stylized floral motif.

Stylistically and technically, this carved lacquer tray is closely related to a few other examples that date to the Southern Song dynasty. In form and structure, the piece compares with other Song carved lacquer trays in the Sackler Gallery (nos. 166, 167); the nature of the bright yellow lacquer is also similar. Like other Song carved lacquers having pictorial designs, the motifs in this example are shallowly but precisely carved and are individually defined in relation to the ground rather than overlapping each other as in later carved lacquers.

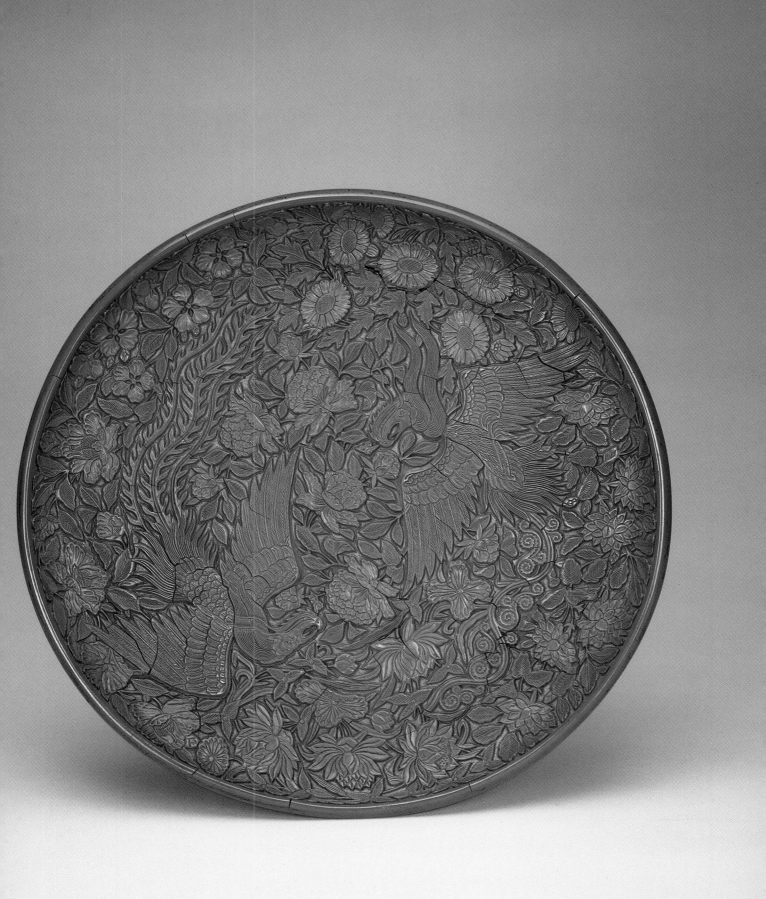

169 Circular Dish with Inlaid Mother-of-Pearl

Southern Song–Yuan dynasties,
13th–14th centuries
red, black, and green lacquer on wood with
inlaid mother-of-pearl
height 2.3, diameter 19.8 cm
($^{15}/_{16}$ × $7^{13}/_{16}$ in)
S87.0369

A strong, naturalistic pictorial decoration comple-
ments the very simple circular form of this dish. The
ground color of the upper surface is red lacquer; the
outer surface of the rim is coated with green lac-
quer, and the base with black. The main design—a
pair of birds in a blossoming plum tree—is executed
in inlaid mother-of-pearl, with some traces of *qiang-
jin* (engraved lines filled with gold) along the perim-
eter of some of the inlays.

The dish shows evidence of damage and repair,
and the extent of the original decoration is difficult
to determine. In comparison to other Chinese inlaid
mother-of-pearl lacquers, the inlay on this dish is
executed in relatively large yet carefully shaped
pieces of mother-of-pearl with engraved detail.

It is difficult to place this piece securely within the
chronological sequence of Chinese lacquers inlaid
with mother-of-pearl, a decorative technique that
was in use as early as the Shang dynasty (ca. 1700–
ca. 1050 B.C.). Evidence of surviving examples of
this technique datable from the Tang dynasty (618–
907) through the early fifteenth century demon-
strates a general trend toward the use of smaller,
thinner pieces of shell in the later periods. This dish
may represent a relatively early phase in the evolu-
tion of pictorial mother-of-pearl inlay, which flour-
ished in lacquers of the Yuan and Ming dynasties.

Note
For discussion of *qiangjin*, see Sir Harry Garner, *Chinese
Lacquer*, London, 1979, pp. 155–56.

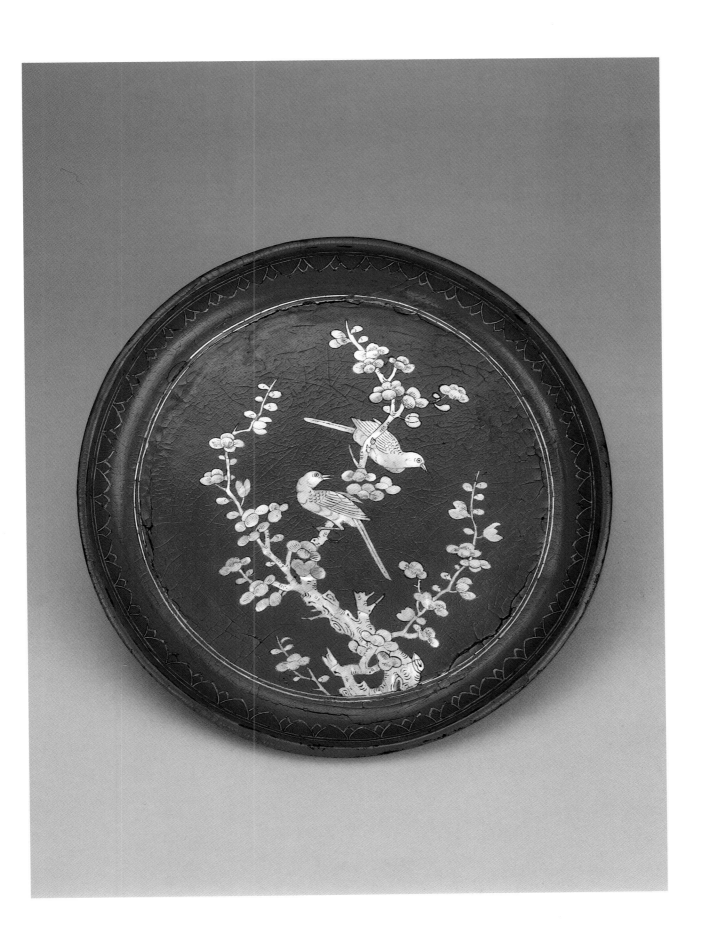

170 *Octagonal Box with Qiangjin Decoration*

Yuan dynasty, 1279–1368
red and black lacquer and gold on wood
height 17.5, width 17.8, depth 18 cm
(6⅞ × 7 × 7¹⁄₁₆ in)
s87.0376a,b,c

The exterior surfaces of this octagonal box were decorated using the *qiangjin* technique—engraving the lines into the red lacquer surface, then filling the recesses with gold leaf held in place by an additional application of lacquer. *Qiangjin* appears in Chinese lacquers datable to the Southern Song dynasty (1127–1279). *Qiangjin* wares were exported to Japan as early as the fourteenth century, and the technique may have been introduced by the Chinese to the Ryukyu Islands in the early fifteenth century.

 This box is constructed in three sections: a footed base, a central octagonal ring, and a lid. The undecorated interior is lacquered black. A naturalistic peony spray is the central motif on the lid; on the sides are peony scrolls. Horizontal lines demarcate the floral panels, and a blade-like motif is repeated on the base. This elegant box represents one of the earliest types of *qiangjin* lacquerware and is probably datable to the fourteenth century.

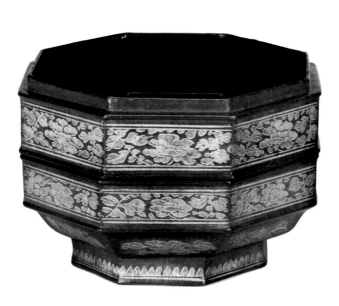

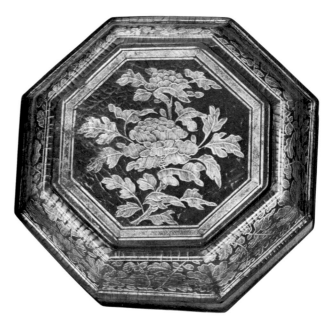

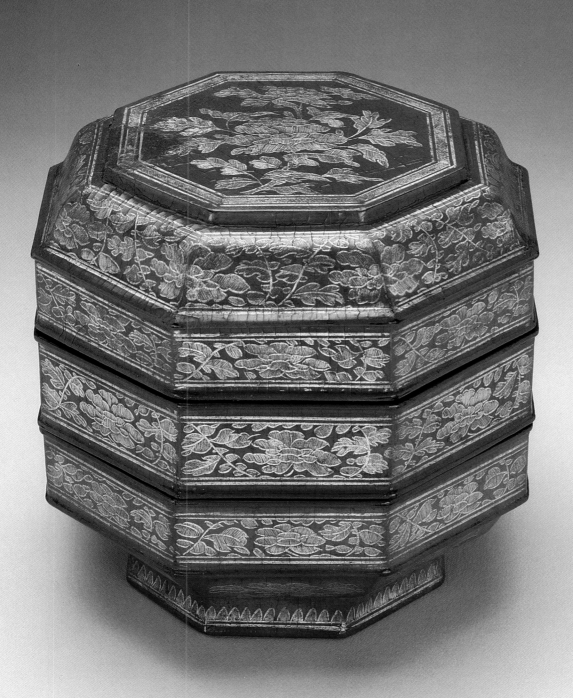

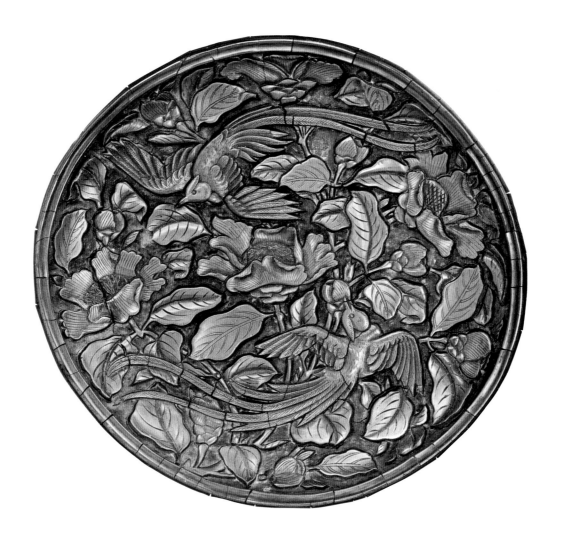

171 *Carved Lacquer Circular Dish*

Yuan dynasty, 1279–1368
red, yellow, and black lacquer on wood
height 3.2, diameter 18.2 cm
(1¼ × 7³⁄₁₆ in)
s87.0385

Two crested birds with long tail plumage fly among camellia branches to form the carved decoration of this small circular dish. Like the square dish (no. 172), the design is carved in a predominantly red lacquer layer, exposing a contrasting brownish yellow lacquer ground. The underside of the rim of the dish is decorated with simple, rounded scroll designs. Inside the low footrim, the underside of the dish is lacquered black. The decorative scheme of paired birds and flowers appears often on Yuan dynasty carved lacquer trays, but this example is unusual for its small scale.

172 Carved Lacquer Square Dish

Yuan dynasty, 1279–1368
red, yellow, and black lacquer on wood
height 2.8, width 19.8, depth 19.6 cm
(1⅛ × 7¹³⁄₁₆ × 7¹¹⁄₁₆ in)
s87.0384

This dish has a square shape with indented corners and pointed sides that is very rare among Yuan dynasty carved lacquer dishes. The low foot is shaped identically to the contour of the dish. The thick red lacquer upper surface of the dish is carved with a dense, overlapping design of peonies arranged naturalistically as if growing from a point along one side of the frame. The brownish yellow tone of the base layer of lacquer contrasts with the red, giving a soft definition to the design. The underside of the rim of the plate is carved with a simple scroll motif.

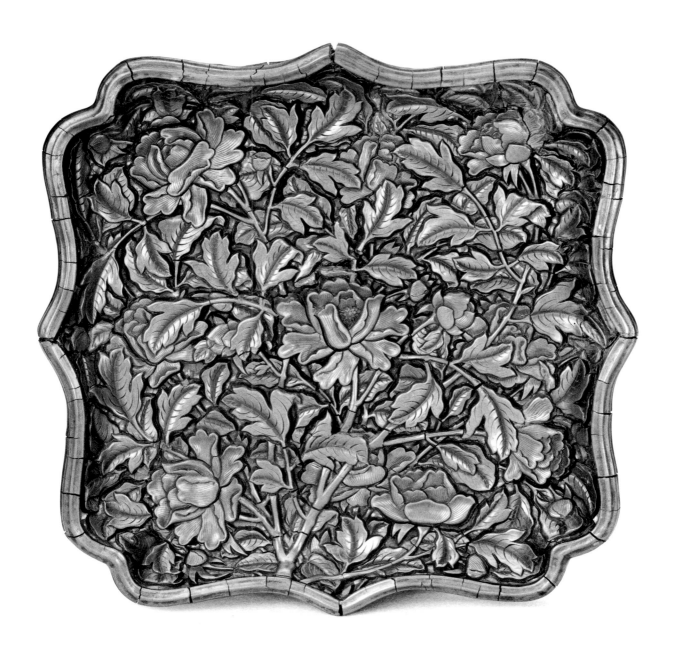

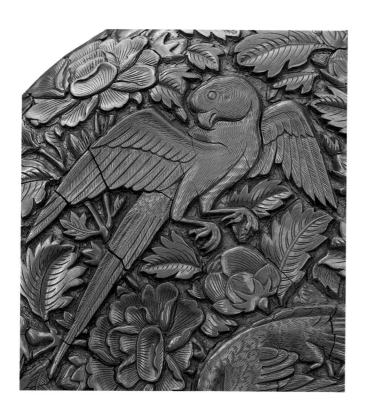

173 Carved Lacquer Circular Box

Yuan dynasty, 1279–1368
red, yellow, and black lacquer on wood
height 7.5, diameter 17.8 cm
(2¹⁵⁄₁₆ × 7 in)
s87.0390a,b

A carved design of two parrots among peonies gives this small circular box its lively and charming quality. Red lacquer serves as the medium for carving, while brownish yellow lacquer is the ground color. The interior and rim of the box are lacquered black. Circular boxes are relatively rare among Yuan dynasty carved lacquers. This is the only known example from this period of a small-scale carved lacquer circular box.

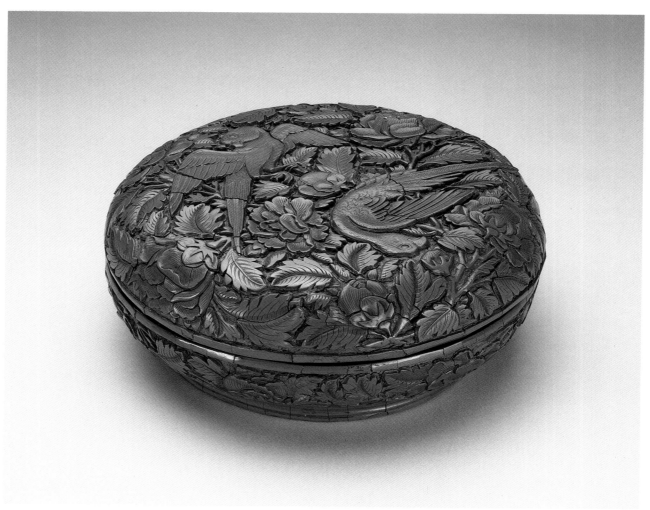

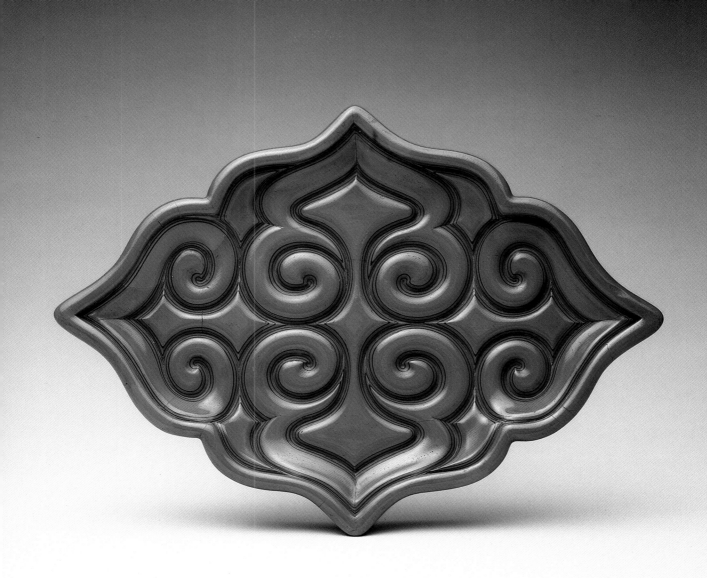

174 *Carved Lacquer Dish*

Yuan dynasty, 14th century
red and black lacquer on wood
height 2.9, width 21.8, depth 16 cm
(1 1/8 × 8 9/16 × 6 5/16 in)
s87.0395

Shaped like a lozenge with bracketed corners, this graceful dish has a foot that repeats the contours. In a thick veneer made of many layers of red lacquer punctuated by two thin layers of black, four deeply carved sword-pommel motifs (*jianhuan*—see Glossary) complement the contour of the dish. The deep, rounded carving and polished finish enhance the simplicity of the decoration.

On the black lacquered bottom of the dish, inside the footrim, are two inscriptions. One is a four-character inscription of uncertain meaning. The other inscription attributes the dish to Zhang Cheng, a famous Yuan dynasty lacquer artist. Although the attribution to Zhang Cheng is not verifiable, the dish represents a high level of skill in fabrication and decoration.

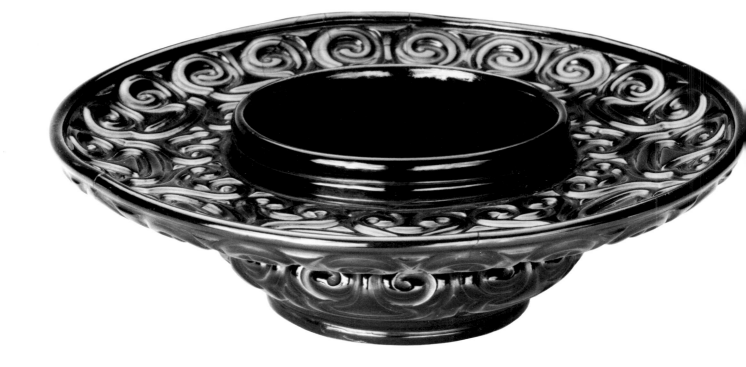

175 *Carved Lacquer Bowl Stand*

Yuan dynasty, 14th century
black and red lacquer on wood
height 6.3, diameter 19.8 cm
(2½ × 7¹³⁄₁₆ in)
s87.0382

Lacquer stands were used to support ceramic bowls that had very narrow bases and steeply flared sides. Hot liquids such as tea were served in these bowls. This stand has a graceful and unusual shape with a low, rimmed opening the same height as the outer rim of the circular flange. The bottom of the stand is closed, and the interior is hollow from the opening at the top to the base.

The elegant shape of this stand is enhanced by the simple rounded carved decoration of sword pommels. The glossy black lacquer surface has aged to a warm, brownish tone. A single thin layer of red lacquer is visible in the incised grooves. This thin layer of contrasting color is thought to have served as a guideline to the carver when making his first cuts into the opaque lacquer surface, preventing damage to the substructure that could occur if the cuts were too deep.

176 *Five-Lobed Carved Lacquer Tray*

Yuan dynasty, 14th century
black and red lacquer on wood
height 3.7, width 30, depth 30.2 cm
($1^7/_{16}$ × $11^{13}/_{16}$ × $11^7/_8$ in)
s87.0377

The upper surface of this tray has been coated with many layers of black lacquer alternating with red to form seven distinct strata. Sword-pommel motifs are carved into the lacquer surface.

Technically, the alternation of strata of colored lacquer is similar to the Sackler Song dynasty tray (no. 167), in which the colored layers have an essential role in the decoration. Here, only two colors are used, and the effect is generally more subdued. Rather than dominating the design, as in the earlier piece, carved grooves are balanced with the glossy black of uncarved areas. The edges of the relief areas are rounded off and polished. This carefully arranged and executed design creates an overall effect of balanced harmony and refinement.

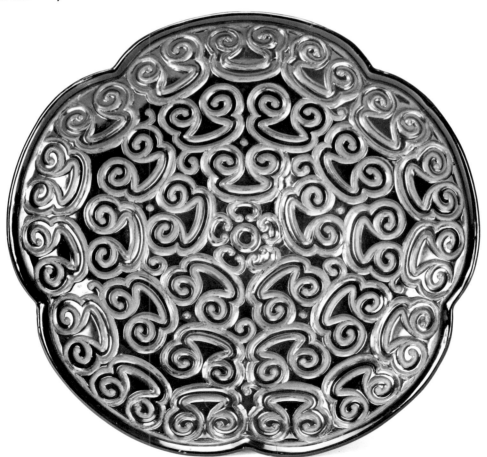

177 Set of Inkstone Boxes with Inlaid Mother-of-Pearl and Qiangjin Case

Yuan–Ming dynasties, 14th–15th centuries
red and black lacquer on wood,
mother-of-pearl, and gold
red outer box
height 30.6, width 23.8, depth 21.4 cm
(12 1/16 × 9 3/8 × 8 7/16 in)
black inner box set
height 24.7, width 21.2, depth 18.6 cm
(9 3/4 × 8 3/8 × 7 5/16 in)
s87.0386a–pp

Thirteen inkstone boxes decorated with inlaid mother-of-pearl are nested to form this set. Six pairs of miniature boxes are set on the larger base box and are surmounted by a single lid. Each unit contains an inkstone and water dropper as well as compartments for brushes. Such sets of boxes were probably used at gatherings where poetry was composed.

The sides of the boxes are decorated with floral and diaper patterns of inlaid mother-of-pearl. On the lid, plum branches and a crescent moon shimmer on a black lacquer background. On the bases of six of the boxes, the character *tian*, meaning "heaven," is engraved and filled with gold leaf.

The outer case, which was apparently made to house the set, is lacquered red and decorated by the *qiangjin* technique. On one side is a pair of *qilin* (supernatural animals), and on the top, a pair of phoenixes.

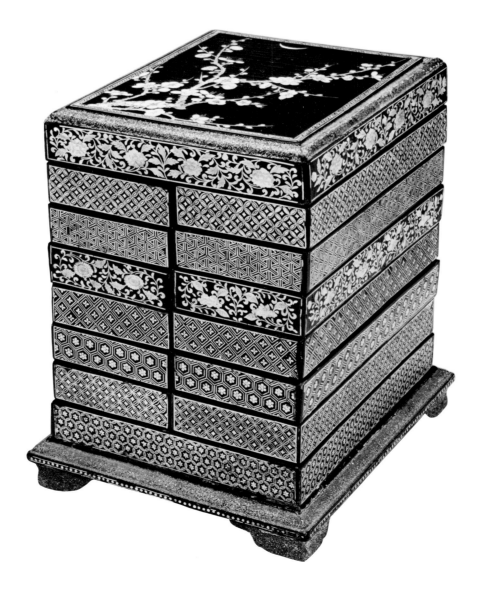

178 *Undecorated Pedestaled Tray*

Yuan–Ming dynasties, 14th century
black lacquer on wood and textile
height 4.8, diameter 29 cm
(1 7/8 × 11 7/16 in)
s87.0365

Narrow lobes suggesting the petals of a chrysanthemum shape the rim of this tray. The raised circular foot, which is angled slightly outward, echoes the crisp lobes of the rim. The beautifully articulated form of this tray gives an impression of lightness and grace.

The foot and center of the tray are constructed of wood, and the rim is formed of layers of coarse textile. The method of constructing lacquer objects from textile is called "dry lacquer." Dry lacquer construction is lightweight and durable, even when very thin. It was favored for detailed or complex shapes, such as the wide rim of this tray. Although less common than wood as a principal structural material for the bodies of lacquer objects, "dry lacquer" has been used in China for small dishes and vessels as well as for large Buddhist sculptures.

Inscribed on the underside of the plate, inside the footrim, is a single character partially effaced. It has been interpreted as reading *you*.

Note
For further discussion, see Lee Yu-kuan, *Oriental Lacquer Art*, New York and Tokyo, 1972.

179 Carved Lacquer Box Inlaid with Ivory

Ming dynasty, 1368–1644
red and black lacquer on wood,
inlaid with ivory
height 7.5, diameter 23.8 cm
(2¹⁵⁄₁₆ × 9⅜ in)
s87.0393a,b

Originally, this box was an example of red carved lacquer typical in shape and decoration of those made in the Yongle era (1403–24). Chinese carved lacquers of this period were manufactured to a high standard by artisans who enjoyed the patronage of the imperial court. An intact example of similar size and shape in the Freer Gallery of Art has virtually identical floral decoration on the sides and a landscape with a garden pavilion carved on the lid.

The circular carved lacquer panel forming the top of the lid of this piece was replaced at a later date with a panel that was lacquered black and inlaid with a pictorial design in ivory. Enclosed by a hex-agonal border with indented corners, the illustration shows a boat and travelers approaching a two-storied pavilion. Although it is difficult to determine the date of the repair and ivory inlay, the style of the design is consistent with late Ming dynasty (early seventeenth century) examples. The careful repair and preservation of this piece reflect the prestige and value of Yongle era carved lacquers, which rank among the finest ever made.

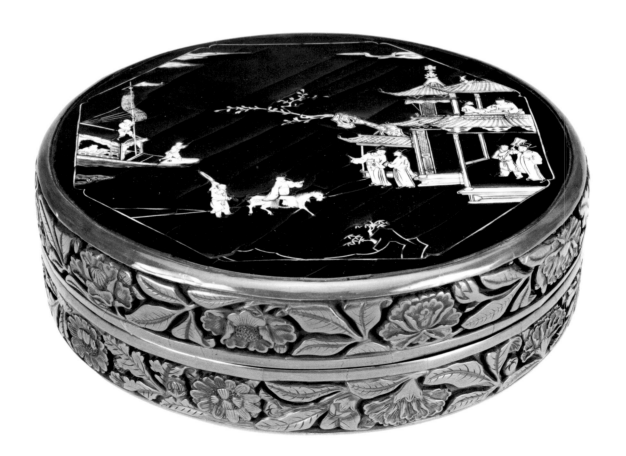

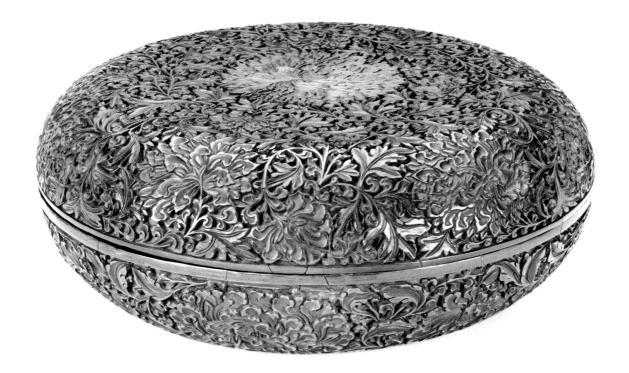

180 Carved Lacquer Circular Box

Ming dynasty, 1522–66
red and black lacquer on wood
height 9.6, diameter 24.7 cm
(3¾ × 9¹¹⁄₁₆ in)
s87.0405a,b

The chrysanthemum scrolls on the exterior of this box exhibit a distinctive sharp, oblique carving technique characteristic of certain pieces bearing inscriptions of the Jiajing era (1522–66). The color of the red lacquer on many of these pieces is slightly dark and smoky in tone, in contrast to the bright vermilion of most Chinese carved red lacquers. Usually the bases are coated with a thin black lacquer. Despite the lower quality of the lacquer that coats these pieces, the fine, crisp carving of detailed motifs on uncomplicated shapes produces an elegant pattern that is enhanced by the play of light and shadow over the surface.

The manufacture of this type of ware has been associated with Yunnan Province on the basis of descriptions in Chinese texts on lacquer manufacture. Although little is definitely known about regional variations of Chinese carved lacquer, the group of pieces to which this example belongs is readily distinguishable in terms of materials and technique.

Note
For further discussion, see Sir Harry Garner, *Chinese Lacquer*, London, 1979, pp. 131–34.

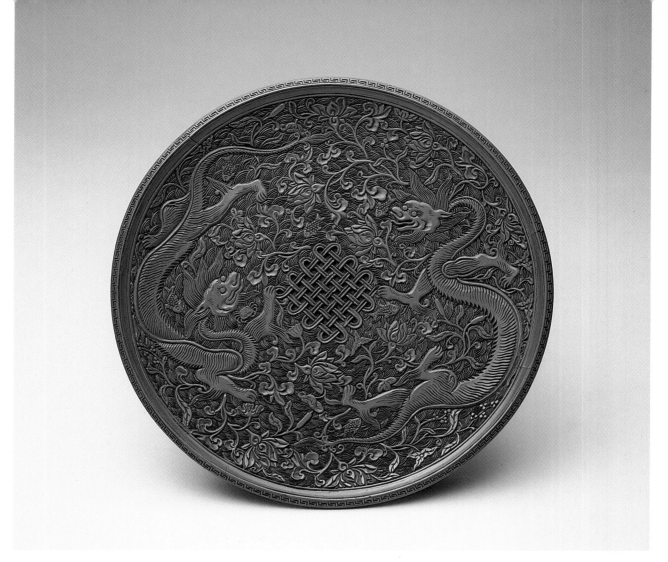

181 *Carved Lacquer Circular Dish*

Ming dynasty, 16th century
red and black lacquer on wood
height 2.4, diameter 18.1 cm
($^{15}/_{16}$ × 7$^{1}/_{8}$ in)
s87.0391

A pair of dragons against a background of stylized waves and lotus scrolls is carved into the red lacquer surface of this dish. On the underside of the rim are chrysanthemum scrolls. The sharp carving of this piece resembles that of the circular box decorated with chrysanthemum scrolls (no. 180). The carving tool held at an oblique angle to the surface produces the beveled incisions on the lacquer. It is difficult to determine the date of execution of this piece, but the dragon motif appears frequently on Ming dynasty porcelains. The dragon, a Chinese supernatural animal, is associated with rain and rivers.

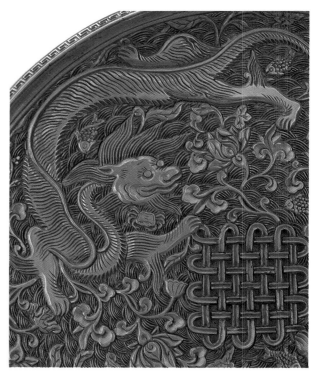

182 Rectangular Box with Pedestaled Foot

Ming dynasty, 1573–1620
red lacquer with polychrome decoration
and gold on wood with bamboo panels
height 18.1, width 44.8, depth 19.6 cm
(7⅛ × 17⅝ × 7¾ in)
S87.0373a,b

Panels of fine woven bamboo basketry, usually accompanied by polychrome or inlaid decoration, characterize the group of late Ming dynasty lacquers to which this exquisite box belongs. The efflorescence of lacquerware made with panels of bamboo basketry and usually with polychrome decoration in southeastern China from the late sixteenth to the early seventeenth century was fostered by the prosperity of the region as well as by the availability of fine bamboo for weaving. The taste for polychrome decoration in lacquers of the Wanli era (1573–1620) parallels trends in other arts, such as wood-block prints and textile design.

Indented corners and delicately woven curved basketry panels are typical of boxes from the late Ming period. Three holes in the base section that would once have held porcelain cups have been filled in. The red lacquer surface of the box covers a layer of black lacquer, and the interior of the lid and the underside of the base are black. Over the top of the lid and base, floral medallion designs have been painted in pastel colors, including white, green, pink, blue, and yellow with touches of gold. Oil is likely to have been the medium for the polychrome decoration, since pigments producing pure blue and white were not compatible with the lacquer medium.

Note
For discussion of Chinese lacquers with basketry panels, see James C.Y. Watt, *The Sumptuous Basket*, New York, 1985.

183 Circular Food Box with Painted Decoration

Ming dynasty,
late 16th–early 17th centuries
black lacquer and polychrome on wood
and gold lacquer on bamboo
height 13.9, diameter 33.8 cm
(5½ × 13⁵⁄₁₆ in)
s87.0401a,b

The open-weave basketry panels forming the sides of this circular box were intended to promote air circulation when the box was used for transporting food. The upper panel and base are made of black lacquered wood. Floral scrolls decorate the rims, and a simple geometric scroll is painted on the foot.

The design on the lid of a pair of pheasants in a landscape is executed by painting with colored pigments. The palette, which includes bright hues such as blue, indicates that an oil medium was employed in the painting. Gilding on the outer woven panels provides an elegant contrast to the colored designs.

Note
For further discussion, see James C.Y. Watt, *The Sumptuous Basket*, New York, 1985, pp. 46–47.

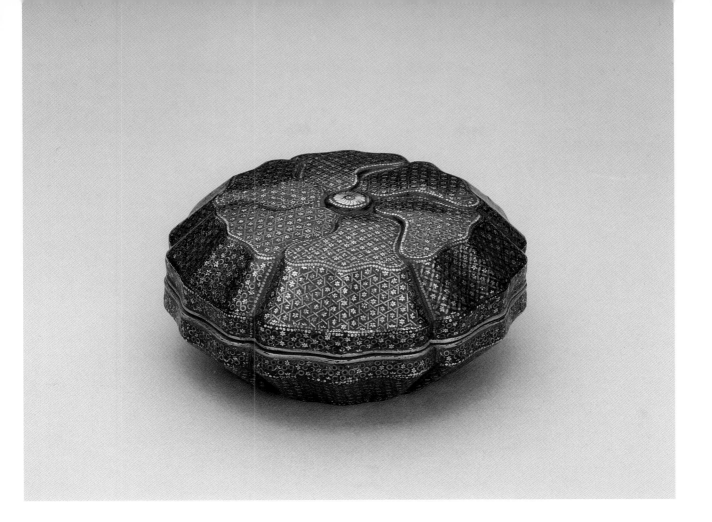

184 *Lobed Box with Inlaid Decoration*

Qing dynasty, 17th century
black and gold lacquer on wood with
mother-of-pearl, silver, and gold
height 3, diameter 6.3 cm
(1³/₁₆ × 2½ in)
s87.0404a,b

The jewel-like surface of this small lobed box shimmers with inlays of gold and silver foil and iridescent mother-of-pearl. The fine designs are formed of minute, precisely shaped pieces of these precious materials. The shell has been split to extremely thin layers, then selected according to natural colors that range from green to violet. Even the base and interior are inlaid with decoration of flowers and fruit.

An inlaid seal on the base provides the name "Jianli," which is identified with a lacquerer named Jiang Jianli, known for finely inlaid lacquer work that combines precious metal foils with colored mother-of-pearl. The attribution to Jiang Jianli is supported by the exquisite design and workmanship of this box.

185 Octagonal Box with Inlaid Decoration

Qing dynasty, 17th–18th centuries
black lacquer on wood with
mother-of-pearl, silver, and gold
height 25.2, width 25.1, depth 24.7 cm
(9¹⁵⁄₁₆ × 9⅞ × 9¾ in)
s87.0407a,b

This meticulously decorated box has a graceful eight-lobed form that is lacquered black and inlaid with figures and landscapes enclosed by borders of lotus scrolls. Men, women, and children are depicted in idyllic settings of gardens and pavilions. Alternating with these scenes are distant views of mountains, rivers, and lakes. Along the base are depicted a brush stand, inkstone, and antique bronzes that would have been used and appreciated by a Chinese scholar.

The quality of workmanship and pictorial design is outstanding and bears a close relationship to the fine technique represented by the small lobed box with the seal of Jiang Jianli (no. 184). The color range from green to violet tones of the minute pieces of mother-of-pearl has been carefully exploited. Brilliant details cut from gold and silver metal foil also accent the design.

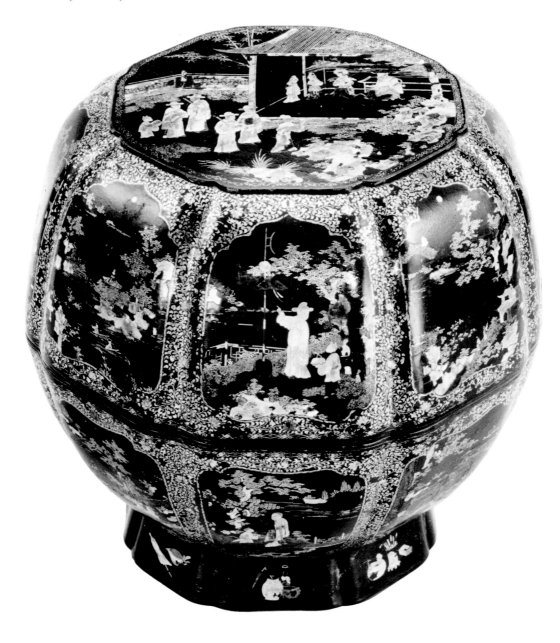

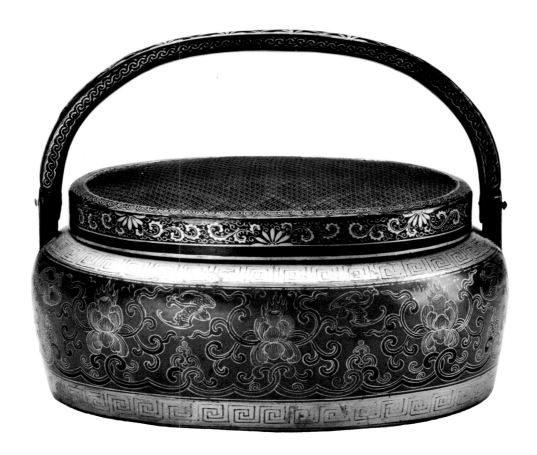

186 *Hand Warmer with Painted Lacquer Decoration*

Qing dynasty, 18th century
colored lacquers and gold on wood with
woven metal wire
height with handle raised 13.8, width 17.9,
depth 13.5 cm
(5⁷⁄₁₆ × 7¹⁄₁₆ × 5⁵⁄₁₆ in)
s87.0403a,b

This small portable lacquer box has a wire mesh
panel in the lid and a metal liner that indicates that
it was adapted for use as a hand warmer. The insu-
lating properties of the lacquered wood provided a
convenient and beautiful container for carrying
warm coals from room to room. The red lacquered
base is decorated with a stylized pattern of bats and
floral scrolls in colored lacquers outlined with gold.
Stylistically, the design appears to be related to Chi-
nese textiles of the eighteenth century.

Painting

P AINTING RANKS with calligraphy and poetry as one of the Three Perfections, the most honored arts in China. Chinese archaeologists have discovered paintings on silk, dating from the third century B.C., in tombs near Changsha, Hunan Province, in the heart of the ancient State of Chu. These paintings depict real and symbolic figures and beasts, which are outlined in fine brush lines with occasional touches of color within the contours.

Painting seems to have developed particularly as mural art in succeeding centuries; examples are found in tombs and in Buddhist caves and temples. The paintings were executed on a white chalklike ground, with a quarter-inch-thick base composed of sandy mud containing a large quantity of rice husks and straw. The names of the great painters of the Six Dynasties (A.D. 220–589), Sui (581–618), and Tang (618–907) periods, and the subjects they explored, are recorded in early histories of painting, but their works do not survive. Figural (human) subjects, both secular and religious and often richly colored, evidently dominated Chinese painting through the tenth century. Although the preference for figure paintings waned after the fourteenth century, portrayals of people still represent an important dimension in the history of Chinese painting (nos. 193, 203, 205).

A class of artists, the literati-painters, who engaged in scholarly activities, became more active and influential after the eleventh century. The literati-painters were not professionals in the way that artisans or court painters were and so did not usually seek to make money or to satisfy a patron. Rather, they pursued painting, calligraphy, and poetry at their leisure and were highly respected in China. The literati-painters developed an orthodox school that differed from the academic or court painters, whose work was more detailed and decorative, and from the individualists, who tended to prefer a more personal style.

Modes of brushwork and expression changed with the rise of the literati-painters, and so did favored subjects. Landscape replaced figures as the dominant theme by the time of the Yuan dynasty (1279–1368), but the literal depiction of nature was not in itself the aim of the landscape painter (no. 190). The goal was the expression of feelings with brush and ink in the symbolic language of pictorial form. Thus from this period on, paintings incorporated calligraphy written directly on the pictorial surface. Often integral to the interpretation of the work, these writings included poems and notes by artists and their friends, contributions by other participants in a gathering of like-minded scholars, and the poems and comments of later connoisseurs. These paintings provide glimpses of the lives, thoughts, tastes, and artistic activities of Chinese literati and literati-painters.

Another important theme for the Chinese artist was that of birds-and-flowers, whose appeal has endured from the tenth century to the present. The genre (which includes animals among its subjects) was enjoyed by both the professionals and the literati-painters, resulting in the development of a great variety of styles, ranging from realistic to expressionistic. Existing for many centuries as a minor theme, birds-and-flowers eventually surpassed landscape in importance during the eighteenth century—after the essential evolution of landscape painting virtually ceased—and remained foremost until the early twentieth century.

Among the other motifs whose meanings resonate for Chinese people through centuries of religion, myth, and custom are the lotus, a symbol of purity deriving from Buddhist sources and frequently appearing in Chinese poetry; bamboo, traditionally a reference to gentlemen; peony, the king of flowers, symbolizing wealth and honor; and chrysanthemum, the emblem of autumn.

The Chinese artist usually painted on silk or paper, the latter fashioned from mulberry bark, hemp, bamboo, or other fibers. (Rice paper was *not* used; it is perishable and serves primarily as wrapping.) Chinese inks, which were made from pine soot or paulownia-oil soot mixed with glue, came in solid cakes and sticks, often ornamented with inscriptions and decorative designs. To obtain liquid ink for writing or painting, the artist methodically ground the inkstick with water on the polished surface of an inkstone. To apply the ink to the paper or silk, the painter used brushes made from various types of animal hair, such as horse, wolf, sheep, sable, and rabbit, selected according to the pliancy desired.

The Chinese have traditionally favored linear qualities in painting rather than the three-dimensional modeling of form. The expressive movement of the artist's elegant brush, creating outlines and texture strokes, was of primary importance, and color was secondary. Indeed, color often seems not so much to enhance the naturalism of forms as merely to clarify pattern areas. The colors can be grouped as water-based vegetable colors and glue-bound mineral pigments. Techniques of monochrome ink painting were frequently chosen by literati-painters for rendering both landscapes and figures, allowing the artist to explore the full range of ink tonalities and textures.

Chinese paintings tend to appear in three major formats. The handscroll, which developed from bookrolls (Chinese books originally were rolled up, scroll fashion), offers free space for the horizontal development of a compositional theme. The viewer who unrolls a

handscroll in private study from right to left may experience the feeling of traveling in space and time. There is no comparable format in Western art (nos. 191, 193, 196, 202, 205).

The hanging scroll, which evolved from Buddhist temple banners, murals, and screen paintings, is the most important format for effective display in private studies as well as in public buildings. The vertical space is ideal for depicting soaring mountains as well as close-up views of flowers and birds (nos. 192, 204, 207).

Fans and album leaves provide yet another alternative for the artist. During the Song dynasty (960–1279), small round or oval fans made of silk stretched over a frame and mounted on a single shaft were fashionable. Folding fans mounted on radiating sticks attained great popularity in the Ming and Qing periods up to the early twentieth century. The round and curved picture spaces provided challenging new compositional frames. Fans and small paintings in square or rectangular shapes by various artists were often collected into album sets, and eventually the painters themselves conceived subjects in sequential and uniform album leaves (nos. 194, 197, 203).

Chinese paintings in all formats—handscrolls, hanging scrolls, and fans and albums—are very easy to carry or store. Each of these formats also provides some blank space for the sister art of calligraphy, typically before and after the central section of a handscroll, on the reverse side of a fan, or on extra album leaves. In addition to the artist's inscription and seals, friends, collectors, and connoisseurs might also add poems, comments, and seals, either on the painting itself or on the mounting. These attached documentations accumulated through centuries help us to interpret and appreciate the beauty and fine art of Chinese painting.

SHEN FU

187 *Seated Musician*

Central Asia
Tang dynasty, 7th–8th centuries
wall painting on stucco
height 38.2, width 36.2 cm
(15 1/16 × 14 1/4 in)
s87.0265

Wearing a bejeweled diadem, earrings, and volumi-
nous robes, the musician is playing a lute. Several
rock-like elements in the right section of the compo-
sition hint at landscape, but it is the figure itself that
fills the arch-shaped space. Apparently, this was one
of a series of musicians that would have been part of
a large composition, perhaps grouped around a
seated Buddha attended by bodhisattvas.

The traditional provenance for this wall painting
is Kizil, located near the important caravan city of
Kucha, in Central Asia. Large numbers of wall
paintings from the rocky caves at Kizil were ob-
tained by members of the Royal German Turfan Ex-
pedition during the last two of four trips to Central
Asia (1905–1907 and 1913–1914). Those paintings
are in the collection of the Indische Kunstabteilung,
Staatliche Museen, Berlin. But those paintings reveal
no influence from East Asia. Given the emphatically
East Asian style of the Sackler *Seated Musician*, it
seems that the traditional Kizil provenance should
be reexamined.

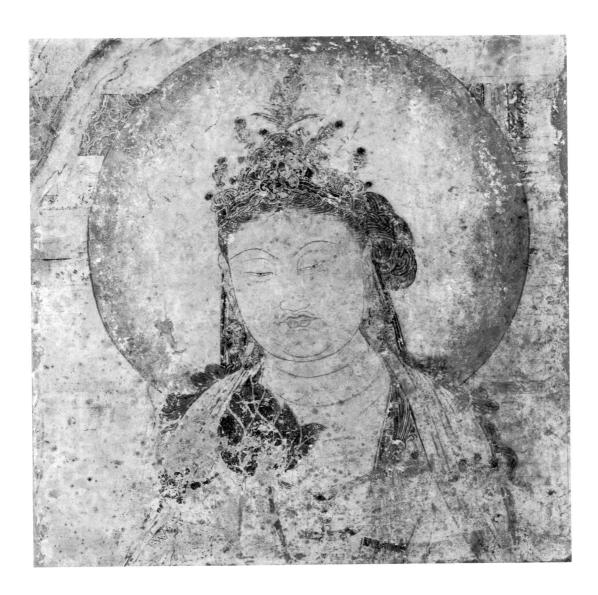

188 *Bodhisattva Holding a Lotus Bud*

Northern Song dynasty, 10th century
wall painting on stucco
height 63.5, width 61.6 cm
(25 × 24¼ in)
S87.0223

The bodhisattva wears an elaborate diadem over long plaited tresses and on each ear a large foliate earring. Thin lines of even width define the facial features. The contrast between those elegantly curving lines and the rich design of the diadem, earrings, and hair is further accentuated by the necklace, armlet, and drapery patterns. A large, dark lotus blossom evidently held in one of the bodhisattva's hands contrasts with the light-colored flesh of the deity. A circular halo sets the bodhisattva apart from the geometric designs in the background.

This wall painting fragment is one of several that C.T. Loo acquired on his second visit to China after World War I in 1923. The fragments came from a ruined temple somewhere near the border between the provinces of Henan and Shanxi.

In 1946 Mr. Loo brought the fragments from his Chinese pavilion in Paris to the United States. After 1951 he donated some other fragments to the Nelson Gallery of Art in Kansas City, the Minneapolis Institute of Arts, and the St. Louis Art Museum.

189 Bodhisattva and Dark-Skinned Figure

Northern Song dynasty, 10th century
wall painting on stucco
height 175.6, width 85.5 cm
(69⅛ × 33⅝ in)
s87.0224

The standing bodhisattva and dark-skinned figure originally were part of a larger work, possibly an assemblage of deities clustered around a central Buddha or *Guanyin*. The regal elegance of the standing bodhisattva provides an indication of the high quality of Song dynasty wall painting from an area of northern China where Buddhism enjoyed strong support and patronage.

With a remarkable economy of line, the artist defined the bodhisattva's facial features, hands, and halo. In contrast to the terseness of those elements, the bodhisattva's hair and diadem, richly rendered robes, and jewels are meticulously embellished. Of special interest is the rendering of the semitransparent bowl filled with blossoms that the bodhisattva holds aloft in its right hand. The head of the dark-skinned figure in the lower left of the composition is also encircled by a halo and is splendidly garbed and ornamented.

A poem appears to the left of the arm of the bodhisattva. Called "A Poem by a Previous Master," it is almost completely legible and was composed by the Tang poet Han Yu (768–824); the original title is "Light Rain at Early Spring." The calligraphy is unsigned and undated.

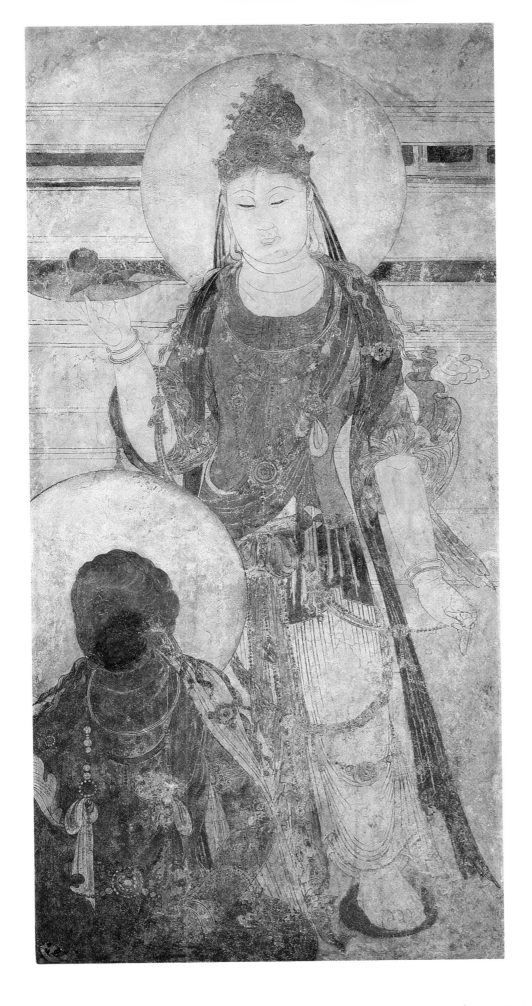

190 *Spring Landscape*

by Ma Wan (ca. 1310–1378)
Yuan dynasty, dated 1343
hanging scroll, ink and color on paper
height 83.2, width 27.5 cm
(32¾ × 10⅞ in)
s87.0215

Two riders on horseback are approaching a bridge on their way to buildings at the top of the hill overlooking an inviting expanse of water. Two boats catch the strong spring breeze as they move lightly across the lake in front of the distant mountains. The earliest dated painting by Ma Wan, this is the only genuine work by him in a Western collection.

A typical literatus-painter from the late Yuan period, Ma Wan (also known as Wenbi and Ludunsheng) was a native of Qinxi in what is now Zhejiang Province and later moved north to Huating, Jiangsu Province.

Influences of Zhao Mengfu (1254–1322) and Wu Zhen (1280–1354) are clearly evident. However, judging from most of his extant works, Ma Wan mainly followed Huang Gongwang (1269–1354) and occasionally Gao Kegong (1248–1310). The painter's contemporaries inscribed two poems on the scroll. One is by his teacher, Yang Weizhen (1296–1370), the other by Gong Jin (active 1340–68).

191 *Studio in Bamboo Grove*

by Shen Zhou (1427–1509)
Ming dynasty, ca. 1490
handscroll, ink and color on paper
height 25.5, width 111 cm
(10 × 43¾ in)
s87.0225

of Xiangcheng, close to Suzhou. He was the teacher of Wen Zhengming and Tang Yin—together with Qiu Ying—the Four Great Masters of the Ming dynasty. Shen Zhou founded the Wu school and made Suzhou a leading center for art.

Surrounded by a bamboo grove on a small, flat island is a studio, consisting of small thatched and tiled huts. A scholar with a lute and a container of books sits in front of a calligraphy screen in one of the huts. A bridge behind the hut connects the island with the mountain path. An open pavilion is located on the shore across from the island, and tall trees in the left foreground hills provide the view from the studio.

A poem by Shen Zhou in seven-character meter on a separate piece of paper is attached at the end of the scroll. This poem and that by Wang Ao, also at the end, concern "The Love of Bamboo" on the part of the studio owner.

Poet, calligrapher, and painter, Shen Zhou (also called Qinan and Shitien, Baishi Weng) was a native

192 *Chrysanthemum, Bamboo, and Rock*

by Wen Zhengming (1470–1559)
Ming dynasty, datable to 1535
hanging scroll, ink on paper
height 48, width 26.5 cm
(18⅞ × 10⁷⁄₁₆ in)
S87.0214

This work records an occasion at which the painter and a friend, Xu Jin, were tasting tea and savoring the fragrance of chrysanthemum in the cool autumn twilight. In a fashion typical of connoisseurs of the day, poetry and painting accompanied the event. The long inscription by Xu Jin, a fourteen-line poem in five-character meter, commemorates the event in 1535 and the friends' mood. Wen Zhengming most likely rendered this work spontaneously at the time.

Chrysanthemums and bamboo stand against a garden rock and slope. The brushwork is vigorous, achieved with the wrist and arm in lively motion and producing a look of dryness in the ink, which is also partly the result of the texture of the sized (coated) paper.

Wen Zhengming (also called Zhengzhong and Hengshan), whose early given name was Bi, was known by his style name, Zhengming. He was one of the great scholar-calligrapher-painters of the Ming dynasty and a major figure of the Wu school, centered at Suzhou.

193 *A Donkey for Mr. Zhu*

by Qiu Ying (ca. 1499–1552)
Ming dynasty, ca. 1550
handscroll, ink on paper
height 26.5, width 70.1 cm
(10⁷⁄₁₆ × 27⁵⁄₈ in)
s87.0213

A poor but noted poet and bibliophile, Zhu Cunli accepts the gift of a donkey purchased with funds collected on his behalf by friends. The story the picture depicts is told in the calligraphy section, forming the second major portion of the scroll. The painting is undated, but the calligraphy was written early in 1500, before Qiu Ying illustrated the event.

Qiu Ying (also known as Shifu and Shizhou) was born in Taicang and raised in Wuxian, Jiangsu Province. He received instruction from the master Zhou Chen and enjoyed the patronage of the leading private collectors of his day. Although he came from a humble background, he grew up to be one of the Four Great Masters of the Ming dynasty.

Qiu Ying is best known for his colorful and meticulous "palace" manner (court style) of rendering landscapes and figures. This scroll displays the descriptive power of pure line when visualized by a master, and it shows Qiu Ying's subtle and elegant characterization of people from different stations in life.

194 *Eight Views of the Xiao and Xiang Rivers*

by Sheng Maoye (ca. 1600–1640)
Li Shida (ca. 1550–1622)
Chen Huan (active 1590–1620)
Shen Xuan (active 1600–1621)
Ming dynasty, dated 1620–1622
album of eight leaves,
ink and color on paper
average height 24, average width 25.2 cm
(9½ × 10 in)
S87.0270.001–.008

This album of eight leaves is by four late-Ming painters, each of whom depicted a poetic view of the Xiao River and of the Xiang River. These paintings date from the fall of 1620 to January or February of 1622. Each leaf was inscribed with a quatrain in seven-character meter by one of the two late-Ming dynasty poet-calligraphers, Fan Yunlin (1558–1641) and Wen Zhengmeng (1574–1636), the great-grandson of Wen Zhengming. Four of the leaves are illustrated here.

Evening Bell from a Monastery at Dusk—painting by Sheng Maoye, calligraphy by Fan Yunlin. Sheng Maoye was a professional painter from Suzhou. Using inkwash, the artist built up a bend in evening mist that envelopes the hidden temple behind the pine grove and mountains.

Mountain Village on a Clear Day—painting by Li Shida, calligraphy by Wen Zhengmeng. Li Shida, a painter from Suzhou, excelled in both figure and landscape painting. Two gentlemen engage in a leisurely conversation in front of a mountain village on a clear day with the morning mist still covering part of the area.

Fishing Village at Sunset—painting by Chen Huan, calligraphy by Fan Yunlin. Chen Huan was also from Suzhou, and his painting followed the style of Hou Maogong, the student of Wen Zhengming and Qian Gu. The painting depicts fishing boats with standing nets drying in the evening, moored on the river banks next to the villages. Three fishermen in the foreground are returning to their homes.

Night Rain on the Xiao and Xiang Rivers—painting by Shen Xuan, calligraphy by Wen Zhengmeng. Shen Xuan, a native of Hangzhou, was famous for his poetry. His interest in landscape painting became more pronounced in his old age. Under the big umbrella, a figure in the rain is returning through the thick bamboo grove. Dark mountain peaks emerge above the heavy mist.

The late Ming calligrapher Fan Yunlin was from Suzhou. His calligraphy was not only as famous as that of Dong Qichang (the founder of the early Qing orthodox school) but stylistically was very close to it. Wen Zhengmeng's calligraphy was also greatly admired. The substantial brushwork and squat structure of the characters indicate that he followed the style of the Song master Su Shi.

Evening Bell from a Monastery at Dusk

山市晴嵐
辛酉冬寫
石洞精舍
李在

untain Village on a Clear Day

Fishing Village at Sunset

瀟湘夜雨
辛酉冬寫
沈宣

ht Rain on the Xiao and Xiang Rivers

195 *Pavilion in an Autumn Grove*

by Cheng Jiasui (1565–1643)
Ming dynasty, dated 1630
hanging scroll, ink on paper
height 48.1, width 25.8 cm
(19 × 10⅛ in)
s87.0212

Having failed in the official examinations for public service, Cheng Jiasui chose instead to devote himself to poetry and painting. He spent most of his life in Jiading, near Shanghai, and knew many of the cultivated elite of the late Ming period. Along with the painters Li Liufang (1575–1629), Dong Qichang (1555–1636), and others, Cheng Jiasui was counted among the Nine Friends of Painting. Although many of his poems and essays have survived, few of his paintings are extant today.

Cheng Jiasui's poem on the painting evokes the spirit of the Yuan master Ni Zan (1301–74):

[We] have not seen Yunlin [Ni Zan] for three
 hundred years,
Whose ordinary bone has ever transformed into
 the immortal's?
Sorrowful misty breeze after the clear autumn,
[I] picked up the golden cinnabar [pill of
 immortality] in front of the eye.

The artist, known also as Mengyang and Sung-yuan laoren, dated the painting early winter 1630, when he was sixty-five years old.

196 *Orchids and Rocks*

by Gu Mei (1619–1664)
Ming dynasty, dated 1644
handscroll, ink on paper
height 27, width 170.8 cm
(10⅝ × 67¼ in)
s87.0269

Born in Nanjing, Gu Mei was a famous songstress before she married the renowned poet Gong Dingzi (1615–73) during the late Ming period. She occupied a special place among Chinese intellectuals of the time because she was not only an outstanding musician but also a poet and a painter of landscapes and ink orchids. Gu Mei (also known as Meisheng and Hengbo) is regarded as second in reputation only to the late-Ming songstress-painter, Ma Shouzhen (1548–1604).

This painting by Gu Mei is composed of three sections depicting orchids and rocks. The orchids in the first and last sections grow upward in a normal way, and the orchids in the middle section overhang a cliff. The orchids and rocks are painted with thin brushwork in a fluent and easy manner. Although her inscription indicates it was painted at Nanjing and does not specify the year, there is a five-line inscription by Gu Mei's husband, between the second and third sections of the composition, dated 1644, the last year of the Ming dynasty. Gu Mei was only twenty-six years old at that time, according to the Chinese system of calculating age.

Aside from the painting itself, this long handscroll includes a frontispiece and fifteen colophons by later admirers of the artist.

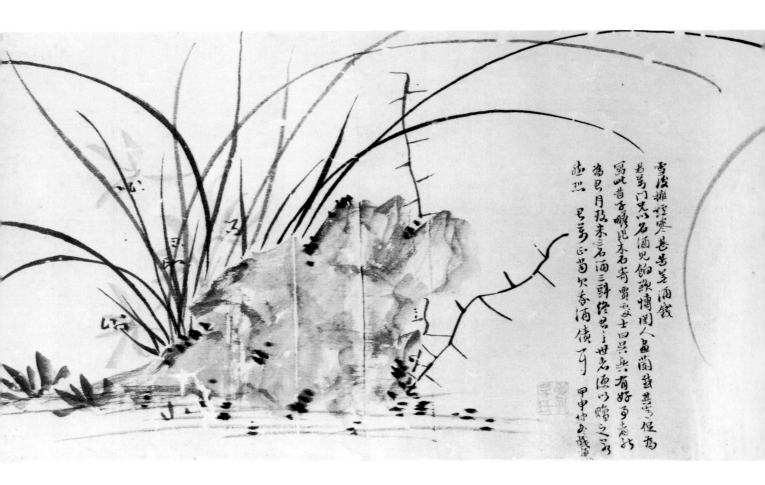

197 *Feng River Landscape*

by Hongren (1610–1664)
Qing dynasty, dated 1660
album of ten leaves, ink on paper
average height 21.4, average width 12.9 cm
(8⁷⁄₁₆ × 5¹⁄₁₆ in)
s87.0211.001–.010

Hongren, the Buddhist name of Jiang Tao, was a native of what is now Anhui Province. When Nanjing fell to the Manchus in 1645, Hongren fled with his teacher to Fujian. There he received the tonsure and entered the Buddhist faith, adopting the name Hongren. He spent several years in Fujian before returning to his old home in Anhui.

Hongren was influenced by his teacher Xiao Yuncong and the late-Yuan dynasty master Ni Zan. His prolonged contact with the natural scenery of the Wuyi Mountain in Fujian, and the scenery along the Xin'an River, led him to express a distinctive, elegant personal style. Together with Zhu Da, Kuncan, and Shitao, Hongren was one of the Four Eminent Monk Painters of early Qing, each of whom developed a strong individual style.

The Sackler ten-leaf album demonstrates Hongren's wide spectrum of brush and compositional styles. The various leaves associate his stylistic sources with Ni Zan, Huang Gongwang, Wu Zhen, Wang Meng, and even the Song master Mi Youren. He dated the last leaf in the spring of *gengzi* (the Chinese year 1660), four years before his death.

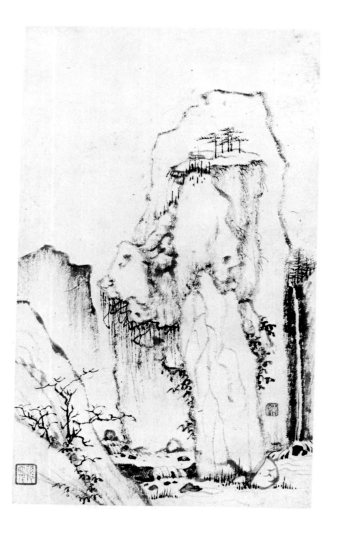

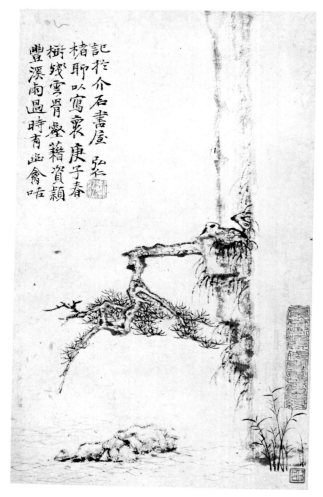

198 *Enjoying the Pomegranate and Hollyhock Flowers*

by Gao Jian (1634–1707)
Qing dynasty, dated 1662
hanging scroll, ink and color on paper
height 122.6, width 59.8 cm
(48¼ × 23⁹⁄₁₆ in)
s87.0271

At the age of twenty-eight, Gao Jian imagined him-self wearing a light, loose robe, sitting on a breezy stream bank in the shade, and viewing beautiful flowers while they were in the full bloom of sum-mer. The artist was tasting wine and composing poems at the same time.

Gao Jian (also called Danyou and Yiyun shan-ren), painter and poet and a native of Suzhou, fol-lowed the Yuan masters in landscape painting. He preferred a simple—plain yet elegant—style. Com-positionally his paintings are stable.

This work is one of Gao Jian's larger paintings, yet it is not considered monumental in composition. A scholar with a jar of wine sits on a carpet under a large tree growing on the flowering stream bank. The stream meanders toward distant mountains and disappears in the haze.

The artist's inscription dates this painting four days before the festival of Duanyang in 1662, which is on the fifth day of the fifth lunar month (usually in early June).

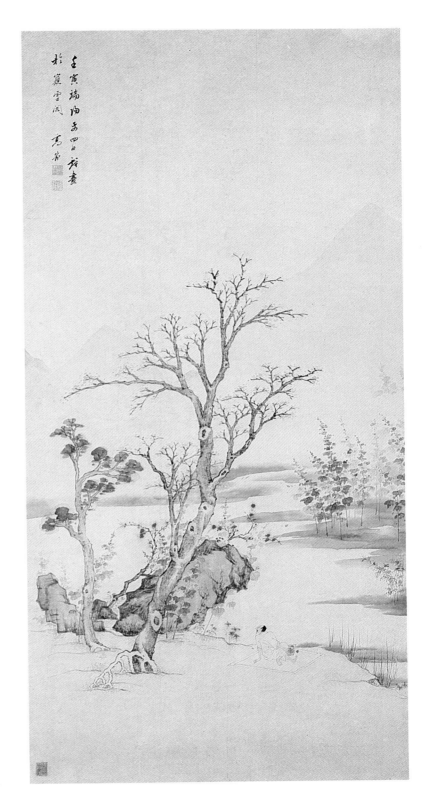

199 *Landscapes*

by Gong Xian (ca. 1618–1689)
Qing dynasty, ca. 1678
album of thirteen leaves, ink on paper
average height 22.5, average width 52 cm
(8⅞ × 20½ in)
S87.0228.001–.013

Gong Xian filled his works with unusual light and air as had never before occurred in Chinese painting. He deliberately cultivated his unique style of ink landscape painting, characterized by graded texture strokes or dots applied in different directions, to produce a rich chiaroscuro effect. Therefore the artist consciously boasted about his painting style: "There has been no one before me and will be no one after me."

This album contains the title, written on two separate leaves, ten leaves of painting, and one leaf of inscriptions by the painter, which is dated 1678. A horizontal composition mostly depicts river or lake scenery with sails or boats. The rest of the paintings portray mountain scenery with white clouds. Half of the paintings are in Gong Xian's typical style using cumulative brushstrokes; the rest are much lighter in tone or are achieved with a single layer of brushwork. The willow grove is delicately painted with a fine-tipped brush.

Gong Xian was born in Kunshan in what is today Jiangsu Province and spent most of his life in Nanjing. Associated with the Nanjing school of painting, he was recognized as its leading master.

200 *River Landscape in Rain*

by Zha Shibiao (1615–1698)
Qing dynasty, dated 1687
hanging scroll, ink on paper
height 88.5, width 49.7 cm
(34⅞ × 19⁹⁄₁₆ in)
S87.0210

Gradations of gray wash capture the feeling of a line of poetry—"Several distant peaks are separated by rain beyond the river"—that the painter quotes in his inscription. Wetness is the theme of the painting and is expressed through simplification and abbreviation of form. The feeling of dense atmosphere and depth suits the sense of water; the effect of driving rain is successfully achieved by the slanting inkwash and the sailboat floating through the mist, its occupants wearing large rain hats.

Zha Shibiao (also known as Erzhan and Meihe) was born into a wealthy Anhui family known for its collection of antiquities and Song and Yuan paintings. He earned his first degree (*xiucai*) but sought no political advancement, preferring to devote his energies to literary and artistic pursuits.

As a native of Anhui, Zha Shibiao was included among the Four Masters of Haiyang. He was praised by Shitao for possessing the same qualities of "pure elusiveness" as did Hongren. He was an individualist, but his style of painting and calligraphy was very much influenced by Dong Qichang.

201 *Landscapes Inspired by Tang Poems*

by Liu Yu (active 1670–1690)
Qing dynasty, dated 1689
album of fourteen leaves, ink on paper
average height 23.8, average width 20.5 cm
(9⅜ × 8¹/₁₆ in)
S87.0227.001–.014

Liu Yu, a painter from Nanjing, also excelled in poetry. The famous scholar-official collector Song Luo (1634–1713) recruited Liu Yu for his staff. This album is dedicated to Song Luo by the painter.

There are twelve leaves of paintings; each one quotes and depicts a couplet, but without citing the individual poet. Although the painter pointed out that these couplets were written during the Tang dynasty, one couplet among the six identifiable couplets was actually composed earlier, by the poet-emperor Liang Yuandi (reigned 552–54).

The couplet on the third leaf (see facing page) may be translated as follows:

The thin clouds blurred the Milky Way,
The sparse rain drops on the wutong tree.

The poet has been identified as Meng Haoran (689–740).

In the painting two figures sitting in the hut under the wutong tree in front of the banana grove engage in conversation while drinking. The dark misty atmosphere suggests a night scene.

On two leaves of the album, there is a colophon dated 1689 by the artist, also called Gonghan and Yugu. His friendship with four famous contemporaries and painters is mentioned.

微雲滄河
灌漭雨涌
接桐

detai[l]

202 Thousand-Character "Eulogy of a Great Man"

composed by Zhan Wende
calligraphy by Shitao (1642–1707)
Qing dynasty, ca. 1698
handscroll, ink on paper
height 26.9, width 99.8 cm
(10⅝ × 39⁵⁄₁₆ in)
s87.0209

This impressive handscroll displays a rare aspect of Shitao's accomplishment—calligraphy in a diminutive and formal hand. The lengthy text was transcribed by the artist at the peak of his physical and spiritual energies and may be dated to around 1698.

The scroll is written in a uniform, fluent standard (xing kai) script modeled after that of Ni Zan (1301–74) and Chu Suiliang (596–658). It opens with a five-character title in clerical (li) script. The "Eulogy of a Great Man" is an essay in four-character rhymed parallel prose (analogous to two-line stanzas) composed of one thousand characters, none of which is repeated. The text was composed by Zhan Wende (probably a late-Ming scholar), using the same characters found in the famous and popularly known Qianziwen (Thousand-Character Classic) composed by Zou Xingsi (active 535) by

302

千字大人頌

余嘗道周興嗣千字文不惟當取其原本另翦裂而縫綴之徐
野君領予言而去未幾文就沈不傾聞之曰前代有作此想者
矣傾撓於人言謂枇杷二字未易離鄉竟沈吟而止今野君其
謂之何余謂枇杷為棘棗枇也杷也為田顋也見於經子甚顆
耶苦者飄飄逍遙等字耳雖野君皆未之離余請得而離之
于是閉門七日作頌以示野君野君忽忽此斷續不成章此一氣
呵成萬變而不出吾宗二也周轉韻處多寡求均平六不相間
此四平四仄無或素者三也離黙余實自愧其一短則以余以
七日不敵周之一夜耳野君曰是有一難彼以君命臨之其意
迫此以遊戲行之其神暇彼作始者苟然而已此踵其事既欲
過之文欲字字易其故位是按可同日而語且夫七日而千字
就與夫十稔而三都乎校生敏捷同馬淹公適子以於周創雙
美余慨然曰淹邅則誠淹邅吳頌誰為讀大人賦而嘆凌雲者
因篇首有大人二字遂名大人頌

詹文德撰

大人御天君子名世立千秋基興諸夏利高文起家建景閭帝二百餘

detail

the order of the Liang emperor Wu. The characters have been written with the fine tip of a highly resilient writing brush. In contrast to his Zhong You (A.D. 151–230) style, this scroll by Shitao, one of his most distinguished works of calligraphy, stresses fluidity and the contrasts of thick and thin lines within the movement of a single stroke.

Shitao (known as Daditzu, Qingxiang chenren, Kugua hoshang, and by other names) was a prince from the imperial Ming dynasty ruling family. He was born in Guilin, in present-day Guangxi Province, but fled to the lower Yangtze River area and became a monk after the fall of the Ming dynasty. Before he moved to Nanjing in the late 1670s, he spent time in Anhui Province near Mount Huang. After his trip to Beijing around 1690, Shitao settled in Yangzhou as a professional painter and became the most important individualist and one of the most influential painters of the Qing dynasty; his renown has continued into the twentieth century.

Chinese Painting 303

203 *Album of Flowers and Portrait of Shitao*

by Shitao (1642–1707)
Qing dynasty, ca. 1698
album of nine leaves,
ink and color on paper
average height 25.6, average width 34.5 cm
(10⅛ × 13⅝ in)
portrait height 27.5, width 35.1 cm
(10⅞ × 13⅞ in)
s87.0207.001–.009

Shitao was not only a versatile painter but also excelled in all the traditional subjects of figure, landscape, and bird-and-flower painting. In this album of nine leaves, he demonstrates his love of tender and beautiful plants and flowers. Eight of the leaves depict these subjects, in order: flowering crab apple, orchids, bamboo and narcissus, peonies, lotus and red polygonum, banana plant, hibiscus, and plum blossoms and bamboo. Orchids, bamboo, plum blossoms, and lotus were Shitao's favorite subjects.

In technique, Shitao emulated the late Ming masters, particularly Chen Shun (1483–1544) and Xu Wei (1521–93), but Shitao was more inventive in

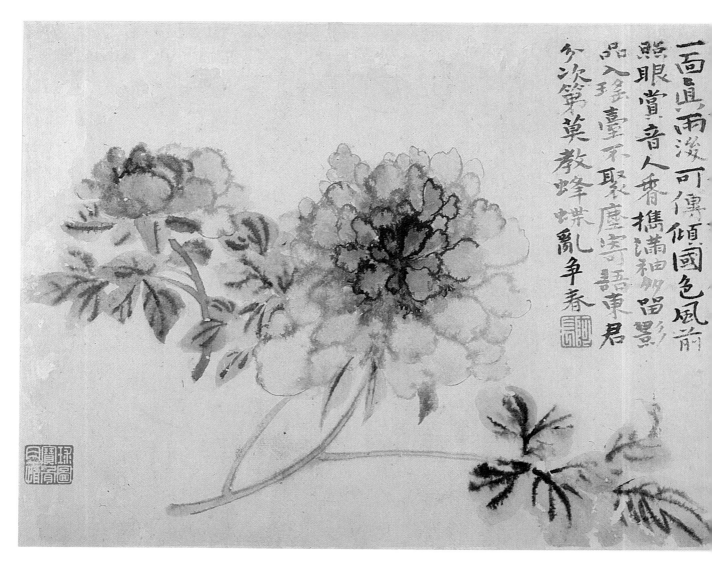

Peonies

composition. He added the ink lines for the veins of the leaves before the color of the leaves was dry, so that a vivid sense of moisture is created. The technique is especially effective in rendering the quiet beauty of peony flowers and lotus leaves. Yet he added the lace-like veins of lotus flower petals after the color of the petals was dry.

An extra leaf accompanies the album—a picture based on Shitao's self-portrait, *Supervising the Planting of Pine Trees*.

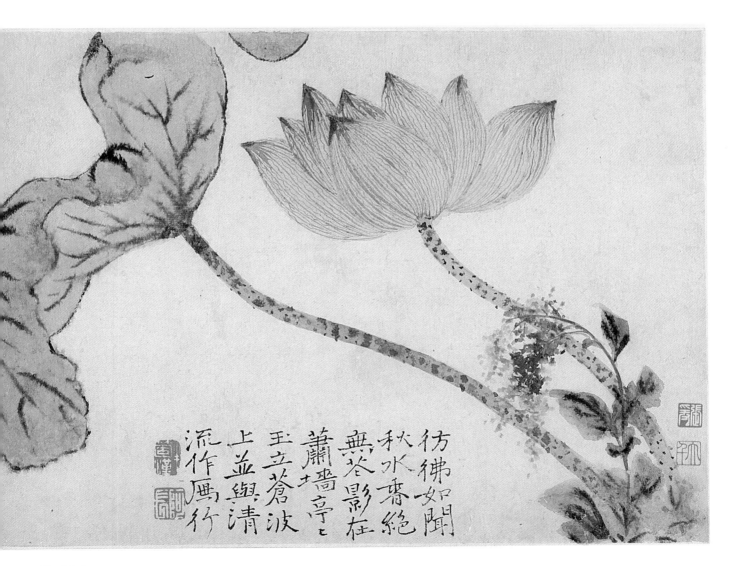

tus and Red Polygonum

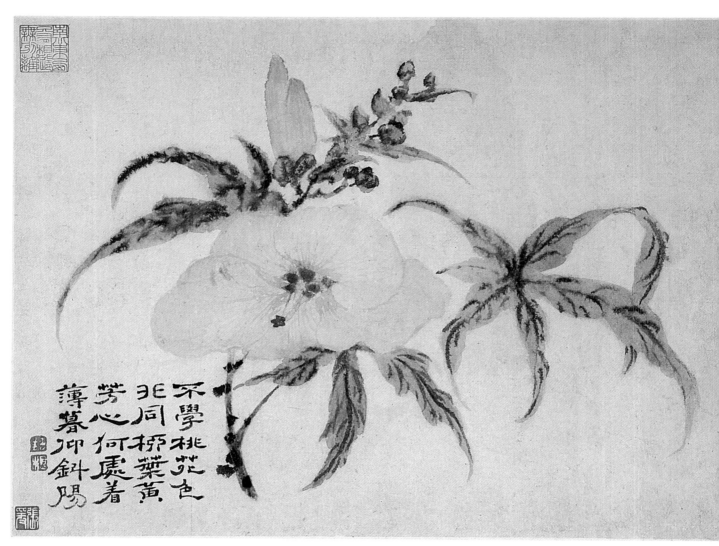

不學桃花色
非同柳葉黃
勞心何處着
薄暮仰斜陽

Hibiscus

306

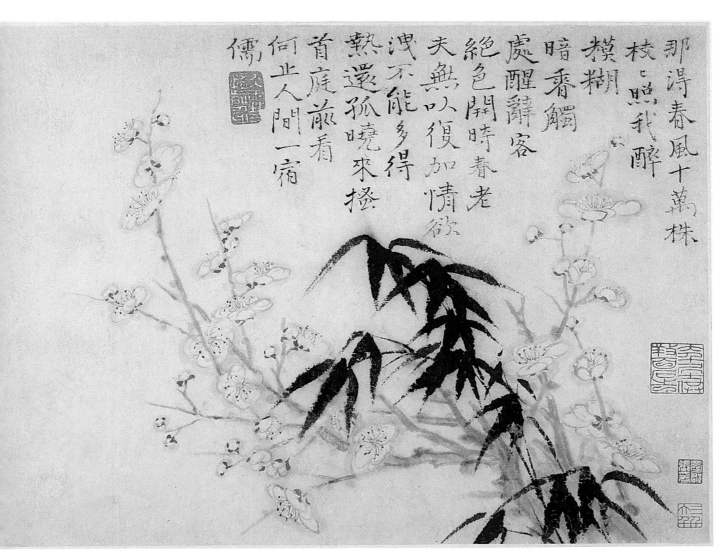

那得春風十萬株
枝枝照我醉
模糊
暗香觸
處醒辭客
絕色開時春老
夫無以復加情欲
洩不能多得
熟還孤曉來搔
首庭蕭看
何止人間一宿
儒

Blossoms and Bamboo

204 *Orchids, Bamboo, and Rock*

by Shitao (1642–1707)
Qing dynasty, ca. 1700
hanging scroll, ink on paper
height 72.5, width 51 cm
(28½ × 20¹/₁₆ in)
s87.0206

A close-up view of a rock placed diagonally across the picture plane dominates this work. A clump of orchids emerges at the far left, rendered with pale, graded ink reflecting that of the taller bamboo. But the rich ink applied on the bamboo is the focus of the painting. The subtle ink gradation and watermarks on the bamboo leaves create a contrasting sense of delicacy. The Yangzhou master Zheng Xie (1693–1765) later adopted this technique of conveying tonality.

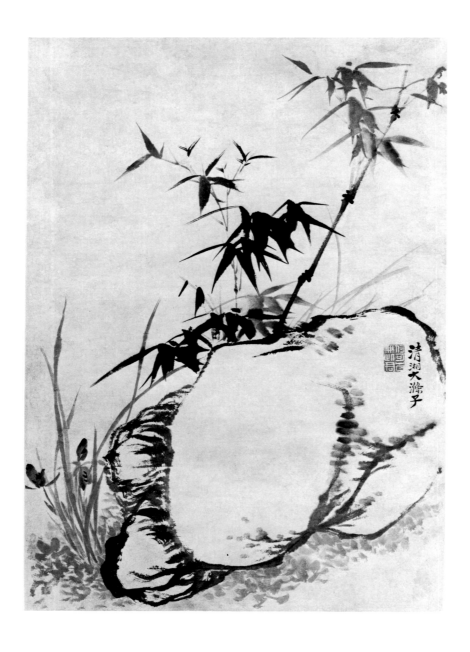

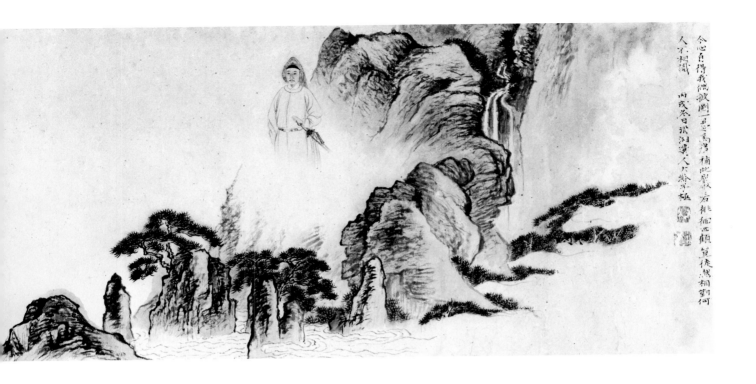

205 *Landscape and Portrait of Hong Zhengzhi*

landscape by Shitao (1642–1707)
portrait by Jiang (ca. 1700)
Qing dynasty, dated 1706
handscroll, ink and color on paper
height 36, width 175.8 cm
(14³⁄₁₆ × 69¼ in)
s87.0205

According to the inscription by Shitao, the portrait of Hong Zhengzhi (1674–1731) was painted by a young artist named Jiang. Shitao then completed the composition by adding the landscape background in 1706, one year before his death.

Hong Zhengzhi's image rises like an apparition from the mist. Shitao has abandoned his usual respect for figures and landscape in proper scale to heighten the sense of drama. Hong Zhengzhi's personality emerges in the painting, as it does in Shitao's poem:

A man of breeding and style,
An antique sword girdling his waist, he gazes
 into the vast heavens.
With his vision extending ten thousand miles,
 can it ever reach a horizon?

Not many pupils of Shitao are known, but Hong Zhengzhi was one of them. (Hong Zhengzhi's other names are Kaihua, Tingzuo, and Wanguan jushi.) A native of Yangzhou, Hong Zhengzhi had a close relationship with his teacher during Shitao's old age and was given many of Shitao's paintings.

206 *Reminiscences of Nanjing*

by Shitao (1642–1707)
Qing dynasty, dated 1707
album of thirteen leaves,
ink and color on paper
average height 23.8, average width 19.2 cm
(9³⁄₈ × 7⁹⁄₁₆ in)
S87.0204.001–.013

In the twelve leaves by Shitao, recurring themes are reinterpreted, often autobiographical in nature—portraits of his studio, the traveler riding on horseback or walking alone with his staff, and the ancient tree surviving the passage of time.

An extraordinary inventory, this album from 1707 includes the latest dated landscape by Shitao. The brushwork and forms are simplified and the colors reduced to primary hues. The brush tip Shitao preferred was by then blunt and worn out; the line it drew suggests the multidimensional possibilities of a stone carver's chisel.

The majority of the scenes can be identified as actual sites in and near Nanjing. But Shitao undoubtedly painted them in Yangzhou, where he settled in the early 1690s. Thus these leaves are reminiscences, idealized portrayals of the landscapes of the past, fed by the inner richness of his experiences.

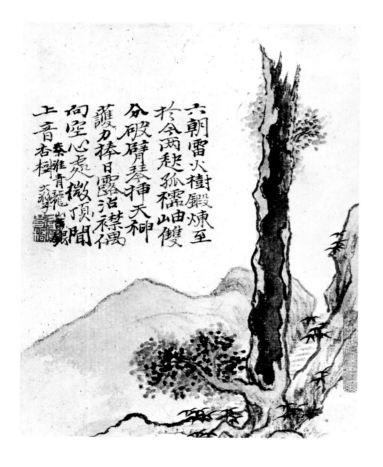

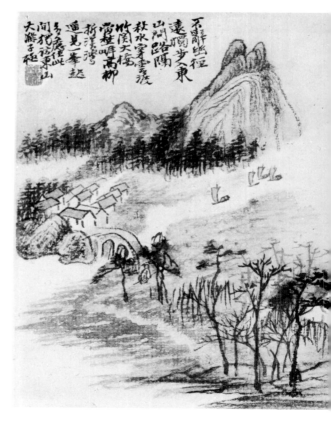

310

207 *Pavilions in Immortal Mountains*

by Wang Hui (1632–1720)
Qing dynasty, dated 1712
hanging scroll, ink and light color on paper
height 175.5, width 36.2 cm
(69⅛ × 14¼ in)
s87.0268

This large painting depicts travelers passing dwellings at the foot of the mountain by a running stream and journeying toward the mountainside highway under tall pine trees, a waterfall, and an overhanging cliff. Pavilions situated in the high mountain valley are surrounded by towering peaks.

The composition, the texture strokes on the mountains, and the form of the pine trees are all reminiscent of the style of the Yuan master Wang Meng. Wang Hui's inscription, dated 1712, also confirms this. According to this date, Wang Hui was already over eighty years old. But his personal style always prevailed, regardless of the model that inspired his work.

The talent of Wang Hui (also called Shigu), a native of Changshu, in modern Jiangsu Province, was first recognized by Wang Jian and later by Wang Shimin. Together with Wang Yuanqi, these artists are known as the Four Wangs of the early Qing dynasty. They all embraced the orthodox school, which was guided by the theories of Dong Qichang.

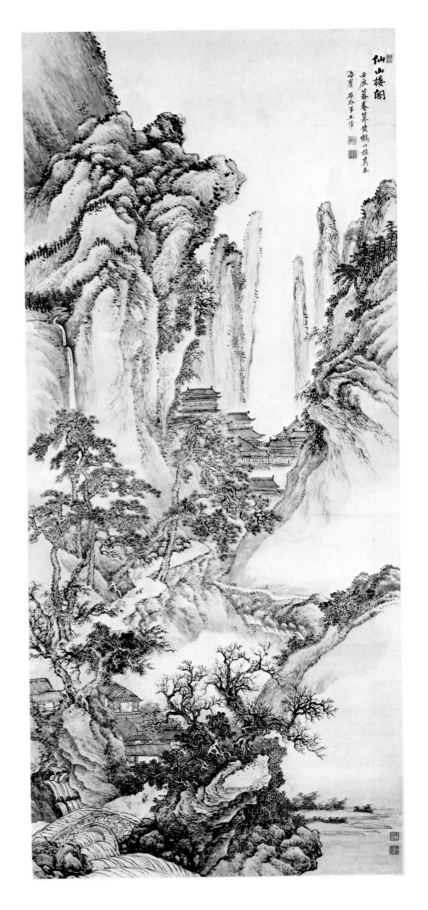

208 Dwellings in a Rocky Landscape

by Huang Binhong (1864–1955)
Republic period, ca. 1920
hanging scroll, ink and color on paper
height 103.7, width 32.5 cm
(40⅞ × 12¾ in)
s87.0237

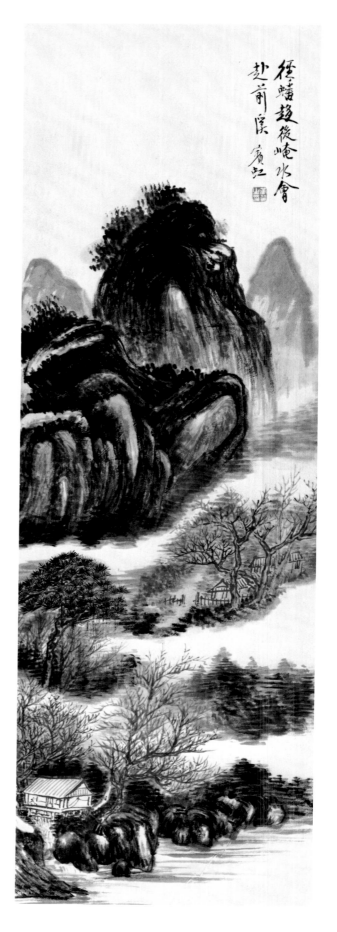

During his long life, Huang Binhong traveled widely, visiting famous mountains and making thousands of sketches. In this painting the artist applied fine horizontal strokes to create the mist, together with the dark rocks and mountains. Although its dark style appears not fully developed, it reveals Huang Binhong's interest in the somber tones, which developed later in his career. Based on the style and Huang Binhong's seal, this painting may be dated to the early 1920s. It exhibits the influence of the early Qing painter Gong Xian.

A couplet was inscribed by the painter in five-character meter:

> The small path meandering toward the
> back mountains
> The gathered water runs toward the
> front stream.

Huang Binhong was a native of Xixian, Anhui Province, but spent his childhood and late years in Zhejiang Province. He went to Shanghai in 1907 and stayed for some thirty years, then spent eleven years in Beijing before returning to Hangzhou. He is certainly one of China's most important twentieth-century landscape painters.

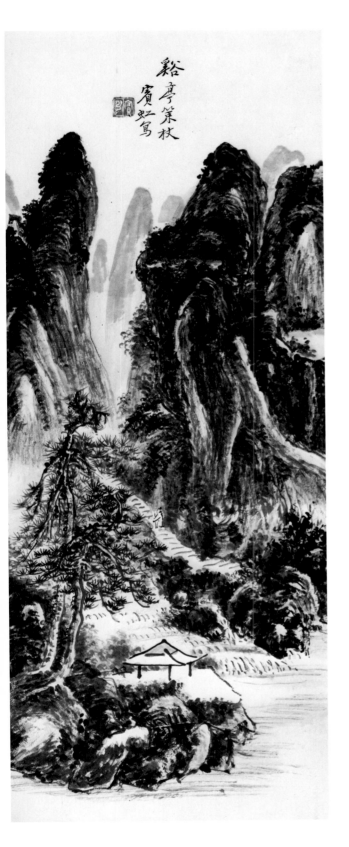

209 *Walking with a Staff near the Stream Pavilion*

by Huang Binhong (1864–1955)
Republic period, ca. 1930
hanging scroll, ink and color on paper
height 92.2, width 36.2 cm
(36¼ × 14¼ in)
s87.0261

Under the tall pine trees is a pavilion on the terrace where the running stream and the river merge. A single figure with a staff is walking on the mountain path along the stream beside the dark and towering peaks. The dense texture strokes, the dots, and the misty mountain range are reminiscent of the Yuan dynasty master Wang Meng, whose painting deeply inspired Huang Binhong when he went to Hangzhou at the age of ten.

The artist wrote the title for the painting, *Xiting cezhang* (Walking with a Staff near the Stream Pavilion). Both the signature and the seal read "Binhong." The painting is not dated, but this seal of the artist was used mostly between 1928 and 1933. Thus the work was probably executed around 1930.

210 *Lotus*

by Qi Baishi (1863–1957)
Republic period, dated 1939
hanging scroll, ink and color on paper
height 101.5, width 34 cm
(40 × 13⅜ in)
S87.0221

Qi Baishi depicts two full lotus leaves at the moment their color starts to turn brown. The lotus cupules are dark and mature. A late-blooming lotus flower bends down behind the leaves. A touch of red in the remaining petals and the delicate color of the new cupule accent the composition.

The lotus was Qi Baishi's favorite and most successful subject. There were many lotus ponds in his home district in Hunan Province, and at one time, he cultivated a lotus pond just in front of his leased house. Qi Baishi dated this painting 1939, two years after the beginning of the Japanese occupation of Beijing, where he remained until his death.

Qi Baishi, a native of Xiangtan, Hunan Province, is the best known Chinese painter of the twentieth century. He came from a humble farming family and demonstrated his artistic talent during his short time at school. He later became a cabinet maker. Qi Baishi began his career as a portraitist, but he also painted landscapes. However, he is best known for bird, insect, and flower paintings.

211 *Chrysanthemum and Wine Jar*

by Qi Baishi (1863–1957)
Republic period, dated 1944
hanging scroll, ink and color on paper
height 99, width 50 cm
(39 × 19¾ in)
s87.0218

Qi Baishi outlined and then colored the huge chrysanthemum flowers. However, he colored the leaves first, adding the black veins while the washes were still wet. The wine jar with a sealed cover was painted with a large brush, similar to the type used in Western watercolor painting, and then the thick strong handles were added in black ink.

At first, the artist signed the scroll on the right edge: "Painted by the rich man who owns three hundred seal stones, Qi Huang." By 1892 Qi Baishi (also known as Qi Huang) had collected more than 300 seal stones, some carved with his own name. To commemorate that collection, the artist named his studio "Three hundred stone seals." To make fun of himself, Qi Baishi also started to call himself "the rich man."

Later Qi Baishi added four large seal scripts that mean "the wine of chrysanthemum can lengthen one's life." The painting of this subject was appropriate as a gift of good wishes. Qi Baishi also indicated that he was eighty-four years old. According to his own count, the year would have been 1944.

Glossary

Anatolia
The Asian territory of modern Turkey that corresponds roughly to Asia Minor.

Anyang
Traditionally the last capital of the Shang dynasty is said to have been located near Anyang in northern Henan Province. That portion of Shang history, frequently designated the "Anyang period," can be dated ca. 1300–ca. 1050 B.C. Archaeological excavations at Anyang have yielded many Shang dynasty royal tombs and artifacts.

archaeologically attested
Refers to artifacts that have been unearthed under controlled conditions, making it possible to ascertain, with greater certainty, their specific strata, position and, with the help of other tests, their age.

archaic script
The early script, often referred to as "seal script," found in inscriptions on Chinese bronze ritual vessels.

archaism
Throughout Chinese history, bronze artisans regularly interpreted and transformed the canons initially established by ancient vessels produced during the Shang and Zhou dynasties; the interest in interpreting and transforming these original prototypes is known as archaism and has also been central to the work of jade specialists, painters, and other Chinese artists.

bodhisattvas
Buddhist deities that, having attained Enlightenment, selflessly refrain from immediate Nirvana to devote themselves to aiding earthly beings.

bottle horn
A horn motif appearing on the masks of the hybrid creatures that decorate Chinese bronze ritual vessels.

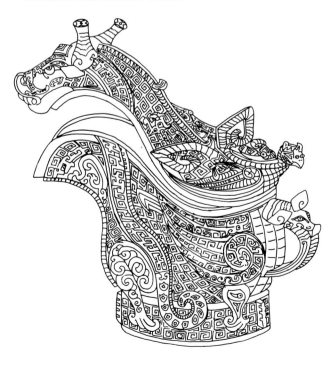

317

bowstring
A narrow, raised horizontal band appearing as a motif on ancient Chinese bronze vessels.

Buddhism
A religion that developed first in India. Its basis is the teaching of the sage Shakyamuni (ca. 563–ca. 483 B.C.), who became known as the Buddha (Enlightened One). Different sects have formed around varying interpretations of the Buddha's words and actions. His initial message, however, outlined a code of behavior to overcome the illusion that personal individuality existed. Through missionary activity, Buddhism spread into Southeast Asia and East Asia, where it remains a vital religious force; in India itself, however, it is no longer widely practiced.

carved lacquer
Technique of lacquer decoration in which designs are carved into a hard lacquer surface that has been built up through multiple applications of colored lacquer to a thickness of up to several millimeters. Alternation of the colors of the lacquer layers and of the depth of carving can produce variations in the complexity of abstract or pictorial designs.

Caucasus
The mountainous region between the Black Sea and the Caspian Sea.

chasing
Decorating the metal by hammering from the front or exterior surface of the object, employing variously shaped punches, tracers, chisels, and other tools.

context
When a "Neolithic context" is cited, it means that an artifact was unearthed at a site or in an area that has been determined by controlled conditions to have yielded artifacts dated to the Neolithic period.

Daoism
A philosophical system and, later, a religion; its formulation is traditionally attributed to Laozi (sixth century B.C.). The complex rituals and beliefs associated with Daoism, many of which relate to the pursuit of longevity, are believed to have originated in ancient Chinese folk traditions.

dragon
An auspicious creature, traditionally associated with rivers and rain in ancient China; found as a decorative motif on ancient Chinese bronze ritual vessels and in the other arts of China.

five-character meter (or seven-character meter)
The most common form taken by an individual line in Chinese poetry, which is a line consisting of five or seven characters; each character represents one syllable.

Hinduism
A complex religious system, the roots of which are found at the beginning of Indian civilization. It incorporates both local, village gods and the trinity of Brahma, Vishnu, and Shiva (gods of creation, preservation, and destruction) and is known throughout the country. Hinduism became—and remains—a major element in the cultures of Southeast Asia and Indonesia.

inlay
Technique of embedding materials in a surface for decoration. Lacquerware may employ inlay of relatively thin, light materials, such as mother-of-pearl, gold and silver foil, ivory, and tortoiseshell. Bronze supports heavier inlays of precious metals, jade, and semiprecious stones.

jadeite
One of the two distinct minerals recognized as jade by mineralogists. Characterized by its greenish color and hard, translucent surface, jadeite was not worked in China until the late seventeenth or early eighteenth century. A silicate of sodium and aluminum, jadeite is classed as a pyroxene. See nephrite.

Jainism
A religion emphasizing asceticism and monasticism that formed around a contemporary of the Buddha, the sage Mahavira. To Jains, however, he is the twenty-fourth of a series of saviors (*tirthamkaras*) that extends to the distant past. Jainism remains strong, especially in western India; it never developed a following beyond the borders of India.

jianhuan
Decorative motif called "sword pommel," frequently seen on carved lacquers of the Yuan dynasty (1279–1368).

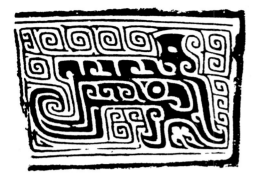

kui dragon
　Seen in profile with head, one claw, and serpentine body. The motif appears on Chinese bronze ritual vessels.

lacquer painting
　Decorative technique employing natural lacquer colored with pigments and applied with a brush to the surface of a lacquered object. The palette of lacquer painting, limited by the reactivity of lacquer with many common coloring agents, can be expanded by the inclusion of pigments in an oil medium.

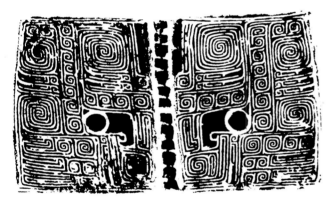

leiwen
　"Thunder pattern"; a variety of spiral forms, either rounded or squared. Used as background or as border on Chinese bronze ritual vessels.

literati-painters
　Chinese painters who are learned scholars and not merely professional painters; also referred to as scholar-artists.

Luristan
　A region in the central Zagros Mountains of western Iran.

Mesopotamia
　The region between the Tigris and Euphrates rivers, roughly corresponding to modern Iraq.

nephrite
　One of the two stones recognized by mineralogists as true jade and apparently the only one worked in ancient China. Nephrite is a silicate of calcium and magnesium belonging to the amphibole group of minerals and having fibrous crystals structurally interlocked to produce an extremely hard stone. See jadeite.

pictograph
　Pictorial symbols used in the ancient world and also found in Chinese bronze ritual vessel inscriptions. These early forms reflect the origins of many writing systems, including the Chinese.

post-archaic
　Refers to the periods in China after the Han dynasty (206 B.C.–A.D. 220).

qiangjin
　Decorative technique in Chinese lacquers consisting of engraving lines into the lacquer surface and applying gold leaf into the engraved designs.

repoussé
　A metalworking technique in which raised areas are produced on a vessel or a sheet by hammering from the inside or the back of the object.

rhyton
　A ceremonial drinking vessel incorporating the head or body of an animal.

scroll pattern
　Ornamental pattern usually derived from plant or vine motifs organized into a regular scheme for borders or bands of decoration.

seal script
　One of the Chinese ancient scripts that appear on bronze and stone inscriptions mostly dating from the tenth to the second century B.C.; it was later applied on inscriptions used for seals.

style name
　Alternative name used by a Chinese painter, similar to a sobriquet or pen name.

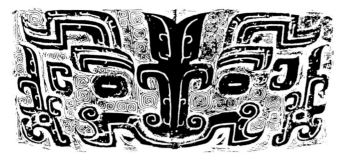

taotie
Ferocious demon mask that appears on many Shang and Zhou dynasty Chinese bronze vessels; the precise meaning of this popular motif is unknown.

Tomb of Fuhao (Tomb No. 5)
Discovered at Anyang, Henan Province, in 1976, the tomb of Fuhao, a consort of the Shang dynasty ruler Wuding, is the only royal Shang tomb found undisturbed, with its rich contents intact.

trigram
In ancient China, trigrams were signs used for divination. Each trigram is a unit of three lines, one over the other; the lines may be broken or unbroken and, therefore, may be assembled in eight different arrangements, each having a different meaning.

yaxing cruciform
A cross-shaped motif found in many Shang dynasty bronze inscriptions.

Selected Bibliography

ANCIENT NEAR EAST

Amiet, Pierre. *Art of the Ancient Near East.* New York: Harry N. Abrams, 1980.

An excellent general survey of major third- to first-millennium B.C. monuments and objects. Richly illustrated.

Ghirshman, Roman. *Iran: Parthians and Sassanians.* Translated by Stuart Gilbert and James Emmons. London: Thames and Hudson, 1962.

———. *Persia from the Origins to Alexander the Great.* Translated by Stuart Gilbert and James Emmons. London: Thames and Hudson, 1964.

These volumes provide a detailed historical survey with good illustrations and numerous tables and charts.

Harper, Prudence O. *The Royal Hunter: Art of the Sasanian Empire.* New York: Asia Society, 1978.

An extremely well-documented and detailed study of Sasanian art with a succinct introduction and sections on silver, gold, bronze, seals, glass, ceramics, and stone.

Markoe, Glenn, ed. *Ancient Bronzes, Ceramics, and Seals.* Los Angeles: Los Angeles County Museum of Art, 1981.

The catalog to the Nasli M. Heeramaneck Collection of Ancient Near Eastern, Central Asiatic, and European Art at the Los Angeles County Museum of Art, with good illustrations, introductory essays, and an extensive bibliography.

Masson, M.E., and G.A. Pugachenkova. *The Parthian Rhytons of Nisa.* Translated by Caroline M. Breton Bruce. Florence: Le Lettere, 1982.

The most accessible study of the excavations at Nisa, with elaborate descriptions and illustrations of the rhytons discovered there.

Moorey, P.R.S. *Catalogue of the Ancient Persian Bronzes in the Ashmolean Museum.* Oxford: Oxford University Press, 1971.

An extremely thorough and precise study of the Ashmolean's extensive collection of western Iranian bronzes. Objects are grouped by function (tools and weapons, finials, pins, personal ornaments, etc.) and described at length. Moorey provides, as well, detailed technical information concerning materials and methods of manufacture.

Muscarella, Oscar. "Unexcavated Objects and Ancient Near Eastern Art." In *Mountains and Lowlands: Essays in the Archaeology of Greater Mesopotamia,* edited by L. Levine and T. Cuyler Young. Malibu, California: Undena, 1977.

A provocative essay on the problems raised by the archaeology of the ancient Near East and the study of objects from undocumented excavations.

Negahban, Ezat O. *Preliminary Report on Marlik Excavation.* Tehran: Ministry of Education, 1964.

An important, though brief, discussion of one of the major ancient Near Eastern sites in Iran.

Porada, Edith. *Ancient Iran: The Art of Pre-Islamic Times.* London: Methuen, 1965.

An extensive and extremely useful survey of pre-Islamic Iranian art and archaeology with good illustrations and plans.

Stronach, David. *Pasargadae: A Report on the Excavations Conducted by the British Institute of Persian Studies from 1961–1963.* Oxford: Clarendon Press, 1978.

One of the most recent and best documented excavation reports from a pre-Islamic Near Eastern site.

Turkish Ministry of Culture and Tourism. *Anatolian Civilization.* Vol. I. Istanbul: 1983.

This catalog of the prehistoric, Hittite, and early Bronze Age section of the Council of Europe's eighteenth exhibition provides the most thorough and up-to-date information on pre-Islamic Anatolian works of art.

SOUTH AND SOUTHEAST ASIA

Huntington, Susan L. *The Art of Ancient India: Buddhist, Hindu, and Jain.* With contributions by John C. Huntington. New York: Weatherhill, 1985.

An extremely thorough examination of Hindu and Buddhist architecture, sculpture, and painting, with especially strong sections on Tibet and Nepal.

Rowland, Benjamin. *The Art and Architecture of India: Buddhist, Hindu, and Jain.* London and Baltimore: Penguin Books, 1953.

This has long been the standard art historical study of India, Pakistan, and Southeast Asia.

Zimmer, Heinrich. *The Art of Indian Asia, Its Mythology and Transformations.* 2 vols. Completed and edited by Joseph Campbell, with photographs by Eliot Elisofon and others. New York: Pantheon Books, 1955.

The discussion by Zimmer is organized according to themes, and Volume 2 contains superb photographs by Elisofon.

————. *Myths and Symbols in Indian Art and Civilization.* Edited by Joseph Campbell. New York: Pantheon Books, 1946.

Although this can be read simply for the stories it contains, it is also an evocative examination of the relation of myth to artistic attitudes and forms.

CHINA

Jade

Hansford, S. Howard. *Chinese Carved Jades.* London: Faber, 1968.

Concise analysis of jade carving in ancient China. Hansford was one of the first Western specialists to benefit from information provided by twentieth-century archaeological finds in China.

————. *Chinese Jade Carving.* London: Humphries, 1950.

Cautious, precise introduction to what was known about Chinese jade carving prior to the discovery of extraordinary quantities of jade from datable archaeological sites.

Loehr, Max. *Ancient Chinese Jades.* Cambridge: Harvard University Press, 1975.

Discussion of the more than 600 ancient Chinese jades assembled by Grenville Winthrop and bequeathed to the Fogg Museum of Art, Harvard University, in 1943. Noteworthy for the descriptions of individual pieces.

Rawson, Jessica, and John Ayers. *Chinese Jade Throughout the Ages.* London: Oriental Ceramic Society, 1975.

Catalog of an exhibition organized by the Oriental Ceramic Society and held at the Victoria and Albert Museum, London. Informative introductory essays with impressive interpretations, especially of the archaic jades.

Watt, James C.Y. *Chinese Jades from Han to Ch'ing.* New York: Asia Society, 1980.

Catalog of an exhibition of Chinese jades dating from the second century B.C. to the nineteenth century. The author discusses questions relating to the most problematic groups of Chinese jades and gives admirable interpretations and compelling conclusions.

Bronze

Bagley, Robert W. *Chinese Bronze Vessels in the Arthur M. Sackler Collections.* Vol. I, *Shang.* Washington: Arthur M. Sackler Foundation; Cambridge: AMS Museum, 1987.

Comprehensive stylistic and chronological analysis of Shang ritual bronzes, with extensive comparative illustrations. Definitive bibliographical references make this volume a major scholarly contribution.

Kaufmann, Walter. *Musical References in the Chinese Classics.* Detroit: Information Coordinators, 1976.

Includes selected translations on music from the Chinese classics.

Lawton, Thomas. *Chinese Art of the Warring States Period.* Washington: Freer Gallery of Art, Smithsonian Institution, 1982.

Discusses a broad range of bronze vessels, mirrors, garment hooks, and other bronze artifacts; jade ornaments and garment hooks; and lacquer vessels in the collection of the Freer Gallery of Art. Objects from the Freer Gallery are compared with related objects from other collections, as well as with archaeologically attested artifacts excavated in China in the twentieth century.

Lieberman, Fredric. *Chinese Music: An Annotated Bibliography.* 2d rev. ed. New York: Garland, 1979.

Provides an excellent source of references to nearly 1,500 publications of studies in Western languages on Chinese music.

Loehr, Max. "The Bronze Styles of the Anyang Period (1300–1028 B.C.)," *Archives of the Chinese Art Society of America,* 7 (1953), pp. 42–53.

The original article in which Loehr set forth his famous "styles."

————. *Chinese Bronze Age Weapons.* Ann Arbor: University of Michigan Press, 1956.

Meticulous, scholarly presentation of more than 100 specimens of Chinese weapons, chiefly dating from the Shang and Zhou dynasties, assembled by the German collector Werner Jannings.

————. *Ritual Vessels of Bronze Age China.* New York: Asia House Gallery, 1968.

Catalog of an exhibition of Shang, Zhou, and Han dynasty bronze vessels held at the Asia House Gallery. The detailed analyses of the shapes and decoration of the individual bronzes are particularly noteworthy.

Pope, John Alexander, Rutherford John Gettens, James Cahill, and Noel Barnard. *The Freer Chinese Bronzes.* Washington: Freer Gallery of Art, 1967.

Stylistic, chronological, and technical analyses of Chinese bronzes in the Freer Gallery. Extensive discussion of methods of bronze fabrication is noteworthy.

Rawson, Jessica. *Ancient China: Art and Archaeology.* New York: Harper and Row, 1980.

Informed critical discussion of developments of early Chinese artistic traditions from the Neolithic period to the Han dynasty. The author's perceptive analyses of stylistic developments are especially informative.

Watson, William. *Ancient Chinese Bronzes.* London: Faber and Faber, 1962.

An important introductory statement about the evolution of Chinese bronze traditions.

Wen Fong, ed. *The Great Bronze Age of China.* New York: Alfred A. Knopf, 1980.

Catalog of an exhibition of Chinese bronze ritual vessels and jades held in the United States during 1980–81. There are introductory essays by Ma Chengyuan, Wen Fong, Kwang-chih Chang, and Robert L. Thorp, followed by catalog chapters and entries by Robert W. Bagley, Jenny F. So, and Maxwell K. Hearn. An excellent discussion of major theories regarding the styles, chronology, and decoration of Chinese bronze vessels. The objects included in the catalog were selected from collections in China.

Garment Hooks

Karlgren, Bernhard. "Chinese Agraffes in Two Swedish Collections," *Bulletin of the Museum of Far Eastern Antiquities,* 38 (1966), pp. 83–159.

Detailed discussion of the formal aspects of garment hooks. The large number of illustrations makes this study a convenient reference work.

Nagahiro Toshio. *Taiko no kenkyu.* Kyoto: Tohōbunka kenkyūsho, 1943.

An essential compendium of textual references to garment hooks in early Chinese texts and to different types of garment hooks. Nagahiro's stylistic analyses and chronological sequences are based primarily on formal considerations.

Nakano Toru. *Chugoku no taiko.* Osaka: Osaka City Museum, 1982.

Catalog of the 145 garment hooks in the Osaka City Museum. A large portion of these examples formerly were in the collection of Osvald Siren, and most were included in Karlgren's study of 1966 (see Karlgren above). Appended to the Osaka catalog is a chronological chart listing a comprehensive selection of garment hooks unearthed in China.

Lacquer

Garner, Sir Harry. *Chinese Lacquer.* London and Boston: Faber and Faber, 1979.

An excellent study of the history and techniques of Chinese lacquer, including related techniques in neighboring regions.

Kuwayama, George. *Far Eastern Lacquer.* Los Angeles: Los Angeles County Museum of Art, 1982.

The introduction to Chinese lacquer includes an excellent survey and assessment of Chinese archaeological excavations.

Lee Yu-kuan. *Oriental Lacquer Art.* New York and Tokyo: Weatherhill, 1972.

All of the lacquer objects given by Dr. Arthur M. Sackler to the Sackler Gallery are illustrated and discussed in this book.

Watt, James C.Y. *The Sumptuous Basket.* New York: China Institute in America, 1985.

Two lacquers in the Sackler Gallery are included in this catalog, which discusses the history of Chinese baskets and their decoration with lacquer.

Painting

Bush, Susan. *The Chinese Literati on Painting.* Cambridge: Harvard University Press, 1971.

Provides a comprehensive, theoretical background for the understanding of the mainstream of Chinese painting—literati painting.

Cahill, James. *Chinese Painting.* Geneva: Skira, 1960. Reprint 1977.

Provides a comprehensive, readable introduction to the history of Chinese painting. All of the paintings discussed are illustrated in color.

Fu Shen, and Marilyn W. Fu. *Studies in Connoisseurship.* Princeton: Princeton University Press, 1973.

Treats the forty-one Chinese paintings and calligraphy by Shitao (1642–1707) and other artists in the Sackler Gallery in great detail; stresses problems of authentication and issues in connoisseurship.

Lawton, Thomas. *Chinese Figure Painting.* Washington: Smithsonian Institution, 1973. Rev. ed. 1987, in press.

Provides a comprehensive history via the thorough study of fifty-nine Chinese figure paintings in the collection of the Freer Gallery.

Lee, Sherman E. *Chinese Landscape Painting.* rev. ed. New York: n. pub., 1971.

A good general history and framework for the appreciation of Chinese landscape painting.

Loehr, Max. *The Great Painters of China.* New York: Harper and Row, 1980.

A comprehensive, precisely written history of the great masters of Chinese painting.

Siren, Osvald. *Chinese Painting: Leading Masters and Principles.* 7 vols. New York: Hacker Art Books, 1956–58. Reprint 1974.

Although published in the mid-1950s, these seven volumes remain the most ambitious attempt to discuss all of the major issues in Chinese painting history, with more than 800 plates.

Entry and Accession Numbers

Entry Numbers	Accession Numbers	Former Sackler Inventory Numbers	Entry Numbers	Accession Numbers	Former Sackler Inventory Numbers
1	S87.0135	80.3.12	21	S87.0136	80.3.17
2	S87.0121	72.9.23 (S–125)	22	S87.0106	72.9.3
3	S87.0195	81.2.37	23	S87.0117	72.9.19
4	S87.0018	81.2.53		S87.0118	72.9.20
5	S87.0072	70.4.183	24	S87.0107	72.9.4
6	S87.0068	70.2.531	25	S87.0105	72.9.2
7	S87.0100	75.7.8	26	S87.0200a–i	82.2.3
8	S87.0120a,b	72.9.22 (S–124)		S87.0201a–ii	82.2.4
9	S87.0099	75.7.5	27	S87.0016	L68.13.26
10	S87.0132	80.3.5	28	S87.0905	L68.13.31
11	S87.0071a,b	70.4.140a,b	29	S87.0911	72.11.1
12	S87.0127	72.2.328	30	S87.0907a,b,c	L70.16.2
13	S87.0078	70.4.295	31	S87.0909	72.11.13
14	S87.0079	70.4.296	32	S87.0626	J–744
15	S87.0146	81.2.58		S87.0842	J–1483
16	S87.0031	81.2.46	33	S87.0722	J–1272
17	S87.0131	80.3.4	34	S87.0468	J–160
18	S87.0130	80.3.3	35	S87.0734	J–1324
19	S87.0119a,b,c,d	72.9.21	36	S87.0450	J–6
20	S87.0033	72.9.1	37	S87.0449	J–2
			38	S87.0514	J–340

Entry Numbers	Accession Numbers	Former Sackler Inventory Numbers	Entry Numbers	Accession Numbers	Former Sackler Inventory Numbers
39	s87.0880	72.1.26	74	s87.0774 s87.0806	J–1393 J–1434
40	s87.0861	72.1.3	75	s87.0024	J–1442
41	s87.0837	J–1473	76	s87.0814	J–1444
42	s87.0673	J–1002	77	s87.0805	J–1433
43	s87.0566	J–587	78	s87.0028	J–1321
44	s87.0466	J–156	79	s87.0727	J–1313
45	s87.0454	J–98	80	s87.0826	J–1457
46	s87.0706	J–1085	81	s87.0794	J–1419
47	s87.0712	J–1099	82	s87.0807	J–1435
48	s87.0457	J–104	83	s87.0725	J–1311
49	s87.0518	J–352	84	s87.0752	J–1367
50	s87.0701	J–1071	85	s87.0819	J–1449
51	s87.0869	72.1.14	86	s87.0767	J–1386
52	s87.0862	72.1.4	87	s87.0792	J–1417
53	s87.0521	J–357	88	s87.0825	J–1455
54	s87.0464	J–128	89	s87.0726	J–1312
55	s87.0497 s87.0498	J–297 J–298	90	s87.0824	J–1454
			91	s87.0773	J–1392
56	s87.0526 s87.0527 s87.0528 s87.0529	J–379 J–380 J–381 J–382	92	s87.0769	J–1388
			93	s87.0022	v–59
57	s87.0612 s87.0613	J–711 J–712	94	s87.0041	v–108
			95	s87.0060	v–11
58	s87.0469	J–164	96	s87.0053	v–264
59	s87.0482	J–242	97	s87.0040	v–100
60	s87.0881	72.1.27	98	s87.0043	v–380
61	s87.0868	72.1.11	99	s87.0054	v–226
62	s87.0029	J–704	100	s87.0042	v–379
63	s87.0030	72.1.10	101	s87.0046	v–14
64	s87.0604	J–686	102	s87.0034a,b	v–375
65	s87.0645	J–830	103	s87.0038a,b	v–341
66	s87.0598	J–679	104	s87.0056	v–33
67	s87.0683	J–1023	105	s87.0279a,b	v–37
68	s87.0025	J–1410	106	s87.0023a,b	v–316
69	s87.0026	J–1408	107	s87.0063a,b	v–247
70	s87.0697	J–1061	108	s87.0045	v–19
71	s87.0785	J–1409	109	s87.0052	v–342
72	s87.0796	J–1423	110	s87.0001a,b	v–13
73	s87.0801	J–1428			

Entry Numbers	Accession Numbers	Former Sackler Inventory Numbers	Entry Numbers	Accession Numbers	Former Sackler Inventory Numbers
111	s87.0065a,b	v–195	149	s87.0302	v–124
112	s87.0035	v–378	150	s87.0282	v–50
113	s87.0066	v–155	151	s87.0287	v–65
114	s87.0330	v–269	152	s87.0004	v–102
115	s87.0010	v–49		s87.0005	v–103
116	s87.0050	v–53		s87.0006	v–104
117	s87.0062	v–328		s87.0007	v–105
118	s87.0048	v–376		s87.0008	v–106
119	s87.0064	v–411		s87.0009	v–107
120	s87.0059	v–183	153	s87.0011	v–326
121	s87.0051	v–2		s87.0019	v–29
122	s87.0037	v–38	154	s87.0285	v–63
123	s87.0303	v–126	155	s87.0014	v–30
124	s87.0003a,b	v–185	156	s87.0439	72.2.10
125	s87.0329	v–267	157	s87.0418	v–3529
126	s87.0328	v–244		s87.0435	v–3888
127	s87.0055	v–385	158	s87.0413	v–3019
128	s87.0044	v–32	159	s87.0438	72.2.9
129	s87.0058	v–85	160	s87.0437	v–3919
130	s87.0333a,b	v–309	161	s87.0441	72.2.12
131	s87.0047a,b	v–372	162	s87.0436	v–3916
132	s87.0334a,b	v–310	163	s87.0434	v–3820
133	s87.0361a,b	75.5.1	164	s87.0447	72.2.350
134	s87.0352a,b	v–362	165	s87.0364	74.5.15
135	s87.0327	v–227	166	s87.0380	74.5.42
136	s87.0036	v–320	167	s87.0372	74.5.27
137	s87.0049	v–376	168	s87.0396	74.5.75
138	s87.0002a,b	v–80	169	s87.0369	74.5.23
139	s87.0325a,b	v–218	170	s87.0376a,b,c	74.5.33
140	s87.0896	v–111	171	s87.0385	74.5.49
141	s87.0314a,b	v–178	172	s87.0384	74.5.48
142	s87.0326	v–221	173	s87.0390a,b	74.5.61
143	s87.0067	v–193	174	s87.0395	74.5.72
144	s87.0291a,b	v–77	175	s87.0382	74.5.46
145	s87.0039a,b	v–352	176	s87.0377	74.5.35
146	s87.0277	v–24	177	s87.0386a–pp	74.5.50
147	s87.0295	v–91	178	s87.0365	74.5.17
148	s87.0299	v–96	179	s87.0393a,b	74.5.69
			180	s87.0405a,b	74.5.102
			181	s87.0391	74.5.62
			182	s87.0373a,b	74.5.28

Entry Numbers	Accession Numbers	Former Sackler Inventory Numbers	Entry Numbers	Accession Numbers	Former Sackler Inventory Numbers
183	s87.0401a,b	74.5.92	198	s87.0271	76.2.2
184	s87.0404a,b	74.5.99	199	s87.0228.001-.013	72.5.36a–m
185	s87.0407a,b	74.5.104	200	s87.0210	s-in-c XIII
186	s87.0403a,b	74.5.98	201	s87.0227.001-.014	72.5.34a–n
187	s87.0265	72.5.117			
188	s87.0223	72.5.5	202	s87.0209	s-in-c XXIV
189	s87.0224	72.5.6	203	s87.0207.001-.009	s-in-c XV
190	s87.0215	s-in-c I			
191	s87.0225	72.5.12	204	s87.0206	s-in-c XXIX
192	s87.0214	s-in-c II	205	s87.0205	s-in-c XXXII
193	s87.0213	s-in-c III	206	s87.0204.001–.013	s-in-c XXXIV
194	s87.0270.001-.008	76.2.1a–h			
			207	s87.0268	72.5.128
195	s87.0212	s-in-c V	208	s87.0237	72.5.51(s-59)
196	s87.0269	72.5.129	209	s87.0261	72.5.75(s-64)
197	s87.0211.001-.010	s-in-c XII	210	s87.0221	68.5.6
			211	s87.0218	68.5.3

Index

Typeset in Sabon by Graphic Composition, Inc., Athens, Georgia
Printed on Warren Cameo Dull 100 lb. text
by Meriden-Stinehour Press, Meriden, Connecticut
Edited by Karen Sagstetter
Photography by John Tsantes
Designed by Carol Beehler